Performances of Capitalism, Crises and Resistance

Inside/Outside Europe

Edited by

Marilena Zaroulia and Philip Hager
Department of Performing Arts, University of Winchester, UK
Department of Drama and Theatre Arts, University of Birmingham, UK

First published 2015 by
PALGRAVE MACMILLAN

Palgrave Macmillan in the UK is an imprint of Macmillan Publishers Limited, registered in England, company number 785998, of Houndmills, Basingstoke, Hampshire RG21 6XS.

Palgrave Macmillan in the US is a division of St Martin's Press LLC, 175 Fifth Avenue, New York, NY 10010.

Palgrave Macmillan is the global academic imprint of the above companies and has companies and representatives throughout the world.

Palgrave® and Macmillan® are registered trademarks in the United States, the United Kingdom, Europe and other countries.

ISBN 978–1–137–37936–8

This book is printed on paper suitable for recycling and made from fully managed and sustained forest sources. Logging, pulping and manufacturing processes are expected to conform to the environmental regulations of the country of origin.

A catalogue record for this book is available from the British Library.

A catalog record for this book is available from the Library of Congress.

Typeset by MPS Limited, Chennai, India.

Contents

List of Illustrations

Acknowledgements

The editors' first and biggest thank you goes to every contributor to this book. This project would not have been completed without the critical rigour, commitment to scholarship and performance, engagement with the wider context of 'crisis' and passion that each one of you brought into the process. For your time, hard work and your challenging essays featured in this volume, we are grateful.

Thank you to the Faculty of Arts' Research and Knowledge Exchange Committee at the University of Winchester for generously supporting the project in various ways, including granting Marilena a semester of research leave. We are also grateful to artists who gave us permission to use their images in our volume. Moreover, the support and advice we received from Paula Kennedy and Peter Cary from Palgrave have been extremely helpful; many thanks to both, as well as to Judith Forshaw for her care and attention during the copyediting stages.

This has been a lengthy but rich process that all of us in the Inside/ Outside Europe Research Network shared with a number of people, who we would like to thank. Our conversations with Sophie Nield, Mustafa Dikeç and Joe Kelleher in two of our workshops inspired, challenged and helped us extend our thinking. Discussions with Marios Chatziprokopiou, Simon Parry, Eleftheria Ioannidou, John London and Fahim Alam in two events organised by the network in 2013 and 2014 were also very helpful as the project was developing. Thanks also to Mandy Bloomfield, Grant Tyler Peterson and Joel Anderson who joined our dialogues at different stages in the research process.

We would also like to acknowledge the generous feedback of those who attended events organised by the network as well as conference papers in Greece, UK and the Netherlands, and Philip's and Marilena's talks at the Terminal (Bermondsey, London) and at the University of Kent in autumn 2013. A special mention goes to these events' organisers: Something Human Collective and Peter M. Boenisch, David Roesner and the ETRN. We are also grateful to friends who introduced us to other friends, helping us build the Inside/Outside Europe Research Network – Ozlem Unsal and Natasha Siouzouli in particular.

The editors and some of this volume's contributors met in the 2000s as postgraduate students at the Drama and Theatre Department of Royal

Holloway University of London, a rich environment that left a mark on our thinking. Marilena and Philip would like to extend a personal thanks to Chris Megson for mentoring and supporting us through our doctorates and in the first difficult years as early career academics.

A last word of gratitude goes to friends, families, companions and comrades – to those close to us for helping in more ways than could ever be acknowledged.

Notes on Contributors

Rachel Clements is a Lecturer in Drama, Theatre and Performance at the University of Manchester, where she specialises in contemporary British playwriting and performance. She has published on hauntology and British theatre in *Contemporary Theatre Review* and in an edited collection on *Theatre and Ghosts* (Palgrave, 2014). She is one of the convenors of the TaPRA Performance, Identity, Community Working Group.

Emma Cox is a Lecturer in Drama and Theatre at Royal Holloway, University of London. Her work examines human migration and object mobility in performance, activism and new museology. She also has research interests in postcolonial and cross-cultural productions of Shakespeare and Jonson. She is the author of *Theatre & Migration* (Palgrave, 2014) and the editor of *Staging Asylum: Contemporary Australian Plays about Refugees* (Currency Press, 2013). Her work has been published in books such as *Shakespeare Beyond English: A Global Experiment* (Cambridge University Press, 2013) and *The Alchemist: A Critical Reader* (Bloomsbury, 2013) and in journals including *Theatre Research International* and *Shakespeare Studies*.

Cristina Delgado-García teaches at the University of Leeds and is a member of two international research projects: 'Ethical issues in contemporary British theatre since 1989: globalization, theatricality, spectatorship', funded by the Spanish government (FFI2012-31842), and 'Representations of precariousness in contemporary British theatre', financed by the German Academic Exchange Service. She has published on Sarah Kane and Tim Crouch, and her monograph on contemporary renegotiations of character and subjectivity in British theatre is forthcoming with De Gruyter as part of the Contemporary Drama in English Studies series. Cristina was one of the thirty-six performers in Quarantine's *Summer.* (2014).

Marissia Fragkou is Senior Lecturer in Performing Arts at Canterbury Christ Church University. Her research interests include feminist nomadic politics, ethics of responsibility, precarity, and citizenship in contemporary British and European performance. She has published essays on debbie tucker green, Stan's Cafe and Rimini Protokoll in the

journals *Contemporary Theatre Review* and *Performing Ethos* and in volumes on contemporary theatre.

Louise Owen works as a Lecturer in Theatre and Performance at Birkbeck, University of London. Her research examines contemporary theatre and performance in terms of economic change and modes of governance. Her writing has been published in *Performance Research*, *FRAKCIJA*, *Contemporary Theatre Review* and *RiDE: The Journal of Applied Theatre and Performance*. Recent publications explore site-specific performance, forms of immersive art and theatre, performance and post-feminism, and histories of community theatre in London. She is preparing a monograph entitled *Agents of the Future: Theatre, Performance and Neoliberalism in Britain*. She co-convenes the London Theatre Seminar.

Giulia Palladini is a researcher and curator in Performance Studies, currently an Alexander von Humboldt fellow at the University of Erfurt. Her main research interests concern performance labour, free time and modes of production in performing arts. She co-curated the international project *Affective Archives* (Vercelli, 2010) and the lecture series *Living Rooms* (L'Aquila, 2011) and has taken part, as a theorist, in several international art projects, such as *Taking Time* (Helsinki, 2013) and *Experimenta/Sur* (Bogotà, 2014). Her work has been published in several international journals, and her first monograph, *The Scene of Foreplay: Theatre, Labor and Leisure in 1960s New York*, is forthcoming.

Florian Thamer studied Theatre Studies and German Literature in Berlin. Since 2011 he has been working as a Research Associate for the International Research Center 'Interweaving Performance Cultures' at Freie Universität Berlin. In his PhD thesis he examines theatrical strategies of commercialization in the modern global football business. In 2011 he co-founded the collaborative network Europäische Gemeinschaft für Kulturelle Angelegenheiten (EGfKA or European Community for Cultural Affairs) together with other scholars and artists. For EGfKA, he has co-conceptualized various workshops and formats, including the performative political discussion format 'Europäische Depeschen' to bring people together who are interested in either arts or politics.

Myrto Tsilimpounidi is a social researcher and photographer. Her research focuses on the interface between urbanism, culture, and innovative methodologies. She is a post-doctoral fellow at the University of East London and the co-director of Ministry of Untold Stories. Recent publications include 'Performances "in crisis": what happens when a

city goes soft?' for *City* and 'The disappearing immigrants: hunger strike and invisible struggles' for *Journal of Theory in Action*. She is the co-editor of *Remapping 'Crisis': A Guide to Athens* (Zero Books, 2014), a book on crisis and its urban manifestations.

Tina Turnheim studied Theatre, Film and Media Studies in Vienna and Berlin. In 2012, she was awarded a scholarship from the International Research Training Group 'Interart Studies' at Freie Universität Berlin. She is currently writing her dissertation, asking if and to what extent performances can initiate and anticipate (political) imaginations, perceptions and practices reaching beyond the present state of things into an unleashed alternative future. After multiple research stays in crisis-ridden Greece, she co-founded the collaborative network Europäische Gemeinschaft für Kulturelle Angelegenheiten (EGfKA or European Community for Cultural Affairs) together with other scholars and artists. In March 2013, EGfKA was invited to work at the occupied and self-organised Embros Theatre in Athens, where they held a workshop that became the basis for their theatre piece *Fatsa/Koina: Athen* (premiered in Mülheim in July 2013).

Aylwyn Walsh is a performance-maker and scholar working on the arts and social change. Her work is concerned with exploring the intersections of interdisciplinary methodologies. She is involved in projects on performances in prisons as well as an international network on the arts and interdisciplinary social justice. She lectures at the University of Lincoln and is artistic director of Ministry of Untold Stories. Recent publications have appeared in *Contemporary Theatre Review, RiDE: Journal of Applied Theatre and Performance, Journal for Applied Arts and Health* and *South African Theatre Journal*. She co-edited *Remapping 'Crisis': A Guide to Athens* (Zero Books, 2014).

Introduction: Europe, Crises, Performance

Marilena Zaroulia and Philip Hager

'London-Athens-and-Berlin-we-will-fight-we-will-win': imagine the slogan reverberating as protesters walk down London's Fleet Street in May 2012.[1] The chant of struggle and victory connects the streets of a financial centre of the developed world, the 'new capital of Europe' (Rachman 2012), and the locus of a potential Eurozone contamination. An invisible thread connects London, Berlin and Athens – three cities with loaded past and complex relations to the formation of the European idea – and their people; this diagonal line, we argue, is instrumental for understanding current articulations of the European idea(l) and its Others, the tension between centre and periphery, Old and New Europe, Europhiles and Eurosceptics.[2] This book sets out to understand the role of performance in the making of contemporary, in-crisis, European identities by presenting perspectives from the London–Berlin–Athens axis while also engaging with questions of crisis as it ripples beyond the borders of Europe. We propose that the 'inside/outside Europe' conundrum, which marked the tone of the post-2008 Eurozone crisis, reframes Europe, both the idea and the geopolitical formation, as at once exclusive and privileged. The recent uses of this dichotomy point to the discursive value and in-crisis permutations of notions of *inside* and *outside*; the May 2012 slogan attests to such shifts insofar as the 'we' who will ultimately rise victorious is juxtaposed with an imagined 'them'. But who is 'we'?

'One protagonist with 103 heads': this is the German theatre collective Rimini Protokoll's description of the chorus of 103 amateurs in their 2010 meditation on democracy in its mythical cradle, *Prometheus in Athens*. In her chapter, Marissia Fragkou discusses this work as an intervention on European myth-making processes, as the performance invites the inclusion of repressed and invisible Others in the fabric of a plural,

future Europe. The amateur stage actors were 'experts' in their lives as Athens' citizens. There, in the summer of 2010, 'we' stand onstage as a city; in spring 2012, 'we' walk London's streets, but this imagined 'we' seems to extend beyond the city's limits. As bodies occupy and voices overpower habitual cityscapes, this 'we' comes into being as collectivity, performing indignation and solidarity with other Europeans. It embodies a diverse, direct-democratic, popular and urban subject. Yesterday in London, tomorrow elsewhere; 'we' shapes temporary communities but 'we' stands firmly against the neoliberal European 'we', that is rational, singular and best mirrored in the European Union's (EU's) material sign of integration, the single European currency. By expressing an irrational, passionate vision of the world, by producing a performative multiplicity, 'being a part without exactly being a part' (Butler and Athanasiou 2013: 155), this collective 'we' performs a monstrous (yet ridiculous) threat to the EU's orthodoxy. *Performances of Capitalism, Crises and Resistance* maps the performative re-turn of such multiplicities, while considering the methodological challenges that performances of crises and crisis as performance pose for our discipline.

Performance, writes Guillermo Gómez-Peña, 'as an artistic "genre" is in a constant state of crisis, and is therefore an ideal medium for articulating a time of permanent crisis such as ours' (2000: 9). Crisis has been a recurrent trope marking the European and global *zeitgeist* since the Lehman Brothers collapse in September 2008. This book is concerned with the intersections of crisis and performance in quotidian and artistic terms. On the one hand, the crisis brought about a 'state of emergency', where debt-ridden populations were inflicted with collective guilt, while sacrifices were deemed necessary for a return to 'normality'. A glossary of 'sticky' (Ahmed 2004) terms, metaphors of natural disaster, plague and illness and geographies of productivity or laziness spread across Europe. This is no novelty: Walter Benjamin, writing in 1940, in the midst of another capitalist crisis when similar metaphors and discourses were thriving, invites us to look at crises from a quite different perspective: '[t]he tradition of the oppressed teaches us that the "state of emergency" in which we live is not the exception but the rule' (1999: 248). On the other hand, performance, both as creative and economic process and product, as labour in the theatrical frame and beyond, in its ephemerality and its relational, intimate and affective registers, is bound to be precarious – in crisis. Responding to Benjamin's formulation of the 'state of emergency' and understanding performance as that 'which uses the condition of crisis as its essential trope [...], that contains its struggle within the making and its articulation' (Delgado and Svich 2002: 6–7),

Performances of Capitalism, Crises and Resistance does not seek to fetishise or lament Europe, nor to construct another European myth; rather, we ask whether and how performance can unsettle normative narratives on crises and inside/outside binaries.

Metaphysics of Europe

In the midst of a crisis that led philosopher Étienne Balibar (2010) to argue that 'unless it finds its capacity to start again on radically new bases, Europe is a dead political project', the Nobel Committee's unexpected and controversial decision to award the EU with the Prize for Peace attempted to restore faith in the European project. In October 2012, the Committee saluted the EU for transforming Europe from 'a continent of war to a continent of peace' (Europa 2012), fulfilling its mission as laid out in the 1951 Treaty of Paris that founded the European Coal and Steel Community, a first post-Second World War step to a united Europe:

> [T]o create by establishing an economic community, the basis of a broader and deeper community among peoples long divided by bloody conflicts and to lay the foundations for institutions which will give direction to a destiny henceforward shared. (EUR-Lex 2014)

Cloaked in a narrative of peace and reconciliation and a pledge to produce a community of 'shared destiny', this Treaty and the subsequent 1957 European Economic Community's (EEC's) foundational Treaty of Rome reveal how an economic basis consolidates such a political union. Further, the transition from the EEC to the EU in the 1980s and 1990s coincided with the rise of neoliberalism; this was a synergy that defined the shape of many European institutions, including theatres, as Louise Owen shows in her reading of the historical intersections of crisis, capitalism and ideology in the foundation and repertoire of the Royal National Theatre of Great Britain.

Caught between crisis and celebrations, post-award commentary highlighted the EU's role in safeguarding 'the common interest of our citizens' (Barroso 2012). An exclusive and excluding logic emerges in these words, assuming economic and cultural commonalities among Europeans that only Brussels' officials can protect. This logic marks and is marked by what we consider a dominant factor of the current crises: integration, both as a centralised transnational mode of governance (see Delanty 2014; Delanty and Rumford 2005) and a performance of *one* European consciousness.

The Euro promotional campaign launched by the European Central Bank (ECB), featuring slogans such as 'a piece of Europe in your hands', combined with a representation of the European Commission (EC) as 'objective and non-political', was instrumental for the spreading of what Cris Shore has termed a 'Cartesian rationalism': the Economic and Monetary Union (EMU) appeared 'objectively persuasive', since, 'given the "right information", the citizen will reach the same conclusions as the Commission' (2000: 118). Initially conceived as a 'by-product, and part of the mechanism, of the Cold War' (Balibar 2002b: 80–1) but having ostensibly moved on to a 'united in diversity' sensibility, the EU continued shaping binary, inside/outside, centre/periphery dichotomies, excluding those that did not wish to adhere to its expert knowledge, which amounted to cases of silencing the European public sphere. For example, the failure of ratification of the early 2000s Constitutional Treaty, the subsequent 'period of reflection for Europe' and its amendment into the 2007 Lisbon Treaty are symptomatic of the lack of a firm political basis for the Union; the post-2008 European crises are as much a manifestation of the global financial crash's domino effect as of the EU's crisis of legitimacy. Richard Bellamy and Dario Castiglione argue that, in the EU's bureaucratic, administrative and legal maze – a 'complex polity [...] with no single hierarchy and no overarching authority to which all other powers are clearly accountable' (2005: 298–9) – bodies of representation do not actually hold any power: *this* constitutes the EU's democratic deficit.

Paraphrasing the famous dictum of Jean Monnet, one of the Union's 'founding fathers', the last two decades solidified the making of Europe and European citizens. In the early 1990s, Europeans were exposed to an awe-inspiring, majestic discourse about the EU; the words of Yves-Thibault de Silguy, Commissioner for Economic and Monetary Affairs, exemplify this semi-religious tone that defined the ways in which the integrated Europe was imagined:

> [A]rchitects and masons busying themselves around an edifice, while onlookers must wait until it is completed before they can appreciate its quality. All are laying the stones of a cathedral, the design and majesty of which will only be appreciated by our successors. [...] This is the secret of the European alchemy initiated by the founding fathers: the 'great work' is achieved in stages. (quoted in Shore 2000: 2)

Technocrats and expert knowledge were elevated to a mystical status, while Europe's pluralism and diversity were contained in a singular shape, projected on European cityscapes. This is a new, populist stage of

imagining the European idea, as EU elites interpreted the '"Europe idea" to the European laity', often employing Christian references, while 'the "European citizen" [remained] largely a rhetorical construction' (2000: 119, 120).

Europe, as concept, idea, figure, image (cf. Passerini 2002; 2007; Gasché 2009; Laera 2013), has often been mystified. Edmund Husserl's 1935 Vienna lecture 'Philosophy and the Crisis of European Humanity' marks a milestone for the essentialist metaphysics of Europe. For Husserl, Europe is 'a spiritual shape', 'intimately tied to the [...] promise of reason and rationality' (Gasché 2009: 1), while its separation from such principles of origin led to the crisis that his contemporaries were facing, the rise of Nazism. More than fifty years later, responding to Paul Valéry's 1919 imagining of Europe as 'a headland', a 'head [...] turned to one side [which] scans the horizon, keeping watch in a determined direction' (Derrida 1992: 20, 21–2), Jacques Derrida's *The Other Heading: Reflections on Today's Europe* deconstructed this spiritual basis of Europe. Nonetheless, the idea of Europe as conceived by (among others) Husserl and Valéry, this 'dated', 'traditional discourse' (1992: 27), was instrumental in shaping Europeanness under federal Europe. Luisa Passerini returns to the 1973 Declaration of European Identity, tracing the metaphysics of Europe in the rhetoric of the EEC, which emphasised the 'basic necessity to ensure the survival of the civilisation which [the Nine] have in common' (quoted in Passerini 2007: 80). Such rhetoric informs post-1985 cultural policy, which 'was conceived [...] as an instrument to build a cultural identity for the Europe of the European Union' (Sassatelli 2002: 436; see also Sassatelli 2009).

The latest incarnation of the metaphysics of Europe is a 'divine Europe' (Baudrillard 2005), which is tied up with the premises of neoliberal rationality: a political constellation where '[e]verything is decided in advance, and consensus is all that is being solicited' (Baudrillard 2005). As the 'temple of late modernity' was completed, Europe returned to a model of 'federal Empire' (Bellamy and Castiglione 2005: 298–9), which exposed a blank, void space where Europe is imagined as 'a community of fate' (2005: 306) like the modern nation. Although EU federalism often appears to threaten national sovereignty, thus offering a platform for nationalist or fascist ideologies (most recently demonstrated in the 2014 European elections), in essence Europe and the nation share 'obscurantism' as a common characteristic. Gerard Delanty writes:

> Though the idea of Europe rarely evokes the same degree of irrational reverence and deification that the ideal of the national community can demand, it is also ultimately based on an obscurantist

interpretation of community: a fantasy homeland that goes hand in hand with a retrospective invention of history as well as a moralisation of geography. (1995: 8)

This 'fantasy homeland' was perhaps an object of desire for the rectors of the European edifice, which has now proved to be broken. This fantasy homeland, Europe as an *a posteriori* invention, was what Europeans were urged to wait for. The advent of the crisis exposed the conflations of past, present and future in the imaginings of Europe, revealing that ultimately it is not 'the subject of history but its product' (1995: 3). What the crisis does with regard to temporality, writes Giulia Palladini in her contribution, is to expose 'a time dispossessed of a future and yet projected towards – and marked by – a horizon of potential, forthcoming failure and collapse'. This paradoxical encounter with the future, as both prescribed and cancelled, may transform into the desire for and anticipation of a messiah. However, Athena Athanasiou's question to Judith Butler on the performative potentiality of an 'incomplete, disjunctive, and radically open temporality (predicated as it is on the negative messianic)', which echoes Benjamin's historical materialism 'profoundly inscribed by [...] an unyielding insistence on the unpredictable openness of history' (Butler and Athanasiou 2013: 128–9), gestures to a different conceptualization of time in crisis. The temporality suggested here implies resistant performatives, which reinvent the concept of time or, as Delgado-García puts it in her essay on prefigurative politics, 'the possibility for renegotiating what we understand as "the right moment", "the right conditions" for something to happen'. Responding to Derrida's paradoxical and ostensibly Eurocentric call, this is the moment 'we must fight for what of Europe remains irreplaceable for the world to come, for it to become more than a market or a single currency, more than a neo-nationalist conglomerate, more than a neo-armed force' (2004: 410); Derrida's 'Europe of Hope' requires a resistant rhythm or momentum, rather than the right moment for 'a fine day to come'. In such encounters with time, the past and its returns as ghosts, hauntings, legacies; the present and its paradoxes; the future and its hopes; all make space for the emergence of a moment that is yet to come but is already now.

European spaces

On 9 November 2009, Berliners, along with the world's political leaders, celebrated the twentieth anniversary of the fall of the Berlin Wall. Berlin

was celebrated as the paradigm of unity, the synecdoche of German reunification and an example of reconciliation at the heart of Europe, while commentators hailed the fall of the Wall as the momentous event that gave birth to a new Europe (Jenkins 2011; *Independent* 2009; *Telegraph* 2009). At the climax of the spectacular celebration, a giant domino, representing the Wall and erected in the old border between East and West, further reiterated this idea: when the domino fell, the space between tiles dissolved and in a symbolic manner so did the space between all European states – of East and West – thus making Europe *appear as* unified. Moreover, Berlin appears as the model European metropolis in terms of its urban development since 1989. Prime examples here are the redevelopment of Potsdamer Platz, the new government buildings and, most prominently, the Reichstag's new glass dome that present an image of transparency (cf. Delanty and Jones 2002: 457–8). Such transparency materialises as an objective political ethic, a rational device based on expert knowledge and delegation of power from the European people to the bureaucratic mechanisms of a federal Europe.

Delanty and Jones acknowledge a parallel growth of the European project and its city stages and observe that Europeanisation features 'in the design of city centres [in the sense] that architecture can play an important part in the reflexive constitution of post-national identity' (2002: 463). While the neoliberalisation of national and transnational institutions coincides, European cities are colonised by the neoliberal doctrine: in *New Europe* (an official EU publication), Vanda Knowles suggests that 'sustainable and inclusive growth in Europe will only be achieved through smart, sustainable and inclusive cities' (2012). Here emerges one of the paradoxes of the economic development of the Union: in cities under capitalist urbanisation what is championed as a tool for economic growth is in fact the 'root' of crisis (Harvey 2012: 27–66). Myrto Tsilimpounidi reverses this paradox, turning her attention to another: she proposes that under crisis, waste – a symptom of urban life – can be managed in 'illicit' ways that challenge capitalism's promise of perpetual growth and expose the blind spots in urbanisation. Tsilimpounidi's argument echoes Henri Lefebvre's critique of the seemingly scientific character of urban development, which conceals the ideological and class character of capitalist urbanisation and 'blocks a view of the horizon, a path to urban knowledge and practice' (2003: 160) – an argument with important purchase when considering the naturalisation and consolidation of the neoliberal doctrine in European cities through the privatisation and gentrification of public space and increasingly deregulated conditions of labour. As in the example of the Reichstag, the ideological drives of such processes are

camouflaged under architectural transparency. When (urban) popula-
tions are dominated by the capitalist class, David Harvey contends, so are
'their cultural and political values as well as their mental conceptions of
the world' (2012: 66). The role of the urbanist, another expert of capital-
ist scientificity and European technocracy, is to prescribe everyday life by
discursively producing the spaces in which it occurs.

As the post-2008 global capitalist crises unfold, increasingly 'contami-
nating' the EU, new subjectivities seem to emerge out of the aggressive
restructuring of capitalism, reshaping class struggles. The rise of unem-
ployment, debt, and exclusion in urban and suburban constellations is
making an increasing number of people abandon urban spaces.[3] Cities
are the stages of the crisis where urban and deviant – although not in
the least bit homogeneous – subjectivities appear in public. Aylwyn
Walsh emphasises the significance of appearance and performance in a
particular kind of urban space, what she terms 'meanwhile spaces'; for
her, such performances of appearance and disappearance are pertinent
for approaching the 'wider issue of Europeanness'. A series of questions,
then, emerges about subjects of resistance and their being and appearing
in space; about non-urban environments as places (and processes) of cri-
sis and resistance; about imagining 'other' (non-urban and non-capitalist)
spaces where Other (non-imperialist, non-technocratic, non-parochial)
European identities can be performed. For Lefebvre, writing in 1970,
the urban society was a *'virtual object'* of inquiry; a *'possible object*, whose
growth and development can be analyzed in relation to a process and a
praxis' (2003: 3). *Performances of Capitalism, Crises and Resistance* looks
at performance of and within London, Athens and Berlin as a *virtual
object*, both a conceptual device and a practice. Performance, we argue,
as strategy and analytical method, addresses the possibilities of becom-
ing European beyond the process and praxis of urbanisation and within
the normative and single/singular narratives of European integration and
federalism; that is, by becoming Other. Performance, therefore, is our
tactic towards an analysis of urban Europe and its transparent spectacles,
while performances operate as imaginings of 'other' spaces of crisis and
resistance, and signifiers of the temporal and spatial 'elsewhere'; towards
new forms of sustainable, solidary and non-objectified cohabitation.

Performance as vanishing mediator

Σου γράφω αυτές τις λέξεις γιατί το ξέρω πως αυτές οι μέρες θα ξεχαστούν
(I am writing these words to you, because I know these days will be
forgotten.)

Written on the wall of Athens' theatre Embros, occupied and run by a collective of artists and citizens since late 2011,[4] the words of the unknown Athenian citizen capture the immediacy of the current moment and in many ways articulate this project's impossibility. If, as Peggy Phelan (1993) has famously argued, performance is the art of disappearance, the attempt to produce a collective account of performances of crises and crisis as performance, while the crises are still ongoing, is unavoidably bound up with discourses and methodologies that negotiate disappearance. In another context, prefacing the publication of *The Other Heading*, Derrida ponders whether and how the two pieces that were originally conceived as newspaper articles[5] – that is, as reflections on events 'at that date, on that day' – might appear 'dated' in 1991 (1992: 3). Accordingly, performance, both in theatrical and quotidian settings, is read as a trace of a present that is soon becoming past, while indicating a gesture towards the future. This book – aspiring to engage with methodologies of historicizing and responding to the contemporary moment – can be approached as an artefact of the present or a souvenir from a time that is soon to become past.

Conversations with regard to *Inside/Outside Europe* began during the last months of 'revolutionary' 2011, but the project was shaped by the knowledge of the aftermath: the end of the Occupy movements, the increasingly violent repression of protests and industrial actions in the European periphery, and the acceleration of the EU's singular, monetary logic. Nevertheless, a narrative of ostensible hope for the end of the crises seems to be emerging among EU technocrats and being reproduced by European governments. A synchronic reading of the crisis, its performances and consequences presents multiple challenges for the contributors involved in this book; as we cannot foresee what will happen next, we are writing this book from a state of limbo, where the ruptures of the previous years have already been veiled as deviant practices of irrational, dissatisfied and 'anti-European' minorities. Our aim is not to offer a comprehensive account of European crises but to make a contribution to a growing conversation on Europe and performance, which so far has studied European theatre directors and collectives (Kelleher and Ridout 2006; Delgado and Rebellato 2010; Kear 2013), the politics of Europe in popular performance (Fricker and Gluhovic 2013) or the adaptation of canonical texts (Laera 2013), and post-war memories and recent traumas in New Europe (Jestrovic 2012; Gluhovic 2013).

Chapters in this volume examine 'representations and images of Europe produced outside of Europe, as well as those created by people who want to be at the same time European and not European' (Passerini

2002: 32), thus illustrating Balibar's argument that 'there exist no absolute border lines because Europe as such is a borderline' (2004: 219). This book, then, looks at performance as the disappearing borderline that may produce new collective subjectivities and webs of solidarity beyond monolithic definitions of Europeanness, acknowledging that Europe 'is a superposition of heterogeneous relations to the other histories and cultures of the world [...] which are reproduced within its own history and culture' (Balibar 2004: 219). Employing performance, we address questions of disappearance as a constitutive element of the performance event and, in the context of crisis, as a mediator of resistant practices, a 'vanishing mediator':

> This is the figure [...] of a *transitory* institution [...] that creates the conditions for a new society [...], albeit in the horizon and in the vocabulary of the past, and by rearranging the elements inherited from the very institution that has to be overcome. [...] It creates therefore the conditions for its own suppression and withering away. But without this 'vanishing' mediation no transition from the old to the new fabric of society would have been possible. (2004: 233)

Balibar questions the role of the European intellectuals, proposing that they can play the part of such a 'vanishing mediator', 'necessary but without monopoly', 'borderlines themselves'. For us, universities by nature occupy a borderline position, *inside* hegemonic, civic structures but also *outside*, as they are bound to critique these structures. In this moment of crisis, academics occupy an inside/outside position; it may appear that academia functions *outside* the crisis, documenting and critiquing its different aspects elsewhere. Yet, given shifting funding structures, precarious work conditions and mounting pressures for financially viable institutions, it seems that universities are sites of crisis too. But what is the labour that we put into our institutions occupying this inside/outside position in society? We replicate systems of productivity, debt and payback that have stalled European state economies; stress, disillusionment and frustration are all symptoms of the pathology of crisis. Can we think of universities as sites of struggle? And, if so, how?

Often returning to such questions, a group of early career academics – mainly from theatre and performance studies, and that initially gathered in February 2013 at the University of Winchester – set out to explore the multiple facets, aspects, nuances and performances of crises, capitalism and resistance. We embarked on a discussion that we continue in the following pages and, we hope, extends important work in the

field (Kershaw 1992; 1999; Kelleher 2009; Nielsen and Ybarra 2012; Lichtenfels and Rouse 2013; Hopkins *et al.* 2009; Hopkins and Solga 2013). Since the project's start, we were committed to making time for intellectual work that resisted the accelerating rhythms and the changing landscape of contemporary universities, mainly in Britain, where most of the book's contributors are based. In a series of three workshops ('On Europe', 'On Commons', 'On Performance, Identities and Ruptures'), the Inside/Outside Europe Research Network members invited colleagues to dialogue and reflect on issues pertaining to this book's remit: inheriting European myths and the purchase of symbols for European identifications; fixed and porous borders; the value of European cities; subjectivities and social classes amidst crisis; strategies and tactics of resistance; and excessive politics and affects in crisis. In short, we tried to make sense of what crisis makes appear lost and what remains. Following Rebecca Schneider's response to Phelan – that performance hosts disappearance as 'materiality' and, in doing so, it 'challenges loss' (2011: 102–5) – we hope that this project will make a contribution to an understanding of performance's role in this age of disappearance.

Chapter breakdown

Although the eleven chapters could be grouped according to thematic resonances or geographic focus, we are employing three terms that emerged during our conversations in the workshops to structure the book: *Returns*, *Paradoxes* and *Interpreters*. These terms lend themselves as entryways into crisis. Performance thus appears as that which re-turns crisis and its returns; that which makes visible the paradoxes of crisis and in doing so becomes a paradox itself; that which interprets and is interpreted by crisis.

Chapters in the book's first part negotiate the notion of return in temporal and economic terms: return as repetition and return as profit. Palladini's essay deconstructs how, since the eruption of the recent crisis, the Weimar Republic's ghost has been repeatedly evoked as a prelude to disaster. Via an analysis of a 2009 performance intervention/collective viewing of the film *Kuhle Wampe*, Palladini invites the reader to return to the 1930s, opening up an alternative perception of temporality and revolution. The point of departure for Philip Hager's chapter is 'the indebted man' as another form of haunting. Drawing on Deleuze and Guattari's treatise on nomadology and walking through revolutionary or quotidian moments, Hager argues that the return of class struggle in the European neoliberal city can be seen in its conflicting rhythms.

Tsilimpounidi's ethnographic rhythmanalysis of Athens concludes this first section by turning our attention to another ghost: that of the 'illicit market'. Refusing to read urban debris either as junk or as aestheticised prop, she finds value's re-turn in scroungers' marginal performances.

Essays in the second part negotiate structural anomalies, paradoxical logics and practices symptomatic of the crisis; in short, that which both challenges and reproduces the conditions of the crisis. Returning to Brecht's *Lehrstück* theory, Florian Thamer and Tina Turnheim offer a manifesto for 'making political theatre *politically*' in a context of austerity. Starting from the paradoxical position of care work, they read theatre as a laboratory where a politics of solidarity is rehearsed. Responding to Jacques Rancière's 'politics of aesthetics', Delgado-García's analysis of Quarantine's *Entitled* adds to the debate on the place of political theatre in crisis. She argues that the piece, particularly through its use of amateurs, unsettles 'sensible regimes' of agency, togetherness and value. Owen's chapter also looks at British theatre but she turns her focus to the nation's main stage, the National Theatre, and its transnationalism. She reads the paradox inherent in the NT's repertoires of recent national crises, such as multiculturalism, demonstrating how the institution's history precedes such vocabularies of crisis. Concluding this part, Walsh questions the position of the racialized Other in a second kind of border, which paradoxically appears in inner-city geographies. Looking at La Pocha Nostra's 2013 residency in Athens, she identifies performance's misfires in radical border crossings in crisis.

Chapters in the third part offer different acts of interpretation *of* crisis and interpretation *as* crisis; interpretation itself becomes a performance, as contributors quote, translate and echo marginal, outsiders' perspectives and attitudes. Rachel Clements reads four stage and screen, fictional and documentary framings of the 2011 English riots as interventions in an ongoing struggle for justice. Deconstructing dominant readings of the events as symptoms of 'pure and simple criminality' (in the words of the British prime minister), she points to the complex histories and 'geographies of grievances' shaping the subjects of the riots. Fragkou continues the discussion of how performance apprehends the invisible, precarious Other in the urban fabric. Dislocating the Prometheus myth from a European theatre festival context, she notes the actions of the amateur onstage experts/citizens producing a complex stage geography that translates the Greek present. Geographies of dispossession are also the focus of Marilena Zaroulia's reading of a series of public art installations, made from the remains of migrants' boats and staged in emblematic European sites. Drawing on Foucault's exploration of heterotopias, she contends

that, by locating the boats' remains in such spaces, what appears is an ambiguous and often problematic monument to the migrants' voyage. Emma Cox concludes the conversation on remains, as she studies complex debates of cultural diplomacy for the repatriation of human remains to indigenous communities, thus turning the lens to the crisis of the Museum and of what is included and of value in European visual economies. This chapter marks a departure from the locations that this volume covers, as the author interprets notions of 'debt' and 'return' beyond their capitalist frame and positions 'crisis' in locations outside yet inextricably linked to the European landscape. Cox's contribution invites the reader to consider colonialism's legacy in the shaping of what can be read as a new phase in European metaphysics, which she terms 'post-rational'.

'London-Athens-and-Berlin-we-will-fight-we-will-win': the memory of a recent past returns as a ghost, piling up on top of all other ghosts – echoes from distant pasts: unemployment, xenophobia, war, failure. There may be something 'ridiculous' about recording the rhythms of bodies/rhythms of dissent; mapping the spaces they produce, spaces of resistance; following the temporalities they inscribe, temporalities of revolution.

'Not that fast! Revolution?', the cynic might stop us there.

We find ourselves in the paradoxical position of writing about this 'ridiculous' subject of resistance in (capitalist) crisis. The romantic and the cynic debate in our heads: does it really matter if we write? After all, ours is the work of an interpreter.

Notes

1. The protest was organised by Occupy London Stock Exchange (LSX) to mark the first anniversary of the 15M movement of the Spanish *indignados*.
2. The Eurobarometer 73.4 (European Commission 2010) records citizens' responses to the question 'How much do you trust the EU?' As the Eurozone crisis erupted, the three countries at the bottom of the list were Germany, Greece and the UK.
3. This is particularly true of the countries of the EU periphery most hit by the economic crisis (for example, see Smith 2011).
4. For more on the occupation of Embros Theatre and the model of politics it proposed, see Argyropoulou (2012).
5. The articles were 'The other heading: memories, responses and responsibilities' (1990) and 'Call it a day for democracy' (1989).

Part I
Returns

1
The Weimar Republic and its Return: Unemployment, Revolution, or Europe in a State of *Schuld*

Giulia Palladini

A spectre is haunting the post-2008 economic crisis – the spectre of the Weimar Republic. This spectre is polymorphous: it appears in a range of different forms and circumstances, and inhabits a transnational space.

First of all, it comes as a powerful image: the synthetic, quintessential image of the 'crisis'. From the pictorial archive of world history, Weimar Germany has made its way into Western collective imagery as the most recognisable visual repertoire of social malaise. Photographs shot in Germany during the period of hyperinflation (1919–23) – those portraying children building paper castles out of packs of worthless banknotes, or the long lines of unemployed workers waiting for the dole at the beginning of the 1930s – offer themselves as familiar references to a recognisable history. In its excessively iconic quality, in its intrinsic memorability, such a history is nevertheless unknown: the phantasmatic past of the economic crisis, a past that was evoked more and more often in newspapers, on television and on the internet as the depression established itself as a social reality, is less an index of historical accuracy than a *memento* – a way to turn memory into a warning.

The spectre of the Weimar Republic, in fact, is not evoked accidentally: its resurfacing acquires specific political connotations according to the different contexts in which it is invited to operate. Returning to the start of Marx and Engels's *Manifesto*, we could suggest that most 'powers of old Europe' seem to 'have entered into a holy alliance' (2012: 33) regarding this spectre, but this time not in order to *exorcise* it (as was the case with the spectre of communism in 1848), but rather to establish it at the centre of a common discursive arena.

How come?

A starting point in understanding this scenario may be the visual repertoire mentioned above. On closer observation, we notice that recognisable images of Weimar Germany are themselves haunted. They are, in fact, not only a visualisation of the crisis in its distant yet tangible reality, grounded in bodies and spaces other than ours. They are also, and inevitably, images pregnant with a future that today has already happened: a future in which the materiality of poverty, social malaise and unemployment constituted the basis of the takeover by National Socialism in Germany. Such a future haunts the past of these images, which, for their part, unwittingly provided a prelude to it. Similarly, that future haunts spectators who encounter the images and, for whatever reason, decide to return to them.

Hence, the spectre of Weimar Germany returns not only as an immediate signifier of 'crisis'. It brings with it a peculiar temporality: one of anticipation, and – seemingly – of an ineluctable fall towards the future. That is, from the standpoint of the future, the Weimar hyperinflation of the early 1920s appears to be *always already* a prelude to the 1929 Wall Street Crash: the climax of the biggest financial crisis of the twentieth century. Likewise, the fragile democracy of the Weimar Republic survived in the collective memory first and foremost as a prelude to the rise of a populist, anti-democratic force, and eventually to the establishment of Hitler's dictatorship, which made its way into the Reichstag during the final Weimar years and grounded its consensus in the crisis that Germany's first democracy had proved unable to solve.[1]

In the following pages, I shall interrogate the phantasmatic return of the Weimar Republic in light of the peculiar temporality that it calls forth: a projective temporality par excellence. I suggest that the logic according to which the Weimar Republic 'returns' today is one that establishes a tension between the present and an imminent future: a future to which the present necessarily seems to be a prelude. As I hope to demonstrate, it is precisely on the terrain of this projective temporality that different politics of use, for this return, are taking place.

Which projective temporality?

In a sense, the projective temporality that the spectre of Weimar brings into the discursive arena of the post-2008 crisis doubles the intrinsic temporality of crisis itself: a time dispossessed of a future and yet projected towards – and marked by – a horizon of potential, forthcoming failure and collapse. Alternatively, this horizon has recently been termed 'state bankruptcy', 'ultimate credit crunch', or exclusion from

majoritarian economic and monetary unions (such as the Eurozone). According to this logic, the 'return' of the crisis functions as a vector of the definition of time, doubling and validating the present.

We shall consider this temporality as a form of *political temporality*, insofar as it affects both the individual and the collective body by imposing a continuity of time perception: defining the present as a perpetual falling towards its end. In another respect, it is a political temporality in that it propels political consequences: namely, projecting on the present 'the end of the story' (the economic collapse, the advent of political terror, the danger of the war, and so on) is a way of making the present more responsible for its own events, and at the same time subject to political fatality. It is a way of affirming that it is necessary to reach compromises with the present, *if we do not wish the future to return*. As we shall see, in the wake of the European debt crisis, the projective temporality of the Weimar Republic is employed in conservative discourses precisely to foster or to defend political choices, in the present, as the only possible way of preventing the reappearance of the past.

Weimar's projective temporality, however, can also be regarded as a different form of political temporality. A projective temporality, in fact, is also one of the defining features of revolution: revolution conjures a time yet to come, to which the struggle will lead and for which the struggle shall endure. The temporality of revolutionary songs, for instance, is projective, encouraging the listener to persist in the struggle and moving her to action, imagining another world yet to come – and, in so doing, starting to construct this different future, to establish its rhythm.[2] Bertolt Brecht's political ballads, in this respect, are exemplary: their tune expresses a projection towards the future of the possible in the actuality of the struggle. They inhabited theatre – but also film, or the written page of poetry – as the space of this struggle, looking forward to revolution.

Interestingly, the years of the Weimar Republic, in which Brecht composed his most famous political songs, are also pregnant with images of revolution. The Republic itself was born out of a revolution – the revolution that, between November 1918 and August 1919, put an end to Germany's imperial government. Furthermore, from the start, the history of the first German Republic was marked by the memory of aborted socialist revolutions: the Spartacist Uprising in January 1919, followed by the murders of the two political leaders Rosa Luxembourg and Karl Liebknecht, as well as the attempt to establish a socialist republic in Bavaria that had been instigated by, among others, Kurt Eisner, Ernst Toller and Erich Mühsam (1918–19). Overall, the intense twelve

years of the Weimar Republic are profoundly informed by the horizon of a revolution 'about to come': the socialist revolution in Germany that Soviet Russia thought would follow the 1917 Bolshevik one; the revolution that the German Communist Party (KPD) kept preparing until its final defeat with the advent of Nazism; the revolution that we find conjured up in many political pamphlets, songs and intellectual and artistic works from the Weimar era (see Willett 1996).

Returning to these works, to that horizon of revolution, is also a form of haunting: it is a way to conjure the potentiality of a revolution that never happened in the 1930s, but was conceived as possible. It means welcoming in the present reflections and forms of solidarity long forgotten, and that may be called upon to sustain the struggle in the present, in a different projective temporality, in a new logic of anticipation of the future. As Simone Weil noted insightfully in an article written in summer 1932, early 1930s Germany was a nation in *a state of waiting*: the crisis had precipitated its population into a state of suspense that opened up the potentiality of questioning the very structure of society, looking forward to the future. The future, as it were, had not yet been determined; on the contrary, 'the situation', according to Weil, 'seemed to perfectly meet the definition of a revolutionary situation' (1960: 104), although revolution, in the final stages of the *Republik*, remained latent and never actualised. If history repeats itself, however, this time the 'end of the story' might be imagined as being different: in other words, it is licit to imagine a future in which the hopes of revolution, and the forms of solidarity experienced in the Germany of the 1920s and 1930s, may also return.

Hence, the return of Weimar might indeed be regarded as a more complex phenomenon than it seems at first glance. Or at least I am interested in suggesting that alongside the slanted employment of the Weimar spectre on the part of conservative political parties, there is also a possibility of mobilising this spectre, and the projective temporality it embodies, and reclaiming it for a radically different politics of use – one in which the anticipatory logic of revolution inhabits the present territory of the potential. In what follows, I shall look at the scenario of Weimar's return, investigating first of all the distinctive rhetoric of crisis that informs contemporary politicians' and journalists' discourses in which the Weimar Republic is employed as a powerful analogy for various national contexts. Secondly, I shall turn to the possibility of imagining a different politics of use for such 'return', taking as a starting point an interesting example: the art/research project entitled *Red Channels Meets the Red Megaphone – Kuhle Wampe Revisited*. This took

place in Berlin in July 2011, was organised by the New York-based col-
lective Red Channels, and was hosted in the art space OKK/Raum 29.
The project, whose subtitle, significantly, was *Suicide or Solidarity*, was
conceived as a collective research work around the movie *Kuhle Wampe*,
which had been made in Berlin in 1932 as a collaboration between
several artists including Slatan Dudow, Bertolt Brecht and Hanns Eisler.
The film, which premiered in Berlin on 30 May 1932 and was banned
on 23 March 1933, was a political reflection on unemployment, labour
and solidarity, portraying working-class Berlin life in the Republic's cru-
cial last year. The project proposed by Red Channels was an invitation
to 'reimagine, retrace, remix, reenact, and reload *Kuhle Wampe*' (Red
Channels 2011).

After discussing how the return of Weimar is performed on the stage
of international politics, I shall look at this experiment as a way of
reflecting on the position of Berlin in contemporary discourse on the
crisis: interestingly, in fact, in such discourses Berlin (and Germany
overall) seems to exist only as a spectre, and not as a direct protagonist
in today's history of the 'crisis'. While, on the level of decision-making,
in contemporary discourse Berlin's position appears absolutely cen-
tral, such prominence is radically detached from the Weimar spectre,
which is evoked so often when discussing other European countries.
Intercepting the proposal that Red Channels made to the project's
participants in 2011 – to bring back *Kuhle Wampe* and the historical
moment in which the movie was made as material for study, but also as
the possible basis for playful enactment – we shall discuss the characters
of a potential re-appropriation of such return, in a logic of anticipation
of a revolution that may, indeed, already be starting to happen – most
likely *elsewhere*.

The Weimar syndrome

A brief tour of the landscape of the international press from the last
five years offers diverse examples in which the Weimar spectre is called
upon in explicit dialogue with contemporary politics, functioning as a
strobe light that illuminates portions of the present and projects fea-
tures, attributes and omens upon those portions.

On 5 October 2012, for example, in an interview with the German
newspaper *Handelsblatt*, the Greek Prime Minister Antonis Samaras
compared the recent scenario of Greek democracy with the Weimar
Republic: according to him, the country was not only confronting an
unprecedented unemployment peak, but the social unrest engendered

by the economic situation was key to the rise of dangerous populist movements of extreme left and right,[3] which had even made their way into parliament (2012). Samaras employed the powerful image of pre-Nazi Weimar to present his own government as a crucial opportunity not only to restore the national economy but also to 'save' Greece from an imminent destiny of political chaos. In this scenario, Germany's support to Samaras's commitment to maintain Greece's position in the Eurozone was presented as vital for preventing both economic collapse and the 'return' of extremist politics in the heart of Europe, today bastion of an established social democracy, whose success Germany's wealth is at pains to exemplify (*Zeit Online* 2012).

A few days after Samaras's statements, the comparison between Greece and the Weimar Republic appeared again on the German news, this time in the context of an analysis by the 'Eurozone expert' Wolfgang Münchau (2012). According to the economist, Greece in 2011–12 found itself in a very similar condition to Germany in the 1930s, insofar as the country confronted a situation of high debt (like Germany after World War One, because of heavy war reparations), deflation and the impossibility of exiting the impasse by devaluing its currency, which was tied to a fixed exchange rate. What the rigid link to the gold standard represented for the Reichsmark in the early 1930s, the adoption of the Euro represented today for Greece: a connection to a fixed value that prevented national banks from responding to the economic emergency with a politics of greater monetary flexibility, rather than austerity. Therefore, in polemics with Chancellor Merkel's determination to enforce austerity measures in Europe as a solution to the recession, Münchau's article advised Germany to learn one more lesson from its own history: that the Weimar Republic ended in such economic and political catastrophe after 1929 above all because of its rigid adherence to a standard monetary value. The same mistake, Münchau concludes, should not be repeated today, positing the Euro's value as a heavy burden that all European national economies should carry on the back of their social and political bodies.

Interestingly, a few months later in the *Financial Times*, Münchau evoked Weimar Germany again in relation to another European context. Commenting on Italian politics, shortly before the elections of February 2013, Münchau compared the economist and newly appointed Italian Prime Minister Mario Monti[4] with Heinrich Brüning, the longest-serving chancellor of the Weimar Republic (2013). Just like Mario Monti, Brüning was an expert in finance, and he led a highly unstable governmental coalition between March 1930 and May 1932

that pursued a policy of heavy cuts to public spending and salaries (a reduction of more than 30 per cent in two years), claiming that retrenchment would save Germany from high levels of deficit and debt to the US; meanwhile, living conditions in the country worsened unimaginably.[5] While Italy avoided financial crisis during Monti's tenure in 2011, Münchau rightly suggests that his politics of rigor provoked the growth of the economic crisis in the country.

The comparison between Monti and the 'Hunger Chancellor' had appeared earlier in an analysis by Joseph Halevi, published in the leftist newspaper *Il Manifesto* (2012). Here, too, the reference to Brüning pointed to Monti's inability to realise in time the negative effects of his austerity politics, especially in the absence of a strong demand for symmetrical adjustments among all countries participating in the single European currency. As Maria Grazia Turri points out, the uncanny resemblance between the Italian scenario and the 1928–31 Weimar Republic, however, acquired its most striking features after the most recent national elections (2013). The 2013 electoral results led to conditions in which governance was difficult, since no party achieved a majority: the Five Star Movement, an anti-Europe populist movement (led by a charismatic leader, and refusing to adopt the label of 'party', as did National Socialism at the beginning), gained enormous consensus among those voters disappointed with traditional political parties.[6] Furthermore 'for the sake of the nation', the 84-year-old President of the Republic Giorgio Napolitano was asked by the main political parties – Partito Democratico and Popolo della Libertà – to renew his mandate as an extraordinary measure aimed at strengthening presidential powers and to back a large government coalition led by the democrat Enrico Letta, gathering together both centre-left and right-wing parties. The same logic had characterised the re-election, in 1932, of the 84-year-old German President Paul von Hindenburg, who backed the wide coalition led first by Brüning, then by Franz von Papen and Kurt von Schleicher. Shortly afterwards, this coalition collapsed, leaving the stage to Hitler's first chancellorship, which von Hindenburg reluctantly endorsed.

These comparisons, which vary in their political connotations, are all symptomatic of what sociologists Charles Derber and Yale Magrass have defined as the 'Weimar syndrome', which they summarise as consisting of the following elements:

1. A severe and intensifying economic crisis
2. A failure by majoritarian liberal or Left groups to resolve the crisis

3. The rise of right-wing populist groups feeling economically threatened and politically unrepresented
4. The decision of the conservative political establishment to ally with and empower these right-wing elements, as their best way to stabilize capitalism and prevent the rise of progressive movements against corporations or capitalism itself. (2012)

The use of the term 'syndrome' (designating a group of symptoms that together characterise a specific disease) is significant in the specific context we are observing: curiously, in the public discourse, the European crisis often appeared to be associated with metaphors of plague and illness (spreading across Europe from one country to another), and the related predicament was that the collective body of the continent urgently needed treatment. In this discursive logic, austerity itself was depicted as a necessary medication, able to arrest the imminent contagion.

Interestingly, however, Derber and Magrass develop their analysis of the 'Weimar syndrome' in the context of a reflection on contemporary American politics, when, following the 2012 election, Mitt Romney's Republican Party became increasingly dependent on far right-wing components such as the Tea Party in order to gain electoral consensus. Their definition of the 'Weimar syndrome' suggests yet another remarkable aspect that we should consider: the flexible spectre of Weimar Germany has distinctive transnational characteristics. Not only does Germany today play on the stage of the international debt crisis the part performed by the US in the 1930s, but North America itself, to a certain extent, re-enacts 1920s Germany, as do all the European countries described using Weimar metaphors in the articles mentioned above.

Overall, the comparison of the current crisis with the one preceding and culminating with the 1929 Wall Street Crash, which had severe consequences for the German economy, utilises the legendary German depression but eludes the actual social scenario of the Germany of today. The *return of the crisis* – so to speak – is staged in Germany by means of an image of Germany (currently one of the European countries less affected by the economic impasse) but is happening elsewhere: for instance, in Greece and Italy, but also in Spain, Portugal, Ireland, Bulgaria and other countries – and even in the US. But this is an elsewhere that is strongly linked to Germany, not least because in most cases it participates in the European collective body that German international politics is at pains to defend – or, to be more precise, to define. It is an elsewhere that, in its variety, makes up a European project and

a relationship with the US that post-reunification Germany seemed, on its part, to *prelude*. Hence, to a certain extent, the return of the Weimar spectre also performs on the stage of Germany's elaborate process of national identification, playing a complex *détournement* in terms of time and space in the country's imagining of itself.

The austerity politics strongly encouraged by Chancellor Merkel – especially after the 2012 treaty establishing that all Eurozone countries have to incorporate into their constitutions a deficit limit modelled on the German *Schuldenbremse* (debt brake) – seems to legitimise Germany's view that its political body is greater than itself. In a sense, the *Schuldenbremse* marks the legacy that Germany – and German history – performs toward the other European countries, and also to the capitalist US.

As Walter Benjamin pointed out as early as 1921, the 'demonic ambiguity of the word *Schuld*' (1996: 289) in the German language is worth stressing here: in German, *Schuld* also means blame and guilt, as much as debt. The semantic landscape encompassed by this word is a conceptual connection too – perhaps the most significant insight into what Benjamin described as the functioning of capitalism as religion: 'the first instance of a cult that creates guilt, not atonement. [...] [A] religion which offers not the reform of existence but its complete destruction' (1996: 288–9). Such a predicament, in a sense, expresses the gist of the peculiar temporality imposed by the economic crisis.

As economists Sebastian Duller and Ulrike Guérot explain, Germany's long tradition of ordoliberalism, or social market economy, is more suggestive of the German approach to the Eurozone crisis 'than the much-discussed historical experience of the hyperinflation in the Weimar Republic on the one hand and simple national interest on the other' (2013). The specific form of capitalism that contemporary Germany performs embodies almost literally Benjamin's analysis of a cult 'that makes guilt pervasive' (1996: 288) – so pervasive that it exceeds national boundaries. In a sense, the predicament with which all European countries have to comply is one established by Germany according to its own internal regulations, entailing a governmental stability (at any price), a strong social democracy with a free market economy, and an internal system of organising the members of the nation, understood primarily as an economic entity.

In this context, it is relevant to recount another passage from Benjamin's 1921 notes:

> It contributes to the knowledge of capitalism as religion to imagine that the original paganism certainly and most proximately grasped

religion not as a 'higher' 'moral' interest but as the most immediately practical – that it had with other words been aware of its 'ideal' or 'transcendent' nature, just as today's capitalism is, but saw the irreligious or individual of different faith as infallible members of its community, in precisely the same way the modern bourgeoisie [sees] its non-earning members. (1996: 290)

The 'Weimarisation of Europe' staged in the German and international press seems to correspond to a simultaneous affirmation that all European citizens are members of the same community, 'in precisely the same way [as] the modern bourgeoisie [sees] its non-earning members' (Benjamin 1996: 290). The *Schuldenbremse*, in other words, can be considered the dogma that the 1920s capitalism-as-religion described by Benjamin had not yet fully elaborated: it is its theology and teleology, implying political consequences. It increases and regulates the despair in which the horizon of the future keeps its members – however faithful (or unfaithful) to the capitalist cult – in the impossibility of reaching that future without 'worries'.[7]

It is perhaps according to this logic that the 'Weimarisation of Europe' has, at least on a rhetorical level, reached Germany itself. During the 2013 electoral campaign, Bernd Lucke, the leader of the newly formed 'Eurosceptic' party Alternative für Deutschland, was attacked during a speech in Bremen by (in his words) 'far left activists'. Commenting on the episode, Lucke associated it with the violence of the *Schlägertruppen* (goon squads) during the Weimar Republic (*Die Welt* 2013). Significant in this context is the fact that the populist movement Alternative für Deutschland, which has identified itself with a radical nationalist and 'anti-Euro' politics, emphasising the disadvantages of Germany's participation in the common European currency, also draws on the 'Weimar repertoire' to address social and political unrest in Germany, according to a logic that similarly places the economic crisis at the centre of a supposed historical re-enactment.

To a certain extent, the fact that Weimar 'returns' to be evoked in Germany by the leader of a party advocating the dismantling of the Eurozone – and one associated with right-wing and nationalist sentiments – reflects the growing feeling of insecurity that Germany itself is facing, while its economy is still offering itself as a *last resort* against the hardships experienced in the Southern European countries – the countries most clearly suspended in a state of *Schuld*. Indeed, the crisis has started to inhabit Germany too, especially because Germany today is a territory of encounter for many citizens from different

European countries, and from the rest of the world. It is a place whose economy still offers possibilities of labour, leisure, study and productive work. Indeed, it is a transnational space where different 'immigrants' from other 'European Weimar Republics' take refuge, at least temporarily, but not without consequences.

In general, Germany's inhabitants, old and new, face a different context of unemployment than the one portrayed in *Kuhle Wampe*: unemployment here meets the discontinuous horizon of precarious labour and flexibility, which is central to the social market economy. In the increasingly neoliberal system of competition, in which all kinds of labour – including artistic and intellectual production – are regulated in the German social democracy, unemployment has ceased to be visualised as an empty waiting on the streets (as Weimar Germany would have it), but it is still present and is increased by the arrival of many more jobseekers in the country, from *elsewhere*.

The jobseeker is the emblematic figure of the crisis, and certainly the quintessential figure in which the Weimar Republic spectre is crystallised. The jobseeker – or precarious worker – is someone disposing of an unregulated amount of labour power, which coincides with her very bios: her time is not used productively but is suspended between deadlines, potential opportunities, and a search for wages that consumes her own free time. Not surprisingly, in the creative economy of the Berlin art scene, the overlap between free time and precarious work is impressive: for example, voluntary participation in arts projects is an undeniable arena for jobseeking, in a precarious condition in which the German social democracy provides basic support for temporary survival as well as the lure of a forthcoming job. Germany today is once again in *a state of waiting*: it embraces its inhabitants within the social space, which owes its existence to the country's own 'faithfulness' to capitalism, blurring free time and unemployment in a condition of precarious future.

However, today, as much as in the 1920s, the politics behind the use of free time is a matter of choice. Although it is suspended between the potentialities of work, free time can also be turned into a space in which one can imagine a different order of things – not as escapist fantasy, but as a form of study and as a form of pleasure.

Red Channels Meets the Red Megaphone: rehearsal for revolution

When I first started searching for information about the project *Red Channels Meets the Red Megaphone: Suicide or Solidarity*, I could find little

more than the materials gathered on the website launching the project: a series of texts offered as historical and theoretical readings around the movie *Kuhle Wampe*,[8] a programme of the activities proposed by Red Channels during their stay in Berlin,[9] and a statement offered as a starting point:

> How is it possible to invent new forms of solidarity in times of imposed capitalist absurdity? How can we define new spaces of struggle against the suffering of budget cuts, mass unemployment and nationalist threat? And not what is to be done, but how is it to be done? [...] For the week following our screening of *Kuhle Wampe*, we will be based out of okk/room29 in Berlin-Wedding. We hope to facilitate a collective response to the film, open to all. Using video as our primary means of documentation, we invite everybody to collaborate with us on this research project, which is open to any media or practice. (Red Channels 2011)

After the Berlin project, the collective Red Channels dissolved, and the work realised in 2011 was never followed up. A potential outcome, however, was never planned, nor was it considered essential by the organisers themselves. As I discussed with two former members of Red Channels, Martyna Starosta and Matt Peterson, the mobilisation of a collective response to *Kuhle Wampe* was, in a sense, the whole point of their project. The strategy they proposed – using film to foster discussion and collective political reflection – was one that Red Channels had experimented with before. They described it in a 2010 interview in the following terms:

> You might see participation in classrooms or reading groups, but these are contained, private exchanges. We're after something both public and participatory. This is the rehearsal for revolution. [...] We should be creating more autonomous spaces for dialogue and exchange through our work and organizing. (Squibb 2010)

I am interested in picking up on this idea of 'rehearsal for revolution' in order to reflect on what it means to take a week to watch an old movie, with strangers, and to visualise some of the nodes that are crucial in interrogating the present, and to do this in the transnational space of contemporary Berlin – a point from which economic consequences radiate out to the rest of Europe, and a space where free time constantly overlaps with precarious work.

It is relevant, for this analysis, that the Red Channels' project was not funded by any art institution and took place in the participants' free time: their current positions (supported by fellowships, part-time jobs, private investments, or other income sources) allowed them the 'privilege' of spending time in Germany outside a work structure. In fact, organisers and participants were mostly temporary inhabitants of Berlin, in transit to some 'elsewhere', as is so often the case. In Berlin, the group that gathered around Red Channels mainly discussed ways to follow up the movie, which never became artistic products. They shot some film, which was never edited; they collectively wrote a script, *Fritz and Annie*, which was neither put on stage nor filmed; and they repeatedly visited the Brecht Archive, trying to gather materials on the censored sequences of the movie,[10] with a plan in mind to re-enact them and edit the film with the new scenes.

None of this was realised. Indeed, as Natalie Gravenor, one of the participants, told me in an email: 'Collective film re-enactment is very worthwhile for the processes it sets in motion, not for any finished product that might result [from] it.'[11] In fact, what interests me about this project is not so much what happened during that week of free time, but the potentiality it opened up for those who decided to spend their free time thinking about *Kuhle Wampe*. To some extent, it was indeed a 'rehearsal for revolution', especially if we consider the number of political uprisings that, in the immediate future, would take place all over the globe, and which had already started in 2011 with the so-called Arab Spring and continued shortly afterwards with Occupy Wall Street. In general, the protest movements around the globe claimed and posed to the present the same questions that appeared in the statement of Red Channels: demands for solidarity, for autonomy from the given conditions of capitalist absurdity, for the re-appropriation of futurity.

While in national politics the spectre of the Weimar depression is projecting on tomorrow a catastrophic horizon, and enhancing the urge for political compromise, another part of the world has been employing the projective temporality of revolution – which was also elaborated during the Weimar years – in order to affirm that the end of the story is not, in fact, 'the end of history'.

As Bini Adamczak pointed out:

When Francis Fukuyama announced 'the end of history' in 1992, he simply meant that there was no alternative to liberal capitalism – forever. [...] The hope for a better future was replaced by the fear that the present would become worse. And this present, which

continuously degraded the lives of the majority, would expand, it seemed, forever. Now the end of history is itself history. Seen from the future that has already started, this historical era will have begun in 1991 and will have lasted exactly 20 years until the Arab Spring. As if history were shrewdly trying to find the most effective stage for a comeback, its return has taken the beginning, of all places, in that region of the world that both colonialism and the new world order have deemed ahistorical, or backwards at best. (2013)

Revolution challenges the idea of the end of history, understood as the ever-growing cult of capitalism, and questions the very structure of those societies that have imposed, and then blamed, Weimar-style economic depression: Weimar's memory of *Schuld*. It imagines a different world, a world yet to come. This imagining is not immediately recognisable, however: in tracing 'the end of the end of history', Adamczak observes that 'revolutions in general raise not only the question of their predictability but also of their recognizability once they have started to begin'.

The idea of rehearsal, in this case, resurfaces as a useful conceptual tool with which to read the discontinuous and simultaneous revolutionary moments that have punctuated both the European and the wider international scene since 2011: if not proper beginnings, these moments could at least be considered as rehearsals for revolution. The urge to ask questions such as those posed at the end of *Kuhle Wampe* – '*Wesser Morgen ist der Morgen? Wesser Welt ist die Welt?*' ('Whose tomorrow is tomorrow? Whose world is the world?') – connects these moments; some are more incisive, some more pervasive, but they are 'common in their unlikeness' (Adamczak 2013).

Overall, I suggest, the ensemble of these different moments of protest and international solidarity can be considered as the rebuilding of a culture of revolution, in which images, words and habits are rehearsed and tested again in the present, even if they have no immediate or precise political outcome. Taken together, these moments, these rehearsed revolutions, can be considered an interesting response to the task attributed by Brecht to the domain of culture:

Culture, that is, superstructure, is not to be seen as a thing, possession, result of a development ... but rather as a self-developing factor and above all as a process. [...] The expression of the cultural needs of the masses are the ways of life that steadily develop under economic and political pressure and, in our time of the class-conscious proletariat, acquire a revolutionary function. (1992: 570)

Vorwärt und nicht vergessen: forward-thinking solidarity and the return of revolution

In the last part of this essay, I shall be a latecomer participant to the Red Channels project, picking two sequences of *Kuhle Wampe* that resonate for me as counter-images of the Weimar spectre: images of work (and non-work), of blame and despair, of free time and solidarity, and, finally, of liberated work. I will focus on the two poles identified in the Berlin project as the alpha and omega of *Kuhle Wampe*: suicide and solidarity.

Kuhle Wampe's first sequence, underscored by Hanns Eisler's anguished staccato music, offers one of the most striking visualisations of unemployment in the competing struggle for work under capitalism. The unemployed are a nameless crowd of cyclists, first idly standing in the streets of Berlin's working-class district of Wedding, then launched in a desperate rush towards work possibilities once the newspaper, with its advertisements of job offers, is distributed among them.

One of them, the young Bönike, is followed eventually by the camera into the space of his family, haunted by the misery of depression and by the sense of blame – *die Schuld* – that Bönike's parents express towards their son. Following a scene set around the family table, the movie portrays the suicide of the unemployed boy through a mechanical

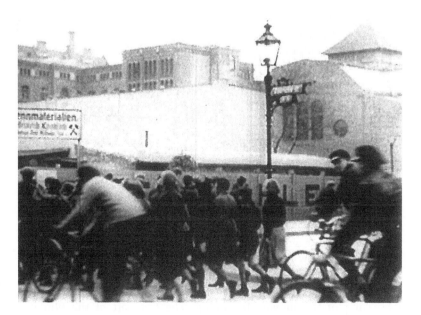

Figure 1.1 Image of unemployed on bikes. Courtesy of Praesens-Film AG

sequence of acts, including the removal of a watch from the boy's wrist, as if to measure the abandonment of time, the final exit from the empty time of unemployment.

In Brecht's analysis of the suicide scene, he points out that the young Bönike's suicide does not portray an individual tragedy but stands for the destiny of a whole class.[12] It is a suicide devoid of any heroism: one of many, each provoked by an unjust system of beliefs and work. It is also the sort of suicide, one might add, that Benjamin considered distinctive of the 'collapse of the market for human commodity' (1994: 306) that corresponded to the post-war unemployment of the 1920s: a suicide no longer relating to a power of resistance to the existing world. The figure of the unemployed is central to the constellation of Benjamin's thought, since, as Rolleston suggested, she is 'an individual enduring a not-yet-defined universality of suffering' (1996: 39). In the singularity of such a condition, the unemployed individual comes to epitomise the disposability of time and labour under capitalism, in a logic according to which the possibility to produce, hence to consume, is crucial to existence itself. In this scenario, the figure of the unemployed becomes conflated with the very category to which Benjamin devoted his research on nineteenth-century capitalism: the discarded commodity. The figure of the jobless is one that, just as the discarded commodity does for the products of fashion, contributes to the disappearance of the gap between being 'employed' and 'unemployed': it constitutes the shadow of suffering, guilt and hopelessness (in a word, the state of *Schuld*) that characterises work under capitalism.[13]

As a counter-image to this predicament, we could think about Benjamin's interest in Charles Fourier's utopia of a future of liberated work, a future that can already be imagined in the present: not by chance, as Benjamin notes (2003b: 5), as an example of a *travail non salarié mais passionné*, Fourier used to offer the revolutionary gesture of building barricades, very familiar to those who, like him, were writing in the France of the late nineteenth century. In other words, against the backdrop of Fourier's socialist utopia of an emancipated future, we can perceive the empty time of the unemployed as a potential space in which to imagine another world, as well as the space for passionate activities acting as a prelude to revolution.

In very much the same spirit, in the last sequence of *Kuhle Wampe*, Brecht and Dudow decide to stage a sports festival in which the spectator is confronted with a radically different organisation of labour, competition and joy than the domain of work haunting the anguished jobseeking of the movie's beginning. The last part of the film is a

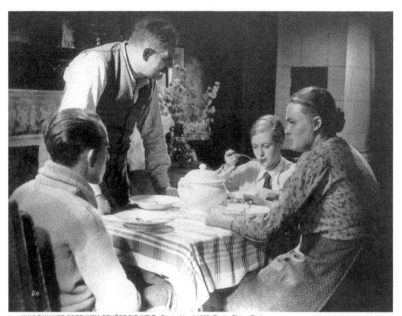

KUHLE WAMPE ODER WEM GEHÖRT DIE WELT - Deutschland 1932 Regie: Slatan Dudow
Quelle: Deutsche Kinemathek

Figure 1.2 Still from *Kuhle Wampe*. Courtesy of the Deutsche Kinematek

re-enactment (realised with the active participation of 3,000 voluntary members of Fichte, the umbrella organisation of Berlin's workers' athletic clubs) of the mass sports gatherings that in the summer of 1932 were actually taking place in Berlin, and constituted a concrete horizon of 'another world' in contrast to the hardship of depression and unemployment.[14] As the film sequence emphasises, these festivals were indeed a space in which a *travail non salarié mais passionné* could be experienced first-hand as an image of the future rehearsed in the present. They were a space in which competition was turned into joyful collaboration, and in which the despair of unemployment could be turned into class-conscious solidarity.

In her lucid notes on 1932 'Germany in a state of waiting' – suspended between the potentiality of revolution and the advent of fascism – Simone Weil made an explicit reference to the joyful characteristic of the sporting gatherings organised by young German proletarians (employed and unemployed), indicating that this joy was a symptom of the potentiality of imminent revolution, which still remained

KUHLE WAMPE - Deutschland 1932
Regie: Slatan Dudow
Quelle: Filmmuseum Berlin - Stiftung Deutsche Kinemathek

Figure 1.3 Still from *Kuhle Wampe*. Courtesy of the Deutsche Kinematek

completely plausible in the scenario of the Weimar Republic's last year
(1960: 112). And in the summer of 1932, *Kuhle Wampe* was screened for
the first time, crystallising this joy in images that remained, surviving
the subsequent Nazi ban, and being delivered, afterwards, to the future.

The sports festival in *Kuhle Wampe* culminates and concludes with the
collective singing of the Brecht/Eisler song *Solidaritätslied*, whose most
remarkable line is itself an invitation to enter the future, an invitation –
as it were – for the future to begin: 'forward and don't forget'. It is a
song that remained emblematic of a notion of solidarity, which, in the
early 1930s, was simultaneously pervasive and strongly connected to a
political demand to question the existing order of things, to look for-
ward to a different future. The construction of such a future, however,
could not be based on forgetfulness: to a certain extent, this significant
line from *Solidaritätslied* resonates with the words of a 1915 pamphlet
by Karl Liebknecht – the incitement to 'learn everything, and not forget
anything' (1952: 300) which played a part in the construction of that
language of revolution which Brecht and Eisler themselves learned and
pursued fifteen years later.

In a sense, Liebknecht's incitement – in dialogue with and resonating with the notes of *Kuhle Wampe*'s final ballad of solidarity (at least for this particular spectator) – seems to seal, from a radical perspective, the return of Weimar's projective temporality, and to entice a strategic appropriation of the use of the Weimar spectre as a memento. Learning from Weimar also means conjuring up in the present a forward-thinking solidarity, along with the joy that it entails; it also means reconceiving free time as a space in which it is possible to imagine and to engage with a different horizon of work; it can be a space – to echo Red Channels' words – in which to rehearse revolution, in a legacy of solidarity with old spectres – such as Brecht, Liebknecht, Benjamin and Fourier – but hopefully also with new comrades, present and future.

Notes

1. Most titles of historical surveys devoted to the Weimar Republic (which remained neglected in the German academic debate until 1973, when the first important conference on the topic was hosted in Bochum) are quite telling with regard to the terms in which the logic of anticipation, which I discuss here, has characterised the narrative of Weimar history for a long time, and still does today. Suffice to mention a few major studies, published in different periods, that incorporate in their titles a terminology attributing the role of 'prelude' to the Weimar Republic: Brecht (1968); Dejonge (1978); Weitz (2007).
2. On the peculiar temporality of revolution songs, see Palladini and Ridout (2013).
3. In this interview, Samaras implicitly associated the Coalition of the Radical Left, Syriza (today the party leading the Greek parliament), with the neo-Nazi party Golden Dawn, which achieved alarming electoral results in the 2012 elections.
4. Mario Monti was nominated prime minister in November 2011 by Italian President of the Republic Giorgio Napolitano, with the mandate to lead a government of technocrats for implementing emergency austerity measures to restore Italy's financial stability.
5. In November 2011, in the wake of the Greek debt crisis, the figure of Brüning was evoked in comparison with Lucas Papademos, another economist and prime minister of Greece between 2011 and 2012. This comparison accompanied the association, proposed by Fabian Lindner, between contemporary Germany and 1931 United States, as both were in the position of being the beneficiary of the crisis countries' debt (2011; 2013).
6. The comparison between the Five Star Movement and 1920s National Socialism was referred to in the media during 2013, and certainly drew on the same logic of comparison with the Weimar Republic I am analysing here. Although it is undeniable that some specific forms of rhetoric, as well as the aggressive style employed by the movement's leader, the comic actor Beppe Grillo, are uncannily resonant with Hitler's pre-1933 populist rhetoric (especially in the visceral anger towards 'the system'), I would be careful in

stressing further this comparison outside a more rigorous historical analysis (especially since this comparison was much emphasised by Italian right-wing journals; see Sacchi 2013). In 2014, however, during the campaign for European elections, such an association once again became a matter of discussion, as a result of a statement made by Grillo during a speech: namely, 'they compare me to Hitler, but I am beyond Hitler'. This provocative statement addressed precisely the way in which the comparison had been employed by the media. This time, however, such a comment appeared to be particularly uncanny, especially in the wake of the European electoral results, which saw the rise of extreme right parties in many European countries. Prominent among these parties was the United Kingdom's xenophobic UKIP, a party that made no secret of its 'Euroscepticism' and that, precisely on this basis, found a terrain of dialogue with Grillo and the Five Star Movement. In 2014, the two parties formed a common grouping in the European parliament.

7. It is worth noting that in the same text Benjamin defines 'worries' as 'a mental illness that suits the capitalist epoch' (1996: 290).

8. Among the preparatory readings for *Red Channels Meets the Red Megaphone* were *Reading Capital Politically* (Cleaver 1979) and 'Pre-fascist Period: To Think and To Want: *Kuhle Wampe*' (Luppa 2009).

9. Activities included a session of screening and discussion on the movie, following sessions of collective research and editing work, as well as walking tours retracing historical spots of radical left politics in Berlin.

10. *Kuhle Wampe* had two complete bans and several cuts before the film could be released.

11. 'RE: *Kuhle Wampe*', email to the author, 3 September 2013.

12. Brecht reports the censor's quote, which accuses the authors of having made a political point by means of their characterisation of the unemployed: 'You have not depicted a human being, but let's say it, a type [...] Your unemployed worker is not a real individual [...] He is superficially portrayed, as artists pardon me this strong expression for the fact that [*sic*] *we learn too little about him*, but the consequences are of a political nature [...] Your film has the tendency to present suicide as typical, as a matter not of this or that (morbidly inclined) individual, but as the fate of a whole class' (1974: 46).

13. This view on unemployment appears especially evident in Benjamin (2003a).

14. Emblematic, in this respect, is the figure of Fritz (played by Ernst Busch), who has just been fired from his job and joins the sports festival almost by chance, following his class-conscious girlfriend Annie, and in the space of the gathering seems to overcome the singularity of his suffering in the collective attempt to elaborate a new political subjectivity.

2
Towards a Nomadology of Class Struggle: Rhythms, Spaces and Occupy London Stock Exchange

Philip Hager

A spectre is haunting Europe – the spectre of debt slaves refusing to pay. All the powers within Europe have entered into a holy alliance to regenerate a failing economy, to realise a lethal dream of returning to business as usual, and to [...] transform the educational and cultural sectors into a consumer society success story. (Arts Against Cuts 2010)

On the evening of 9 December 2010, while a large student protest against the trebling of tuition fees and the overall cuts in the education budget was under way in London's Parliament Square, at the other end of Whitehall a group of arts students (Arts Against Cuts) entered the National Gallery and staged a protest of their own: they squatted on the space in front of Édouard Manet's painting *The Execution of Maximilian* (1867–68) and collectively created their 'Nomadic Hive Manifesto' (see Mason 2012d: 53–4). As the arts and humanities are most notably affected by the cuts in higher education and the arts sector suffers from decreasing state funding, the staging of such a performance in a highly subsidised museum challenged at once the economic order that makes debt slaves as well as the institutions complicit with its logic. Moreover, the choice of Manet's depiction of a poignant moment of the revolution against the Mexican Empire (a political project championed by European imperialist powers and the Mexican aristocracy of wealth) has its own significance too: Manet's painting was re-appropriated by the students (after being initially appropriated by the logic of the museum); it was no longer a masterpiece by a great master, but a representation of a revolutionary act. While their fellow students were being contained (or 'kettled') by the police half a mile down the road and attracted most of the attention, they performed a 'minor' act of resistance that,

nevertheless, set the tone for a wave of protests that followed. In his trea-
tise on Carmelo Bene's theatre, Gilles Deleuze points out that theatre's
revolutionary task – that is, to 'rediscover [its] potential for becoming' –
can only be realised by a minor author: 'without future or past, she has
only a becoming, a middle, by which she communicates with other
times, other places' (1993: 208). In this sense, paraphrasing the open-
ing sentences from Marx and Engels' *The Communist Manifesto* (2012:
33), Arts Against Cuts' playful performance imposed on the iconic text
'a minor or minimising treatment in order to extricate the becomings
of history' (Deleuze 1993: 208), thus framing the class struggle of our
times. On the side of the oppressed we find the debt slaves and on the
side of the 'holy alliance' stand the states and the aristocracy of capital
within an increasingly neoliberal Europe (financial institutions, specu-
lative funds and ratings agencies): the capitalist elite that produces debt
not as a means of exchange, but as a weapon for shaping individuals
(subjects) and the processes that produce them (subjectivities).

The 'Nomadic Hive Manifesto' chimes with Maurizio Lazzarato's call,
in *The Making of the Indebted Man*, for a 'reinvention of "democracy" as
it traverses and reconfigures what even very sophisticated political theo-
ries conceive of separately – the political, the social, and the economic'
(2012: 162). The task, therefore, of class struggle in his critique of the
debt economy is to conceive of a democratic politics that will operate
on all levels of the social, outside the debt economies that make 'debt
slaves', not only in economic but also in social terms. Debt and its
economies, Lazzarato argues, operate not only on the level of economic
slavery, as noted in the 'Nomadic Hive Manifesto', but on the level
of the biopolitical formation of subjects. Indeed, class struggle in the
twenty-first century must reinvent a political subjectivity outside the
logic of debt; that is, to invent a political project that will cancel debt
both as an economic reality (a means of exchange) and as discourse (a
process of subjectivation).

This chapter places Occupy London Stock Exchange (OLSX) at its
centre, suggesting that 'minor' performances staged outside St Paul's
Cathedral from 15 October 2011 and for four-and-a-half months are
related to a multiplicity of political performatives that occurred since
the beginning of the post-2008 capitalist crisis inside and outside the
UK and Europe. In the following pages, I map the political trajectory
sketched out by performances of the 'debt slaves refusing to pay':
the 2010 student protests, the 2011 English riots and OLSX are the
main points of reference.[1] This trajectory, however, appears to stretch
across geographies and events such as the successive occupations of

Tahrir Square in Cairo between 2011 and 2014 and the 2011 move-
ment against Ben Ali in Algeria; the 2011 movement of the *indignados*
of Spain and Greece; the 2011 Occupy Wall Street (OWS) movement
and all the subsequent occupations of public spaces around the world;
the 2013 Occupy Gezi in Istanbul and the subsequent country-wide
protests; other events – signifiers of crisis – such as the 2014 riots in
Ferguson, Missouri in the US, the 2013 riots in the Swedish suburbs,
the 2008 riots in Greece, the 2005 riots in the Parisian *banlieue* are also
mapped in this trajectory. Following Gilles Deleuze and Félix Guattari,
I wish to argue that such multiplicities of events perform a rhizom-
atic writing of crises: they are at once markers (signifiers) and makers
(agents) of crisis; their 'minor' performatives rupture hegemonic logics
and performances of crises. These events map crises as much as they
are mapped by crises. Ultimately, I propose that these events tally with
Lazzarato's call for a reinvention of class struggle; that at the heart of
all these political performatives lies the desire to exit one's predicament
and abandon a world saturated by debt.

A rhizome 'is an acentered, non-hierarchical, non-signifying system
without [...] an organising memory' that 'pertains to a map that must
be produced, constructed, a map that is always detachable, connectable,
reversible, modifiable, and has multiple entryways and exits and its own
lines of flight' (Deleuze and Guattari 2004: 23). Not a pre-existing struc-
ture, with no end or beginning, no centre or periphery, a rhizome resists
arboreal binary structures; it appears as a whole in its parts, always
already in the middle as it 'connects any point to any other point, and
its traits are not necessarily linked to traits of the same nature' (2004: 23).
There is no vantage point to a rhizome; the connections between
events, texts and places are not linear, but affective.[2] A rhizome is a
heterogeneous multiplicity constituted by multiplicities; it is ruptured
or metamorphosed by its lines of flight. The rhizome moves outside the
segmentary logic of the State into the nomadic trajectory that '*distributes
people (or animals) in an open space*, one that is indefinite and non com-
municating' (2004: 420). This open space is a map to be constructed and,
contrary to the 'sedentary space [that] is striated, by walls, enclosures,
and roads between enclosures, [...] nomad space is smooth, marked only
by "traits" that are effaced and displaced within the trajectory' (2004:
420). Smooth space is mapped by the nomad's journey, each time anew;
the traces are lost, broken, only to resurface somewhere else or in some
other form. The nomad does not move; the nomad *is* movement.

In this chapter I propose a twofold analytical strategy; on the one
hand, I map the (nomadic) trajectories of the crises outlined above

and, on the other, I attempt a rhythmanalysis of the performances that make up this trajectory. As 'rhythms escape logic, and nevertheless contain a logic', Henri Lefebvre's rhythmanalytic method allows us to observe and consider returns, ruptures and conflicts of a world in crisis; to 'grasp [the] moving but determinate complexity' that is everyday life (2013: 20–1). It is in this rhythmanalytic mapping that the reinvented class struggle emerges through the performative production of a smooth space that forges class allegiances outside quotidian schemas determined by 'homogeneity', 'fragmentation' and 'hierarchization' (Lefebvre 2005: 83). A nomadic rhythmanalysis based on personal fieldwork at OLSX is at the centre of the narrative that follows. But first, I will turn my attention to some aspects of the contemporary incarnation of the 'holy alliance', the (neoliberal) State and its constituents: debt, urbanisation and militarisation.

'Feral' capitalism

Debt, tax evasion and capitalism's inequalities were the main themes in the protests staged in April 2009, during the G20 summit in East London's ExCeL convention centre, the first gathering of this kind after the US financial sector's (near-)collapse. Most of the protests took place in the City of London, one of global capitalism's headquarters. Bishopsgate was taken over by the climate camp, whose main slogan was 'nature doesn't do bail-outs', emphasising our (human) debt to the environment that hosts us – a debt not calculable in monetary but ethical terms. Outside the Royal Exchange and the Bank of England, a number of themed protests were staged, including a group dressed as dead bankers (alluding to vampires[3]) and a duo advertising *Project Knight*: a fictitious 'crusade to tax evade' ostensibly launched by Barclays Bank. One of them was in full medieval armour, playing the knight-crusader, while the other was dressed in an old-fashioned black suit with white stripes and a black bowler hat, performing the banker. They walked around holding a placard and distributing leaflets in which they suggested that this is 'the ultimate in tax-avoidance schemes, [that] shrewdly allows your money to evade the burden of social responsibility'. Marx characterised the politicians of his time as 'Capital's executives' (quoted in Badiou 2012: 13). In a context where taxpayers were forced to carry the failing banking system's burden in the form of state debt, even though financiers continued receiving substantial bonuses, *Project Knight's* sarcastic representation of the corporate tax evader as a commonsensical figure reflects the cynicism

of a corrupt and profit-oriented system beyond any (and all) ethical considerations that certainly agrees with Marx's commentary. As David Harvey explains:

> in the event of a conflict between the integrity of financial institutions and bondholders' returns, on the one hand, and the well-being of the citizens on the other, the former was to be privileged. (2005: 48)

Project Knight – with its armoured knight being, to use the duo's parodic terms from the leaflet, 'committed to secrecy (and with the gagging order to prove it)', thus offering security to the financiers who own and command the City – staged an exclusive world of wealth: a state within a state that taxpayers have to bail out in case of crisis.

The class allegiances very aptly illustrated in *Project Knight*, alongside the principle of capital's privilege over people, are important aspects in what Lazzarato calls *the making of the indebted man*. Debt, for Lazzarato, is a 'mechanism' that standardises economic behaviours and allows capital accumulation: it is *through* debt that wealth has been transferred from taxpayers to banks, and it is *because of* debt that austerity packages have been installed in all European states since the beginning of the current crisis. Debt establishes the creditor–debtor relationship that, as Lazzarato points out, is integral in the 'production and "government" of collective and individual subjectivities' (2012: 29). The creditor–debtor relationship, therefore, manifests a relation of power, whereby the debtor is compelled to labour in order to gain institutional (bank, welfare state, employer) *confidence* and *trust*; and this is an 'ethico-political labor constitutive of the subject' (2012: 42). Thus, debtors have to *appear* as credible receivers of debt that is no longer only, or predominantly, an economic value, but rather is a moral principle of individuation, whereby the expectation is not that the debt will be repaid, but that people will become good debtors. The state sovereign debt crisis in European periphery countries, for example, has transformed 'social rights [such as the welfare state] into debts and beneficiaries into debtors' (2012: 104). Apart from the economic implications of this shift in terms of the impoverishment of whole populations, there are also social and ethical repercussions. Following Michel Foucault's analysis of the biopolitical processes at work in the neoliberal world, Lazzarato suggests that:

> Between private debt and sovereign State debt, 'social debt' must be introduced, a debt whose management, through [...] a technique of

'pastoral' control, makes it possible to individualize the government of behavior and totalize the regulation of the population. (2012: 125–6)

The debtor is constantly scrutinised by institutions exerting both material and moral pressure; institutions that through 'guilt' and 'bad conscience' produce both the subject and the disposition and desire to become '"*homo debitor*" (indebted man)' (2012: 127).

In his *Critique of Everyday Life*, Lefebvre argues that neoliberal societies have moved beyond the disciplinary model described by Foucault. If in the '"belle époque" of discipline and punish' subjects were *controlled* by prohibition, in the neoliberal era subjects are *produced* through permission. In other words, Lefebvre points out that 'the state manages daily life directly or indirectly [...] because it helps to create it' (2005: 126), while the production of space is a privileged site for the management of the quotidian. Urbanists (planners, developers, real estate agents) describe the *fragments* of the urban (and, by extension, of the quotidian); they talk not of the city but its facilities: 'housing conditions, the built environment, things mineral and vegetable, amenities' (2005: 132). Through this process of fragmentation, urban dwellers are gradually reduced to consumers of the cities' commodities and 'it is in this *framework* – a very precise term which encapsulates the rigidity or inertia of the result – that the people of daily life have to live' (2005: 132). No longer citizens, their daily life is produced alongside splinters of the historical city, while common (shared) wealth is turned into privatised commodities. For Harvey, capitalist urbanisation 'is about the perpetual production of an urban commons (or its shadow-form of public spaces and public goods) and its perpetual appropriation and destruction by private interests' (2012: 80). The crucial differentiation between the (non-commodified) commons and (commodified) public space and goods also distinguishes between two discrete processes of subjectivation within urban space: one that operates outside the debt economy and one that is shaped by it. By way of privatisation and dispossession (through urban development and gentrification), urban space is transformed into another form of social debt, while the collectivities that undertake the practice of 'commoning', just like the beneficiaries of the welfare state, are turned into debtors.

The production of daily life in the neoliberal city is further augmented by the militarisation of the urban fabric, which is also invoked in the *Project Knight* performance. First, the allusion to the crusades, a military and imperialist campaign in the name of religion, seems to make a certain reference to capitalism's own crusades (such

as the 'war on terror') that were staged in the name of freedom and democracy. Second, the very presence of a knight in full (fake) armour protecting a banker in one of the most securitised areas of the British capital emphasised the resonances that were further intensified later that day when riot police appeared in full (real) gear, with armoured cars and horses to protect the City's financiers (see Figure 2.1). This mobilisation of the repressive apparatus not only substantiated the *Project Knight* parody but also displayed the class character of militarisation, as protection seems to be an exclusive right of specific class interests. Yet the narratives of security have permeated Western/ European societies across class divisions; police presence is perceived by many as a sign of protection, although, in fact, such narratives further establish the mechanisms of scrutiny and control that shape indebted subjects.

In *Cities Under Siege: The New Military Urbanism*, Stephen Graham marks another twist in the history of urbanisation, whereby the function of the city as a 'key space for dissent and collective mobilization' is substituted by what he calls 'complex geographies made up of various enclaves and camps' that are securitised from the rest of the urban fabric. Graham

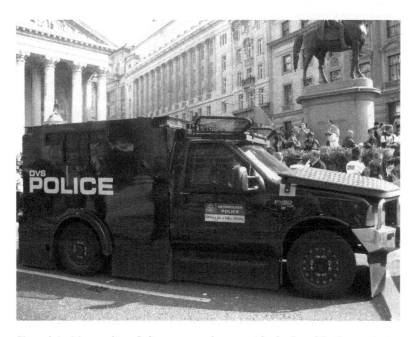

Figure 2.1 Metropolitan Police armoured car outside the Royal Exchange during the G20 protests, April 2009. Photograph by Philip Hager

wonders whether such processes might 'decouple the strategic economic role of cities as the key drivers of capital accumulation from their historic role as centres for the mobilization of democratic dissent' (2011: xxii), thus reflecting on the gradual de-democratisation of capitalism in terms of everyday practices. Militarisation 'involve[s] the normalization of military paradigms of thought, action and policy' (2011: 60); it produces subjects within the neoliberal city, not only because of the constant presence of military signs (increased policing, securitised zones), but – and most importantly – due to the fact that 'everyday life is now being modulated by a sense of ever-present tracking, scrutiny, and electronic calculation' (2011: 63). Through the daily use of a network of electronic devices (mobile phones, GPS, computers) and other means of digital surveillance (electronic train tickets, bankcards, loyalty cards), the individual is willingly transforming him- or herself into a 'data subject' (2011: 63) who is at ease with the knowledge that 'behind every social moment operates a vast array of computerized calculations dispersed through a global matrix of linked computers and computerized devices' (2011: 63–4). The indebted man (turned into data subject) is thus controlled and scrutinised not only in economic but also in social, political and ideological terms.[4] In his 1992 'Postscript on the Societies of Control', Deleuze discussed the passage from what Foucault called 'disciplinary societies' to 'societies of control' (1992: 4). Whereas disciplinary societies operated around places of enclosure (hospitals, schools, prisons, factories), societies of control operate through generalised control spreading over time and space. And, Deleuze argues, 'controls are a *modulation*, like a self-deforming cast that will continuously change from one moment to the other, or like a sieve whose mesh will transmute from point to point' (1992: 4). Control in times of capitalist crisis becomes a key facet of the social and it is implemented through debt, urbanisation and militarisation; awareness of the modulation that Deleuze speaks of, then, implies the same kind of 'work' on the self that Lazzarato mentions in relation to debt, but in regard to all three milieus of control.

In the context of the post-2008 crisis, we observe an intensification of all three dimensions of control across Europe: the debt crisis has compromised state sovereignty in a number of European states, while their urban centres are increasingly privatised and militarised. And, as Margaret Thatcher's mantra 'there is no alternative' resounds with renewed force from the mouths of technocrats and politicians, we recognise that, behind capitalism's libertarian façade, lurk its 'inherently feral instincts' (Harvey 2012: 156–7).

Nomadic rhythms

1

It was mid-afternoon, on 20 October 2012. I was standing at London's Oxford Circus, where an action organised by Boycott Workfare, UK Uncut and other collectivities was to take place. Only a few blocks down towards Piccadilly, an impressive (in numbers) TUC march was moving slowly towards Hyde Park. Here, at Oxford Circus, there was no sign of protest: shoppers were happily walking around. Buses and taxis were moving through the regular traffic of one of the most celebrated consumerist circuses of the world. Mechanical sounds were mixing with human voices and shoes against the paving stones. Then the first signs of 'irregular' activity appeared: people with placards and banners of various colours and sizes emerged (as if from nowhere). I approached someone distributing leaflets; she handed me one – there was a map of the area on it – and said: 'The marked spots are outlets of companies using workfare. We are paying them all a visit today.' For the next couple of hours, we (it was roughly two hundred of us) ran around Oxford Street targeting the various outlets marked on the map. We all got behind a large banner that read 'If you exploit us, we'll shut you down' and went on our way. There were masks, drums, a music box on a bike, and some costumes. We ran, danced, booed, and blocked shops' entrances; we talked with people asking why we were there. The police was there too, trapped in a pointless routine of trying to contain us on the pavements, or trying to guess what our next target would be. Some people from buses smiled or waved at us, while others seemed frustrated. After a while there was chaos in Oxford Street, nothing was moving. We imagined we had managed to bring the city to a standstill. It did not matter that we all knew our victory was only temporary. We had managed to stop the traffic of consumers; to bring Oxford Street into an arrhythmia.

'For there to be a *change,*' Lefebvre maintains in his final book *Rhythmanalysis: Space, Time and Everyday Life*, 'a social group or a caste must intervene by imprinting a **rhythm** on an era' (2013: 24). Although I am not suggesting that the above action imprinted a rhythm on our era, I believe that it did reflect London's changing rhythms due to a multiplicity of movements, collectivities, initiatives and campaigns that emerged after the summer of 2010, as the Conservative and Liberal Democrat coalition government launched the first round of austerity measures. A milestone in this process was a student demonstration on 10 November 2010 in central London which turned into a riot whose target was Millbank Tower, the headquarters of the Conservative Party.

After that, diverse performances of dissent in public spaces became increasingly visible. Arts Against Cuts, the example with which I opened this chapter, was indicative of such resistant collectivities that were adding colour, noise, music and imagination to London's geographies (and beyond); that is, they were 'messing' with the city's rhythms and landscapes.

The direct action organised by Boycott Workfare and UK Uncut in October 2012, almost two years after the beginning of this turbulent period and a year after the London Occupy movement, was in line with its milieu as it attempted to disrupt the rhythms of urban life. It was not merely a march, but a disorderly intervention in the flow of traffic and commodities; not simply a protest, but a collective denunciation of mechanisms of labour exploitation which also marks its geographies; not really a demonstration, but a playful encounter with shoppers and police, unsettling spatial and social hierarchies as the forces of law and order could not perform their authority by controlling the movement of bodies and restoring the 'normal' rhythms of consumption and capital circulation. This arrhythmia, caused by a disruption of Oxford Street's polyrhythmia, produced an alternative space, or a space of alternatives, where other possibilities of the cityscape were evoked. As Sophie Nield contends, 'the impact of protest events pivots on the forms of space they produce [...] – what kind of world becomes possible, and what can (and cannot) take place there' (2006b: 54). Protests such as the above demonstrate that urban space can be inscribed with ambiguous and playful rhythms, equally (corpo)real and imagined, that unsettle assumptions of urbanity and the everyday. As in a children's game, you enter an 'other' world and play along; you can dance on the asphalt, you can lie on the pavement; you can create new worlds as long as you can perform them.

> *About eighty of us walk in the streets of Bloomsbury in London; we carry two flags of different colours. We stop at the heart of the University of London, in front of Birkbeck College. It's late evening, some time during the students' winter of discontent. We add the last details in the rules of the game we are about to play: 'Capture the flag.' After a while, half of us leave with one flag and red ribbons in our hands – insignia of our team. We walk past Malet Street, the 'no-man's-land', towards Tottenham Court Road, and place the flag on a spot that 'can be accessed by three sides' and then a small group of us goes to set up a jail. We walk down Tottenham Court Road, towards Centre Point and turn left a couple of streets later. One of us marks a square and the word 'gaol' on the pavement with chalk.*

While some will have to return to let the rest of our team know the location of our jail, I join four of my comrades in an expedition to the enemy lines. So there I was, walking among strangers, part of my team's vanguard, a scout launching into symbolic warfare in the centre of London.

2

'Another world is possible' was one of the main slogans of the post-1994 anti-globalisation (or anti-capitalism) movement (see Nield 2006b: 55–6). Plastic strips carrying the same slogan were placed around the OLSX camp outside St Paul's Cathedral, in some way delineating the borders between the City and this 'other' world that disrupted flows (of bodies and commodities), assumptions, narratives and rhythms of that particular space, the heart of London's financial district. The camp's rhythmical patterns revolved around the general assemblies that were held twice a day, when people gathered in the space in front of the steps of St Paul's to discuss and draw strategies. At lunchtime and dinnertime, food was cooked in the kitchen tent; the tent city university organised events, discussions and seminars in its own tent or elsewhere; the working groups convened at various points during the day and reported to the evening assembly; sometimes, there was live music in the evenings; on some days the camp organised events with guest speakers, while on other days protests were staged outside the camp; there were nightshifts for the security of the camp and an open-air cinema; finally, at any given moment, if someone had something to announce or share with the rest of the campers, they would shout 'mic check', to which others would respond with the same shout. As the OLSX camp took up most of the space in front of and next to the cathedral, leaving only a narrow path for those who wanted to pass through to Paternoster Square, there was a chance for intermingling between the two worlds, that of the camp and that of the City of London. The passers-by sometimes stopped to look at the posters and other messages mounted on the walls – and even to discuss with the Occupy-ers. Although not always friendly, these encounters offered the possibility of dialogue or disruption.

The presence and absence of bodies, smells, voices and other sounds, the increasing number of tents in the space, and the posters on surrounding walls all contributed to a diversification of the cityscape around St Paul's, both in terms of the kind of people who gathered at the camp and the times of day they appeared. Whereas usually the place empties after the workers leave their offices or other workplaces and tourists return to their hotels (for them it is only a *transitional space*), during the occupation people were there day and night (for them it was

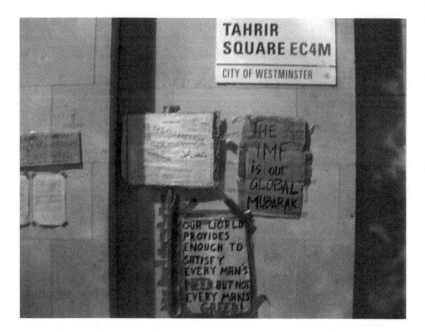

Figure 2.2 A plaque installed by protesters near the OLSX camp, renaming St Paul's Churchyard as Tahrir Square. Photograph by Philip Hager

home). While the City of London embodies the fragmented, homogenised and hierarchical polyrhythmia of capital circulation and the daily life implied by capitalist urbanisation, the camp performed a smooth, multiple and horizontal[5] polyrhythmia that was external to the logic of the neoliberal state. While the former operated through mechanical rhythms (the rhythm of capital, the rhythm of production), the latter operated through bodily rhythms (the rhythms of human needs and functions: sleep, eat, drink and think together in public).

In 'Bodies in Alliance and the Politics of the Street', Judith Butler points out that:

> it was only when those needs that are supposed to remain private came out into the day and night of the square, formed into image and discourse for the media, did it finally become possible to extend the space and time of the event with such tenacity to bring the regime down. (2011)

Although her point of reference is the 2011 Egyptian revolution in Cairo's Tahrir Square, Butler's observation is useful here. The performative value

of bodies doing 'private' functions produced spaces that were neither public nor private; they were 'other' spaces where the appearance of the collective unsettled the normative categorisations of space, proposing spatialisations that existed outside the logic of the State; spaces that put on the line, as Butler asserts, the body's 'insistence, obduracy and precarity, overcoming the distinction between public and private for the time of revolution' (2011). In other words, bodies that persist and recognise their precarity in public produce spaces of revolutionary possibilities. And indeed that *was* the revolutionary milieu, and the Egyptian revolution was an exemplary case and a constant frame of reference (see Figure 2.2): bodies dispossessed of both material possessions and the sovereign self, bodies that are mortal and ephemeral can escape the slavery of debt, for its logic is irrelevant to a human condition stripped of debt's moral and economic prescriptions.

Tahrir Square 'played out in the realm of the sign', Nesreen Hussein points out, as protesters never 'engage[d] in direct violence, but an effigy of Mubarak hung from a lamppost' (2013: 237). Yet their presence and self-organisation in space transcended the semiotic; it was the lived experience of a solidary community whose rhythms rehearsed a Cairo without Mubarak and his spectacles of power that, as Hussein implies, were indebted to the colonial past of Egypt (2013: 232–4). Similarly, the occupations in Spain, Greece and later in the US (where the Occupy movement started its journey that passed through London) rehearsed analogous spaces of solidarity, beyond the spaces produced by *their* tyrant, the creditor. The performances of the political in squares and other public spaces all seem to be in dialogue with each other, as their critique seems to revolve around the three main issues that Salvador Martí Puig proposes for the Spanish *indignados*: failure of political representation, dominance of financial markets over the political sphere, unemployment (2012: 213). Although there are significant differences not only in the staging of the occupations, but also in the socio-political contexts from which they were departing, they all propose a new form of class struggle not yet formulated as such or in any way articulating a homogeneous class ideology. Yet we can begin to recognise an urban and precarious subjectivity emerging from these spaces of resistance. A subjectivity that stands up to different types and degrees of indebtedness. A subjectivity that operates in and claims persistently the here and now of the body.[6] If in the realm of debt economy the present is always already indebted to a future, bodies appearing together in streets and squares make a case for abolishing indebtedness.

3

Alongside the events in Spain, Greece, the US and eventually the UK, Egypt's example demonstrates that the neoliberal state rarely tolerates occupation or disruption of capital's spaces and rhythms. The Egyptian revolution managed to overthrow Mubarak, but the cost in human lives was high; in the other examples, the police gradually moved in and with varying degrees of brutality removed the protesters. Moreover, the repressive apparatus followed a long process of vilification of such spaces by part of the media and the political system. The occupation of Tahrir Square and other Arab revolutions, however, were treated differently by Western media: as Badiou points out, they were seen as the Arab peoples' 'desire finally to be included in the "civilized world" which Westerners, incorrigible descendants of racist colonists, are so certain of representing' (2012: 48–9). Yet, as Hussein argues, 'Tahrir's occupation disrupted the simulated spectacle of colonial and state powers ingrained in Cairo's public spaces' (2013: 234). The protesters in Egypt resisted Mubarak as much as they resisted their former (and, in the economic and representational realm, present) colonisers.

On the contrary, British media and politicians denounced the Occupy movement as an uncivilised political performative and reiterated the same discourse that had been employed a few months earlier in response to the 2011 English riots.[7] Mayor of London Boris Johnson, for example, referred to the Occupy camp as a 'thoroughly maddening protest against capitalism' (quoted in Mulholland 2011). In a similar spirit, the British Prime Minister, David Cameron, termed the 2011 riots 'appalling violence and thuggery' and 'criminality pure and simple' (*Telegraph* 2011), while Max Hastings of the *Daily Mail* suggested that the rioters were 'young people bereft of the discipline that might make them employable' (2011). In much the same spirit, the courts of justice passed judgments on rioters in the form of exhaustive sentences that extended not only to the people arrested but also to their families, who lost benefits or were evicted from the council estates where they lived. The vilification of the dispossessed and precarious Other thus entered the frame of debt. They are not conforming to their indebtedness to the system that raised them, they all seem to suggest: they are not doing the work on themselves required to become credible members of a debt economy; they cannot pay the price of inclusion. They are 'feral children' (Hastings 2011).[8]

It was around 10pm on 9 August 2011 and I was on a carriage of the Northern Line, in Clapham Common station, coming back from summer holidays. A homeless woman got on the train and asked for some money

so that she could find shelter for the night. She said she could not stay in the place she usually slept, outside Debenham's at Clapham Junction, because of the rioting. I reached in my pocket and found a few coins, which I handed over to her. At Clapham South she got off the train. I knew that the riots were happening, but had no idea they had spread to Clapham, so I asked the woman sitting next to me if she knew anything about the Clapham riots. She replied that there was nothing going on there. 'She was just a drunk,' she continued, 'probably looking for money to buy another pint – you shouldn't have given her money.' I turned back and looked around me; the train was half empty, everyone was minding their own business, no one looked particularly worried. I concluded that the woman next to me was probably right; there was no rioting at Clapham Junction. When the next morning I read the news, I saw on my computer screen the images of the burning building on the corner of Falcon Road and Lavender Hill, just across from Debenham's.

Like the homeless woman in the above incident, the rioters of London and the other English cities remained by and large invisible. What the rioters achieved was not creating a space where capitalism could be challenged by those affected by the *'structural violence* of unemployment, of insecure employment and of the *fear* provoked by the threat of losing employment',[9] in the words of Pierre Bourdieu (1999: 98), but merely a space where capitalism could be seen as what it *really* is. As Harvey suggests:

Thatcherism unchained the inherently feral instincts of capitalism (the 'animal spirits' of the entrepreneur, apologists coyly named them), and nothing has transpired to curb them since. Reckless slash-and-burn is now openly the motto of the ruling classes pretty much everywhere. (2012: 156)

If the riots exposed the images of 'feral' capitalism through attitudes and rhythms that capital is employing, OLSX seemed to respond differently: theirs was a space of suspension of the rhythms and logics of capital and private property, logics that engender the 'deterritorialized relation between the human being and the earth' (Deleuze and Guattari 2004: 428). Theirs was a space of play (see Figure 2.3), where people were 'the true currency' (according to one of the mottos), where capitalists were taking the place of the beggar, and the homeless would feel at home.[10] Although emblematic of capitalism's structural violence and politics of exclusion, the homeless 'may have been portrayed as a detriment and

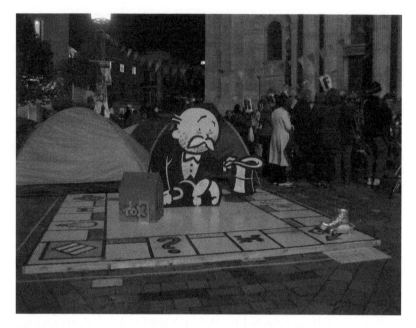

Figure 2.3 A walk-in Monopoly board placed next to the space where the general assembly took place. Photograph by Philip Hager

a risk' because their habits and attitudes (sanitation, cleanliness, commitment to the political cause) may have '[offended] the sensibilities of middle class campers' (Herring and Glück 2011: 165). However, in most Occupy camps, the homeless found places where they could share food and shelter with other people, without being marginalised. Occupy camps, then, perform and anticipate:

> new forms of solidarity and alliance. Although protesters and the homeless may differ in their use of occupied spaces, the movement cannot afford to let this difference mask the more relevant question of why both groups have come to share the same ground. (2011: 167)

Dispossession, indebtedness and homelessness are exposed as different facets of our 'common predicament' (2011: 169). The 'other' space of the camp was thus an inversion of the capitalist world, whose polyrhythmia of constant movement (of cars, bodies, capital) was countered by OLSX's embodiment of a polyrhythmia of *stasis* (meaning, following the Greek root of the word, stopover, stance, standstill and rebellion). OLSX's polyrhythmic stasis allowed the campers to exit the debt

economy (if only temporarily) and offered a glimpse into a nomadic space of resistant politics where class struggle *is* possible.

Conclusion

A 'heterogeneous smooth space', Deleuze and Guattari explain:

> is wedded to a very particular type of multiplicity; nonmetric, acen-
> tered, rhizomatic multiplicities that occupy space without 'counting'
> it and can 'be explored only by legwork.' (2004: 409)

The activist practices in question here, I argue, are such nonmetric, acentred, rhizomatic multiplicities that lie outside the realm of neoliberal rationality and its sensibilities. In this chapter, I have mapped the current crisis by recomposing this nomadic trajectory and unearthing the 'turbulences across the smooth space' (2004: 401). As such smooth spaces can only be explored through 'legwork', thus my account here was inevitably limited, partial and subjective.

The mapping here of this resistant trajectory aspires to contribute to a nomadology of a class struggle to come, which is urban in that its stasis resists the rhythms and processes of capitalist urbanisation. This stasis was reflected in the complete lack of capital or commodity circulation as such within the camp, as opposed to the consistent and frenzied movement of capital in the Stock Exchange, and as opposed to the manic flow of looted commodities in the days of the riots. However, this stasis must be distinguished from stillness – and, contrary to the centralised and channelled movement of capital, in the smooth space of resistant performatives that OLSX produced, campers playfully mapped out journeys 'by legwork'. Unlike the '*homo debitor*', the subjectivities shaped and articulated there (as well as shaping and articulating it) were plural, horizontal and self-constituted. As Athena Athanasiou points out in her discussions with Butler, 'the calls for "real democracy" [...] (that is, self-constituting as opposed to market democracy) [...] prompt us to try to unravel the foreclosures on which the space of the polis is constituted' (Butler and Athanasiou 2013: 151). Accordingly, the nomads of OLSX, by rejecting their indebtedness, rehearsed not only a different economic organisation but also 'other' modes of cohabitation, political participation and production of space based on new forms of solidarity and class allegiances. The call for 'real democracy' corresponded to the rhythmical disruption of the neoliberal city and extended a rhizome to Cairo, Madrid, Athens, New York and other places.

The neoliberal 'holy alliance' seems to have consolidated its power since the beginning of the crisis, as debt-instigated austerity charges through European countries and technocrats in the European Union's higher ech-elons gather more power in their hands: although St Paul's Square was temporarily 'renamed' Tahrir Square by the protesters, the revolution did not come. It may well be that the International Monetary Fund *is* 'our global Mubarak' (as the poster would have it); the point is not to bring down the tyrant (debt), but to abandon the systems that produce tyr-anny (indebtedness). The examples of Egypt, Greece and Spain confirm this as much as OLSX. Yet the nomadic mapping of the crisis rehearsed by their resistant performatives produced 'minor' spaces of hope, where what counts is the 'becoming-revolutionary, and not the future or past of the revolution' (Deleuze 1993: 207). OLSX, in its affective and material-ist reinvention of class struggle, exposed the temporality of revolution, while imagining its nomadic trajectory. 'Feral' capitalism may have won this round, but, as Schneider (2011) would have it, the performances of the alternative remain: they stand as evidence of that space of becoming; as reminders of the revolutionary potential of performance.

Notes

1. A focus on a post-2008 crisis trajectory is imperative, for it reflects an important shift in the resistant and/or deviant subjects' identity formation that relates to a shifting understanding of how debt affects the everyday. Nevertheless, the crisis trajectory spills over to previous and coming years (and events). Yet, I wish to make a distinction between post-2008 events, such as the Occupy movement, and the 1990s and 2000s anti-globalisation movements. Although organically they are affiliated to interconnected traditions, their constitu-tional difference is that Occupy assemblies, as opposed to anti-globalisation collectivities, did not employ a predominantly anti-capitalist rhetoric. For example, in OLSX, there was a long discussion about a banner that hung at the entrance of the camp that read 'Capitalism is Crisis'. Eventually, it was replaced by another that read 'Real Democracy Now'; in many ways, this was more representative of the general sentiment of the occupation.
2. Deleuze and Guattari see affect as that which 'relate[s] only to the moving body in itself, to speeds and compositions of speed among elements. Affect is the active discharge of emotion, the counterattack, whereas feeling is an always displaced retarded, resisting emotion. Affects are projectiles just like weapons' (2004: 441). It follows that rhizomatic space and thought are formed by movement, speed, discharge; it is the rhythmical turbulence of affect that maps a rhizome.
3. The vampire and/or the zombie has appeared as a recurring theme in protests since the beginning of the financial crisis. OLSX and OWS both staged their own zombie walks in October 2011. Tavia Nyong'o's (2012) and Rebecca Schneider's (2012) explorations of the two occupations interrogate

such representations of the un-dead vis-à-vis the temporalities of capitalism. My work here contributes to the discussion on the temporalities of occupation, but takes a somewhat different path as it merely explores its immediate (affective and material) impact.

4. Although it is not within the scope of this chapter to unpack the implications of the emerging digital communities related to resistant movements in recent years, it is important to acknowledge that, apart from the 'data subject', technology has produced the 'networked individual' (Mason 2012d: 127–52).

5. In 'Precarity Talk', most of the contributions emphasise the idea of horizontality at work in OWS and other Occupy camps. Butler, in particular, stresses that the 'assembling of bodies does not have to be organized from on high (the Leninist presumption), nor does it need to have a single message (the logocentric conceit) to exercise a certain performative force in the public domain' (Puar 2012: 168). Horizontal organisation suggests a break with logocentric liberal representative politics; a break that is evident in OLSX.

6. Lorey points out that the 'temporality of protests of the precarious' such as the Occupy movements 'is located in the present; it is a presentist democracy. Presentist refers to a present of becoming, to an extended, intensive present' (Puar 2012: 172). The subjectivity I am referring to here is 'presentist', as protesters produce temporary spaces of becoming, outside the spaces delineated by debt.

7. See Rachel Clements' chapter in this volume (Chapter 8) for a more detailed account of the 2011 English riots and their stage and screen representations in the immediate aftermath. Like the vilification of OLSX, the occupation of Syntagma Square in Athens was fully discredited by part of the media and the political system (Hager 2013: 248–9).

8. Such Othering has been a common discursive practice in a number of riots that have taken place in recent years (the French *banlieue*, the Swedish youth, the Ferguson rioters). See Clements' analysis in this volume, borrowing from Mustafa Dikeç's deconstruction of 'geographies of grievances' and sensible evidence regarding the French *banlieue* revolts. These 'geographies of grievances' are at once a product of capitalist urbanisation and militarisation and in turn mark the intensification of such processes.

9. It is important to clarify here that not all rioters belonged to that social category. Nevertheless, as the riots started in areas where the average income is low, it seems valid to offer such an account of the events.

10. Alan Read's reading of OLSX in dialogue with Inigo Jones' seventeenth-century masques, Romeo Castellucci's *On the Concept of the Face, Regarding the Son of God* (staged at London's Barbican in 2011) and the long-standing production of *Les Misérables* seems pertinent here: the 99 per cent, neoliberalism's (human) waste, is equally 'profane' to the excrement pouring out of the face of Jesus in Castellucci's production, defacing the (faceless) spectacle of capitalism, if only by giving it the face of the banker in Monopoly. Moreover, Read's suggestion to place St Paul's Occupy-ers on the stage of the Queen's Theatre and the actors of *Les Misérables* on the OLSX site would in turn deface the audience's 'peculiar pleasure in immunising themselves' from the 'precarity, the vulnerability, the dependency of the human now' (2013: 78).

3
Topographies of Illicit Markets: Trolleys, Rickshaws and *Yiusurum*[1]

Myrto Tsilimpounidi

'You take delight not in a city's seven or seventy wonders, but in the answer it gives to a question of yours' (Calvino 1997: 38). With this Calvinian dictum in mind I approach Athens; as both an insider and an outsider. I am a researcher pleading for objectivity in my birthplace, which frames my subjectivity. I am also a *flâneur*, always already trapped by the choreographies of the city's rhythms, moving away from Athens' ancient wonders. In this peripatetic struggle, I aim to articulate my question in relation to the current vulnerabilities in the era of stringent austerity and crisis. When nostalgia about the past prevails, the future is uncertain and therefore difficult to imagine, and the present is trapped in the transient state of crisis. In this dance, crisis becomes a frame-breaking moment of transcendence, which dismantles the hegemonic blueprints that govern everyday practices. How ought I to analyse an unfolding reality when crisis breaks the contract of time?

This investigation is designed as a methodological experiment that focuses on the situated everydayness in crisis, in an attempt to gloss the daily stories of space and identity formation within the wider frame of a society in rapid change. As such, it is designed to offer a passage into the 'unspeakable', the 'unspoken', the 'unsaid': things that are not registered in the realm of speech but in the spectrum of action (Knowles 2013). In a similar line of thought, Rebecca Schneider argues for a notion of everyday performativity as complex reappearances, since 'performance should be regarded not as that which disappears, but as a practice marked by messy and eruptive reappearance' (quoted in Hopkins and Orr 2009: 46). Thus, this investigation offers both glimpses of 'hard' data such as statistics, observations and casual conversations, and an analysis of 'soft' data such as everyday performances, affects and images. It is through this interplay of soft and hard data that social change is

explored in all its messiness and complexity. Echoing Calvino, then, a question is outlined: 'What are the new topographies of crisis?' I find myself following the rituals of trash pickers and the trajectories of their trolleys, witnessing the ways in which precarious bodies occupy the city's streets, discovering their weekly meeting points and the rhythms of illicit markets. In order to locate myself within these stories, I deliberately insert a political, embodied and subjective perspective. In telling the story of this particular city, I ask readers to imagine the answers it provides to their questions.

Topography derives from the Greek words *topos* (place) and *graphi* (writing, inscription). I refer to this analysis as topography since it attempts to grasp the new inscriptions of austerity in central Athens after the fifth consecutive year of economic crisis. In doing so, the chapter moves away from the tendency to reduce economic and social phenomena to mere numbers and colourful graphs; rather, it focuses on the daily, untold stories, urban encounters and social performances that define this new milieu of crisis in Greece and Southern Europe. Generally, topography refers to the process of capturing a local history and then writing about it. In other words, it is concerned with the detailed exploration of a certain place, including local stories, culture, and daily residual signs. It also involves observation, excavation, analysis, and representation of the findings. Topography is thus not only about landscapes but about everyday encounters, stories and resistances (Papastergiadis 2002). From a methodological perspective, a focus on topography also questions the authority of the researcher, as it frames the place and its inscriptions as co-producers of meaning. This is indeed a chapter with many authors for a city of multiple stories. Following the fundamental tenets of visual sociology, the chapter provides photographic evocations of the illicit market and its urban trajectories. This mode of engaging with social phenomena does not attempt to provide fixed definitions or closed categories, but rather to evoke them through a range of approaches. The use of photographs alongside the text encourages a double reflection on the stories told, in an act of witnessing (Tsilimpounidi 2012a). In other words, the images are not treated as real representations but as manifestations that demand further theorisation and self-reflection. As Sarah Pink suggests, 'vision itself is a culturally constructed category, as are sound, smell, taste and touch'. Thus, 'visual images are not simply visual; they are experienced through multiple and intertwined sensory channels' (2011: 602).

Finally, I refer to topographies because urban realities are never single but multiple, always already informed by power, politics and our subjectivities. In this milieu of crisis and rapid social change, this chapter

is an attempt to revise and reveal the assumptions and prejudices that may have determined what stories, spaces and realities have been privileged. It narrates a story from the margins but does not attempt to give voice to or represent any marginal subjectivities; rather, it recaptures the margins as a space of radical openness (hooks 1990). The story focuses on the micro-level impacts of the politics of austerity; it follows the trajectories of people and objects in order to unravel the complex dynamics of urban decay, trash picking and street scavenging. At the same time, it reveals capitalist patterns of consumption, and symptoms of a neoliberal crisis. In Athens (and elsewhere in Europe), urban deprivation has resulted in a 'loot and scavenge' culture of black market trade and dumpster diving, which itself demands a critical analysis of the hegemonic patterns producing impoverishment for the majorities in the first place. Who belongs to this new tribe of urban scroungers? How do they navigate the city? In what ways do their routes of survival parallel the functional cityscapes? Following the rituals of the urban scroungers, this chapter provides snapshots into precarious lifestyles, subversive uses of space, and social 'leftovers'.

The story unfolds in three parts. Firstly, it sets the scene, providing an insight into the economic and social conditions in Athens in order to understand the everyday realities that push people to impoverishment and despair. Which strands of the population are facing further precarity, and therefore dumpster diving and trash picking become their performance of survival? How are trash and garbage perceived in our Western societies and what happens when the hegemonic systems produce human waste? Secondly, following the tenets of the Situationists, it provides a rhythmanalysis of urban scrounging following the paths, smells, sounds of people and objects. By pinning down their trajectories, the chapter navigates through diverse and subversive maps of black market trade and consumerist culture in moments of economic crisis. The central motif is the meeting point of the scroungers with their customers, the illicit flea market (*yiusurum*) in the centre of the city. The rituals of urban scrounging are evoked through photographic documentation and casual conversations. The last stop is a critical theorisation of the notions of trash, value and capital in the midst of the crisis.

On Athenian topographies

The idealised notion of Athens as the archetypal city – the place where Western democracy and civilisation were born – is juxtaposed nowadays

with a different understanding that captures the city as a chaotic paradise of corruption, mismanagement and civil unrest. The 'cradle of Western democracy' has transformed in mainstream imagination into one of the European 'PIGS' (Portugal, Italy, Greece and Spain). Before proceeding with our analysis, some topographical information is necessary in order to set the scene and engage with Athenian realities in crisis.

Scraps of data

Time zone: The fifth consecutive year of crisis, a few days after Memorandum 3.

Climate: Seasons are not marked out by changing temperatures and falling leaves but by austerity measures, pensions and salary cuts, and debt relief memoranda.

Population: Approximately 5 million with a third living below the poverty threshold. (Douzinas 2012)

Unemployment rate: 25.5%, but for the age group 18–30 that figure rises to 62.5% – however, even these figures could be skewed by the fact that many people who are still considered employed may not have been paid for the last six months. (Kollewe and Inman 2012)

Homelessness: 20,000 new homeless people in central Athens alone. (*Ekathimerini* 2012)

Psychological profile: There has been a 45% increase in the use of antidepressants; suicide rates doubled in 2011 and tripled in the first months of 2012. (Mason 2012c)

Even if official statistics can provide a valuable frame, they represent only part of the picture, as they fail to take into consideration the invisible part of Athenian society: the nearly 1 million *sans-papiers* migrants (Smith 2012). And it is this invisible populace that faces further precarity as it becomes the ultimate scapegoat of a failing system. To this already explosive cocktail one can add the rise of fascism, which should come as no surprise since historically there has been a parallel between societies undergoing crisis and the rise of fascist ideologies. As Robert Paxton explains, fascism can flourish when there are widespread national perceptions of decay, victimisation and humiliation in society. According to him, that is the moment when fascist groups effectively collaborate 'with traditional elites, abandon democratic liberties and pursue with redemptive violence and without ethical or legal restraints goals of internal cleansing and external expansion' (2004: 218). The neo-Nazi political party of Golden Dawn won eighteen parliamentary

seats in the June 2012 national elections and has already infiltrated the Greek police and the juridical system (Chatzistefanou 2012a). To follow Paxton's argument, when trembling ruling elites face a destabilisation of the hegemonic patterns of governance, they adopt an extremist narrative in order to retain their control by creating an external enemy. Fascism, in other words, is a systemic tool used to maintain the hegemonic order and to keep the elites intact.

Welcome to Athens: a city with a crumbled middle class; a working class facing precarity and massive unemployment; and immigrant workers facing discrimination, starvation and homelessness. But, as Bhabha reminds us, every state of emergency is also a state of emergence (1994). As such, the urban fabric is also inscribed by anti-systemic reactions to the crisis: massive protests and marches against further austerity measures, occupations of public squares, anti-racist demonstrations, and grass-roots solidarity networks are some of the city's new landmarks. As people fight for their right to have rights, the official answer is the intensification of police control and violence. Public demands are counterbalanced by clouds of tear gas, water canons and police batons. The government, in an exaggerated performance of power, directs funds to employ and equip more riot forces while the healthcare system is collapsing.[2] Welcome to Athens: a European metropolis in 'humanitarian crisis' (Balezdrova 2011).

Currently, in Athens, tens of thousands of people live in an 'underground way: squatting instead of renting, cadging food from friends and family', and participating in exchange bazaars (Mason 2012c). Mason's observation suggests that citizens need to find alternative, sometimes off-the-grid, models of survival. As the economic collapse continues, these re-appropriated acts of belonging become the norm rather than the exception. In this light, trash bins and dumpsters are the new meeting places of the underground economies of crisis, economies where recyclable materials, junk and scrap metal are the new currencies. When strands of the population are pushed down and remain excluded from the social, political and economic spheres, then the margins of urban 'leftovers' are the only environments that do not deny them a sense of identity. Formulating a sense of belonging is always a process of meaningful identifications, and in this era of intensified neoliberalism it seems that the hegemonic narrative of self-identification comes through consumption. The strands of the population that are impoverished and therefore excluded from this capitalist market of consumption and identity formation are left in search for survival and identities among urban waste. And, in turn, their search among the detached

leftovers of the urban fabric becomes a powerful manifestation of a failing system – one that (re)produces inequalities, divisions and despair.

As Scanlan notes, the creation of waste in Western societies is the result of 'a separation – of the desirable from the unwanted, the valuable from the worthless' (2005: 32). As a manifestation of such separation of wanted and unwanted goods, trash is all that is 'lowly [and] that has sunk to the depth of the value system' (2005: 14). In other words, trash consists of the remnants of our culture that no longer fit the cognitive, moral or aesthetic maps of the dominant practices. As such, the creation of trash and waste is itself a culturally inscribed process. In particular, the intensification of wastefulness goes hand in hand with capitalist consumer patterns, as the growth of markets depends on the continuous disposal of old products and the creation of new 'needs' or desires. With this in mind, the fact that people search for identity between discarded and devalued products is an alarm call indicating that the norms and value systems that dictated our behaviours in the first place have failed. And it is indeed in the moment of crisis that the failure multiplies and manifests itself violently on the bodies, practices and attitudes of the marginalised Others who can be seen as the shadows of the 'original' consumers.

Engaging with the rituals of these Others of the consumer era, this story unpacks the ways in which an economic crisis transforms into a deep crisis of values and beliefs. Following the navigation of these Others across grass-roots topographies, the story also creates an alternative map of Athens – one in which urban gaps and margins are not necessarily symptoms of failure but also spaces of solidarity and new subjectivities. In navigating this story, there is a call, then, to further question the capitalist frames that govern our lives and that produced this milieu of crisis in Greece and Southern Europe. There is also a hope to dismantle them and imagine anew.

Urban scrounging

The everyday is simultaneously the site of, the theatre for, and what is at stake in a conflict between great indestructible rhythms and the processes imposed by the socio-economic organisation of production, consumption, circulation and habitat. (Lefebvre 2013: 82)

In this section, topographies of urban manifestations of crisis evoke the social and the spatial by focusing on the rhythms of daily life. As such, they take into consideration the grand narratives by telling the everyday stories and at the same time embrace the social fabric in all

its messiness and contradiction. The city is a living laboratory where the acts of the human body interact with social flows – a collection of walking narratives and living archives. Henri Lefebvre also highlights the dialogical formulation between place and social performances by examining the ways in which 'people produce the spaces that produce them as human subjects' (Knowles 2000: 10). This section is thus an attempt to grasp the qualities of the city, and to move away from the stark quantitative data that exemplify Greece's 'junk' status. It is junk that becomes the focus of the research, as I gather together fragments of how everyday refuse and discarded objects must be re-examined as a currency of sorts, in the milieu of economic and social depression.

Scanlan states that 'objects of refuse have no meaning apart from the negative undifferentiated one that declares their lack of worth – the total absence of distinction in the damaged or soiled object' (2005: 107). However, I believe that the trash, and its tradesmen and women, have begun to re-work this banal, indistinguishable mess in a process of sorting, reselling and reusing materials in innovative ways. In other words, through their actions they break the constructed codes of capitalist materiality by imposing their own alternative meaning onto consumer goods. Even if, in many cases, this sabotage of the hegemonic culture of consumption is not a conscious choice, but rather a performance necessitated by the need for survival, I argue that these precarious rituals hold wider political significance, especially in the creation of a grass-roots alternative system of values and meaning.

When I started this investigation, I sensed that trash had gained capital, as the fortunate citizens bestowed their riches on the less fortunate by disposing of it. I was beguiled by the celebratory, cosmopolitan sensibility of the *yiusurum* – the Sunday market – a place in central Athens where a formal antiques market spills over into a flea market stocking bric-a-brac; the stomping ground of hipsters, designers, bargain hunters and car-boot junkies. But as I deepened my investigation, I noticed that beneath the air of abundance despite austerity, there was a rather more sinister tale of undercutting costs, in which the scroungers needed to become ever more daring and desperate to provide their goods, where 'value' needed to be rethought. This redefinition of value – for example, an old and broken photographic camera transforming into a lamp and parts of broken fridges becoming side tables – is in direct confrontation with the prevailing status of consumption; yet this reveals a greater paradox that undermines the cycles of capitalist production. This is because the consumers who originally disposed of their possessions to the mercy of the street and its trash pickers are usually the customers in

this market – ready to repurchase the same objects that were stripped of meaning in their prior use. This is not a conscious decision of recycling and green politics but resembles more a cultural quest for the new hippest objects and trends. In particular, I argue, the changing function of waste as a potential commodity revisits the divide between the public and the private, between state and individuals, between 'home' and the pavement. For some time, I resisted the urge to sort or define a typology of scrounging, because I too was implicated in these rhythms of collecting, buying, selling and reusing.

The visual ethnography thus begins with this central location, from whence I turn to other, less visible marketplaces of trash, flotsam and urban junk; to explore the ways in which human values are being traded and exchanged. All the while, the crisis looms large. I have picked through several years' worth of visits to the market, where I photographed traders, dumpster divers and scroungers. From my journeys through the discarded remnants of other people's lives, I have curated this collection of images, objects and pathways through the city. The composition and selection process of the images recognises the politics within aesthetics. This is an ethical concern, as the scroungers' faces have not been captured, while market traders were happy to have their portraits taken. Some of the images provide detailed representations of material life and evoke the pain of dumpster diving and living on the streets.

Remnants from the streets

The 'consumer basket'

Everyday life in the era of crisis has been less well documented than the impressive protests that capture international headlines. In recent years, as media reports indicated a rise in homelessness, the city streets told a concomitant story, with makeshift cardboard shelters against the elements seemingly springing up on every corner. Urban homelessness has a particular aesthetic that seems to reinforce the imbrication of market forces within its very conditions; with homeless men and women often purloining shopping trolleys from supermarkets in which to wheel their belongings – firstly, to keep them in one place; and secondly, to be mobile. Instead of transporting purchased goods from supermarkets to pantries and kitchens in high-rise apartments, these trolleys hold the vestiges of 'home', becoming piled high with fresh cardboard boxes and throwaway items.

The 'consumer basket' is a term used by economists to describe the average cost of goods and services and usually depicts the health of an

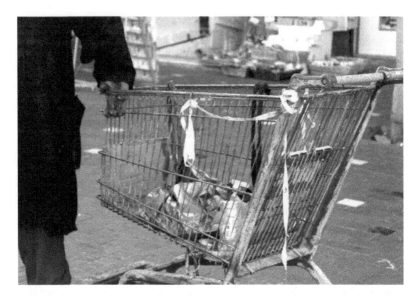

Figure 3.1 Homeless man with his trolley, December 2011. Photograph by Myrto Tsilimpounidi, Ministry of Untold Stories. Project online at www.ministryof untoldstories.gr

economy.[3] Figure 3.1 (one of a series) shows a homeless man clutching his empty shopping trolley, navigating central streets near the Acropolis. We cannot see where he is going, nor what he is feeling. Yet, despite the austerity of his trolley, he seems assured of his destination. Every day, thousands of trolleys are wheeled through the streets of Athens. One supermarket chain reported a €1 million loss from shrinkage of supermarket trolleys (Ntiniakos 2012).

The trajectories of the many supermarket trolleys are offering an entry point into the new map of Athens in crisis. Considering that one-third of the population lives below the poverty threshold, and adding to that the statistically invisible lives[4] of the *sans-papiers*, these new Athenian routes create their own rhythms and redefinitions on the urban fabric. Instead of glorious sightseeing landmarks, big markets and major shops, this new map includes the best dumpster diving spots, which are usually found next to the big markets and in the very expensive neighbourhoods, safe places to sleep, and where to stroll a trolley down the central avenues to the scrap market. If mapping usually begins by defining home and from there outlines the different trajectories of social activities, then this new kind of crisis remapping

begins from the understanding that home as a physical entity does not exist anymore.

Detritus from street observations

The labour of trash picking: counting cardboard boxes, cans and beer bottles. I wonder how many items are sought and loaded until the working day stops? Every now and then there is the discovery of some special items, demanding careful cleaning and observation as these would be the goods for sale at the weekly yiusurum. A second-hand living that questions the limits of the law. In January 2012, a conservative MP (see Pipili 2012) demanded the criminalisation of trash picking as the pickers steal recyclable goods from which the state should be making money. In the same statement, the MP offers a racial profile of the pickers, demonising and further marginalising certain groups of the population. What seems to be missing from the MP's statement is the criminalisation of the profits certain recycling companies are making since the price per kilo of goods from the pickers is much less than the 'legal' price those companies pay to buy from the recycling units of the state. A second-hand living questions the legality of a state that impoverishes one-third of its population while provisions from the social welfare system are non-existent.

'Waste not, want not': DIY survival

Growth economies are contingent on the development of new desires, new markets and new consumables, and thus result in the disposal of the old. Disposal becomes another part of the cycle of production and consumption, and is not a by-product but an integral element within that process. For people who have been excluded from mainstream cycles of production and consumption, the opportunity to extract value from scrap is a means of survival. Yet, the market in scrap metal, for example, is not always legal, as Ntiniakos points out, reporting excessive losses from electricity cable theft (2012), which is commonly attributed to the rickshaw drivers.

For many years, the rickshaws have been a common sight and sound. As they crawl through traffic, the driver, or the passenger, is often heard over a DIY loudspeaker encouraging householders to hand over their unwanted goods for collection. The (often unsteady) rickshaws navigate Athens by collecting and distributing goods: relieving people of scrap metal and household appliances. They have carved a map in which their entrepreneurship is rewarded by the consumption patterns of their 'clients'. From industrial areas to middle-class neighbourhoods,

Figure 3.2 A rickshaw, summer 2010. Photograph by Myrto Tsilimpounidi, Ministry of Untold Stories. Project online at www.ministryofuntoldstories.gr

from the city centre to the high-class suburbs, from early in the morning to late at night, from rail yards to the high street, the 'scrounger's world offers many a spatial permutation' (Ferrell 2006: 2). Jeff Ferrell's ethnographic account of scrounging in the US characterises the street dwellers of his investigation as marginal entrepreneurs.

> Day after day in the empire of scrounge, I discovered, yours becomes mine and mine yours – but haltingly, imperfectly, ambiguously, as part of the city's complex everyday rhythms. In this cast-off material empire the immediacy of individual consumption becomes an ongoing urban aftermath, a collective dynamic interwoven with the city's daily life. (2006: 3–4)

Yet Ferrell's rather romantic characterisation belies the mistrust in the ways in which the 'legitimate' public sphere responds to these illicit dealings. MPs and municipal officials have raised discussions in parliament about the losses faced by the state from people who 'steal' trash (Skribanos 2012). Yet, if trash is already discarded, how can it be stolen? Such concerns are fuelled by a spiralling lack of control over

the economic cycles and a never-ending grasping towards solutions that might be profitable. In a fit of desperation, the elites have noticed that these marginal entrepreneurs are profiteering from recycling, and instead the government is attempting to reclaim waste for its own ends. By turning their attention to who has the right to make money from trash, these government elites and corporate players benefiting from this economy of waste management are avoiding focusing on the erosion of public and private domains that results from extreme poverty and marginalisation. As Strasser has shown, the 'rhetoric of the debate over garbage has shifted during the twentieth century. Described as a problem of poverty at the beginning of the previous century, garbage is now understood as a problem of affluence' (1999: 9). On a household level, non-trash belongs to the house, trash belongs to the streets – it is public. The question that arises is whether profits from trash ought to be reaped by the state and big corporations, and whether these everyday recyclers with their rickshaws and trolleys are illegally undermining the efforts of the state.

This juxtaposition of legitimate and illicit economies of waste between state policies of waste management and urban scroungers opens up a wider debate on the limits of legality and public space. On the one hand, the government and municipalities are using the argument of theft to criminalise scroungers. Yet the Greek authorities have a long history of illegal waste management and are facing severe EU fines over illegal landfill violations.[5] How can a government already convicted for its policies of handling waste denounce as illegal the activities of the scroungers? On the other hand, in an effort to regulate waste management, the government announced the privatisation of waste management and the creation of a vast landfill site on the margins of the city in the area of Keratea. This caused huge public outcry from the local citizens and ecological organisations, which resulted in a series of urban battlefields between the local residents and supportive organisations and the riot police. This signifies yet another misuse of power by the government – one that points towards the hegemonic uses of public space and the enforced control of appropriate acts of citizenship. I propose that this is what reinforces a sense of support shown by the public towards the scroungers – the illegitimacy of the state legitimises scrounging.

To return to the rhythms of the trash collectors, my account circles back to the laden rickshaws. The rickshaw drivers collect goods throughout the week, and on Sundays they converge in the open stretch of public space between the Acropolis and the trendy neighbourhood of Gazi, turning a pedestrian area into a strange bazaar of valuables and cast-offs piled together in luscious displays of colour.

Yiusurum is a word from the Ottoman era that has been adopted into Greek and that means a bazaar or market place. Many tourists to Athens used to spend hours in the market at the foot of the Acropolis. In the era of crisis, however, the market has been divided into two different parts. The upper market is formal and monitored and stallholders pay for a trade permit, which means that their wares are generally antiques, collectibles or crafts. The prices are usually high and the clientele varies from interior designers to tourists seeking fragments of 'authentic Athens'. This genteel market quickly disintegrates as one wanders down the slope, with traders jostling for space in which to set up their domains. Soon, the market visitor encounters piles of clothes, old toys, rusted car parts and collections of items others have discarded. And while the sales are dropping in the upper part of the market, week after week the informal *yiusurum* has gathered crowds looking for bargains and bulk discounts. Occasionally, as I have rummaged through the knick-knacks without a sense of what I wanted, I have discovered documents: old maps, books in foreign languages, marriage certificates, school reports. Another reminder of the multi-layered waste culture and the commodification of everyday life that capitalism is based upon: wasted documents, documentations of waste, and documents of the wasted.

'Utopia is here, underneath this cement'[6]

Despite the awareness that some of these market stalls trade in black market goods purloined from factories, or vandalised homes, the *yiusurum* maintains a convivial atmosphere. Traders are proactive, friendly and approachable, keen to bargain to close the sale. This bargaining reveals the contingent value of the objects – perhaps not directly worth €3 but worth the effort to agree a price.

In Figure 3.3, a tradeswoman has used the cement blocks of an unfinished building as her display cabinet. The debris of the collapsed construction industry becomes a market stall, offering sensory stimulation that draws attention to the paradox of the unfinished building. This image projects the Situationists' slogan 'utopia is here, underneath this cement'.

The *yiusurum* collects and deposits all manner of unwanted goods in what is jokingly referred to as the 'Harrods of the East', since you can get anything you want. In this bazaar, though, in its ludic jumble of public and private, customers are not sold illusions of luxury, but the illusion that they still exist as consumers, that they still have choice, despite having little disposable income. There is an uncertain empowerment in being able to 'go shopping' in a time of austerity. Uncertain because one is not sure where the goods have come from – nor, indeed, whether one is buying them out of necessity or merely for the performance of

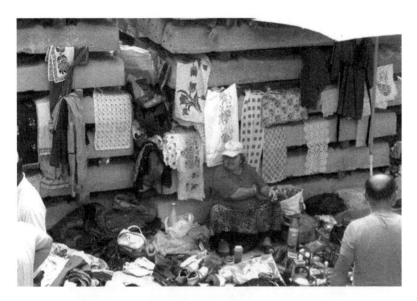

Figure 3.3 Trader with embroidered cloths, December 2011. Photograph by Myrto Tsilimpounidi, Ministry of Untold Stories. Project online at www. ministryofuntoldstories.gr

'getting and spending'. Perhaps the illusion of the ability to perform as consumers – despite the shaky foundations of the black market economy – points towards a dramaturgy of what I have considered empowerment. The consumers still maintain a role that is coherent within the capitalist frame, as they still spend without really questioning the structures of production and consumption, not even in this extreme performance of 'good consumer' in an era of austerity and crisis.

From the perspective of the sellers, however, they have made a claim to the topography of the city: an outcome of a week's work of scrounging, sorting and picking. The displays of the *yiusurum* become the final product in this alternative cycle of production, consumption, disposal and recycling. The traders inject their trademark imagination into the precarious pyramids of lipsticks and the colour-coded toy trains. By the end of the day, traders are ready to rest, and to discard some of what they have not sold (in a strange act of junking the junk). As long as the cycles continue – cycles in which traders turn up at the open space with their bags and boxes, and customers continue to purchase the items – the trash itself has gained value. What keeps the *yiusurum* active is an unspoken contract in which some people of Athens prefer to support these (illegal) traders, even protecting them when municipal

police arrive to crack down on hawkers. I see this as a kind of solidarity of the margins.

The conviviality of traders

The woman in Figure 3.4 was prepared to tell me some stories of her goods. We discussed her journey to the market, and her particular items for sale. She agreed to pose for her picture while a nearby trader told us that he sells in order to supplement his pension. His parting statement was that there are 'too many products, too little life'. Sitting in the remnants of someone else's living room, the woman seemed eager to close the discussion with a sale.

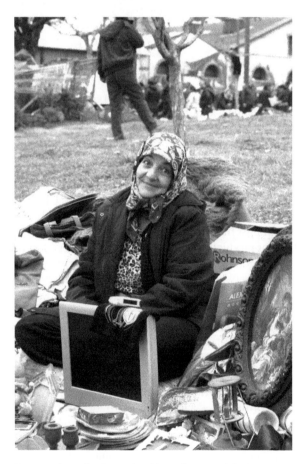

Figure 3.4 Portrait of a trader, December 2011. Photograph by Myrto Tsilimpounidi, Ministry of Untold Stories. Project online at www.ministryofuntoldstories.gr

The image manifests something of the ephemerality of the *yiusurum*, as we are drawn to the woman's pose – sitting coyly amidst crockery and old curtains, her head tilted in the same way as that of the figure in the painting nearby. The reflected posture allows a reflection on the positioning of the private sphere – of intimacy, desire and romance in the painting – with the public, consumer-driven marketing of such desires in relation to goods and possessions.

Scroungers radically reinvent the divide between public and private by reframing the old and forgotten objects and mementoes as desirable items. But on this same day, I was struck by another instance of scrounging that was staged towards the end of the market trading, as people packed up their rickshaws and trolleys to head home. I noticed a municipal skip and a collection of people rummaging through it, scrounging for goods or clothes. Until the onset of the economic crisis, dumpster-diving and trash-picking aesthetics were usually inscribed by class and social standing. In Figure 3.5, we can see well-dressed men and women reaching into the bins to find something. There was a strange desperation, too, as if they were hopeful that they would locate something of value that someone else had missed.

This image resounded with others I had collected over the preceding weeks, in which I had captured old men searching through bakery

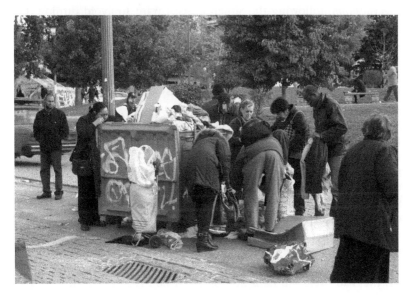

Figure 3.5 The end of the market, December 2011. Photograph by Myrto Tsilimpounidi, Ministry of Untold Stories. Project online at www.ministryofun toldstories.gr

delivery boxes for crumbs and younger people draining a discarded olive oil tin.

How, then, does the *yiusurum* re-inscribe the topographies of Athens? The images and the investigation have considered the means by which traders repurpose discarded goods in the era of austerity. This, I suggest, creates alternative value and meaning and offers a grass-roots sabotaging of consumer practices in the era of crisis. The acts of scrounging – and, indeed, the purchasing of scrounged goods – question the limits of the law by considering how value is produced. The market itself reclaims space and identities while the objects and visual stimuli of the *yiusurum* question the limits of the objects' value(s). I have described the convergence of trash and disposables in this central location as an interruption or interstice, in which marginal lives, voices, people and goods collect and rearrange their configurations. I have demonstrated the ways in which the illicit processes for obtaining goods have undermined the hegemonic capitalist structures that arguably placed Greece in its precarious economic position. The journeys through the streets and pavements of the market have positioned the struggle to survive firmly on the map of everyday life in the city. Despite the artistic value of the *yiusurum*, the creativity of its traders and the transformation of urban debris and leftovers into colourful and aesthetically consumable piles of goods, I have deliberately avoided an analysis aestheticizing the *yiusurum*; following the Situationists, I want to avoid turning the *yiusurum* into another commodity, or a misery freak show that could easily be consumable. Moreover, I hesitate to analyse this informal and illegal market's 'success', as a debate on success or failure of the *yiusurum* would follow the hegemonic logic of neoliberalism. Instead, my analysis follows the fragmented, messy and uncanny trajectories and values of a city in a time of crisis. For me, the *yiusurum* provides a way of examining the socio-spatial dynamics of Athens. Practices and performances of this new urban tribe, which is remapping the city and providing a fresh perspective on trash, recyclable materials and stolen goods, are a new currency in the times of austerity. These views of a city in crisis ask us to witness the shifts in normative relationships with waste, and to consider the potential to reimagine values. Finally, this chapter is an investigation of a contemporary moment of ontological uncertainty, precarity and risk. It moves away from a romanticisation or fetishisation of the scroungers and the *yiusurum*, as it acknowledges the danger of falling into the trap of binaries: the 'good' scroungers versus the 'bad' state mechanisms. Rather, it points towards the multiple

mechanisms of social marginalisation and isolation evident in the time of financial austerity in Europe.

In conclusion, it is perhaps fitting to consider the means by which there is a relationship between the legitimate consumers and the illicit market that reflects, in a microcosm, the mutual imbrication of inside/outside that characterises this volume. Indeed, the wider characterisation of Greece's economy as 'junk' within the global marketplace has required a re-evaluation of the legitimacy of wider market regulations – specifically those of the EU, whose policies relating to the single currency have meant that austerity is not merely a matter of good order and discipline, but is in fact a means of sorting, separating and discarding the seemingly worthless detritus of Europe's development. At the same time, the capitalist economies of waste production and management have become the new currency of post-2008 European neoliberalisation as the deregulation and at the same time privatisation of these economies exemplify the contemporary 'growth economies'. In this light, performances of the *yiusurum* invite us to reconsider and reimagine the detritus of Europe's development, as well as the global forces of capitalism that produce human waste.

Notes

1. A big thank you to the editors of this volume for their invaluable comments in the shaping of this chapter. All photographs taken by Myrto Tsilimpounidi (Sony A100) under the auspices of the Ministry of Untold Stories (see www. ministryofuntoldstories.gr).
2. For example, on 3 June 2012, there was a shortage of medication. People with cancer could not access treatment; state-run hospitals made a call to stop non-essential surgical interventions because of a critical shortage of gloves, syringes and gauze (Davies 2012; Chatzistefanou 2012b).
3. The section 'The "consumer basket"' has been adapted from a commentary written for the International Visual Sociological Association (Tsilimpounidi 2012b).
4. The absence of data for the *sans-papiers* immigrants makes them statistically invisible and as such not included in official data; therefore, even the figures of unemployment and poverty are fundamentally skewed since a large section of society (the one facing further marginality) remains invisible and unrepresented.
5. In 2005, Greece was convicted in the European Court of Justice by the European Commission for illegal landfill violations. In 2013, Greece was hauled back to the European Court of Justice for failing to implement an earlier ruling on illegal landfills. Meanwhile, the austerity-ridden country

was paying severe fines: 'The Commission added that in line with established policy, it has suggested a daily penalty payment of €71,193 for each day following the second Court ruling until the financially challenged country complies with the judgment. A lump sum calculated on the basis of €7786 per day is also being sought for the period between the first judgment and the day of compliance or the day of the second Court ruling' (Messenger 2013).
6. Graffiti tag, Athens, 2012.

Part II
Paradoxes

4

Performing Politics of Care: Theatrical Practices of Radical Learning as a Weapon Against the Spectre of Fatalism[1]

Florian Thamer and Tina Turnheim
Translated from the German by Martin Thomas Pesl

Preface: performances of crises, capitalism and resistance

It was in the 1920s and early 1930s that Erwin Piscator attempted to counter the fascist 'aestheticisation of politics' with 'politicisation of art' (cf. Benjamin 2009) by applying an advanced technical, documentary aesthetic. Up until his emigration, Piscator tried to use this kind of proletarian theatre to immunise a population suffering from the effects of the war and the economic crisis against the promises of Nazism. Much later, in 1965, the same Piscator would write the following:

> Once before did a sterile, neutral and aesthetic art fail to stop our descent into barbarism – this should not be repeated. Political theatre seems to me to be a suitable tool for evaluating the political and social conditions of one's time. [...] Immanent in this image is the tendency to change. Based on evidence, the present is supposed to be altered. Whether this is successful is no longer within the capabilities of theatre. (1968: 340)

We include this historical reference to Piscator's political documentary theatre at the beginning of our essay because critics and intellectuals largely rejected this committed approach due to its fomenting attitude. Even in today's theatre studies, it is acknowledged almost exclusively for its then novel use of stage techniques and media. Once again, this reminds us of the lengthy, conflict-ridden relationship between theatre and (leftist) politics. However, it also points at how pressing is the

discussion of the reactionary backlash that can currently be observed in Europe in the slipstream of the Euro and financial crisis. This swing to the right has found its most recent disconcerting manifestation in the European elections of May 2014. Generally referring back to anti-European tendencies and nationalist narratives, as well as the desire to further cement Fortress EU, it oscillates between an openly nationalist/fascist or even neo-Nazi pole, typified by Golden Dawn in Greece and Jobbik in Hungary, and a more moderate pole hidden under a bourgeois cloak, such as the Alternative für Deutschland that was founded in 2013 and warrants its nationalism mainly thanks to its radically neoliberal line of argument, or the British UKIP, which runs on a kind of prosperity chauvinism that caters to people's fear of their own nation's loss of economic and political power.

While so far only the radical left has looked for strategies to combat this broad social and governmental acceptance of right-wing populist parties – or even right-wing extremist parties[2] – the art world once again runs the risk of getting lost in its own highly self-referential debates.[3] That is to say, even though the extensive situation of crisis has visibly sparked references to political, social and economic issues in recent years throughout various forms of art production, the art world was paradoxically accused of being eager to submit to the hype about social relevance that is owed to a neoliberal grant application culture and thereby of disparaging criticism by exploiting that culture. Much like in Piscator's times, such debates tend to declare that any thematic, political discussion in art is naïve and falls short,[4] and that artistic form and production processes are the only valid criteria of an art that is allegedly political but entirely lacks real-world substance.

In light of the developments outlined above, we believe that it is necessary to follow Piscator's and, as will soon become clear, primarily Bertolt Brecht's approach of committed theatre practice. Our thoughts therefore constitute an attempt to put a model of state-of-the-art political theatre up for discussion. We believe this model can not only stimulate political imagination beyond what already exists, using *radically emancipatory learning practices* and thereby presenting alternatives apart from nation and capital, but also put these imaginings to the test in *presentist* processes. By analysing conceptions of *care work, exodus* and *constituting processes*, we would like to explore how useful these can be in connection with Brecht's *Lehrstück* theory as tools of postulating a new practice of theatre, which we will henceforth designate as *theatre of care*.

In this context, reference to the concept of care arises for three reasons. Firstly, we use it to affirmatively include practices used in site

occupations in recent years,[5] which focused on care and managed to engage extremely heterogeneous parts of society in dialogue by installing facilities such as communal kitchens, free libraries or shared childcare centres. At the same time, the alternative options to act that were *learned* at these places were often successfully converted to self-organised collectives, whereby these forms of coexistence that were free of market-economic efficiency logic became permanent and, being tangible experiments, constituted incentives for society to be conceived in different ways.

Secondly, it can be observed, unfortunately, that right-wing extremist groups have also long discovered care as a strategy for themselves. For example, Golden Dawn organises neighbourhood patrols, hands out meals publicly and escorts elderly people to the bank. Although this ostentatious social work is provided for Greeks only, it still helps the party not only to conceal its neo-Nazi structures and ideas but also to be perceived by the masses as a movement of solidarity. In clearer terms: care must under no circumstances be ceded to the right.

Thirdly, we believe that, following the Marxist scope, social reproduction – as drawn upon by even the most recent care discourses – constitutes the realm of cultural (re)production too. As the German playwright and director René Pollesch explains in a different context using a sentence he borrowed from Donna Haraway, it is important 'to talk "with" someone and not "for" someone!' (Pollesch 2009: 302) Now, *talking with someone* could be paraphrased as Brecht's *Lehrstück* (teaching play) or, as he himself corrected it later, *Lernstück* ('learning play'),[6] as this could, in our opinion, be a weapon not only against the spectre of impuissance-generating self-criticism but also against that of the fatalism which dominates the current capitalist realism (cf. Fisher 2009).

Of kitchens, site occupations and rehearsal stages

The concept of social reproduction is derived from Marxist traditions and includes both the care necessary to biologically reanimate, or animate, human labour power and the reproduction of social and cultural values of society (cf. Haidinger and Knittler 2014: 109). It has been known to a broader public ever since the international 'Wages for Housework' campaign (cf. Kitchen Politics 2012) in the 1970s.[7] Admittedly, the demand for wages in exchange for household chores might sound paradoxical at first, as it appears not only to acknowledge but also to firmly establish the very relationship of wage labour that is to be rejected according to Marxist views. To understand this demand,

it is crucial to consider the entanglement of the campaign's protagonists in both anticolonial struggle and Italian *operaismo*. The latter demanded a return to Marx in order to focus on the fundamental antagonism of capital against labour and to take social struggles as a primary starting point. Workers deserting from factories or struggling for higher and higher wages were to affect the system of wage labour by making it unprofitable. For feminists such as Silvia Federici, writing in 1975, this attack on the capitalist relationship embodied by wages is:

> in the case of the wageless, [...] even more clearly an attack on capital. Wages for Housework means that capital will have to pay for the enormous amount of social services employers now save on our backs. Most important, to demand Wages for Housework is to refuse to accept our work as a biological destiny, [...]. (Federici and Cox 2012b: 37)

Unlike the bourgeois women's liberation movement, the proponents of 'Wages for Housework' had no interest in winning or securing women's access to wage labour in order for them to become (financially) independent, as they recognised this as yet another exploitative relationship and means of time deprivation that would further impede political or other self-determined activities outside the reproductive work they would continue to pursue. In retrospect, Angela Mitropoulos's words provide an apt summary of the campaign:

> The Fordist worker's distinction between work time and leisure time was made possible by unpaid domestic labour. The emergence of the welfare state was underwritten by colonial forms of accumulation, coercion and war. The much-celebrated protectionism of social democracy was made possible by laws and practices that were as nationalist as they were sexist. (2011)

But what is the connection between this Marxist-feminist discourse of the 1970s – which constituted mostly an insurrection against the labour and gender regime of Fordism and contributed to the development of post-Fordism with its workerist criticism and ideas – and political theatre work under the current conditions of *fabbrica diffusa*?[8]

As the capitalist system with its inherent crisis potential is facing the danger of being unable to reproduce itself due to one of its more severe crises, critical examination of reproductive work in the context of queer/feminist theory is in the midst of a comeback in the wake of

such concepts as care work and care economy.[9] The following excerpt from Federici's famous 1975 text, *Counterplanning from the Kitchen*, could well have been written under current circumstances, seeing as divorces are hardly an option in the crisis-ridden countries in Southern Europe for financial reasons; while, in the countries that profit from the crisis, increasing attempts are made to generate security and self-actualisation by means of settling down to family life.

> It is the essence of capitalist ideology to glorify the family as a 'private world,' the last frontier where men and women 'keep [their] souls alive,' and it is no wonder that this ideology is enjoying a renewed popularity with capitalist planners in our present times of 'crisis' and 'austerity' and 'hardship'. [...] This ideology that opposes [...] the productive to unproductive work, is functional to our enslavement to the home, which, in the absence of a wage, has always appeared as an act of love. (2012: 35)

The concept of care, extended so as to include meaning and efficacy, is concerned not only with raising awareness of reproductive work that had not been acknowledged before as adding value, but also with achieving a central position for care as a basic need in all social relationships, because care, intended to create social infrastructure, allows for 'empathetic attention, active participation and an excessive form of solidarity as well as fellowship that can constitute itself in collective forms of the communal' (Winter 2013: 7). Care work can thus intensify subjective energy, as it opens our eyes to 'how the current circumstances are socially developed and fabricated, for their history and thus their changeability' (2013: 13). Based on experiences with site occupations in recent years, much has been thought about a political concept of love, about how care work fosters social movements materially by creating infrastructure and about how it could therefore be able to provide these movements' constituting processes in the long run. In the meantime, we would like to start by quickly pointing out the structural similarities between care work and theatre work.[10]

'They Say It Is Love. We Say It Is [...] Work.'[11]

Both types of work are impossible, or hardly possible, to automate; they involve one's own body producing work with/for other bodies present at the same time without manufacturing a product of either permanent or immediately material nature. Being classified as precarious work, both oscillate between 'curious symmetries, at once public and private, [...]

[b]lurring the distinction between the time of work and that of life' (Mitropoulos 2011). Both are forms of affective (cf. Mezzadra 2005; Hardt and Negri 2004; Federici 2011) and relational labour, which results in a (re)production not only of labour power but also of cultural values and is largely performed by female and queer persons in precarious employment situations.[12] Much like care workers, theatre workers (especially in the so-called fringe) usually do not have much of an option to fight for better working conditions or higher wages, because they are often their very own precarious bosses, because refusal to work would hit the 'wrong' people, and because the respective tasks are not acknowledged as directly adding value anyway. This goes so far as not regarding theatre work as work, as it is financially profitable only in very rare and exceptional cases, but classifying it as play, as a means of self-actualisation, as a hobby or even as love (for the theatre). Unlike, say, visual artists, theatre-makers do not produce a material piece of work that can be sold on the market and that endures until, or might even gain value after, the performance. While many collectives who work in fringe theatre have come to reject the idea of authorship underlying the concept of a work of art, they still produce *cognitive capital* and make considerable contributions to the *general intellect*.

Although much scolded by the notorious 'artist critique' (cf. Boltanski and Chiapello 2005; Rancière 2006) and declared to be a role model for the neoliberal 'subject',[13] this estimation of the workers' own 'situation and utilisation' (Brecht 1997a: 476) bears a sense of orientation that helps them gain new agency, which we will use as a starting point for our thoughts on a *theatre of care* based on the extended understanding of the care concept outlined above.

Theatre as a space of opportunity – exodus from fatalism

As initially pointed out, in the continuing crisis, criticism of capitalism has become a mass phenomenon hardly any artistic production would want to, or be able to, deny itself the pleasure of drawing upon. Still, the combination of disillusionment and exhaustion continues to yield a type of intellectual fatalism which not only has become the biggest obstacle of actual social, political and economic change itself but also helps neoliberalism to reproduce. As Sam Gindin warns, even intellectuals and activists are not immune from falling victim to this *spectre of fatalism* by still believing that capitalism is the only option and not recognising the inherent contradictions of this system, but instead pillorying the greed and failure of individuals (cf. Gindin 2013). And yet it is

Marx himself who, in the preface to the first German edition of *Capital* (1867), explains his depiction of 'the capitalist and the landowner' from a point of view and in a language that represent the exact opposite of this kind of personification and language, which would later be shared by Brecht's materialist theatre.

> But here individuals are dealt with only in so far as they are the personification of economic categories, embodiments of particular class-relations and class-interests. My standpoint [...] can less than any other make the individual responsible for relations whose creature he socially remains, however much he may subjectively raise himself above them. (1977)

However, in the face of a depressing lack of alternatives, it remains easier to shift the blame to individuals than to dream of, actually design or simply insist on social alternatives beyond the personalised level, as this is 'always intimately related to, and limited by, what we consider possible' (Gindin 2013). And this is exactly the point at which Brecht's theatre unfolds political imagination[14] by exposing socio-economic structures and power relations and at the same time fighting fatalism by exploring spaces of opportunity.

> The theater of Brecht seems so appropriate to our times because it challenges his audience to directly confront the issue of fatalism. Brecht's uncompromising starting point is that if we accept the social structures of capitalism, we are indeed left with the limited choices that undermine meaningful human agency. His technique of simultaneously engaging yet distancing the audience is intended to deny us the comfort of either romanticizing events or resolving, within the theater, the dilemmas posed [...] Brecht is concerned to encourage the feelings and thoughts that go beyond this and look to transforming those very parameters. Art then becomes a weapon against fatalism. (2013)

In his *fatzerkommentar*, Brecht deals with precisely this creation of spaces of opportunity by observing and adopting certain attitudes and gestures. The question of whether Fatzer's walk through the town of Mülheim can be considered reality, although it is likely that a man called Fatzer never actually walked through the town of Mülheim, is answered by stating that only a sufficient number of sufficiently good and sufficiently enlightened people would have to acknowledge Fatzer's walk as the truth (Brecht 1997a: 516) to acknowledge it as (possible) reality. In that sense,

contentious theatre practice would not only have to refuse to participate in producing existing fatalism, it would likewise have to defend, and permanently recreate, alternative spaces of thinking and speaking.

Based on the assumption that there seems to be no outside in the 'Empire' (Hardt and Negri 2000), we would like to focus primarily on the meaning of an updated radical *Lehrstück* practice. Therefore, theatre has to be regarded not only as a bourgeois institution and representative integral part of the cultural self-understanding of nation states but also as an island of disorder (cf. Müller 2005: 245) within these orders. Only then can theatre-making be understood as an outward (directed) process that goes beyond mere protest in the form of an exodus. It could thus help create a place beyond current capitalism. Even the exhaustion that is crucial for the existing fatalism could be released from its restorative function and instead be redirected into 'engaged withdrawal' (Virno 1996: 189–209). Such a 'strategy of escape' could then be 'an experience of civilisation based on a continuous withdrawal relative to set rules, on the inclination to mark cards while the game is going on' (Virno 2012: 25). This again would fuel Paolo Virno's logic, according to which:

> disobedience and escape are not negative gestures that deprive us of agency and responsibility. On the contrary, to desert means to change the conditions under which a conflict unfolds instead of submitting to them. The conflict begins where we produce something during escape in order to defend social conditions and new forms of living we are already about to experience. The old idea of escaping so as to be better able to attack is added by the certainty that the fight will be even more effective if we have *something to lose other than our chains*. (2012: 26)

Why else invest and redirect the cognitive and affective capital produced by our work, if not for this kind of exodus into the *Lehrstück* theatre, which could be able to create an outside from within?

For Franco Berardi, this 'act of creation of an outside is the poetic act we need now. Call it, if you want, imaginative transcendence' (Fischer and Berardi 2013: 15). Under these conditions, he even regards the exhaustion referred to above, which is so critical for the construction of fatalism within *capitalist realism*, as the '[...] keyword for the next insurgency, an insurrection that will be based on withdrawal and a refusal' (2013: 16):

> Exodus, the creation of a new space for production and exchange, the creation of a time that is outside debt and guilt and sacrifice, will be the methodology for autonomy. (2013: 18)

In recent years, many vacant theatre buildings have been reanimated by way of occupation in those regions of Southern Europe that were affected most by the crisis. The most prominent ones one should mention are the Embros Theatre in Athens and the Teatro Valle Occupato in Rome. In Italy, where particularly many theatre occupations have taken place, these also invoke the tradition of the workerist *Autonomia* movement of the 1970s. A crucial aspect of this ongoing development with regard to our thoughts on a theatre of care is that these autonomous, self-administered theatres are mostly run by collectives made up of artists and activists. While not all of these collaborations might be free of tensions,[15] we believe that the emergence and deepening of these alliances are welcome developments worth expanding, as these *new places of production* can host the development of new practices of sociality and theatre, which allow people to get together in a non-hierarchical multitude and diversity where everybody is allowed to bring in his or her own specific abilities and talents. In that sense, these places are ideal as potential 'places of the event' (Badiou 2005) of a theatre of care and of our approach of a radically emancipatory learning practice.

Laboratories and ceremonies of a *theatre of care*

Such a theatre of care can be described as a two-phase model. Phase one is about creating a lab situation, in which pre-figurative forms of living, thinking and working are given a presentist trial in a discursive, playful manner and then optionally transferred to constituting processes. Phase two is about the shared conceptualisation, preparation and execution of a public *theatrical exhibition*,[16] which is based on the collective experiences and results obtained in the laboratories above. As a consequence, social resonance can be generated and the constituting processes can be temporarily instituted. It should be noted, though, that while the radical emancipatory learning practice described as phase one here is always a prerequisite for devising the exhibitions of a theatre of care, achieving or implementing this second phase does not constitute a prerequisite for the first.

Phase I: *Lehrstück* practice as a lab for exploring presentist processes

> Bourgeois philosophers make a clear distinction between those who act and those who observe. He who thinks does not make that distinction. If you make this distinction, you cede political agency to those who act and philosophy to those who observe, although in fact politicians should be philosophers and philosophers should be

politicians. Between true philosophy and true political agency, there is no distinction. Once he has discovered this, he who thinks shall propose we train the young people in playing theatre, i.e. we make them both actors and observers, as it is proposed in the protocols for pedagogics. (Brecht 1997a: 524)[17]

In phase one of this process, which we imagine as resembling a theatrical workshop situation, the objective is to learn to experiment with the design and unfolding of affective relationships, diverse forms of organisation and aesthetic ways of perception in and together with heterogeneous groups on a micro-political level and in a pre-figurative manner (in terms of a pre-enactment of future solidary cohabitation). In this way, forms of 'radically inclusive participation and decision-making' (Lorey 2013: 49) can be practised in a microcosm, in which priority is accorded to the search for commonalities beyond individual and concrete features. Theatre lends itself to testing such presentist processes – understood as a 'becoming in the present', which is an 'extended, intense present' (2013: 50) – because it is already in itself double-labelled as 'art and social space at the same time' (Wihstutz 2012: 24). What is most important in this initial lab situation, however, is to avoid defining theatre as a '"place for watching" and therefore as a dispositive that constructs itself by making a division between spectator and staged event' (2012: 24). Instead, participants must be enabled to become an *equal part of the sensible*,[18] by which we also mean increased sensitivity and thus care – for oneself and for others. In order to create situations in which we talk 'with' each other instead of talking 'for' others (Pollesch 2009: 302), we rely on Brecht's learning play concept, which demands uncompromised elimination of the actor/spectator dichotomy. 'Grand pedagogy changes the role of play completely, rescinding the system of player (actor) and spectator. Big pedagogics knows only players (actors), who are also students' (Brecht 1997b: 396). The *Lehrstück* is not a theatre for consumers but a theatre of producers, because it 'teaches by being played, not by being seen' (1997b: 351). By dealing with artistic and political content in a multitude of voices, and through the playful 'execution of certain actions, adoption of certain attitudes, rendition of certain speeches and so forth' (Steinweg 1976: 228–9) in this workshop phase, this 'theatre without an audience' can provide participants with imagination tools for alternative forms of solidary cohabitation. Unlike in conventional rehearsing processes, there are no such (initial) spectators as directors, dramaturges or the like, as these roles are dissolved and replaced with the *general intellect*.

This is about teaching by means of theatre but articulating and making the impossibility of teaching a tangible subject of teaching instead of conceiving this impossibility as a teaching in itself. [...] Playing has absolute priority over understanding. It is thus not a meaning that is represented but a performance that generates meaning; not a theatre under safe conditions but one in which meaning is invented by playing in the first place. (Lehmann 2002: 253)

As the permanent insistence on differences establishes structural impossibilities and thus obstructs constituting processes of political subjectification beyond government, culture and identity, it is an essential aspect of this experimentally explored theatrical anticipation to identify common features. Only the shared trial of constituting processes – understood as 'a recurring rupture that exposes existing circumstances while at the same time clearing the way for new perspectives and new courses of action' (Lorey 2013: 49) – can offer the chance to express oneself politically on both a verbal and a play-related level and to discuss a radical transformation of society. It is therefore crucial for these constantly varying models of constituting processes to be reinvented again and again by all participants together. These situations of collective production can help participants recognise similarities with each other and constitute themselves as active subjects. '"I" am not a person. I emerge every moment, yet remain for none. I emerge in the form of a response. Permanent in me is that which responds to what remains permanent. [...] I make Myself' (Brecht 1997c: 404). The recognition of one's own processuality and legitimate creative power with respect to the self can also be helpful in recognising the processuality and contingency of social realities and one's legitimate personal creative power with respect to these social realities. If this is recognised, observers can become actors in Brecht's sense (cf. Brecht 1997a: 524).

Phase II: Conceptions of artistic *exhibitions* as 'instituting ceremonials'

Students shall imitate the representation by following the first artists of their time. The students shall criticise said representations by the first artists of their time in oral and written form but, in any case, imitate them until the criticism has altered them. (Brecht 1997a: 515)

Brecht himself spoke out multiple times against public performances of his *Lehrstücke*, as he had designed them as 'studies for the players'

and wanted to see such a 'theatre without spectators' devoid of any exploitative logic. However, he also emphasised that, should a public performance nevertheless occur, it would have to be 'more some kind of exhibition' (Brecht 1997e: 96).

Even before the common development of such a theatrical exhibition begins, we would list the following conditions as indispensable pre-requisites. Firstly, every exhibition in the context of theatre of care has to be preceded by a collective process of the lab practice described above. Secondly, all participants should get involved in the conception and implementation of an exhibition by their own choice and only according to their own needs and abilities. Thirdly, these rehearsing processes should in themselves be designed as free, open gatherings during which contents and preliminary findings are put up for open and negotiable discussion.

Given all this, public exhibitions can be extremely useful for the following reasons. The main reason already indicated above is the temporary constitution of the pre-figuratively obtained findings. While the method of experimenting is not exclusively aimed at generating exploitable results and does leave room for speculation, some constituting processes should be protected from coming to nothing. To do so, it is necessary for them – and the findings achieved in them – to be pinned down again and again, albeit only temporarily. If we assume that the laboratories bear the inherent potential of event sites on a subjective level, the idea of ceremonial, as borrowed from Jean Genet by Michael Hardt in his attempt to devise a political concept of love, might provide a useful arsenal of illustration.

> A ceremonial for Genet is a mechanism for prolonging and repeating encounters. The temporality of the ceremonial is key. The ceremonial engages the event, and passing through the encounter, operates a temporal transformation. (2013: 10)

We believe that Hardt's thoughts on Genet's concept of ceremony are highly connectable to Brecht's theatre conceptions, seeing as both take repetitions as their starting point – repetitions that need to be freshly re-examined again and again. Even though Hardt's concept of ceremony implies utter commitment while Brecht's non-Aristotelian theatre is known to demand an attitude of distance, both forms of repetition can result in distancing and decision-making upon re-examination. Also, the practice of exhibiting a piece of collective work will reinforce the players' producer status.[19]

In concluding this second phase – the public exhibition – these pre-figurations of seemingly unthinkable alternatives are perceived publicly due to the presence of an audience and can thus be potentially carried deeper into society. If we define theatre both as a *place of free gathering* in Virno's sense and as 'non-governmental public sphere' (2004: 40), theatre can be a *different public space*, a 'rampant middle' (Raunig 2010) amidst a torrent, exerting its influence on and within society. As Brecht said, it is possible that 'knowledge is needed at a place different from the one where it was found' (1997a: 524).

In order to evoke such resonance within society and to be able to make contributions to political imagination, producers should also make sure that they develop a sensibly and intellectually stimulating aesthetic. Brecht's statement in the *fatzerkommentar* that one should follow the first artists of one's time means framing the claim to experiment with processes of figuration in an advanced manner. It is through inventive artistic concepts that larger audiences can be reached, at least within a small yet slowly expandable structure, and that those addressed can twist themselves free from the capital of craving. Given the aestheticisation of life by capitalism throughout all areas, truly political theatre practice needs to work on other aesthetic forms in the long run to redirect the craving to alternative horizons of opportunities.

Constructively antagonistic cooperation with institutions

For this long-term, contentious work on a different aesthetic, by analogy with the structure of alliances that non-parliamentary leftist groups have formed in recent years both with each other and with institutions, antagonistic collaboration with existing theatre institutions could be imaginable and desirable for a theatre of care that defines itself as part of the fringe. As elaborated above, the occupied theatre houses in Southern Europe offer particularly suitable conditions for practices of our theatre of care thanks to their infrastructure, where any calculating is obsolete and space and time are abundant. But what role can be assigned to federally and municipally funded theatres in Germany? In a discourse briefly touched upon above, representatives of institutionalised theatres in German-speaking countries continue to declare that their houses are the last bastions of the post-war welfare state. Failing to critically reflect on their own Fordist mode of production or to understand that capitalism never has enough for everybody, leaving the fringe theatre workers literally at, or even outside, the fringe of available means of production, these representatives criticise the fringe's project-based, nomadic work

style instead of allowing the workers a share of the means of production in their possession.

> Municipal theatre must stop seeing itself as the theatre proper. Instead, it has to allow a perspective that includes many different forms of theatre, production and work. Actors must have the opportunity to be temporarily hired by companies or, better yet, found their own ones. (Karschnia 2013)

In order to optimally reduce the risk of independent groups and associations being usurped by the institutionalised theatres, their take on cooperation with the 'big ones' would have to be a constructively antagonistic one (see Mouffe 2012), much along the lines of Brecht, who, with respect to handling broadcasting stations as apparatuses for communication, once stated:

> However, it is by no means our task to renew the ideological institutes based on the existing social order, but we have to push them to give up their basis. So, innovations: yes, but renovation: no! By means of continuing, never ending proposals to better use the apparatuses in the interest of the community, we have to shake the social basis of these apparatuses and to debate their use in the interest of the few. (1997d: 557)

Theatre of care – a platform for making political theatre *politically*

To conclude, we would like to summarise the most important points of our proposition to implement a theatre of care, which for us is political theatre made *in a political manner*. Jean-Luc Godard's famous sentence about making films politically instead of making political films has often been quoted and applied to other art forms in recent years (cf. Müller-Schöll 2012; Deck and Sieburg 2011). However, this not only favoured but downright necessary perspective on conditions of production has – out of all reason, as we believe – blanketed or even replaced artistic takes on political issues. Nevertheless, we believe that neither can the only objective in theatre be to put political topics up for discussion nor to simply make theatre in a political manner. In our opinion, genuinely political contemporary theatre would have to link together, and mutually bear in mind, the *what* and the *how*. A prerequisite for this is to critically examine the facts associated with the economic, social and cultural

causes of social inequalities while at the same time adapting internal production conditions to a radical emancipatory attitude and aesthetic.

To do so, in our opinion, a refinement of Brecht's *Lehrstück* practice, taking into consideration an extended concept of care (as relating to concern, sympathy and solidarity), would be suitable because this extended care concept looks for commonalities while respecting differences and manages to reconcile theatre, intimacy and the public sphere. We regard learning plays as constituting processes in their purest form, which create spaces of equal exchange and contact that are in turn able to intensify pre-political situations and thus constitute political subjects.

So if the concept of care is combined with extended variations of Brechtian *Lehrstück* conceptions in a first step and with advanced, curious (artistic) theatre in a second, this enables the opening up of a space in which we can think about what Ludwig Wittgenstein called 'common behaviour of mankind' (1986: 82) before collectively deciding whether certain prevailing norms are still timely – or whether they ever were or will have been. Much like in activist work, which is often characterised by days of action and lengthy, exhausting phases of continuous work on resistance, a decisive problem of this theatrical learning practice is the fact that subjective energy will erupt during the *Lehrstück* phase and tend to deflagrate after immediate involvement. To counteract this, theatrical exhibitions of the collective work process could function in the way of ceremonies, which can renew and propagate traces of what has been experienced in the *Lehrstück*.

A theatre of care is mainly a theatre of attention and sensitisation, which rehearses and shows solidarity instead of just declaring it, while valuing long-term complicity with various social agents. A theatre of care does not move on because a production has been wrapped or a topic is done with. It does not exploit fates, and it has no intention of healing or assimilating anybody. Where the social movements place care at their centre, they graduate from isolated, impulsive and temporary social incidents to permanent, reproducing phenomena. This should also be the starting point of a radical emancipatory learning practice of theatre of care: creating new common spaces of solidary organisation and devising and rehearsing infrastructure, methods and experiences.

Notes

1. This text first appeared in June 2014 in German: 'Theater der Sorge – Politisch Politisches Theater machen' ['Theatre of Care – Making Political Theatre Politically'] in Ringlokschuppen Mülheim an der Ruhr, Matthias Naumann

and Mayte Zimmermann (eds) *Mülheimer Fatzerbücher 3 – In Gemeinschaft und als Einzelner* (Berlin: Neofelis Verlag). We would like to thank Neofelis for clearing the rights and the International Research Center 'Interweaving Performance Cultures' for supporting the translation into English.

2. For example, an international congress in Berlin from 11 to 13 April 2014 entitled 'Antifa in der Krise' ('Anti-Fascism in Crisis') dealt with precisely this new situation and involved debates on potential future strategies. See http://kriseundrassismus.noblogs.org (accessed 31 May 2014).

3. This and the following sentence refer primarily to debates in German art and academic discourses.

4. Armen Avanessian (2013) makes a plea to overcome this self-reflective criticism, which is not only problematic but also debilitating.

5. Here we refer, for example, to the *indignados* movement in Spain and to the occupiers of Syntagma Square in Athens.

6. On Brecht's use of the English term 'learning play' while in emigration, see Steinweg (1976: 140).

7. It should be noted here that the relationship between feminism and Marxism has never been without conflict and that the above-mentioned campaign was vigorously attacked by a number of male Marxists, as it points to a blind spot in Marx's theory itself.

8. 'The history of Post-Fordism lies in these struggles, in this resistance, this non-compliance. A new working class emerged, a new class context was born. Production did no longer only take place in factories but throughout society. Society became the factory' (Lorey *et al.* 2012: 189).

9. When using these terms it should be pointed out that they are quite controversial. There is increasing discussion, firstly, on whether all kinds of reproductive work really could be characterised as 'care work' and, secondly, on whether criticism voiced by advocates of a so-called 'care revolution' was short-sighted by failing to go beyond sugar-coating the benefits of the welfare state (cf. Haidinger and Knittler 2014). With reference to Frigga Haug, the authors expressly criticise a reformist concept of care, the point of view of which was not one of a free society but one of an 'inner-capitalist reform policy' (2014: 12).

10. We shall venture to point out these partially shared structural parallels without wanting to play down the many disastrous, slavish, seldom voluntary exploitative conditions on a global level in the realm of reproductive work.

11. Federici (2012: 15).

12. While we mainly refer to the fringe, much invisible work in federally and municipally funded theatres is also mainly performed by women and queer persons. Only the leading positions of institutionalised theatres are predominantly in male hands.

13. While federally subsidised theatres are attacked in the media on a regular basis for being 'annihilators of tax money' – yet still also necessary investments in nations of culture – while venues across towns are being fused in the name of 'market efficiency' and at the expense of artistic quality, and while, especially in the east of Germany, many theatre venues have been facing closure for several years, there have been recent attempts to widen the rift, which includes calling fringe theatre-makers the self-exploiting zombies of an 'avant-garde of postmodern capitalism' (Stegemann 2013), without,

of course, reflecting the officially funded theatre system's own hierarchic working conditions and its role in nation-building. See Stegemann (2013) and Karschnia's critical reply (2013) in his speech at the free performing arts summit in Berlin.

14. Like Gindin in his text, we chose not to differentiate between epic theatre and *Lehrstück*.

15. This assessment is based on our first-hand impressions at the Embros Theatre in Athens.

16. Our use of the term 'exhibition' (*'Ausstellung'*) refers back to Brecht's commentary of the decision in the *Lehrstück* entitled *Die Maßnahme (The Decision/The Measures Taken)*. See Brecht (1997e: 96).

17. Unless otherwise stated, all quotes from German have been translated into English specifically for this publication.

18. Note that the French term *partage* in the French title of Jacques Rancière's *Le partage du sensible* (2006) can mean both participation and division.

19. When we say players we mean to include all those who participate in such collective production processes; it is irrelevant who actually ends up on stage. All roles integral to the success of the exhibitions are assigned according to needs and abilities. In this context, dramaturgical tasks or outside perspectives are equally important. However, this does not mean that hierarchies are suddenly established, as all decisions are still taken in concert.

5
Making Time: The Prefigurative Politics of Quarantine's *Entitled*

Cristina Delgado-García

Introduction: the politics of aesthetics

This chapter explores how theatre may articulate political gestures not only thematically but also aesthetically. To this aim, the work of Salford-based theatre company Quarantine, and particularly their 2011 piece *Entitled*, is examined against the political, ideological and affective backdrop of neoliberal capitalism. My suggestion is that the political thrust of Quarantine's theatre is found in their work's replacement of the wider conceptual, perceptual and affective foundations of contemporary capitalism – for example, the neoliberal figuration of subjectivity as an entrepreneurial/consumerist project. Zooming in to the specific case of *Entitled*, this chapter argues that the piece enacts and prompts dispositions towards the present and the future that are counter-hegemonic in the specific context of post-2008 Europe and the first wave of austerity cuts in Britain. These insights enable a consideration of Quarantine's work as politically prefigurative. Understood loosely, prefigurative politics entails the anticipation of 'the world we wish to create through our actions in the present, while simultaneously rendering redundant that which we leave behind' (Cuevas-Hewitt 2011).[1] As this chapter seeks to demonstrate, Quarantine's work already embodies ways of understanding and experiencing subjectivity, social relations, temporality and value that revoke their disempowering, neoliberal counterparts.

Elsewhere I have argued that the absence of a specific political agenda in a theatre text or performance does not necessarily diminish its political charge (Delgado-García 2013). It is worth lingering on this point here to ground the case for the political significance of Quarantine's work. Crucial to this argument is the observation that inequality does not exclusively depend on tangible activities or situations, such as

material exploitation or deprivation; it also relies on ways of perceiving, conceptualising and feeling the world. Capitalism is not only sustained by specific forms of production, but also by emotions: we attain pleasure in fantasising about, purchasing, comparing and using commodities, and this affective relationship with the commodity buoys consumption. Under 'the new spirit of capitalism' (Boltanski and Chiapello 2005), workers are compelled to reconceptualise their self-exploitation and precarity as commendable personal and professional attributes, such as 'resilience', 'flexibility' or 'ability to work to deadlines'; this conceptual shift in turn facilitates the perpetuation of strenuous living and working conditions. These links between affect, thought and the mechanisms of contemporary capitalism suggest that the ways we feel, the ways we are affected by the world, and the ways we perceive and conceptualise it are entangled with the material conditions that we inhabit. As Maurizio Lazzarato argues, following Félix Guattari, capitalism 'graft[s] itself onto, among other things, perceptual, sensorial, affective, linguistic, and cognitive behaviour' to the extent that '[a]ffects, percepts, and statements become the matter and reality [...] of the market' (2006: 88). If so, then, affects, percepts and concepts have great purchase as potential vehicles for political critique and intervention when mobilised by art – even if an artwork does not thematically tackle concrete political issues.

Undoubtedly, my argument is indebted to Jacques Rancière's notion of the 'politics of aesthetics'. Rancière's postulations are rooted in the belief that politics perceptibly transforms what is given as self-evident facts. Crucially, he argues, art can also disrupt the ordinary forms of sensory experience, and materially rearrange the field of possible subjects and actions (2006: 39). For Rancière, therefore, it is not the 'political' commitment of the artists producing 'politicised art' (2006: 60) or the 'messages and sentiments it conveys concerning the state of the world' (2009a: 23) that make art political. Rather, what is political in art is its ability to establish 'new forms of visibility' that can in turn 'enter into politics' own field of aesthetic possibilities' (2006: 65). Rancière's critique of the categorisation of artworks as 'political' on the basis of authorial commitment or a piece's themes is momentous, as it reframes the difficult question of art's political efficaciousness. Indeed, art may not intervene in what we would commonly call politics and Rancière names 'the police' – namely, 'the set of procedures whereby the aggregation and consent of collectivities is achieved, the organisation of powers, the distribution of places and roles, and the systems for legitimizing this distribution' (1999: 28). Yet, following his argument, art may still

have an impact on what can be perceived, what can be seen or heard, what can be said, thought or done, by whom, when and where – what he calls 'the sensible' (2009a: 24–5). This is precisely where art and politics may intersect for Rancière: in their capacity to redistribute the sensible. This chapter nonetheless departs from these conjectures slightly, since questions of authorial intentionality and thematisation of politics are not necessarily discarded.[2]

Considering the hegemonic distribution of the sensible as one animated by neoliberalism, this chapter first revisits existing readings of Quarantine's work. This will help to identify the political quality of the company's trajectory beyond questions of representation and visibility, while contributing to a modulation of expectations about what may be political in a theatre piece in our geographic and historical conjuncture. It then moves on to a consideration of the meta-theatrical structure of *Entitled*, setting the basis for an examination of the show's political gestures in the context of Europe after the 2008 debt crisis, with a particular emphasis on its conceptual and affective renegotiation of temporality.

Quarantine's theatricalisation of the real

Quarantine's heterogeneous trajectory has comprised work as diverse as large-scale shows in theatres, one-to-one performances, immersive pieces and installations. Most of Quarantine's theatre practice arguably falls under the wide rubric of Reality Theatre, a mode of theatre performance loosely characterised by:

> an interest in extending public understanding of *contemporary* individuals and society; a focus on representing and/or putting *living* people on stage; and an aesthetics of '*authenticity* effects', artistic strategies designed to generate (and then, in some cases, destabilize) an impression of close contact with social reality and 'real' people. (Mumford 2013: 153, emphasis in the original)[3]

Distinctive to Quarantine's work is the theatrical framing of the real as the meeting point between authenticity, fragility, beauty and hope.

This engagement with reality is most apparent in Quarantine's employment of 'real people'. Since the company was established in Manchester by Richard Gregory, Renny O'Shea and Simon Banham in 1998, Quarantine has worked with individuals from a wide range of backgrounds, devising work *with* and *about* them (Quarantine 2011b).

Often, these collaborators have been from politically or theatrically under-represented backgrounds, and have included what Gregory and O'Shea call 'experts in everyday life' (quoted in Harris 2008: 9n). Borrowed from Berlin-based theatre company Rimini Protokoll, and preferred to the label 'non-professional performers', this terminological choice intimates the company's sensitivity to how identities are discursively produced and how they determine unequal entitlements and hierarchies – in this case, in relation to types of training and professional experience that count.[4] Examples of these under-represented, everyday specialists or 'found individuals' (Jackson 2011: 166) abound in Quarantine's history. In 2003, the company premiered *EatEat*, created in collaboration with a group of refugees and asylum seekers based in Leicester, one of Britain's most ethnically diverse cities. Directed by O'Shea and premiered during International Refugee Week, the piece had audience members and these volunteer performers eating together at a large banquet table. With the group of asylum seekers and refugees offering food and drink, as well as sounds, photographs and narratives, their identity as 'guests' imposed by the law was dramaturgically revoked. The following year, seven white, working-class young men from Greater Manchester worked under Gregory's direction to create *White Trash*. Set around a pool table, they shared personal stories, occasionally performing a choreography created by Christine Devaney and inspired by the performers' own movements. The piece thus offered an insight into and an artistic vision of a demographic bracket that 'get[s] overlooked by the "arts system", whose culture we don't see fit to be part of our "diversity"' (Gregory n.d.). Similarly, Quarantine's acclaimed piece *Susan and Darren* (2006), directed this time by both Gregory and O'Shea, was developed with and performed by a Manchester-based mother and her son. Respectively employed as a cleaner and a dancer, their biographies and relationship were defined throughout the piece, as they conversed about their lives, prepared a sandwich buffet with the audience, and danced.

Taking on board this trajectory, it makes sense that questions around identity, visibility and representation have been summoned to define Quarantine's politically salient engagement with contemporary British society. Annie Lloyd, for example, has located what she considers to be the 'deeply political' significance of their practice in the disruption and reconfiguration of hegemonic regimes of participation and appearance: 'They [Quarantine] make work that matters with people who are not seen on stage that much, people whom the media-driven society often marginalises' (quoted in Quarantine 2011b: 220).

The company's readiness to collaborate artistically with the disenfranchised or under-represented, or to populate the professional stage with bodies of all shapes, races, ages and levels of performance skill, already suggests Quarantine's disruption of implicit regimes of representation and participation, and their reformulation of these on the basis of equality. Geraldine Harris has begun to discuss this in persuasively Rancièrean terms with relation to *Susan and Darren*, suggesting that 'Susan's "appearance" is, in effect, as one of "the parts who have no part"' (2008: 8).

Yet, critical narratives identifying the asylum seeker or the working-class individual as 'the parts who have no part' risk perpetuating the currency of the very identity-based, social and individual categorisations that Quarantine's theatre practice – like Rancièrean theory – seeks to transcend. In other words, an identity-based analysis of their work risks reifying the social divisions that the company is interested in momentarily collapsing, while potentially neglecting important political gestures articulated in their shows. Taking into account the political significance of concepts and affects elucidated above, I would like to suggest that Quarantine's work has also engaged with socio-political aspects of contemporary Britain aesthetically and prefiguratively. To put it differently, there are conceptual and affective elements in Quarantine's theatre that attempt to replace the distributions of agencies, potentials, temporalities and modes of work favoured in today's neoliberal Britain.

To name one example: critical attention to the performers' identities risks overlooking a recurrent structural motif in Quarantine's work – namely, the orchestration of situations whereby strangers share a meal – and its political significance in neoliberal times. The economies of sharing, gifting and collaborating prompted by these strategies have the potential to temporarily replace the implacable logic of the market in today's advanced capitalist societies, and create heterogeneous and affirmative collectives beyond identity.[5] In *No Such Thing* (2012), Quarantine's ongoing, site-specific and one-to-one event, the spectators' position as patrons is destabilised: participants in this free show are offered a meal in one of Manchester's curry houses in exchange for a conversation, requiring value to be sought in the conversation and the company of an unknown individual, as well as in their own performance or collaboration in the encounter.

Quarantine's working ethos is also ideologically significant in neoliberal times. In the opening speech at the 2013 Noorderzon Performing Arts Festival in Groningen, Netherlands, Gregory argued for the arts' potential to rethink value, risk and success:

It seems to me that we've allowed ourselves to get used to looking at the world through the lens of capital, to discussing our problems in the language of bankers, to measuring our success in Facebook 'likes' and Twitter 're-tweets'. Is this how we want to be? Financial and social risks are taken on our behalf, without our agreement [...]. And yet – art might just remind us that risk isn't all about money and that failure, when it's shared, can be a powerful, progressive thing. If we don't experience it, we might not truly know what success looks like, or indeed what we might do next. Art might just remind us that being human is a messy, complex, terrible and brilliant thing. That not everything we produce as a species can be neatly wrapped up and sold in millions of units in a palatable form. That futures might be for imagining not trading. (2013)

Elsewhere, the company has elaborated further on the risk embedded in their particular theatre practice:

We've made theatre in a particular way together for the last 15 years, working with people's personal histories, often with people who aren't performers, often pulling everything together very close to first public presentation. We have found it gives our work a particularly fragile, human quality but inevitably it's a risky business [...]. (Quarantine 2013)[6]

Both public interventions frame Quarantine's recent creative process as consciously challenging structures of thought and feeling that underpin privileged experience in late capitalist societies, structures that manifest themselves in individuals' pursuit of visible social capital, the performance of self and belonging through consumption, or the foreclosing of individual dreaming and risk-taking, among others. The latter is particularly relevant to the context of austerity politics. As Lauren Berlant has noted, citizens' allegedly unbridled dreaming and risk-taking have indirectly been held responsible for the crisis by the state, which 'bails out the banks' but punitively 'tells the polis to tighten up', to 'feel shame for having wanted more than they could bear responsibility for' (quoted in Helms *et al.* 2010: 3). Reclaiming risk, uncertainty and even failure as part of the creative work and relying on practices that demand attention to collaboration and process rather than individuality or productivity (Magnat 2005: 74) are therefore politically salient strategies in their own right – and these have informed Quarantine's theatre practice.

The politics of gifting, listening, conversing and celebrating; the communities of strangers these transactions create; and the value of risk-taking are thus paramount in the aesthetics, architecture and methodology of Quarantine's work. Taking these features on board, my suggestion is that the political commitments and interventions at play in Quarantine's trajectory relate to a concern with bringing together individuals beyond their identity, with rediscovering 'how we must look in order to see' (Virilio 2008: 109) the infra-ordinary and the extraordinary in both art and the everyday, and how such observation may enable us to create an egalitarian and hopeful present. While these are ongoing preoccupations for the company, the ideological, political and material context of post-crash Britain make these concerns more pertinent and urgent. *Entitled* offers a keen example of how their work may respond to and intervene in hegemonic ways of thinking and feeling in contemporary capitalist societies, particularly with regards to temporality and work – areas that are particularly salient in the context of the financial crash and the crises it precipitated. These areas occupy the rest of this chapter.

Time and labour: the prefigurative politics of *Entitled*

Premiered in 2011 at the Royal Exchange Theatre in Manchester, after a winter of significant anti-austerity protests and just before the summer riots, *Entitled* could easily appear to be an apolitical piece. The show is structured as a get-in and a get-out, and is populated by theatre technicians and artists – a section of society that does not immediately register as unprivileged or politically under-represented. However, the show quietly demonstrates something about what we are entitled to be and do, together and alone, that directly contravenes the neoliberal individualist impetus, as well as the perception of a perpetual present.

When the audience enters the theatre space where *Entitled* is to be performed, the stage is almost bare, with the exception of some equipment that has already been laid out. Two young men and a younger woman wearing comfortable clothing move purposefully across the stage: sometimes they look at a screen facing the audience where the piece's title is already projected, they look at the lights, wait for the spectators to sit down. The performance, which has at this point already begun, begins again with these words: 'Before we start does anybody have any questions?'[7] This is Greg Akehurst, the production manager, standing in front of the audience. He deals with any unlikely enquiries that spectators may have at this point, and continues his alleged prelude to the show: 'Before we start there's a few things that I need to go through with you.' He then relays to the audience what will happen next on the

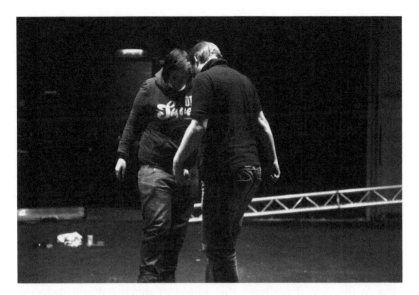

Figure 5.1 Lisa Mattocks and Chris Whitwood mark up the space in Quarantine's *Entitled*, 2011. Photograph by Simon Banham (Designer)

technical side. The unspoken expectation is that the show within the show will begin when the set is ready.

The get-in is then executed by the three members of the technical crew: Greg, Chris Whitwood and Lisa Mattocks. Each technical decision or piece of equipment is meticulously explained to the audience, from the type of adaptors their computers require to the sort of lights that will be used. In leisurely fashion, others begin to come in and go out of the stage, their identities being revealed progressively. They are two dancers (Joanne Fong and Fiona Wright), a writer (Sonia Hughes) and a musician (John Kilroy), who aid the technicians to test the microphones or adjust the lights. Music appears and disappears from the space as low and high frequencies are tested. Throughout this process, Sonia, the writer, dances wonderfully with Joanne. Joanne, a dancer in her forties, tries her hand at singing. In typical Quarantine fashion, what seem to be authentic personal stories unfold, most of them about fulfilment, unrealised potential, moments of decision that came and went through their respective lives more or less eventfully, and what makes us who we are. All of these are described to the audience, posed as the performers' direct addressee.

After one hour and fifteen minutes, the set that the production manager had anticipated has materialised. There are three empty chairs on

the dance floor, facing the audience, each with an item of clothing on it. Nobody is onstage. The wooden wall erected behind the chairs is missing a panel, which leaves a gap through which a star cloth can be seen, twinkling behind – a theatrical reworking of one of the Paris '68 slogans: 'Beyond the theatre, the stars.' The scene conjures up traces of past labour, humanity and death, as well as imminence and potential. The space remains in silence for a few moments. Then, the get-out begins. As Greg, Chris and Lisa carefully dismantle the set, immediate, medium- and long-term plans and unexpected life events are imagined – beyond this night, beyond their lives. Chris sings on the microphone before the sound is cut off. The show finishes with the technicians' thoughts on future loves, losses and memories lingering in the almost empty space.

Absent futures: the politics of temporality in times of austerity

Time has been crucial in discussions around the experience and the management of the crisis, not only in the Mediterranean countries worst affected but also in the UK. For example, the onset and the duration of the crisis have been the subject of much political discourse and strategy – the 'green shoots' of recovery being heralded as early as January 2009 in the UK (Woodcock 2009) and recurrently thereafter. In Spain, the country-wide Plataforma de Afectados por la Hipoteca (Platform for People Affected by Mortgages), one of the most resilient and effective direct-action and non-profit organisations to emerge in the aftermath of the crash, has repeatedly brought attention to the notion of 'mortgaged lives' (Colau and Alemany 2014). The term refers to lives under the material and affective conditions concomitant with Spain's mortgage law and soaring unemployment rates, lives whose present and future are radically precarious. For them, the present time is haunted by the real, likely or feared possibility of eviction, or is colonised by institutional harassment or neglect; mortgaged lives are also dispossessed of the future, with welfare benefits being time-limited and mortgage debts remaining outstanding even when home ownership is transferred to the bank (2014: 23–4).[8] As Lazzarato's study of neoliberal debt economy contends, 'debt appropriates not only the present labor time of wage earners and of the population in general, it also pre-empts non-chronological time, each person's future as well as the future of society as a whole' (2012: 46–7). This is what Nina Power (2012; 2014) has elsewhere labelled the 'weaponisation of time': the painful stretching of an uncertain present or future that constitutes, in itself, a psychological and even material form of violence. In the UK, the figure of the 'graduate without a future' (Mason 2012a) simultaneously epitomised

the scapegoat of the contemporary economic model and its crisis, as well as a potential agent for change. Graduates' greater sense of entitlement and therefore greater disappointment at the lack of opportunities after education were nonetheless identified as crucial for public protests to gather momentum (Mason 2012b: 72).

Understandings of temporality imposed and foreclosed by the current economic climate have also been at the forefront of activist and theoretical thinking. Margaret Thatcher's infamous 'There is No Alternative' doctrine resonates in the current perception of a 'changeless now' (Watkins 2012: 85), 'a present condemned [...] to an endless reproduction of the status quo' (Cuevas-Hewitt 2011). Thinkers across the political spectrum have suggested that the crisis of capitalism has revealed the Left to be stuck in a perpetual present of posturing fruitless resistance, unable to offer 'a rhetoric, a tonality, an imagery, an argument, and a temporality' in which 'capitalism's failures [...] make sense' (Clark 2012: 54; cf. Fukuyama 2012). For Mark Fisher, we are in a moment of 'stasis [...] interred behind a superficial frenzy of "newness", of perpetual movement' (2014: 6). Adopting Franco 'Bifo' Berardi's terminology in *After the Future* (2011), Fisher refers to the present time as the result of a 'slow cancellation of the future', the progressive impossibility of imagining and producing 'the new' in the political, social and cultural realms (2014: 6–16; cf. Fisher 2009: 1–2). While Fisher elsewhere suggests that we need to recover 'a *prospective* time' and foster 'a multiplicity of visions of a post-capitalist future' (Fisher in Fisher and Berardi 2013), T. J. Clark (2012) proposes a tragic stance for the Left in which any expectations about a utopian future are relinquished. In the Spanish context, and in a more hopeful vein, Santiago López Petit argues that such a utopian-less, horizon-less politics can actually productively dislodge the Left from its tragic or melancholic state: without an ideal future to pursue, the present becomes an infinitely fertile site for immediate radical change (2010: 29–30).

These experiences and analyses of temporality following the 2008 crash constitute the discursive, affective and ideological terrain in which *Entitled* was devised and staged. Neither explicitly expressing the anxiety about the present and the future, nor proposing a utopian alternative, Quarantine's piece nonetheless undercuts hegemonic visions of temporality in times of austerity. First, it compels us to rethink the question of the future reinstalling subjective agency and with an awareness of finitude; second, *Entitled* demonstrates that the present is always already 'the right moment', thus challenging implicit pressures to defer pleasure or intervention, to mortgage the present.

'What could we do?': Back to the future

Entitled marshals its political intervention partly by overwriting the conceptualisations and experiences of time in the context of economic recession and aggressive neoliberal policy. The importance of seizing the present as a means to build the future is intimated thematically throughout. Contrasting with the resolve of the technicians and the certainty of their immediate future at the onset of the show, the artists' stories focus on past choices, chances taken and missed, and future decisions. These subtly punctuate the performance with the motifs of agency and decision-making and an acute sense of finitude and the fleetingness of time.

For example, Joanne tells the audience that she is in a childless relationship, out of choice; later on, Fiona claims not to be a mother, albeit for different reasons: 'I didn't plan not to have children. I didn't get to plan to have children.'

Alongside this thematic thread around choice and possibility, *Entitled* seeks to heighten the spectators' sensitivity to their own agency and responsibility towards the present and the future. To this aim, performers directly address several questions to the audience, presenting them with various opportunities to intervene. The first comes from Sonia, and it is interspersed in a narrative about absent

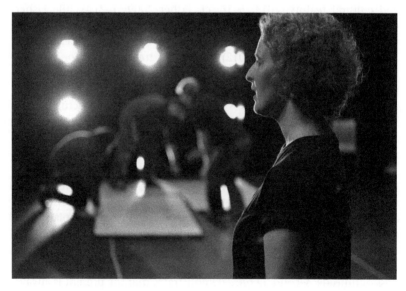

Figure 5.2 Fiona Wright addresses the audience, as Lisa Mattocks, Greg Akehurst and Chris Whitwood lay out a portable dance floor in Quarantine's *Entitled*, 2011. Photograph by Simon Banham (Designer)

futures – one about her recurrent presentiment that her potential would be unrealised. It begins with Sonia's account of the moment when she understood that she would not be a child star, and continues with a description of being struck by the thought that she would 'never do anything heroic' after having been in prison in relation to her activism. The narration continues in a present where hope has not been relinquished:

> I've been feeling like that again recently, but I still have the opportunity to do something ...
> But what shall I do?
> What could we do?

Importantly, the narrative soon shifts from the first person singular to the plural, not only extending agency to the spectators, but discursively producing the sum of performers and audience members as a form of current togetherness that holds the promise of a future:

> There's about [*Sonia guesses how many people are in the audience*] of us in this room and together we could make ...
> We could create something that lasts beyond the end of this show. Past the drink in the bar, past the sleep tonight, past breakfast and linger even into tomorrow afternoon.

As she asks the audience, Sonia raises her arms, elbows slightly bent, moving her hands as if the answer was not on the tip of her tongue but in her fingertips, inviting spectators to call out the alternative present or future she cannot yet name or touch. In the performance I saw at the Royal Exchange in July 2011 and in a recording of the show at the Curve in Leicester three months later, nobody replied. Responding to that silence, Sonia provides another example of her activist past, in which her actions could have led to a riot: 'So I thought about it but I didn't do it. So what could we do now?'

The second direct question to the audience comes from Fiona. She leads the audience to imagine themselves in a bar, overhearing her saying 'Oh, I don't know ... is this life worthwhile?' Fiona then asks the spectators what their response would be. Although an audience member had replied 'I want to kiss you' in one of the first performances of *Entitled* (Gardner 2011), the question was received with another silence the night I saw the piece in Manchester; in Leicester, after some encouraging words from Fiona, a young female replied emphatically: 'Yes, it's always worthwhile, always.'

Framed by Sonia's activist story, the question 'What can we do now?' resonated with the preoccupations of the Left at the time of the performance. The winter of student- and union-led anti-austerity protests was losing effervescence by the summer of 2011 when *Entitled* premiered, and Sonia's open question served as a reminder for the need for new strategies, new collective solutions to resist that other form of togetherness posed by David Cameron's Big Society. Fiona's question, on the other hand, highlighted issues of collective responsibility concerning the affective liveability of certain lives. It invited spectators to consider what makes a life meaningful, and what response may be appropriate when those around us are dispossessed of that which makes the present and future possible, fulfilling or desirable. In Fiona's public addressing of an existential, private question to a group of strangers, and in the difficulty for spectators to provide a sincere and commensurate answer, also lay an awkwardness that post-crash European societies are still grappling with – that of having to undergo a personal or national crisis in public, and that of witnessing it powerlessly.

Alongside these thematic resonances with the ethical and political demands concomitant with life under neoliberal capitalism in crisis, Sonia's and Fiona's direct questions generate moments of decision for the spectators to experience their agency, their ability to intervene in the course of an event. These questions invite spectators to practise how it feels to break collective silence and crack consensus, or to remain silent, either as the result of choice or indecision. These moments enable spectators to experience having a say in what will happen next – in the performance, but perhaps the implication is that this could also be experienced elsewhere. Importantly, questions of representation and of collective and individual agency also come into play here. Indeed, what is being probed is the spectators' willingness to intervene when the possibility arises, the delegation of our agency to others who may or may not represent our views but may have a greater disposition to respond, and the deferral of action for yet another second, in case someone else speaks first. The direct address of questions to the audience in *Entitled* aims to heighten the spectators' sense of agency, responsibility and potential. In so doing, the piece undercuts the assumption of powerlessness and passivity conventionally associated with spectatorship – be this in the theatre or in the realm of politics. Affectively and perceptually, then, the show invites spectators to intervene in and inhabit time differently. Against the powerlessness of being alienated from one's lifetime, an experience shared by many, the piece compels spectators to rethink subjective agency and recuperate

present and future as temporalities to which we are entitled, and which we can partly shape.

The moment is now

If postponement features heavily in the rhetoric of austerity policy, with invocations of a sacrificial present to guarantee tomorrow's growth, the motif of deferral is similarly present in *Entitled*. The piece contains numerous thematic references to future endeavours, decisions or events that seem to occupy the precarious temporal moment of the not yet; the most prominent example is the show within the show. However, *Entitled*'s structure invites spectators to readjust their perception of the present against the discursive traction of futurity within the piece.

Indeed, the implicit suggestion behind Greg's initial explanations to the audience is that 'the real show' will take place once the setting is prepared. However, art is being created before and after what is framed as its condition of possibility, and the suggestion is that aesthetic beauty is ubiquitous if we have the aesthetic disposition to perceive it. The first demonstration of such ubiquity arrives early in the show: Chris and Lisa's coordinated movements as they mark up the stage become a simple, technical choreography to the sound of classical music. Throughout the rest of the piece, technicians and artists sing and dance, speak poetically, are lit up beautifully as the set is assembled and disassembled. Rancière's observation that, in 'the Aesthetic Regime of Art', 'the property of being art is no longer given by the criteria of technical perfection but is ascribed to a specific form of sensory apprehension' (2009a: 29) is vindicated in *Entitled*. This invites spectators to recalibrate temporal expectations and dispositions: it prompts them to relinquish the pull of the economy of deferral – of pleasure, of action, of the good life – and perceive and understand the present as a moment that is not only pregnant with possibility, but already eventful. Against the promise of a better, complete and fulfilling show, *Entitled* compels us to encounter that future in the present we inhabit.

The asynchrony between the time when something is expected to take place and when it actually occurs also offers the possibility for renegotiating what we understand as 'the right moment', 'the right conditions' for something to happen. As the piece proceeds without ever providing a fixed setting, it becomes apparent that little is indispensable for the appearance of art. Dancing does not require a dance floor: it requires the practice itself. This insight proliferates windows of opportunity for action; it dismantles conservative estimates about propitious circumstances, allocations of certain actions to certain times or agents.

In this respect, *Entitled* evokes the praxis-based model of political and amorous subjectivity proposed by French philosopher Alain Badiou. Badiou's account of subjectivity (2005; 2009a; 2009b) can be summarised as a doing: a relentless calling a future into existence by means of practices that create the present anew. Contrary to this eventual philosophy, however, *Entitled*'s structure suggests that prefigurative practices do not necessarily have to pivot on the specific, ephemeral, unpredictable disruption of a situation, the 'real rupture [...] in the world' (2009a: 50) that Badiou names 'Event'. The micro-performances that take place throughout the get-in in *Entitled* suggest instead that waiting for the Event to happen may not only delay action, but also risks occluding what is already under way. Through its structure, therefore, *Entitled* intimates that the game-changer Event may very well be a collection of actions, which need nothing more than praxis to take place. Extending this insight into the realm of political resistance to contemporary capitalism, which thematically and contextually haunts *Entitled*, it follows that the time for the arrival of the new may be now: its practice may be all that is required for its production.

Immateriality, amateurism and revolution

This reflection on *Entitled* concludes with a brief consideration of the notion of immaterial labour. In 'Virtuosity and Revolution: The Political Theory of Exodus', Paolo Virno invokes Marx's definition of a form of labour whereby 'the product is not separable from the act of producing' (quoted in Virno 1996: 191). The labour of the performance artist, Virno explains, is an example of this: indeed, the dance cannot be extricated from the dancer. This type of labour is part of what Michael Hardt and Antonio Negri have labelled 'immaterial labour', which also encompasses affective, cognitive and communicative tasks that do not result in a material product (2004: 108–9).

The imperceptibility of certain types of labour is structurally and thematically important for *Entitled*: the show not only displays the otherwise invisible tasks undertaken by the technicians, but also spares moments of reflection for those whose immaterial work is taken for granted. 'Someone has to make electricity in the power station,' Fiona says while the lights are tested on her. 'There's a woman there, right now, in a room, in front of a screen, watching the national grid flicker.' The piece, however, leaves some creative agents and processes hidden: the director is not present onstage, the lighting designer whose plans the technicians seem to be implementing is also absent, as is the dramaturge; the complex process of devising a show precedes the get-in,

but this is also cut out from the labour appearing onstage. *Entitled* renders some artistic subjects and tasks invisible, frames the artists' activities as graceful and entertaining contributions to the stage, and presents only the technicians' actions overtly as labour. The show thus probes received understandings about labour and work – not only in the arts, but more widely in the varied context of immaterial labour, the dominant form of waged labour in post-Fordist societies (Virno 1996: 192–3). The performance quietly tests what types of labour are publicly perceived and conceptualised as such, what it means to be working or to be productive when one's labour is necessarily off-stage, when the product of one's work is immaterial, when labour is conflated with the development of one's craft, or closely linked to self-realisation or pleasure, when one's work sustains the leisure of others. In short, *Entitled* tests and fine-tunes spectators' horizons of perceptibility and value in relation to both visible and invisible labour at a time of austerity when particular types of immaterial labour are underrated, questioned and underfunded – ranging from the creative work invested in a theatre show to the physical and emotional labour of a carer.

Beyond the economic and ideological context of post-crisis Britain, artistic immaterial labour has long been endowed with empowering political resonances in European thought. As noted by Hannah Arendt (1961: 153–4) and Virno (1996: 192–3), the performance artist's labour-without-a-finished-work very much resembles political praxis: both lack a resulting commodity, and require public co-presence, collaboration and creative freedom. More recently, Cuevas-Hewitt has similarly highlighted the resonances between creative practices and activism: 'Our common art is the crafting of new ways of being, of seeing, of valuing; in short, the cultivation of new forms of life, despite and beyond the deadening, ossified structures all around us' (2011). To this discursive field, *Entitled* adds a consideration of virtuosity and professionalism.

Although Virno uses 'virtuosity' loosely as the potential to create without producing a work, in Arendt's account 'virtuosity' evokes excellence, specialism and technique – attributes that *Entitled* certainly questions in relation to performance. In this, the show connects with a concern with the professionalization of the activist figure. First published in *Do or Die: Voices from the Ecological Resistance* and widely discussed in activist circles since, the anonymously authored article 'Give Up Activism' openly critiqued 'activist mentality':

> To think of yourself as being an activist means to think of yourself as being somehow privileged or more advanced than others in your

appreciation of the need for social change, in the knowledge of how to achieve it and as leading or being in the forefront of the practical struggle to create this change. (Anonymous 2001)

The article critiqued perceived ownership and professionalism regarding political activity, and suggested that class struggle takes place ubiquitously – within and without self-appointed professionals of resistance. In a similar vein, *Entitled* quietly intimates that (artistic) practices do not belong discretely to certain identities, and that the action itself suffices to generate the activity and the subject. It is the aggregation of the technicians' highly qualified work onstage, the dancer's untrained singing, the spectators' silence or spontaneous interventions, and the director's unseen craft that gets the performance, the art, done. Through its dilated capacity for first times, one-offs, false starts, amateurs, dilettantes and virtuosos, then, *Entitled* widens the range of potential subjects who produce immaterial yet valuable work. It intimates that art, like resistance, may flourish anywhere, at any time – and to that creative agency, we are all entitled.

Conclusion

In *The Making of the Indebted Man*, Lazzarato states that '[t]he debt economy has deprived the immense majority of Europeans of political power', wealth and, 'above all, [...] of the future, that is, of time, time as decision-making, choice, and possibility' (2012: 8). This European experience of material and particularly affective powerlessness, impoverishment and stagnation haunts *Entitled*, yet the show eschews particularity and contemplation to emphasise instead agency, creativity, presentness and futurity. Its uses of and invitations around temporality and labour displace conservative discourses and practices that sustain status quo and inaction – unwritten rules about who we are and must be, when and how we are entitled to act, how we understand and experience our own present and future lifetime. Affectively and conceptually speaking, then, *Entitled* prefiguratively paves the way towards the redistribution of agency and the production of the new *within the present*. The show also offers a vantage point from which to re-examine the relationship between Quarantine's Reality Theatre and the political conjuncture in which it emerged, before and after 2008. This relationship, I have argued, hinges neither on an overt thematic critique of the structural inequalities of late capitalism, nor on the imagination of utopian futures. Rather, the political gestures of their work lie in its prefigurative

production of a present lived under principles alternative to the neo-liberal ethos dominant inside and outside Europe: a present where the equality and capabilities of all are presumed and displayed, where there is room for disinterested exchanges, time to create, celebrate and reminisce, spaces to risk, fail and imagine.

Notes

1. There is an ongoing debate on prefigurative politics within the field of social movements. Coined by Carl Boggs, the term 'prefiguration' was originally defined as 'the embodiment, within the ongoing political practice of a movement, of those forms of social relations, decision-making, culture, and human experience that are the ultimate goal' (1997: 100). It has since become shorthand for the attempt to collapse 'means' and 'ends', and the removal of 'the temporal distinction between the struggle in the present towards a goal in the future' (Maeckelbergh 2009: 66–7) within the practices of social movements. For a genealogy and critique of 'prefiguration' in social movements' literature, see Yates (2014).
2. Rancière's misgivings about intention and theme are grounded on the suspicion that discursive practices may be confounded with a genuine intervention in the sensible, in the same way that, according to Rancière, administering and policing are often mistaken for politics. However, my contention is that it is possible to identify an artwork's disruption of the hegemonic distribution of the sensible without having to silence the artist's ethos or the work's thematic engagement with politically salient issues.
3. For further considerations of the real in contemporary performance and scholarship, see Tomlin (2013).
4. The egalitarian drive behind the company's terminological, methodological, thematic and aesthetic choices is unquestionable, but not exempt from difficulties around the received artistic value, ownership and classifications that their collaboration with 'everyday specialists' may arouse. For example, Sally Doughty and Mick Mangan report that, for O'Shea, 'her work is artist-led, with herself as author of the resulting production' (2004: 33). O'Shea's remark is part of a wider conversation around *EatEat*, in which she resists the perception of Quarantine's work as a community theatre. Similarly, artistic co-director Gregory stated during a conference on socially engaged practice in Glasgow that 'Quarantine had never made a piece of participatory theatre, and probably never would' (Gregory 2007). These contentions suggest a friction between the desire to revoke hierarchical distinctions between who is entitled to be onstage on the basis of professionalism, and the acknowledgement of the directors' skills, expertise and artistic vision.
5. Topically, gift economies have been prominent in contemporary British performance. The one-to-one, devotionally intimate shows of the late Adrian Howells, such as *Foot-Washing for the Soul* (2008), Rajni Shah's invitation to gift and receive in a public space in *give what you can, take what you need* (2008), or Lone Twin's building of the *Collective Spirit* yacht using donated wooden items for the London 2012 Cultural Olympiad are some recent

examples. Sharing, however, may occasionally highlight the persistence of notions of taste and distinction, and with them the ideological resilience of inequality. See, for example, Doughty and Mangan's interrogation of 'incivility' in relation to Quarantine's *EatEat* (2004: 37–9).

6. This is an extract from the public announcement of the cancellation of Quarantine's *The Dyas Sisters*, a show that the company withdrew only days before its premiere in Manchester in July 2013 due to difficulties in finalising the piece. The project was abandoned after months invested in research, development and rehearsals with collaborators Grace and Veronica Dyas, and despite touring commitments. '[F]or the first time,' Quarantine's cancellation note stated, 'we've taken a risk that hasn't paid off.' The company nonetheless maintained their working methodology for their subsequent show, *Summer.* (2014), which was created with over thirty 'everyday specialists' of all ages living in and around Manchester.

7. Quotes from the piece are cited hereafter from Quarantine (2011a).

8. Unlike other EU countries, Spanish mortgage legislation establishes that if a bank repossesses a property, the former owner must continue to pay the outstanding debt. The borrower's death does not clear the debt either. According to available data from 2011, the Plataforma de Afectados por la Hipoteca estimates that the daily average of initiated foreclosures throughout Spain was 213; the daily average of evictions was 159 (Colau and Alemany 2014: 210). In March 2013, the European Court of Justice found that Spanish laws were in breach of EU law, as they proscribed judges from declaring unfair a term of a loan agreement in order to halt evictions (Ceberio Belaza and Doncel 2013). It is estimated that 350,000 families have been evicted from their homes since 2008 (Ash 2014).

6
Theatrical Nationhood: Crisis on the National Stage[1]

Louise Owen

In 'State and Society, 1880–1930', Stuart Hall and Bill Schwarz argue that 'crises occur when the social formation can no longer be reproduced on the basis of the pre-existing system of social relations' (1985: 9), applying this thought to the late nineteenth-century crisis of capitalism in Britain. The precarious development of the National Theatre of Great Britain (NT), from a contentious nineteenth-century idea to one of the best-resourced cultural institutions in the country, is an uneven story that resonates with their insight. This discussion explores aspects of that story, examining it through the lens of transnationalism and Europe. In that spirit, I begin a thousand miles from London, with a walk in Barcelona, in September 2013, to the Teatre Nacional de Catalunya (TNC). The TNC opened in 1997 and, like the NT, is a European national theatre established well after their proliferation in the nineteenth century (Carlson 2008: 22). The route to Catalonia's national theatre from Monumental metro station runs past La Monumental, a gigantic former bullfighting arena from which the station takes its name. Established in 1914, La Monumental sits adjacent to a somewhat pedestrian-unfriendly dual carriageway. Modelled strikingly on the neo-*Mudéjar* and Byzantine styles of the 'Moorish revival' (Ijeh 2011), its ornate turrets and arches recall a much earlier period of political struggle, conquest and cultural exchange between Islamic and Christian empires[2] – a complex history which, as Deepa Kumar shows, gives the lie to the reductive contemporary discourse of a trans-historical '"clash of civilizations"' between 'East' and 'West' that underscores Islamophobia in the post 9/11 context (2012: 3). This context and discourse are relevant to the example with which this essay concludes, Richard Bean's controversial *England People Very Nice* (Olivier, 2009).

On the Carrer de Padilla, the street running parallel to the TNC, green parakeets fluttered down from trees to the pavement. Fabric signs publicising the theatre flapped from tall posts standing at equidistant points along the street. Each bore a quotation. One statement, from Federico García Lorca, declared: *'El teatre es poesia que surt del llibre per fer-se humana'* ('The theatre is poetry taken from books and made human'). Another, from Italian actor and director Vittorio Gassman, with shades of Marx's eleventh Thesis on Feuerbach, insisted: *'El teatre no es fa per lloar la vida, sino per canviar-la'* ('The theatre is not about praising life, but changing it'). Alongside these committed sentiments were others that were more tongue-in-cheek. Oscar Wilde: *'La Terra es un teatre, pero te un repartiment deplorable'* ('The world is a stage, but the play is badly cast'). Groucho Marx: *'He gaudit molt amb aquesta obra de teatre. Especialment en el descans'* ('I really enjoyed this play. Especially the interval'). The first sight of the theatre building itself, a squat, glass-fronted example of neoclassicism sitting at the top of an imposing set of steps, brought ancient Greece to mind. For Maria Delgado, the building 'stares out like an unreachable white stone temple' (2003: 166). Marvin Carlson notes that 'architecturally it is almost a parody of the concept [of a national theatre]' (2008: 30) – a rhetoric which, he suggests, gestures towards the contradictions faced by national theatres negotiating the decentralising, and now crisis-ridden, conditions of globalisation. In a similarly postmodern vein, the collection of signs outside the TNC both staged the theatre as a Schillerean scene of cultural improvement and poked fun at the very idea.

Separated by a thousand miles, the TNC and NT share many cultural references and, as contemporary national theatres, hold liberal and neoliberal ideologies of culture in tension – but, equally, they contend with specific national political forces. Their commonalities demonstrate that transnationalism, or (to put it in terms resonating with the title of this book) the status of being simultaneously 'inside' and 'outside' a particular territory, is foundational to the concept of a national theatre. According to Loren Kruger, even where national theatres have been engaged in struggles relating to national sovereignty and independence, as many in central and eastern Europe were in the nineteenth century, they have always necessarily operated within a transnational scene. She writes:

> Far from being a consequence of an allegedly twenty-first century condition of obsolescence, the transnational character of national theatre, whether acknowledged or not, has affected conceptions of

repertoire, location and audience and thus conditions of its legitimiza-
tion or, better, its *naturalization*, from the earliest movements. (2008: 35)

This essay's first aim is to investigate the transnational cultural politics
of the NT's historical development and work. Pivotal to the discussion
is the point that, although the NT's inception in 1963 predates the
imposition of neoliberal forms of governance in Britain, its develop-
ment coincides with neoliberalisation and its political consequences
within and beyond the arts sector. The NT's life also spans Britain's first
engagements with the European Economic Community (EEC) and the
national referendum that resulted in a 'yes' vote in 1975, and, from
1965, three successive Race Relations Acts and a final amendment in
2000 prohibiting racial discrimination, replaced by the Equalities Act
2010. The institution has thus established itself in a Britain starkly dif-
ferent from that of the nineteenth century:

> a post-imperial nation that has experienced the collapse of Empire,
> large-scale immigration from its former colonies, the mass women's
> movement, black power and nationalist movements, institutional-
> ised racism, Thatcherism and multiculturalism. (Donnell 2001: xxii)

In Catalonia, calls for national independence have positioned the
region as 'a new European state' (Burgen 2012),[3] while, in Britain,
Euroscepticism has dominated public discourse on integration since
the early 1990s, with the press often taking a position to the right of
governments themselves.[4] The Coalition's post-crisis austerity measures
have included an increasingly draconian approach to immigration from
inside and outside the European Union (EU). The formerly marginal
right-wing and anti-European party UKIP has taken advantage of this
discursive environment, advancing a nationalistic anti-immigration
political programme widely interpreted in terms of racism.

A look at the NT's repertoire and collaborations between 1963 and
2013 reveal that its programme has broadly described an international-
ist and European cultural politics. But its programme has also unequivo-
cally prioritised the work of white male artists – only 13 per cent of
the works staged have been directed by women, 10 per cent written or
devised by women, and an even smaller percentage written or directed
by artists of the postcolonial diaspora.[5] Bean's drama of immigration
throws the NT's inattention to aspects of its post-imperial context into
relief. *England People Very Nice* is the focus of the essay's second aim – to
consider the NT's response to the global financial crisis that emerged

in 2007–08. In 2008, the NT commissioned David Hare to write *The Power of Yes* (Lyttelton, 2009), a quasi-journalistic theatrical account of the crisis in the financial system. In 2010, it revived Ena Lamont Stewart's 1947 drama *Men Should Weep* (Lyttelton, 2010), a dramatisation of a family's survival in a Glasgow slum during the Great Depression that looked hopefully towards a future welfare state. In 2012, Simon Russell Beale performed on the Olivier stage as the eponymous *Timon of Athens* (*c.* 1605) in a production of Shakespeare's play that Paul Mason hailed as a theatrically constructed 'meltdown of the British establishment played out in full view of the Occupy camp' (2012b). Alongside these and other examples of new writing explicitly dealing with politics and crisis – Mike Bartlett's *13* (Olivier, 2012), James Graham's *This House* (Olivier, 2012) – I argue that the NT's mediation of the crisis is also to be located to an extent on the terrain of multiculturalism, on the basis, as Ali Rattansi argues, that 'too many of the worries caused by growing economic insecurity, and more general social fragmentation, have been displaced onto issues of immigration' (2011: 5). Rattansi defines multiculturalism in terms of 'policies that have been put in place to manage and govern the new multi-ethnicity created by non-white immigrant populations' (2011: 12). The historic contours of those policies and their cultural effects are far from straightforward. Nasar Meer and Tariq Modood identify several contemporary strands of thinking, which include '(1) an integration and social cohesion perspective', '(2) an alternative, explicitly secular "multiculture" or "conviviality" approach', and '(3) a political multiculturalism that can to some extent incorporate the priorities of either or both of these positions, while also being inclusive of "groupings", not least subjectively conceived ethno-religious minority groupings' (2009: 476). *England People Very Nice* takes issue with the last of these constructions; it ultimately frames a reductive battle between two antagonists – liberal secularism versus multiculturalism – with the latter the negative force, having putatively enabled a turn to 'Muslim exceptionality' (2009: 481) in contemporary culture.

In this sense, like DV8's problematic dance-documentary *Can We Talk About This?* (Lyttelton, 2012), the play rehearses 'the dominant, orthodox narrative in the long-running British and European debate [on multiculturalism] since 2005' (Katwala 2012). To conclude the discussion, I focus on the idiosyncrasies of audience responses to a sequence of moments in the play's final act, which I interpret as offering vestigial echoes of the ideological purpose of nineteenth-century national theatres – to call the nation into being as a cohesive political community – and the problems attending such a purpose. Kruger

argues compellingly that 'national assembly, rather than the linguistic or cultural consistency of the repertoire, is the essential point of theatrical nationhood' (2008: 39). Though far from representative of the NT programme as a whole – which, Sunder Katwala suggests, enunciates and implicitly debates 'shared national identity and citizenship within a multiculturalist framework' (2012) – I argue that *England People Very Nice* provided a forum for the ventilation of nationalistic sentiment, pointing towards longer histories of governmental change in which national theatres are implicated.

'Organize the theatre!'

As Carlson indicates, 'the concept of a National Theatre, like the modern concept of "nation" on which it is based, is European in origin' (2008: 21). Initially framed in terms of publisher Effingham Wilson's call for a 'house for Shakespeare' in 1848, the origins of the NT in Britain, however, are also closely linked to the eighteenth- and nineteenth-century efflorescence of the 'Shakespeare myth' – a canonisation of Shakespeare as national poet, providing the grounds for an articulation of culture in terms of 'truth, authenticity, the assurance and consolation of a vanished golden age, the transcendent illumination of transhistorical genius' (Holderness 1988: 8–10), which played its part in the construction of a novel kind of nationalistic fervour (Hollingsworth 2007: 44–95; Taylor 2012: 129–47). Official and unofficial studies of the NT offer linear narratives of the institution's trials, tribulations and successes, essays about its practitioners, or documentary and photographic accounts of its productions – producing a cumulative sense of the institution as an object of cultural biography. The opening statement of the most recent of these texts, Daniel Rosenthal's compendious *The National Theatre Story*, both returns to and demonstrates the ongoing purchase of the myth of Shakespeare as originary 'founding father': 'The National Theatre story begins in 1564, with the birth of William Shakespeare' (2013: 3). However, like *The National Theatre Story*, such studies also show the institution's engagement with and departure from such narratives, and provide ample evidence of its internationalism.

Simon Callow's *The National: The Theatre and its Work 1963–1997*, for example, figures the institution as a microcosmic state presided over by a succession of rulers – 'If Olivier was a king, Hall was an emperor'; Michael Blakemore, 'the disappointed Crown Prince of the Olivier years'; Richard Eyre, 'more constitutional monarch, perhaps, than emperor' (1997: 34, 54, 68) – a trope with continuing currency

(interviewers and critics have repeatedly referred to Hytner's artistic directorship as his 'reign'; for example, Evans 2013). Peter Lewis's *The National: A Dream Made Concrete* opens with a wryly sentimental evocation of Laurence Olivier, who, thanks to his rousing on-screen performance of *Henry V* (1944), 'shone with a special nationalistic light for his quality of command' (1990: 1), which favoured him as the choice for the company's artistic director in 1963. But alongside this discourse of royalism, Lewis's text also narrates the NT's various engagements with European and American theatre, whether as a matter of policy, artistic influence, or its artists (most notoriously Peter Hall) taking on freelance projects overseas. The international practices from which the NT derived sustenance, for Lewis, also pointed towards its own institutional shortcomings:

> The admired names of international theatre, such as Strehler, Bergman, Stein and Brook, are men with permanent groups who are not distracted by complex administration problems or a constant battle for adequate funds. (1990: 232)

Here, Lewis attributes greater artistic freedom to directors working in Italy, Sweden, Germany and France, unencumbered by the managerial bureaucracy imposed on the arts in Britain in the Thatcherite 1980s, which he implicitly invokes and critiques.

The construction of European theatres as enviable counterparts to those in Britain – signifiers of greater artistic radicalism, experimentation and rigour, or state support, often figured as interdependent – has a longer history in relation to the NT, reflecting changing political contexts and the character of the audience imagined by its advocates. Matthew Arnold famously framed the Comédie Française's 1879 visit to London's Gaiety Theatre as a model that 'shows us not only what is gained by organizing the theatre, but what is meant by organizing it' (1879: 241) – that is to say, the commitment of funds by the state. Against the state-subsidised Comédie Française, Arnold saw the 'chaotic and ineffective condition' (1879: 243) of theatre in England thrown into relief. Arnold concluded his article with a daydream of actress Sarah Bernhardt ('a fugitive vision of delicate features under a shower of hair and a cloud of lace') lovingly addressing all of London from the Gaiety: '*The theatre is irresistible; organize the theatre!*' (1879: 243). William Archer and Harley Granville Barker selected this imagined speech as the epigraph to their subsequent *Schemes and Estimates for a National Theatre*, a text that imagined the institution in terms of

a 'healthy and stable civil service', in contrast to the 'debauched market' (Granville Barker 1907: xiii, viii) of commercial actor-management. Kruger's readings of these texts demonstrate the sometimes conflicting ways in which they each hail the prospective theatre as being in dialogue with discourses of aesthetic disinterest and improvement, and notions of a nationally 'representative' middle class, thus uneasily melding 'the unlimited claims of a universal desire for beauty and the effective exclusion of the majority from the national audience' (1992: 94). Yet the National Theatre movement also faced strong resistance from contemporaneous figures such as actor-manager Sir Charles Wyndham, who, in the pages of the *Daily Telegraph* in 1908, decried it 'a type of institution alien to the spirit of our nation', a spirit that, for Wyndham, was typified by values of 'individual effort and personal competition' (quoted in Rosenthal 2013: 17).

In a lecture to the Royal Society of Arts a year on from the NT's first production at the Old Vic in 1963, its literary manager Kenneth Tynan lambasted the continuing incidence of 'outright hostility to the very idea of state subsidized culture' – his first example was a conversation with a well-known writer who, he quipped, 'shall be Amis' – counterposing 'British backwardness' with more enlightened practices elsewhere in Europe:

> The very idea that good theatre should be required to show a profit would seem indecent in Sweden, Denmark, Poland, Czechoslovakia, Hungary, Yugoslavia, Norway, Russia, Italy, both the Germanies and France. You might as well insist that public libraries should profiteer, or that the educational system should pay its way. (1964: 688–9)

Continental Europe here serves as an amorphous index of generous state subsidy. Reflecting on an analysis of the audience for Max Frisch's *Andorra* (1964),[6] Tynan described the finding that 0.3 per cent were 'manual workers' as:

> distressing, demonstrating as it does that live theatre is socially beyond the desires and financially beyond the means of working-class audiences. Something must be done to remedy this, the obvious course being to reduce the prices of admission, which would involve either an increase of subsidy or a lowering of artistic standards. (1964: 695)

Tynan's position demonstrates both the gulf and the continuity between the more egalitarian political values dominant in Britain in the mid-1960s and the patrician liberal humanism of the early twentieth century, and

the complex relationship of both to more recent discourses, in which entrepreneurial 'individual effort and personal competition' have returned to rhetorical ascendancy.

Consolidation and crisis

To this extent, Janet Minihan argues that the 1949 Act making financial provision for the NT 'could only have occurred once MPs and Peers alike had grown accustomed to the greatly expanded role of the state in post-war society' (quoted in Rosenthal 2013: 34). The real condition of possibility for the theatre's emergence was arguably the establishment of the welfare state in the post-war period. The National Theatre Act was passed at the beginning of the years of post-war boom between 1948 and 1973,[7] and the company was finally incorporated, in the face of some resistance from government, in what would become the final decade of those years.[8] But the NT's consolidation as an institution housed in a dedicated building coincided with a protracted period of recession and inflation in the 1970s: in Michael Billington's words, 'a massive, three-theatre operation opening at a time of national nervous breakdown' (2013). It has operated under the ensuing conditions of neoliberalisation in Britain for the majority of its fifty-year life. Carlson argues that the NT's case shows the contemporary purpose of the national theatre model to be not 'a rallying point for an emerging nation, but rather to stand as a cultural monument witnessing to the cultural accomplishment of an already politically well-established state' (2008: 28). In his analysis of the imposing cultural edifices of the South Bank, Denys Lasdun's Brutalist theatre among them, Michael McKinnie makes a cognate point, arguing persuasively that, on their completion, 'it was remarkable how much they articulated, through built form, the ascendancy of the British welfare state and the role of the arts and the state in securing it' (2013: 75). However, the global economic crisis in which Britain was implicated in the 1970s threw the stability these buildings represented into relief. When the first production opened at Lasdun's newly erected NT in 1976 – *Hamlet*, directed by Peter Hall on the Lyttelton stage, with Albert Finney in the title role – the post-war contract was already under attack, with the Labour government slashing welfare budgets as a condition of a loan from the International Monetary Fund (Harvey 2005: 58). In the two years before that, inflation had caused the cost of constructing the NT to rise so sharply that a new bill was introduced, lifting the budgetary ceiling altogether (Lewis 1990: 89). Facing uncertainty regarding the building's ultimate completion, in 1976 Hall enacted a 'foot-in-the-door policy' (Lewis 1990: 110)

to push ahead with occupation of the building and the presentation of work, even though only one auditorium was ready for use. In 1979, the NT management passed on a reduction in its Arts Council grant to its workforce – jobs and productions were cut back, resulting in five weeks of strike action by technical staff (Lewis 1990: 126–30). In 1985, in response to another wave of government cuts, Hall took to a coffee table in the building to deliver a speech making a 'sensational attack on government cut backs to the arts' (Goodwin 1988. 24), and closed the Cottesloe (Lewis 1990: 172–82).[9] These struggles speak less to the NT as a solid index of 'cultural accomplishment' than to its implication in a wider ideological battle being fought between (and among) cultural workers and the state over the terms of cultural subsidy and organisation, and the role of the state as patron.[10]

Hall and Max Rayne (property developer and NT chairman from 1971 to 1988) both strongly resisted governmental pressures to 'diversify' the NT's income in the 1980s by soliciting corporate sponsorship, on the grounds, for Rayne, of maintaining institutional 'dignity' (Lewis 1990: 203). But in 1986, whether in a spirit of grim irony or otherwise, having already accepted support from tobacco company John Player for touring performances, the institution finally took sponsorship for a main stage production – £65,000 from Citicorp/Citibank for a production of Brecht's *The Threepenny Opera* (Olivier, 1986) (Rosenthal 2013: 320; Goodwin 1988: 25). By 2003, the pursuit of corporate sponsorship was seen as a normative ingredient of the prospective £10 ticket deal launched under Hytner's artistic directorship: after a series of precarious negotiations, a deal was ultimately struck with Lloyd Dorfman's company Travelex.[11] In the fallout from the financial crisis and the new Coalition government's insistence on the arts' greater engagement with philanthropy, in the NT's 2009–10 annual report, Hytner talked up the manner in which 'the great London institutions have become, in any event, increasingly adept at paying their own way':

In 1980, 60% of the NT's income came from the state; in 2000, 50%; now, as this Annual Report shows, 30%. This is partly because our turnover has doubled over the last eight years as we have become increasingly entrepreneurial. We also raise £6 million a year in sponsorships and donations and we are by no means top of the league: the Royal Opera House last year raised £19 million. Our relationships with loyal corporate supporters such as Travelex, Philips, Accenture and Bank of America Merrill Lynch continue to thrive, and we've recently welcomed new sponsorships from Neptune Investment

Management and Aviva, as well as generous donations from many individuals, trusts and foundations. (National Theatre 2010: 10)

Additionally, the transnational philanthropic initiative American Associates of the NT enables individual givers in the US to make substantial tax-deductible donations (National Theatre 2014). Hytner's narrative demonstrates the NT's enmeshment in the circuits and flows of twenty-first-century transnational finance to which McKinnie counterposes the solidity of the South Bank buildings' modernist designs, and, at the institutional level, the attenuation of a liberal notion of art's separation from commerce, embraced by the NT's earliest supporters and espoused by philanthropic figures such as Rayne – himself, of course, far from an anti-capitalist (Davenport-Hines 2007).

'Let's not be national, let's be international'

Meanwhile, at the level of its programme, the degree (if not always articulation) of the NT's internationalism has remained consistent. It reflects Tynan's remarks in a television interview – 'the first thing that Sir Laurence and I said to each other when we started on this great journey: "Let's not be national, let's be international"' (BBC 2013a) – a sentiment reiterated in a 2009 *Times* interview by Hytner (Nightingale 2009: 2). Between 1963 and 2013, a little over 40 per cent of the NT's productions were of plays, and to a much lesser extent of experimental works, by writers and artists from outside Britain, more or less evenly distributed year on year. Presentations by directors and companies from elsewhere in the country and overseas – often interpretations of 'classic' texts – have formed a smaller but not insignificant element of its programme. The first year of its life at the Old Vic offers a case in point: the production inaugurating the NT in October 1963 was *Hamlet*, directed by Olivier and starring Peter O'Toole. In September 1964, the NT presented another *Hamlet*, a production by the Italian Proclemer-Albertazzi Company, directed by Franco Zeffirelli. During Olivier's artistic directorship, the NT struck a balance between visiting productions from British companies and European groups such as the Berliner Ensemble (GDR) and Le Théâtre du Nouveau Monde (France). Hall's NT (1973–87) invited companies from countries across the world to present work,[12] a strategy extended during Richard Eyre's tenure (1987–97). Between 1990 and 2001, renowned Quebecois director Robert Lepage presented six pieces – *Tectonic Plates* (Cottesloe, 1990), *Needles and Opium* (Cottesloe and Lyttelton, 1992), *A Midsummer Night's Dream* (Olivier, 1992), *The Seven Streams of the River Ota* (Lyttelton, 1996), *Elsinore* (Lyttelton, 1997) and

The Far Side of the Moon (Lyttelton, 2001). The institution's increased interest in more experimental practice, demonstrated most recently with its support of Shunt, Punchdrunk, DV8 and the TEAM, is also reflected in its periodic collaboration, since 1991, with Théâtre de Complicité (now Complicite), a company whose experimental Lecoq-informed performance-making is widely understood in terms of 'a European tradition of physical theatre work' (Reinelt 2001: 373).[13]

In an interview conducted during rehearsals for his revival of *Measure for Measure* (Lyttelton, 2006), the first question asked of Complicite director Simon McBurney was: 'Do you consider yourself a European director?' He replied: 'I don't really know what that means' (Knapper 2010: 235). If, for the individual artist or company, 'European' is more of a question than a stable category, an institution's work incrementally constructs an imagined Europe. For the NT, this reaches back to the putative first stirrings of European civilisation (Rietbergen 2006: xxii–xxiii). As Nicholas Ridout shows, the theatrical and political practices of ancient Athens have provided a tenacious and ahistorical myth of origin for European cultural endeavours (2008: 14–15) – a myth with which the NT has been persistently aligned. Lasdun and the NT's first artistic directors took the theatre of the ancient world as a critical reference: 'Epidaurus had been the model for the new Olivier Theatre, and their aim was to create nothing less than a new Athens on the south bank of the Thames' (BBC 2013b). Rather than a particular interest in ancient drama, the image of 'a new Athens' signifies values of shared culture, citizenship and democracy, values Hytner also invoked, describing his commitments to 'public theatre at the centre of the community' (Smith 2013: 24), and framing the NT as a 'civic forum' (Hemming 2009: 9). The NT has presented nine ancient Greek plays altogether – most more than once – in adaptation or translation by contemporary playwrights and poets, a practice adopted for the vast majority of works performed in translation at the NT. This commissioning practice imagines the theatrical literatures of different nations, and their exponents, to be in a general relationship of (trans-historical) dialogue. But which nations and historical periods have been given priority?

The NT's 'Europe' predominantly consists of Ireland, France, Germany, Russia, Italy, Norway, Austria, Spain and Sweden – in other words, Western and Northern Europe. And, to a very large extent, the NT has presented writings from this Europe from comfortably before the outbreak of the Second World War. To take a couple of examples: in the case of Ireland, it has produced more plays by George Bernard Shaw alone than by all of the contemporary Irish playwrights whose work it has produced put together.[14] In terms of Italian drama, the

works of Luigi Pirandello, Dario Fo and Eduardo De Filippo dominate, but in amongst these are a couple of fascinating exceptions: Carlo Goldoni's *Il Campiello* (1756) was chosen for the royal gala opening of the Lyttelton in 1976, and, in 1968, *The Advertisement* (1968), a play by the anti-fascist writer and activist Natalia Ginzburg, became the first full-length piece written by a woman to be presented by the NT.[15] Surveyed as a whole, the programme corroborates Bruce McConachie's point that, for European national theatres in the post-war era, 'international plays with international themes' (2008: 53) directed towards a mass audience have displaced a bourgeois celebration of national culture, but they also illustrate the political dimension of the NT's constitution of and selection from the international field. With exceptions – most notably, its early engagements with Brecht – the NT has framed 'Europe' in terms of a Western European canon. Beyond the ambit of European drama, examining this programme data also reveals another priority, offering an echo with British international relations and the competing political priorities of engagement with Europe and the so-called 'special relationship': since the early 1970s, plays and musicals from the US have formed a regular feature of the programme year on year, and, altogether, constitute over a tenth of the NT's total output.[16]

Meanwhile, the NT's international engagements have been markedly less open to the nation's imperial legacies. Productions of plays by artists from Commonwealth countries have formed less than 3 per cent of the NT's programme, and even fewer are contemporary works by artists of the postcolonial diaspora. In his survey article marking the NT's fiftieth anniversary, Billington suggests that, under Hytner's directorship, 'a succession of plays by Kwame Kwei-Armah, Roy Williams and Ayub Khan-Din went some way to acknowledging the realities of a multicultural society' (2013). For the 2013 *Arena* documentary, Kwame Kwei-Armah, whose play *Elmina's Kitchen* opened in the Cottesloe in May 2003, characterised the NT's 'diversity':

It was a lily-white institution. And it was an upper middle-class institution. And probably being upper middle-class was probably more daunting than it being lily-white. I came in, and I think I was the third show in of his [Hytner's] reign, as it were. I think my impression of the National was it's the equivalent of walking into Buckingham Palace. It's just this huge thing, this bastion of culture, that you almost have to have a degree in before you step over the threshold. It's almost an alien land. (BBC 2013b)

Invoking exclusionary cultural 'distinction', this passage asserts that both class and cultural identity are at play in constructions of national belonging, and it complicates the conflation of the categories of nation and territory. On Hytner's policy as artistic director, John Lahr's 2012 feature in *The New Yorker* reported:

> Hytner's big idea from the outset was to democratize the National. At his first press conference, he made, by his own admission, a rookie mistake. 'I am not against older folk coming here to have a good time', he said, 'but the age of the audience will come down when we reflect something other than the homogeneous concerns of a white, middle-aged, middle-class audience.' Hytner told me: 'It was very callow ... a ridiculous thing to say. I've learned that there are scores of audiences.' (Lahr 2012)

While Hytner may refer here to the internal diversity of an apparently homogeneous audience, it is also the case, of course, that a single person occupies multiple identity positions. Kwei-Armah describes himself as 'tri-cultural: I'm African, Caribbean and British. And each one of those has an equal part to play and I can be one or all at the same time depending on which it is' (2006: 240) – a kind of cultural hybridity that *England People Very Nice* ostensibly celebrates.

Right thinking at the National Theatre

In November 2007 (two months after the run on Northern Rock), *The Observer* published, as the cover story of its 'Review' section, a piece about contemporary theatre entitled: 'Why is nobody doing the right thing?' Its author, restaurant critic Jay Rayner, recalled his stint as the *Hampstead and Highgate Express* theatre critic during the late 1980s, an experience he remembered as a punishing exposure to leftist worthiness.

> Now here I am, 20 years later, and it feels like nothing has changed. Except, of course, one very important thing has changed: the government. We can argue long and hard about the political hue of New Labour's economics, but only those on the very fringes of the debate could deny that the establishment is now both liberal and left of centre. Even the Tories have been drawn towards the consensus, with an increasingly touchy-feely social policy which makes the old Conservative grandees look like bigots (which is what too many of them were). Yet where is the theatre that challenges that liberal

consensus, which makes those of us who consider ourselves a part of it think a little? Where is the theatre of the right? (2007)

Rayner's question was prompted by a 2006 interview in which Hytner had commented spontaneously that as NT director, he had yet to receive a 'mischievous, right wing play' (Rayner 2007) for consideration. The discussion that follows broadly mirrors the ideological confusion its author attributes to himself, 'afloat on the political seas of the 21st century' (2007), but on the issue of multiculturalism, he asserts slightly more certainty. Having indicated his own high regard for London's 'multi-ethnicity', but scepticism regarding the continuing 'value and success of multiculturalism', Rayner reflects on his interviews with artists towards the article:

> At various times, and in various conversations, I wonder out loud whether any of them could imagine a play that challenged, say, the values of multiculturalism. Mostly I am met with baffled silences. Sir Peter Hall sums it up for me when he says: 'I'm sure there are people who would like to write that sort of play, but they would fear it wouldn't be acceptable. (2007)

Following reflections from Hytner himself trailing Kwame Kwei-Armah's *Statement of Regret* (Cottesloe, 2007), the piece concludes with praise for the diverting comforts of the NT's production of Noel Coward's *Present Laughter* (Lyttelton, 2007): 'a blissful night of gentle entertainment, the theatrical equivalent of a warm soapy bath' (2007).

When it opened two years later, Bean's satirical comedy *England People Very Nice*, a caricaturish historical survey of immigration set in Bethnal Green, appeared to satisfy Hytner's speculative call for a 'mischievous, right wing play'.[17] Structured as a play within a play, *England People Very Nice* follows a simple premise: the inmates of an immigration detention centre have devised a piece together, facilitated by Olivia Colman's director Philippa, which examines English hospitality to immigrants. We, the audience, witness a dress rehearsal. Set in a 'real' detention centre encompassing the Olivier stage, the rehearsal of the play is enacted at the centre of the stage with the use of a set of wooden flats, standing at the back of a marked-out performance space consisting of wooden floorboards. Cartoonish digital video and stills are projected upon the flats to animate and frame the episodes performed by the actors: four acts that relate sequentially to the arrival of French Huguenots, Irish refugees, Jewish refugees, and Bangladeshis. At the top of the play, a

song, 'A True Born Londoner' (after Defoe's *The True-Born Englishman*) (Bean 2009: 14–15), accompanied by digital animation and live action, communicates a rapid narrative of history prior to the seventeenth century, taking in the Stone Age, Roman invasion and the Middle Ages, each new era marked out comedically by the rape of a woman by a new set of aggressors – in one iteration, for example, two performers engage in an 'after you', 'no, after you' mimed skit. At other times, the projections locate the action, featuring animations that seamlessly segue into the movements of actors emerging through the doors in the flats onto the stage – for example, seventeenth-century weavers entering a street, or twentieth-century fascists marching offstage in search of a ruck. A recurring storyline tells of a man and a woman who fall in love, only to be parted on the occasion of the man's death. In the final story, Mushi, a Bangladeshi Muslim, arrives in London during the Blitz as an Allied fighter; he falls in love with a Jewish cockney with whom he has twins. At this story's conclusion, Mushi does not die, but moves with his family from Bethnal Green to Redbridge, in flight from Muslim clerics to whom he has promised his baby son, and from his new partner's violent husband, about to be released from time in jail for a racially motivated murder.

While framing extremist politics of various kinds as the explicit object of critique, stereotypes and racial epithets pervade the piece, finding legitimation as part of a comedic structure that persistently states and then undercuts them. Yasmin Alibhai-Brown noted of the piece that '[w]ords that are now rightly excised from public discourse – Paki, etc. – are revived here with panache. Audiences laugh at the jokiness of the revival, but later some may feel they conspired with something nasty and reprehensible' (2009: 14). Other critics drew attention to the piece's occlusion of histories of British colonialism, its anti-welfare stereotyping and its citation of right-wing rhetoric (Moran 2012: 18–22; Beswick 2014: 101–2; Bull 2010: 133–6). Linked to all this is its representation of multiculturalism as facilitating cultural separatism. The final act represents the public library system's policy of providing 'equivalent services' (Bean 2009: 106) as a vehicle for the dissemination of radical religious literature. In another moment, a white middle-class character, St John, insults Mushi's daughter Rayhana, a nursery worker who wears the *niqab*, describing her apparel and conduct as strange and childish. His words are counterbalanced even-handedly with a horrified response from his wife.

Critical opinion of *England People Very Nice* ranged between praise, support and condemnation from publications nominally associated

with both the right and the left. The *Evening Standard's* theatre critic Nicholas de Jongh gave the strongest negative critique:

> I have never had a more uncomfortable or unpleasant experience at the NT than at the premiere of Richard Bean's *England People Very Nice*. [...] Its invective is often funny, sometimes inventively so, but in the slick, cruel, abusive style that Bernard Manning perfected ages ago. I am all for withering satire. I approve of bad taste and comic mischief, but in the sensitive field of immigration, it seems irresponsible to fan the ever-ready flames of prejudice by characterising the broad mass [of] refugees in Bean's simplistic manner. (2009)

A packed platform discussion with the playwright was disrupted by a small on-stage protest, the first in the NT's history.[18] Bean was unworried: 'It was never anything much – the play's sold out for April, so who cares? It's a hit' (quoted in Higgins 2009: 25). Director Hytner framed the play's political incorrectness as 'equal opportunities funny' and defended it on the basis that 'it clearly sets out to demonstrate that all forms of racism are equally ridiculous' (quoted in Adams 2009: 13). This defence did not convince author Rabina Khan, who withdrew from another NT platform discussion on immigration and literature, having witnessed, as a member of the show's audience, 'the sea of white, middle-class people falling about in laughter at silly jokes about minority communities' (2009). Khan's account resonates with the concept with which this essay began – the synecdochal 'national assembly' gathered together in the theatre that represents the 'essential point of theatrical nationhood' (Kruger 2008: 39). Khan's dissent from the majority view expressed by the audience's laughter points towards the affective techniques through which an imagined national assembly might be delimited and interpellated – in this case, the deployment of a comedy of recognition.

In each act of *England People Very Nice*, the action returns repeatedly to a pub. Bean's stage directions indicate that the scenographic representation of the various locations beyond the pub 'should be playful and non-naturalistic. The only constant location is the pub, which can be naturalistic' (2009: 7). In all four historical epochs, a barwoman, Ida, presides over the pub, loudly and ridiculously complaining about each new group ('Fucking frogs!', 'Fucking Micks!', 'Fucking Yids!') (2009: 17, 33, 53) to the assembled drinkers. The pub, a paradigmatically English cultural space, functions effectively as a miniature, trans-historical public sphere opening out to encompass the Olivier auditorium. The action

of act four opens in a street in Bethnal Green during the Blitz of 1941. A dark street scene, accentuated by the sound of falling bombs, hosts four characters – a police constable and two stretcher-bearers, standing around the prone body of an unidentified man. The constable speculates as to the identity of the man – 'Indian Lascar. Merchant navy. Stoker? Donkey wallah? Who knows?' (2009: 73) – garnering an unsympathetic response from his colleagues. The constable remonstrates:

CONSTABLE: As a citizen of British India, he has the legal right to come ashore. So come on lads, show some compassion, he's a human soul, and some mother's son.
STRETCHER 1: You alright officer?
CONSTABLE: I've been on a course. (2009: 73)

In the performance recorded for the NT archive, at this exchange, performed with a knowing irony, what seemed a substantial proportion of the audience laughed and applauded enthusiastically. The action rapidly segues to the pub:

IDA: Fucking Yanks! Where are they? I'll betcha they swagger up when it's nearly over, pick up all the dead men's hats, and make an 'ollywood film about how John Wayne won the fucking war on his whatsaname. (2009: 74)

More delighted laughter swelled to fill the pause actor Sophie Stanton allowed to hang in the air after 'Fucking ...', and a ripple of scattered applause. If the first moment represents a satire of the institutional apparatuses of multiculturalism, the second invokes an historical discourse which Norman Davies characterises as the 'Allied scheme of history', which frames the Second World War selectively as '"the War Against Fascism" and as the defining event in the triumph of Good over Evil' (2014: 40). This ideological positioning in relation to national identity resonates with the third moment, which follows shortly afterwards:

Enter a small group of Indian LASCARS. Silence. IDA comes over.
IDA: Fucking ...

This moment was staged in the manner of an encounter in the Wild West. A piano ceased to play, the bustling pub became still, and all its occupants turned their heads stage right towards the two Asian actors

playing the Lascars. But instead of ejecting them, as the set-up indicates she might, Ida responds as follows:

> IDA: ... heroes! The Indian Lascars! The engine room of the British Merchant Navy! Standing shoulder to shoulder wiv us in the fight against whatsaname –
> LAURIE: – Totalitarianism.

The pub stand and applaud the LASCARS. IDA leads the cheers. The LASCARS stand and bow. (2009: 76)

The unexpectedness of Ida's response is the scene's dramatic gambit. Her statement flatters the audience's intelligence and historical understanding ('of course, like me, you have an intimate knowledge of colonial implication in the Allied struggle') – despite the fact that very few such fighters were ever officially commemorated (Jack 2013) – and affirms a liberal politics, which contrasts with the play's reactionary aspects. By subverting the audience's expectations, the structure of this moment both disavows the racism that cannot be disentangled from legacies of British colonialism, while at the same time legitimising the use of such speech elsewhere in the play in the context of 'harmless comedy'. In this sense, we might see *England People Very Nice* as participating in a wider cultural revisionism that critics have associated with neoliberalisation,[19] and which has been thrown into relief in the fallout from the financial crisis.

Conclusion

To conclude this discussion, I follow Hall and Schwarz's compelling suggestion that 'social democracy was formed out of the crisis of liberalism between the 1880s and the 1920s. We are now living through its successor – the crisis of social democracy' (1985: 32). I suggest that the NT's long history reflects this process of transformation and crisis. The national theatre project was first advocated in terms of the improvement and cohesion of the nineteenth-century nation – representing one articulation of the turn to collectivist politics Hall and Schwarz discuss – but realised as a dedicated building many decades later, in the moment in which neoliberal structural adjustment was first initiated, in an architectural form that made optimistic claims for the possibilities of social democracy. As such, beyond its narrativisation of the recent crisis on the stage, since the beginning the NT has grappled with a series of institutional crises and adjustments, precisely because of its implication in the process of nation-building and the political discourses facilitating it. For example,

the solicitation of support from financial institutions to subsidise the theatre's 'democratisation' through lower ticket prices, as pursued during the boom of the 2000s, carries echoes of New Labour's economic policy and its interpellation of the citizen as consumer. Presented in the post-crisis moment in 2009, *England People Very Nice* raises questions as to how conservatives have since made ideological use of the crisis in discrediting values antithetical to the neoliberal project, calling on discourses of nationalism to buttress austerity measures. Yet, casting back for a moment to Barcelona, the play's story of embattled separatism, universal adaptation and assimilation in the capital city of the 'island nation', with one contemporaneous group framed in terms of threat, also rehearses an historical narrative that is decidedly European.[20] The play's crass presentation of the immigration detention centre – institutions where reported disturbances and abuses suggest Kafka more than light comedy – and its metonymic invocation of the nation as a female body subject to sexual assault both point towards contemporary and historic discourses of 'Fortress Europe' and imperialism. The representation of non-EU subjects in search of asylum and relegated to the detention centre also unwittingly rehearses some of the exclusions enacted by the NT's own internationalist artistic programme to 2013 – although Rufus Norris's artistic directorship promises an alternative approach. The state bailout of the banks in 2008 decisively invalidated the argument that globalisation has entailed the supposedly natural decline of the nation state. But, as the example of the NT demonstrates, the relationship between the nation state and transnational and transcontinental formations has always been far more complex than this more recent political narrative. Like Barcelona's La Monumental, a modernist building citing eleventh-century architectural forms, and the parodic neoclassicism of the TNC, the complex institution of the NT suggests manifold ways in which traces of past transformations continue to inform the present, for better and for worse.

Notes

1. Many thanks to the editors and to Tony Fisher, Aoife Monks and Emily Senior for their feedback on this article, and to Maria Delgado for her help in translating the TNC banners.
2. *Mudéjar* refers both to a school of architecture hybridizing Islamic and Gothic styles, and to '[a]ny of the subject Muslims who, during the Christian reconquest of the Iberian peninsula from the Moors in the 11th to 15th centuries, were allowed to retain Islamic laws, customs, and religion and to live in their own quarters in return for owing allegiance and paying tribute to a Christian monarch' (*OED*).

3. This was the motto of a pro-independence rally attended by 1.5 million people in autumn 2012. Catalonia's intended referendum on independence from Spain in November 2014 was ruled unconstitutional by the Spanish government in September 2014, shortly after the Scottish referendum returned a 'no' vote. A symbolic poll went ahead regardless; the Spanish constitutional court responded by charging the Catalan president Artur Mas with 'disobedience, perverting the course of justice, misuse of public funds and abuse of power' (Burgen 2014).

4. In his history of Euroscepticism in British politics, Anthony Forster (2002: 134) notes 'the shift of the newsprint media from a position in which almost all were supportive of British membership in 1973 and 1975 to a position in 2001 in which the majority of newspapers were far more sceptical than both John Major's and Tony Blair's governments'.

5. In researching this article, I created a database of all the NT's productions as documented in three texts – Callow (1997), Haill (2001) and Rosenthal (2013). Callow's is the only text to list productions received by the NT from other countries. None lists those the NT toured overseas, although the narratives of all of the texts refer to multiple examples.

6. Tynan (1964: 695) indicates that the theatre acquired this data by distributing a questionnaire with the *Andorra* programme; 10 per cent of the audience completed it.

7. In his analysis of the crisis, David McNally (2011: 25) offers this periodisation.

8. In 1953, a group of MPs called for the national theatre project to be abandoned. Rosenthal (2013: 38–58) offers a blow-by-blow account of the fraught decade-long negotiations between the NT's representatives, government, and other cultural institutions (most notably the Royal Shakespeare Company and Sadler's Wells).

9. The closure turned out to be temporary; the Greater London Council (GLC) rescued the space with an additional grant.

10. For a detailed discussion of this period, see Peacock (1999).

11. Rosenthal's (2013: 692) account of these backroom negotiations is fascinating – beginning with a casual conversation at a dinner party in a flat, to an eleventh-hour derailment of the deal owing to the outbreak of the war in Iraq – demonstrating the implication of personal networks in the operations of the institution.

12. For example, a privately funded International Theatre Festival took place in 1987 (Goodwin 1988: 26), for which Ingmar Bergman directed Royal Dramatic Theatre productions of *Hamlet* and *Miss Julie*, both performed in Swedish. The programme also featured presentations from the Ninagawa Company (Japan), Mayakovsky Theatre Company (Russia), Schaubühne Theatre (West Germany) and the Market Theatre, Johannesburg (South Africa).

13. See also Jen Harvie's (2005: 135–46) extended discussion of Complicite in terms of its mediation of European identity.

14. There have been fifteen productions of Bernard Shaw's plays, and thirteen altogether of plays by Brian Friel, Martin McDonagh, Frank McGuinness, Sebastian Barry, Conor McPherson and Enda Walsh.

15. Earlier in the same year, the NT presented *The John Lennon Play: In His Own Write* (1968), a one-act play created by African-American playwright

Adrienne Kennedy in collaboration with Victor Spinetti and John Lennon, on whose book the play was based. The first full-length piece authored by a woman to be staged in Lasdun's building was the American writer Lillian Hellman's *Watch on the Rhine* (1941) (Lyttelton, 1980), and the first new work by a British woman, Sarah Daniels' *Neaptide* (Cottesloe, 1986).

16. These works are predominantly revivals of pieces spanning the twentieth century, but include the premiere of David Mamet's *Glengarry Glen Ross* (1983) and productions of Tony Kushner's *Angels in America (Parts I & II)* (1992 and 1993), staged only a year after their US premieres.

17. A *Times* round-up (*The Times* 2009: 14) of the 'Best of 2009' describes the piece as 'mischievous'. In 2007, Richard Bean participated in a roundtable discussion entitled 'Politics and the Theatre: What's Left?' convened by the right-wing *New Culture Forum*, billed as addressing 'the left-wing bias in political theatre, and the challenges which faced it with the possibility of self-censorship over religious issues. The event was inspired by the recent comment by Nicholas Hytner of the National Theatre that what he would really like to see was "a good, mischievous right wing play"' (The New Culture Forum 2007).

18. For images of the protest from outside the theatre and discussion, see londonse1 (2009).

19. For example, Angela McRobbie's (2009) analysis of the 'disarticulation' of feminism and radical politics, and Jim McGuigan's (2009) discussion of 'cool capitalism'.

20. Many thanks to Marilena Zaroulia, who made this observation in a conversation about this chapter. Hall's insight supports this idea: 'the point when we can most confidently say that a European identity exists coincides with the defeat and expulsion of the Muslims from Spain by a militant and purified Catholic monarchy, the expulsion and forced conversion of the Jews and the launching of the great "experiment" of conquest and exploration down the African coast and into the great unknown across the Green Sea of Darkness' (2003: 41).

7
Staging the Others: Appearance, Visibility and Radical Border Crossing in Athens

Aylwyn Walsh

This is a moment in the contemporary milieu in which the idea of Greece is in a state of constant flux. Reeling from the implications that economic and social 'crisis'[1] has for the country, people in Greece are also navigating the ways in which mythologies are being wrought in order to explain and justify actions and reactions. These myths paint pictures of the great nation (birthplace of democracy), the contagion that has been unleashed to destroy it (immigrants), punitive forces that have implemented harsh measures to discipline the nation (*Troika*) and saviours (this is questionable, but for some months far-right Golden Dawn held a growing role in the public imagination as saviours).[2] As a result of such mythologising, Greece no longer seems to be a coherent nation but rather a divided and depleted populace with ever-weakening ties to those who represent them in government. In this light, borders as 'barriers to threats or pollution' gain prominence as they make legible the demarcations of who is legitimate inside and who is not (Rajaram and Grundy-Warr 2007: xxxi). This characterisation of Greece as a leaky, contingent and unstable vector of meaning suggests the need to consider the ways that nation and identity are called into question by the appearance of Others – or what Ash Amin calls 'strangers' (2012) – in the nation state.

It is extraordinarily difficult to write about such a moment – not least because material conditions are changing day by day. More than that, there is the difficulty of unravelling the residue of affect – or what Sara Ahmed (2004) calls 'stickiness' – that taints my research on Athens. The only justification I will offer is that I am not entirely an insider – I am, as a South African who had been resident in Greece, an insider/outsider, an 'alien'. As such, I am always already both an outsider – reflected by my pale skin, lack of fluency in Greek, and non-European world

view – and an insider, by virtue of the same markers of identity that make an outsider. As an English-speaking white South African female, I inhabit that most problematic of categories: hyper-privileged in the country of my birth and, by extension, complicit in racial oppression under Apartheid; and an 'alien' in Europe, despite having ancestral and more recent familial ties.[3] My scholarship is sited on this border between belonging and not belonging. However, although I begin from the disjunction between my ethnic privilege and the juridical exclusions I face, I acknowledge the depth of the racist and xenophobic exclusions perpetrated against other Others. Often, these exclusions are experienced in the realm of bureaucracy, but, more likely, they are discursive, social, everyday tensions that read difference before commonality; threat before communication. The problems I address occur when there is an intersection between discursive framings of what can be described as Barbarian Others and the embodied inscriptions of the implications on the skin – in other words, race, ethnic and national categories become manifestations of the inside/outside dichotomy.

This contribution is thus crafted as a partly autoethnographic reflection on the current social performances of Otherness in Greece, with all the subjective, partial and embodied perspectives that entails. Thus, while I draw on artistic performance, I am particularly concerned about using performance methodologies to unpack the dramaturgies, settings, social actors, scripts and directors that relate to the tragicomedies of everyday life in Athens within the timeframe 2009 to 2013. I make use of interviews with organisers of a La Pocha Nostra residency in Athens in 2013 in order to reflect on the intersecting problems raised by radical performance in times of crisis. I consider this alongside the capacity for performance to destabilise belonging and the seemingly fixed dynamic between inside and outside.[4] I propose, following Ramòn Rivera-Servera and Harvey Young's compelling evocation of the body's processual becoming in relation to borderlands, that performance provides repertoires for navigating self/Other. They argue that 'movement with and toward an/Other, the constitution of collective action and the skin's surface as thoroughly relational, avails subjects with a capacity, perhaps even a necessity, to traverse boundaries en route to becoming' (2011: 3).

In order to approach the difficult topic of Others in Europe, I must specify the origins of how Otherness is understood – and, in the case of Greece, as C. P. Cavafy's 1910 poem 'Waiting for the Barbarians' claims, the Other has tended to be characterised as those outside the city limits, carefully delimited by a solid city wall.[5] While, in contemporary Europe, Others are often conflated with racial and ethnic difference,

the formulation of the Barbarian (with its concomitant connection with Other languages) suggests a definition of Other that is both spatially remote and distanced from legitimate presence in the *polis*. Yet, in the globalised world, bodies, like commodities, are trafficked across borders, rendering urban identities always already polyvalent (Amin 2012). This is where I have found it necessary to consider anew the ways in which Others are produced in Greece in the era of 'crisis' by examining the ways in which strangers' bodies (and the interrelationship with local spaces and identities) draw attention to juridical, spatial and socio-cultural borders. I offer a reworking of Sophie Nield's (2006; 2008) valuable specification of borders and visibility in relation to the 'appearance' of refugee bodies.[6] Her formulation states that the border functions not merely as a geographical or representational space, but that it:

> produces a second border between the body and its visibility to the law. This second border lies between the human and the rights pertaining to the condition of being human. It disaggregates that which should be inseparable, and destroys the possibility of appearance. The body of the refugee is there, but it cannot appear. The person is there, but they cannot be seen. They are present before the law, but invisible to it. They have entered the apparatus of disappearance, and vanished in plain sight. Here, but not Here. (2008: 144)

The argument suggests that there is an extension of the biopolitical mechanisms of the role of international borders in surveillance, documentation, coercion and exclusion that render Others' bodies visible through a declarative process of making a claim for protection (or asylum) from the state (Amin 2012). Yet, in the case of Greece, most immigrants do not in fact appear at borders simply because the physical borders are porous coastlines.[7] In Greece, then, people who intend to claim asylum tend to need to *reappear* in city centres to lodge papers in order to be considered for asylum. Yet, I feel it is important to assert that appearance or a claim to presence before the law is arbitrary and dispersed precisely because of the tensions raised by Nield; the 'Here, but not Here' formulation demonstrates that there is an agential process of staging and recognition in which the perceiver must agree to constitute the conditions under which appearance becomes visibility. Thus, the borders are relocated to inner-city bureaux for aliens, rather than being sterile borders at ports of entry. The bodies' appearance and constitution of borders thus need to be reconceptualised in light of the chaotic and corrupt spaces that I term 'borderlands'. The border is what Prem

Kumar Rajaram and Carl Grundy-Warr consider 'a zone between states where the territorial resolutions of being and the laws that prop them up collapse. It is a zone where the multiplicity and chaos of the universal and the discomfits and possibilities of the body intrude' (2007: x). Theorists writing on borders have repeatedly reflected on the interface between bodies and legal space, with Étienne Balibar suggesting that the borderland becomes the site of repetitive inhabitation that 'becomes, in the end, the place where he [*sic*] resides' (2002b: 83).

Shahram Khosravi takes the notion forward, suggesting that undesirable persons are 'positioned on the threshold of *in* and *out*' (2007: 332), and that borders 'have become invisible borders, situated everywhere and nowhere. Hence the undesirable persons are not expelled by the border, they are forced to *be* border' (2007: 333). Rivera-Servera and Young suggest that 'the border alters the way that bodies carry and, indeed, perform themselves not only in the moment of encounter but also for years (and even generations) afterwards' (2011: 2). This conceptualisation proposes the need to consider the legacies of performance as well as of border crossing. My assertion is that, rather than migrant bodies rendering the border meaningful by appearing there, on the contrary, *any* spaces migrant bodies inhabit become constituted as borderlands; which precisely sets the conditions for states to promote diffuse border control in the ways in which citizens are protected from 'floods' of migrant Others. Nield notes that there is also a normative operation of navigating borders in which failure 'to negotiate this mode of appearing, or to inhabit the space of the border properly, causes a sort of spatial disjuncture, a stasis. The refugee becomes a non-person, a border-dweller' (2006: 68).[8] Yet, while Nield's formulation places ethical relationships and spatiality within the question of appearance, it is predicated on a politics of visibility and presence that ought to be radically questioned in light of the situation faced by migrants in Greece. By this, I mean to revisit the assumption that performance provides concepts relating to what 'appears' and is visible as a public spectacle (see Nield 2010: 39). Rather, it is necessary, in this analysis, and indeed in the wider field of performance studies, to expand the conception of the relationships between bodies, space, legitimacy, legibility, voice and audience in a more robust understanding of civic response-ibility (cf. Butler and Athanasiou 2013). In other words, as the struggles for political agency in what has become known as the Arab Spring have shown, what is important is not merely in and of the performative rupture of a protest or movement, but in the notion that bodies claiming public space carve a potential for political representation. It is not so much

about being in public, but in the transformation of the sanctioned, legitimised usage of public space into a stage on which bodies must be recognised, and human lives must be counted. I propose these stages as transient 'meanwhile'[9] spaces, in which Other identities and subjectivities are platformed for the public to witness. Embodied pain, suffering and, sometimes, martyrdom are framed as performative precisely because they *do* something in relation to the public space in which they are constituted. In other words, they begin to construct a commons predicated on wider ideals than the subjective experiences that are staged.

I am thinking, for example, of a series of lip-sewing protests that occurred in Athens between 2009 and 2010, in which Afghan and Iraqi asylum seekers pitched tents in the forecourts of Propylaia and conducted seated, silent, protests. I approached the protest in order to find out more. Several men stared out, wrapped by protective sheets, while some spokespeople gathered signatures from supporters. The protests were staged in order to draw attention to horrors the asylum seekers described in their own countries of origin (sometimes accompanied by graphic images of war-torn towns and cities), as well as pleading their right to be considered for asylum in relation to the harms they faced at home.[10]

What is at stake in these meanwhile spaces is the wider issue of Europeanness that Amin characterises as 'hospitality, mutuality, solidarity, care for the commons' (2012: 133). So long as the lip-sewing protests continued in these spaces, these struggles appeared, and while not necessarily resulting in the desired outcome (of speedier, more transparent recognition of asylum processes), the performance of a space for mutual recognition was forged. In the three years since those protests, immigrant bodies have tended to remain hidden, invisible in public spaces in Athens; this is largely connected to the rise in xenophobic hate crime perpetrated by right-wing factions in collusion with police.[11] Reports document the 'disappearance' of migrant bodies from streets and squares at night, both as a result of being injured or forced to leave through 'clean-up' operations such as Operation Xenios Zeus (named after the God of Hospitality) and related to the resulting fear of harm and persecution that then drives people to protect themselves by staying out of sight (Marchetos 2013). The problem then becomes to what extent the lack of appearance of strangers/aliens/Others reinforces the problematic of a bounded community based on nationalist ideals that advocate a hierarchy of belonging closely tied to ethnicity. Further,

how might an understanding of the performative conceive of the promise of action in the resistant potential of migrant bodies protesting in urban space? Finally, how can we develop a more robust capacity for using performance in the struggle against invisibility, marginalisation and stereotyped repertoires of alien behaviour?

This line of questioning suggests a tension between visibility/invisibility and appearance/disappearance, which is well rehearsed in refugee studies, suggesting that appearance as an alien does not equal visibility in the public sphere. Thus, personhood, agency and the incorporation of human rights into public space or the *polis* are all in question. Yet mere appearance does not signal recognition nor fair opportunities to contribute to the social. In the lip-sewing protests, for example, despite having appeared daily for several months, the visibility of the demands was not evident in the consciousness of the state. Nevertheless, I believe that state recognition does not equate to visibility – but rather that *making visible* is the terrain of radical political necessity, as pointed out by Taylor and Marciniak (2013: 152). Furthermore, the state's capacity in times of crisis to *see* and respond is reduced. The state cannot or will not see, recognise or witness such acts – voluntary blindness, on the other hand, means that the state is not compelled to act.

By examining the political quagmire of migration in relation to visibility politics, I suggest that it is necessary to reconsider the expansion or diffuseness of borders. Performance provides a means of conceptualising how biopolitical systems of inclusion and exclusion operate at the level of how norms and rules come to dictate everyday access, participation and agency in civic life (see Amin 2012: 24–7). One practice to be considered is Guillermo Gómez-Peña's 'radical border crossing'. Yet most self-aware aesthetic performances of border crossings are not always able to make visible the very real dangers faced by migrants as they navigate the Aegean Sea, or the new Frontex fence at the Turkish border at the River Evros. There is thus an ethical distinction to be made between symbolic representations of suffering (for example, the mass 'die-in' protests that gained popularity in Athens in 2009–10)[12] and the bodily risk endured by migrants on their journeys to Europe. This contribution goes some way towards demonstrating how performance can be involved in revealing the complexities, contradictions and tensions in these issues. In simplistic terms, Europe is seen as a promised land to which migrants have flocked – often depicted as a 'contagion', a 'tide' or a 'flood'.[13] This imagery is not limited to Greece, but, indeed, pervades the European imaginary as a cohesive, bounded, civilised (white) union of benevolent nations that broadly accept the cheap benefits

of a cosmopolitan outlook – support for freedom of movement of the desirable Others while carefully monitoring, limiting and denying such freedoms to undesirable Others, or Barbarians (Amin 2012).[14]

While debates on immigration never cease to provide political fodder for EU countries, it is less common to hear any acknowledgement of the interplay between globalisation, capitalism, gentrification and the concomitant need for cheap labour, often provided by migrants. Thus, in times of plenty, in which construction occurs, a need for labour is created, requiring the flows of migrant workers to fulfil the contracts that (presumably) local workers are not prepared to fulfil. This is usually because labour conditions are poor, wages low, and safety considerations not always met. When economies shift into shrinking modes, construction is always an industry affected by downturns, and thus migrant workers are rendered unemployed – seen as surplus to the market. The implication, usually perpetuated by the media, is that migrants should 'go home' (as, for example, in the short-lived, council-sponsored 2013 'Go Home' campaign in the UK); and there is often visible resentment that emerges between unemployed migrants and locals with the accusation that 'they' are stealing 'our' jobs. This shifting rhetoric dictates what bodies become expendable when an economic 'crisis' demands that the value of labour is in question. Unfortunately, this problem is rarely rendered political through the wider questioning of the values of expansion, growth and development at all costs in the first instance.

Athens' 2004 Olympic Games are a case in point for the concomitant superficial and rapid expansion of urban development at the cost of social cohesion. Immigrant communities once seen as essential to the construction of the urban centre had, in light of the economic 'crisis', become superfluous, a nuisance and, at worst, a threat to the image of a successful neoliberal city. Rather than being welcomed as builders of the dream city, unemployed migrant workers were rendered 'illegal' when they no longer made valid social services contributions. Thus, people were criminalised for losing their jobs.[15]

There are countless examples that bear witness to the growing precarity faced by migrants in Greece, not least due to the brutal impunity with which police forces collude with violence against migrants. A recent *New Statesman* report by Spyros Marchetos (2013) describes a law that criminalises those who 'assist' illegal immigrants. This law is not only aimed at those who traffic people across borders, but has been widely used to prosecute people helping migrants to access food and medical treatment – those ties of solidarity and hospitality that are considered foundational to post-Enlightenment Europe. In short, the

rule of law thus generates a border between 'us' and 'them' by making acts of hospitality and belonging synonymous with human trafficking. The threat of the law is that it supposes the person's legal status to be of primary importance; and, in practice, this status is conflated with racial and ethnic markers of difference. The threat of incarceration for 'assisting' migrants undoubtedly weakens the ties between host communities and migrants. Ultimately, it calls into question the qualities of being human that are upheld by the UNHCR, suggesting that the accountability structures of the EU and other international watchdogs (such as Amnesty International and Human Rights Watch) are perceived as bureaucratic exercises that have no impact on the practices of border politics, especially in relation to migrant detention.[16] Ultimately, the drama of immigration is played out with excessive stakes for the migrants, and as a farce for officials – in which bodies 'disappear', files and claims are 'lost', and bodily harm is rendered a show when there is no legal recourse taken against perpetrators.

Having considered several instances in which borderlands are constituted in public spaces in the city, the next section marks a shift in the chapter towards framing a particular performance practice within the Greek context. I turn from the territories of performance of everyday life (the ways in which migrant bodies appear and constitute border meanwhile spaces) to the ways that aesthetic performance can operate as a radical, political intervention in the animation of dialogue about inside and outside, Self and Other. To do so, I draw on the work of Gómez-Peña and his performance collective La Pocha Nostra, which has crafted a method of radical border crossing in and through performance (see Gómez-Peña 2000; 2005; 2008; La Pocha Nostra 2013). The framework this methodology provides is then used to consider the La Pocha Nostra residency held in Athens in summer 2013, based on interviews conducted with one of the organisers, Fotini Kalle.[17] The implications of their performance processes are then remodelled in light of my interest in the contingent and precarious conditions in Greece in the (emergent) conditions of 'crisis'.

Radical border crossing: La Pocha Nostra in Athens

To the masterminds of paranoid nationalism
I say, we say: 'We,' the Other people
We, the migrants, exiles, nomads, and wetbacks
in permanent process of voluntary deportation
We, the transient orphans of dying nation-states

la otra America; l'autre Europe y anexas
We, the citizens of the outer limits and crevasses
of 'Western civilization'
We, who have no government;
no flag or national anthem
We, fingerprinted, imprisoned, under surveillance
[...]
We demand your total TOTAL withdrawal
from our minds and bodies ipso-facto
We demand the total restructuring
of the world economic system in the name of democracy and
 freedom
[...]
I speak, we speak, therefore we continue to be ... together
even if only in the realm of the poetical
even if only for the duration of this unusual mass.

'A Declaration of Poetic Disobedience from the New Border' (2004)
 (quoted in Gómez-Peña 2005: 227–34).

Gómez-Peña is an influential Mexican-American performance artist
based in San Francisco, whose career spans over thirty years. With his
transnational collective La Pocha Nostra, he has developed a method-
ology that straddles performance, activism and pedagogy. The col-
lective has become renowned for its intensive residencies at which
international artists develop paradigms of being together through and
across difference. Indeed, La Pocha Nostra insists that, through the
boundary-breaking potential of performance, we should render the
very notion of borders (between nations, ethnicities, cultures, sexual
identities and genres) obsolete. Thus, I integrate this methodology by
deliberately applying the thinking of Chicano/cyborg performance art-
ists in America to rethink the problems and possibilities of the border
in Europe in the milieu of 'crisis'.

La Pocha Nostra's methodology draws on hybrid influences from
performance art, live art, ritual, activism, community organisation
(such as the Zapatista movement) and radical pedagogies. The resultant
work is always the product of intensive collective creative processes that
normally rely on a residential model. Its aesthetic is extreme, obscene
and hyper-visual, often relying on excess, subverted or distorted stereo-
types, and the conflation of styles and genres. The collective's manifesto
claims: 'it is our desire to cross and erase dangerous borders between
art and politics, practice and theory, artist and spectator. We strive to

eradicate myths of purity and dissolve borders surrounding culture, ethnicity, gender, language, and métier' (Gómez-Peña 2005: 77). Gómez-Peña explains that much of the collective's work seeks to consciously explore the 'spectacular' presence of Other-as-freak (2005: 62) by decorating and enhancing their bodies (with what they call 'hyperethnic' motifs). According to him, the aim is to exaggerate their 'extreme identities' as already 'distorted' by their mediatisation (2005: 62).

> The composite identities of our 'ethnocyborg' personae are manufactured with the following formula in mind: One-quarter stereotype, one-quarter audience projection, one-quarter esthetic artifact, and one-quarter unpredictable personal/social monster. These 'artificial savages' are cultural projections of First World desire/fear of its surrounding subcultures and the so-called 'Third World Other.' The live performance becomes the process via which we reveal the morphology of intercultural fetishes and the mechanisms propelling the behavior of both our 'savages' and our audiences. (2005: 81)

Since La Pocha Nostra's approach is intentionally political, it seemed welcome that they had chosen to relocate their annual summer intensive residency programme to Athens in 2013,[18] instead of holding it in its usual location in Oaxaca, Mexico. I felt that this was a conscious choice to explore radical performance pedagogy in the moment of radical political need. This reveals my idealistic position that performance interventions can and do provide challenges and provocations to the social realm. Yet my discussion with organiser and participant Fotini Kalle revealed some of the tensions underlying the process. Our conversation revolved around the problem of performance in time of 'crisis'; the place of performance in a context that is highly cultural but more accustomed to traditional drama or theatre as well as the problem of building communities in a space and time in which community is contested, identities are challenged, and national sovereignty is under question. In their manifesto, La Pocha Nostra explains that they:

> [Collaborate] across national borders, race, gender, and generations as an act of citizen diplomacy and as a means to create 'ephemeral communities' of like-minded rebels. The basic premise of these collaborations is founded on the ideal 'If we learn to cross borders on stage, we may learn how to do so in larger social spheres'. (Gómez-Peña 2005: 77–8)

In our interview, Kalle discussed the ways in which systemic borders operated to maintain borders between art worlds. Indeed, much of the modern Greek identity is bolstered by the ancient legacy from drama (Calotychos 2003; Zaroulia 2014).

The process culminated in a promenade in which performers presented *tableaux vivants* (or body installations) using architectural spaces, with Gómez-Peña using a megaphone to annotate the images with words. *Altar of the Dead Immigrant* was created by smaller groups in the exterior of the building at the Athens School of Fine Art. The approach seems to rely on excess, with provocative use of adornment, repurposed props and costumes, but the workshop process tends towards a much more detailed, multi-layered questioning of the constructions of identities in the images created either as individuals or in the group. In the workshop 'jam' sessions, there was a lot of discussion about how to develop and craft images through an 'inside-out' approach, according to Kalle. Yet, there was one element of the La Pocha Nostra methodology that was not fully negotiated in Athens, which is the exploration of city spaces in the personae developed in workshops. It was felt that the extreme xeno-phobia and the rise in conservative protections of public spaces (from both 'the public' and the police) would make the venturing of extreme ethno-rebel artists into city spaces too dangerous.[19] This, along with the threat of xenophobic violence against several members of the troupe, in light of Golden Dawn's stronghold on the public imagination at the time, made performance in public space seem a border crossing too far. Once again, then, the radical performance intervention in public space was not apparent – that is, it did not *appear* to make the forceful claim to space, rights and visibility that it could have done (and has done in other cultural contexts).

Performance makers are used to defending the legitimacy of their art to funders, institutions and citizens who need to understand the mean-ings and intentions behind the work before it can be supported. Kalle highlighted the difficulty in getting any financial or in-kind support for hosting the residency. Yet, we might acknowledge the difficulties of justifying support for the arts in the face of the widespread struggle for survival of the general populace. Despite developing work that con-sciously draws attention to the place of performance to challenge how art or activist interventions become included or excluded, the residency in Athens raised some further problems of the place of performance in times of 'crisis'. From our discussion, it seems that there was a hierarchy of urgency and preoccupation that emerged – with local artists entirely possessed with the problems of 'crisis' (which, by now, may seem like

an empty signifier), from political frustrations, to the lack of hope and financial uncertainties. Instead of being able to use the residency as a means of creatively opening up spaces for discussion and transformation, this preoccupation became a border between 'us' (those experiencing the 'crisis' in an embodied way) and 'them' (artists who were merely visiting). The real and imagined oppressions of 'crisis' meant that the curiosity and the ability to transgress national borders and create wider trans-national communities of 'rebel artists' were hindered. I do not wish to impose meanings on the introspection but to raise it as an articulation of the kinds of terrains of value occupied even within the radical performance-making context. Perhaps La Pocha Nostra would embrace being seen as the Barbarian in this context.

La Pocha Nostra often refers to the non-existence of the word performance in Spanish, and it is the same in Greek, so that it is a linguistic import, as well as a cultural one. What is key in La Pocha Nostra's method is its development of the agency of individuals to construct their own extreme hyper-ethnic (re)presentations, usually incorporating multiple kitsch objects in outrageous tableaux that work with contradictions. Yet, in the Athens residency, one of the most compelling images was strikingly simple and without paraphernalia. In this image, a nude black body (devised by US performer Khi Armand) on a slab of marble is draped with a Greek flag and is wearing a wreath of leaves on his head. These marble slabs immediately evoke a graveyard, and the formal, prone position of the body resembles a corpse on a mortuary slab. The addition of the flag is reminiscent of a military rite of passage, in which 'fallen soldiers' are draped with the flags of their nations in order to commemorate their bravery in dying for their countries. There is an obvious irony in this image, since the Greek flag has, in recent years, become synonymous with a growing, violent and xenophobic right wing. Their deployment of identifications relating to nation is as much about excluding Others as it is about glorifying the Self. The dead or dying body in the image draws attention to the interplay between body and nation. La Pocha Nostra's explicit interest in challenging nationhood and racist identifications is captured in this tableau.

Despite being a practitioner interested in participating in the La Pocha Nostra residency in Athens, I was unable to attend, because my own passport was held by the (then) UK Border Agency for processing a claim for leave to remain. I was (in a way) *sans-papiers* for longer than six months, and, with a different degree of pressure from those considered 'illegal', I experienced the frustration and anxiety of being 'stuck'.

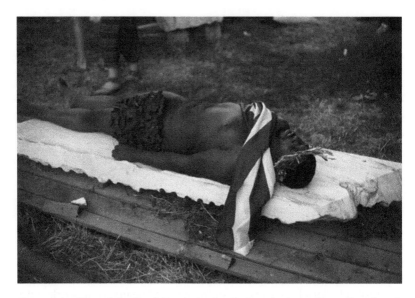

Figure 7.1 Altar of the Dead Immigrant by Errikos Andreou. Reproduced with permission of the artist

This was in contrast to several years previously, when I was waiting for papers to be ratified to stay in Greece.

> *Last time I arrived at the alien's bureau I got waved to the front of the queue because I put on lipstick that day. (I didn't know at the time that people suffered in that queue for days at a time – sometimes weeks.) I did know that I benefited from my whiteness one more time. That officials spoke to me in English without shouting or tutting in frustration. That I only had to visit seven different agencies, translate three different papers and purchase two types of insurance to get rubber-stamped. That I was lucky because I had an insider with me to translate.*

My experience of being judged as an insider with a legitimate claim to Europeanness was based on my skin colour. I appeared to fulfil the pre-conceptions of what the State approved, and as such was not subject to the humiliating and often dangerous limbo faced by fellow aliens. My own implicit position as holder of privilege serves also to reinforce the institutionalised xenophobia and racism that are causing immigrants to remain invisible. My concomitant insider-alien-outsider status leads me

towards a radical performance in opposition to insidious everyday practices. Along the same lines, reflecting on the uncertainty and ambiguity relating to the quashing of civil liberties since 9/11, Gómez-Peña tells an interviewer that:

> [the] performance stage has become, by default, a demilitarized zone, a sanctuary for critical culture and progressive behavior, a space where people can really talk about important issues, the issues that aren't being raised in the media, in the workplace, or at home. (2005: 280)

For Cavafy, the Barbarians were a 'sort of solution' for the citizens. The pregnant waiting of the citizens draws attention to a time of political stagnation and disillusionment that is nevertheless filled with the possibility that the Barbarians' presence will bring solutions. To return to the imagery of the meanwhile spaces, this waiting for destruction or salvation at the hands of Others can be identified beyond the political sphere, in which the *Troika* performs the ostensible saviour/destroyer role, depending on the perspective taken.

This repetition of the Barbarian is worth considering in relation to the La Pocha Nostra residency – and is perhaps a fitting analogy for the company's intention to cross borders of all kinds, while claiming positions of marginality. It is unlikely that the company would think of itself as a 'solution', but, nevertheless, the reception given to radical border crossing in the context of the residency in Athens reflects the stickiness (Ahmed 2004) of the besieged nation, constantly waiting.

In closing, I return to the characterisation by Rivera-Servera and Young (2011), who propose that border crossing is processual, painful, and relates always to movement. This suggests an ongoing practice that both draws attention to the borderlands and contests them. This is done by staging these arguments in public space, by exposing the contestation within the notion of creative communities, and by re-examining the assumptions made in and through performance practices that continue to serve the notion of the border as holding meaning. This suggests an urgent project – both theoretical and in praxis – that explores how performance reproduces the logic of the border, and to consider what performance allows us to see after all. Until performance residencies designed to explicitly reframe borders can occur without an inside/outside dynamic that positions people as locals/strangers, then borders – discursive, embodied and national – will continue to exert their force.

Notes

1. Throughout this chapter, I use quotes around the word 'crisis' in order to draw attention to its use as an empty signifier, and the fact that it is used generically and abundantly and is thus problematic.
2. It is necessary to mention that I do not believe these to be accurate characterisations of the status quo, but rather I am ironically deploying these narrow populist views by means of introducing the terrain of the argument. Other scholarship that deals with the foundations of modern Greek identities includes Calotychos (2003) and Christopoulou (2014). The particularity of how culture and performance replicate the modelling of nationhood is discussed in Zaroulia (2014) and Zaroulia and Hager (2014).
3. I am drawing on the work of Janet Woolf, whose account of a feminist approach to categories of belonging acknowledges the degree of choice that some aliens hold, and thus makes explicit the wide spectrum of marginality that can be experienced as a (resident) alien (see Woolf 1995: 210). Katarzyna Marciniak has developed a further theorisation of the alien as a cultural construct in film studies (2006).
4. This methodology requires signals between the theoretical arguments, the reflexive autoethnographic accounts and analysis.
5. Cavafy's poem begins with the citizens in a perilous state waiting for the invasion of the Barbarians. Its last stanza demonstrates the discursive constructedness of the Other: 'Why this sudden restlessness, this confusion? / (How serious people's faces have become.) / Why are the streets and squares emptying so rapidly, / everyone going home so lost in thought? // Because night has fallen and the barbarians have not come. / And some who have just returned from the border say / there are no barbarians any longer' (Cavafy translated by Keeley and Sherrard 1984: 19).
6. Here, too, I acknowledge the difficulties of using terminologies that relate to the legal status of persons according to which paperwork they have been accorded. In Greece, many migrants who would otherwise have lodged papers for asylum are rendered 'illegal' because they are not able to 'present themselves' (or appear) to lodge claims in time. The corrupt and un-transparent processes have been widely critiqued, yet very little has changed (Human Rights Watch 2012; 2013). Thus, in this chapter, I shift between the terminology of Others and aliens as well as resorting to the juridical terms where authors make use of these terms. In part, I suggest that the distinctions – in the example of Greece – are arbitrarily determined, and that they serve a particular ideological/discursive construction.
7. I feel it is important to recognise that the 'problem' of coastline borders is not unique to Greece, as the multiple deaths of migrants near Lampedusa in October 2013 demonstrate so viscerally. There is, however, a historical difference in the ways in which different Mediterranean nations have policed their coastlines, with human rights organisations claiming Italy in particular as negligent in its recognition of the human rights of the migrants. This is particularly acute when migrants do not appear on land but remain in boats. The phenomenon of 'pushing' back or refusing access, or even interception of boats with trafficked people, draws attention to the diffuse borders of nations. See Pugliese (2009) and Zaroulia's chapter in this volume.

8. Drawing on Nield's work, Amoore and Hall consider that the performativity of the border:

 also lies in the creation of a particular kind of space: one that relies on ritualized sequences and calculations to produce the appearance of securability, but which retains a liminal potential, and which is theatrical, not in a playful illusory sense, nor in the sense of a scripted, rehearsed pretence, but as a space configured as theatre in which appearance, and identity, is always in question. This, then, is the paradox in drawing out the theatre and ritual inherent in the border, which reveals something of its inconsistencies. (2010: 304)

9. I would like to acknowledge Myrto Tsilimpounidi for this term – referring to land that has been allocated for gentrification but which remains undeveloped. There are usually hoardings placed around such areas, demarcating them as surveilled property. The land serves no purpose when in 'meanwhile' status, except to announce the promise of coming development, through mechanisms of fences, CCTV cameras and threats of prosecution against trespassers. Meanwhile spaces are thus exemplary of the performative signalling of the border.

10. This section, and a subsequent one, have been generated by writing according to La Pocha Nostra methodologies, in which the personal, reflexive, often contradictory embodied narrative is put into dialogue with critical materials without hierarchies. This braiding of the subjective will become apparent as a rationale later in the chapter.

11. See Human Rights Watch (2012; 2013).

12. Some examples are discussed by Marios Chatziprokopiou (2014), whose anthropological/performance research focuses on lament.

13. This notion is explored in Hein de Haas (2008). See also Levy (2010) in relation to migration and securitisation.

14. As a further example from the UK, there was growing xenophobia reported in relation to the accession to the EU of Romania and Bulgaria, largely stirred up by populist politicians and tabloid media (see Quinn 2013).

15. Levy (2010) writes of a European context of migration–development nexus versus an asylum–migration nexus. See Golash-Boza (2010) for a US perspective.

16. Levy points out the discrepancy between member states in specific cases, such as Afghani asylum seekers. Italy recognised 98 per cent of Afghan asylum seekers; the UK recognised 42 per cent; while Greece denied all cases (2010: 106–7).

17. Skype interviews with the author on 9 September 2013.

18. The two-week residency was hosted at the Athens School of Fine Art (with a trip to Delphi) and accommodated twenty-two participants.

19. There are several accounts of the influence of the far-right Golden Dawn and the concomitant strength of populist politics in Greece, and across Europe more generally (see Human Rights Watch 2012; 2013; Marchetos 2013). The effects of this understanding of Greece in relation to Europe are explored by Zaroulia and Hager (2014).

Part III
Interpreters

8
The Riots: Expanding Sensible Evidence

Rachel Clements

In the narrative of the economic crisis and the developing picture of an increasingly unequal society, the August 2011 UK riots have been read as a paradoxical flashpoint; as a moment in which consumption and combustibility became manifest and legible although not easily comprehensible. This chapter considers a range of cultural responses, including Gillian Slovo's documentary theatre piece *The Riots* (Tricycle Theatre, 2011), Kieran Hurley and A. J. Taudevin's two-hander play *Chalk Farm* (Oran Mor, 2012; Underbelly, 2013), the community dance and poetry work *Unleashed* (Barbican, 2012), and Fahim Alam's documentary film *Riots Reframed* (2013).[1] Through these, the chapter explores the possible interventions, and limitations, of theatrical and documentary responses to an already mediatised, intensely image- and language-driven 'crisis', and to a set of events that were, in various ways, performative. To do so, I focus on the representational strategies employed and the politics these strategies reveal or enable, considering how such cultural responses contribute to and intervene in the discourse around social inequity, violence and crisis. These works, I argue, do more than react or respond: they offer interpretations, suggesting ways of apprehending and discussing the riots in particular and crisis more generally. That is, these works explore not only the riots and their multiple causes, but also the issue of retributory justice and widening inequality; they show that inequality, justice and spatial practices are not just products of crisis but its markers and producers.

In the introduction to the second edition of *Out of the Ashes*, MP for Tottenham David Lammy bemoans the fact that, in his perception:

> The riots in August 2011 united the nation in grief for their local areas and anger at the perpetrators. By the autumn, though, the

political class had turned its attention to the sovereign debt crisis sweeping through Europe. Thereafter, the riots never permeated national debate. (2012: ix)

This chapter's case studies suggest that Lammy's description is partial. If the 'national debate' had turned elsewhere, to focus on the Eurozone's financial crises, the pieces discussed here show that, in some forums, the riots attracted sustained and critical attention. Although the works discussed are rooted in the particularities of the UK and its local inequities and issues, it is also the case that while, as Lammy suggests, the political class were preoccupied with the sovereign debt crisis, others were more aware of their peripheral vision. These pieces try to fathom the connections and correlations between events in the UK and across Europe, and between this particular moment of 'crisis' and the histories that might have created it.[2]

Throughout, I am interested in the potentiality of cultural forms as spaces for responding to events with extreme rapidity and in order to contribute to and shape public discourse. Borrowing several concepts from human geographer Mustafa Dikeç's analysis of riots in the Parisian *banlieue*, I explore artists' attempts to shift the ground of the 'sensible evidence' around the riots, and the ways in which these pieces articulate different 'geographies of grievances'. The case studies attempt to make a range of histories, locations and contexts visible: parallels with the Broadwater Farm riots of the 1980s; questions about the future of a generation hamstrung by previous generations, by an economic crisis that affects them disproportionately, and by disillusionment with the power structures around them; neoliberalism's colonial legacies. I argue that the recalibrating and reframing that these pieces attempt exemplify a range of resistant strategies and that they make a case for reading the events of August 2011 both in closer detail and in a broader global context. I focus on each piece's moments of performative resistance not, I hope, to overstate their efficacy, but in order to map the variety of their interpretations and critiques – of the typecasting of inner-city teens, of prevailing discourse and imagery, of the hypocrisies of capitalism and particularly the political elite – and to begin to trace the dense textures of effect, affect and argument that the case studies stage.

History and rupture

In Kieran Hurley and A. J. Taudevin's *Chalk Farm*, fourteen-year-old Jamie describes the riots on the streets as the end point of a game of

Lego: 'That bit when the game is over. When what you've built has come as far as it can go. When you get to the end and there is nothing else to do but smash it all up, tear it up and start again' (2013: 41–2).[3] Later, he says:

> There was this other bloke on telly [...] saying that riots is what happens when people don't got a voice. And looting is what you get when you tell people you're worth what you can buy but don't leave them enough money to buy nothing. He says it shows that it's all at breaking point. That it's all stopped making sense.
>
> I dunno. I dunno about any of that. But maybe that's what Junior means when he talks about history. A point marked in time when it all began to crack, when the game is over, when the surface is ripped open showing what the world really looks like. And we were there.
>
> And then I think, nah. This'll never get taught in history class, not the way Junior sees it anyway. We'll go back to nobody noticing, nobody caring, and nobody looking up at Chalcots.[4] We're not making history, we're just having a laugh. (2013: 63)

Jamie's attempts to describe the bodily affects of the smashing and grabbing, his ways of trying to explain the 'everything and nothing' of those days, and his articulation of the riots as a moment of rupture – or not – might be put into conversation (and some disagreement) with Slavoj Žižek's discussion of the English riots in *The Year of Dreaming Dangerously*. Žižek mobilises the Hegelian idea of the 'rabble' to describe rioters: that is, 'referring to those outside the organized social sphere, prevented from participating in social production, who are able to express their discontent only in the form of "irrational" outbursts of destructive violence, or what Hegel called "abstract negativity"' (2012: 53).

Describing these riots as 'a zero-level protest, a violent act which demands nothing', Žižek felt 'an irony in watching the sociologists, intellectuals, and commentators trying to understand', because in the attempt 'to translate the protests back into their familiar language, they only succeeded in obfuscating the key enigma the riots presented' (2012: 54). He finds both the conservative and the liberal response predictably insufficient; the former because it ignores both 'the desperate social situation that drives young people to such violent outbursts' and 'the way those outbursts echo the subterranean premises of conservative ideology itself' (2012: 55); the latter because it 'merely lists the objective conditions for the riots, ignoring the subjective dimension: to riot

is to make a subjective statement, implicitly to declare how one relates to one's objective conditions' (2012: 58). For Žižek, the conflict and set of tensions revealed 'is, at its most radical, a *conflict between non-society and society*, [...] between those without a stake in their community and those whose stakes are the greatest' (2012: 60).

Žižek picks up on Zygmunt Bauman's suggestion that these riots were acts of 'defective and disqualified consumers' (2011), and therefore 'a kind of ironic reply to the consumerist ideology by which we are bombarded in our daily lives' (Žižek 2012); for Žižek the problem is that they evidenced 'reactive, not active, impotent rage and despair masked as a display of force, envy masked as a triumphant carnival' (2012: 60). However, in a chapter on plays about riots, Nadine Holdsworth reads against Žižek's 'disappointment at the lack of coherent socialist agenda', suggesting that theatre might offer 'a means of interpreting and subsequently articulating the "meaningless outburst" Žižek laments [...], in order to reinvest it with meaning' (2014: 81), not least because it provides opportunities for transforming the facelessness of the 'rabble', using theatricality to move beyond the spectacle of the riot.

Jamie's description opens up interesting space in relation to both Žižek's disappointment and Holdsworth's counter-reading. Hurley and Taudevin are politically committed Scottish theatre-makers, but Jamie's interpretation of events – which, as above, often shows him trying to work out how to assimilate and evaluate others' opinions and ideas – sidesteps the pitfalls that Žižek levels at left-wing commentary without falling into the reactionary, conservative traps either. *Chalk Farm* works – as Holdsworth argues much theatre does – through specificity and individuation: focusing on two characters and their understanding of events; taking seriously two of the most vilified figures of that summer (the teenage boy and the single mother) and treating them with empathy and humour. Simultaneously, Hurley and Taudevin see the laying of responsibility primarily on individuals as an easy dodge, arguing that the blame game that was played out around 'the individual choices, actions, and morality of those involved and their families' was 'too obviously a simplistic cop-out, an extension of the Thatcherite ideal that there is no such thing as society' (2013: 17–18), so the play works to crack open these characters' worlds in order to foster wider conversations. *Chalk Farm*, in common with the other works explored here, stems from a desire for a better, fuller discussion.

Throughout *Chalk Farm*, Jamie tries to articulate his experiences and understanding; his descriptions are as poetic and eloquent as they are fraught and confused. Through the teetering description of a historical

rupture, a moment of revelation and savage clarity, and the urgency of Jamie's sense that 'we were there' coupled with the retraction from this vision and the inwards snarl of 'We'll go back to nobody noticing [...] We're not making history, we're just having a laugh,' *Chalk Farm* explores the complex dynamics of social movement and revolt. Hurley and Taudevin pose questions similar to those asked by Clive Bloom in his book *Riot City*: 'Do the years 2010 to 2011 represent an awakening or mere frustration, a new beginning or mere repetition?' (2012: 18). This question – and the attempt, like Jamie's, to work towards an interpretation of events – recurs through a number of 'documentary' works. In the following analyses, I am particularly interested in how each interpretation seeks to puncture or challenge the consensus readings of which Žižek is so dismissive.

'Geographies of grievances'

Perhaps the most widely known theatrical response is *The Riots*, a documentary play based on spoken evidence, commissioned and directed by the Tricycle Theatre's then artistic director Nicolas Kent, and written by Gillian Slovo.[5] The process began in August 2011, as Kent asked Slovo 'to try to make sense of the looting and mayhem by talking to as many people as possible'; the play opened three months later on 17 November, and in January 2012 transferred to the Bernie Grant Arts Centre.[6] As Holdsworth explains: '*The Riots* attempted to give voice and hence to animate those individuals who had been largely reduced to a faceless collective or lost in statistics – whether as the marchers, rioters, victims or police' (2014: 95). For Kent, documentary plays function in their immediate present; any value lies in their contribution to public discourse: that is, '[t]hey're a response to a moment. I'm not looking at them as art ... [but] as a journalistic response to what is happening' (quoted in Hammond and Steward 2008: 165).

As Holdsworth says, one facet of this contribution is the space given to voices and individuals. Another – perhaps more significant – is *The Riots'* attempt to recover and make visible Tottenham's complex 'geographies of grievances'. In his 2012 article 'Immigrants, *Banlieues*, and Dangerous Things: Ideology as an Aesthetic Affair', Dikeç details the development of prevailing negative, stereotyped attitudes to *la banlieue*.[7] He describes how prevailing discourse, via acts of legitimisation and delegitimisation, reduces *banlieue* revolts 'to acts of pointless violence committed by delinquents [...] [that], in other words, *do not make sense*' in the public imagination (2012: 32). Dikeç argues that

'delegitimisation obscures the complex *geography of grievances* by highlighting merely the acts of violence involved in revolts' (2012: 32). Comparable acts of delegitimisation and erasure were at work in the UK in the immediate aftermath of the riots: the 'us' and 'them' division; the use of language associated with disease, vermin and regression; the extraordinary measures of courts sitting through the night to hear cases.

The play's first half traces the development of events in Tottenham and then across London on 6 August, and up to Manchester the following night. It deals with precise details and questions – why did the police not divert traffic as normal? What was the atmosphere like? What time did people leave, or arrive? These details help to explain what had seemed so unclear to many at the time: the various sparks, and the nature of the touchpaper that was lit that night. The attention to detail and specificity is not solely a documentary attempt to work out the minutiae of events and prove the production's factual credentials, but also an attempt to use particularity as a way of avoiding blurring and effacement. *The Riots*, then, attempts to map – sometimes literally, projected onto its screen – the 'geographies of grievances' of Tottenham, particularly through the testimony of people such as Stafford Scott, Pastor Nims Obunge and Martin Sylvester Brown. They position events in a wider picture of community tensions and a longer historical perspective. These include Sylvester Brown's discussion of local attitudes to the false reports about Mark Duggan's death;[8] Obunge's explanation of the justified upset that police had not visited Duggan's family;[9] Scott's detailed descriptions of both the march and the police's (mis)handling of events.[10]

The second half of *The Riots*, in particular, draws attention to the erasure of specificity and individuality that the judicial process enacted: as the Assistant General Secretary of NAPO (the trade union, professional association and campaigning organisation for Probation and Family Court staff) says, usually 'the court sentence each individual based on the individual circumstances of that case', but that during the riots trials:

> they clearly couldn't have had sufficient information to determine whether the motivation was socio-economic, whether it was purely opportunistic and greed. The courts were also under tremendous political pressure to deliver swift justice. (Slovo 2011a: 50)

The Riots argues that the need for justice to be seen to be done, in fact, created more problems than it solved. It doesn't just explain the

procedures and measures that kicked in – it questions their motivation and efficacy.

Along with the complex and specific 'geographies of grievances' of Tottenham, other histories surface. These include the recurring spectres of past clashes between police and communities: the multiple unexplained and untried deaths of black people while in police custody, and PC Keith Blakelock's death during the 1985 Broadwater Farm riots;[11] Blakelock's death haunts the whole police force as represented here. So, alongside its 'currency', *The Riots* shows how the past – particularly the traumatic, unresolved or violent past – continues to reverberate in and affect the present. In so doing, it speaks and acknowledges the histories that knee-jerk reaction and political hyperbole were drowning out. Further, the transfer to Tottenham's Bernie Grant Arts Centre, close to the site of the initial peaceful protest, makes a significant gesture towards siting discussion within the community that was most directly affected by Duggan's death. In the context of the play's attempt to map local complexities, the journey across London at the least suggests that *The Riots* was seen not as the end point in itself but as a forum for public engagement with live questions. As Slovo argues, theatre might be able to fulfil the urgent need 'to create a space in which people can think about what has happened together' (Allfree 2011).

Police, justice and 'sensible evidence'

In the introduction to *Softcops* (1978), which is directly influenced by Foucault's *Discipline and Punish*, Caryl Churchill argues that: 'There is a constant attempt by governments to depoliticise illegal acts, to make criminals a separate class from the rest of society so that subversion will not be general' (1996: 3). Churchill's pithy analysis of this attempt, clearly evident in the treatment of both miners and rioters in the mid-1980s, sprang to mind in August 2011 when politicians, particularly Prime Minister David Cameron, vilified those involved in unrest, rioting and looting by dubbing this behaviour 'Criminality, pure and simple'.[12] The makers of the works discussed here have sought to explore the riots as politicised and within a political context, and to articulate counter-narratives that rewrite the events of summer 2011 as anything other than 'simple'. Interviewed by Zoe Williams, Stuart Hall explains two concerns in response to the riots: first, that '[s]ome kids at the bottom of the ladder are deeply alienated, they've taken the message of Thatcherism and Blairism and the coalition: what you have to do is hustle. Because nobody's going to help you'; and, second, 'consumerism, which is the

cutting edge of neoliberalism, has got to them too' (2012). He argues that 'three decades of neoliberalism have got into people's consciousness and infected the way young people respond to poverty just as they have neutered the way politicians express themselves' (Williams 2012). Hall's despondency – which echoes Žižek and Bauman in its concerns about consumerism, but focuses particularly on its effects on young people – is a reminder that the act of staging complex representations of teenagers (as *Chalk Farm* does) hardly redresses the inequities of the urban experience and the ways in which the decks have been stacked against particular demographics and communities.

But while Hall's sense of the overwhelming structural inequities and ideological frameworks is important, putting Churchill's statement in dialogue with Dikeç's arguments suggests that art and culture might offer ways out of or around such apparently entrenched difficulties. Dikeç explores France's 'securitarian ideology' as an example of the ways in which ideology 'works through what it makes available to the senses and what it makes to make sense'. Borrowing from Ernesto Laclau and Jacques Rancière, he suggests that 'the focus of ideological critique becomes how sensory and sensible experiences are made common' (2012: 31) (the obscuring of 'geographies of grievances' is one example of this). Dikeç is interested in unpacking the ways that, for example, government publications and policy are enacted (and the ways in which ideology is aesthetic), but here I am more interested in how works of art might shift the ground of this 'sensible evidence' – that is, by intervening in prevailing 'chain[s] of inference' (Dikeç 2012: 39) and thereby making public, making sensible, other kinds of evidence.

In this regard, the fact that regular talkback sessions were scheduled at both the Tricycle and the Bernie Grant Arts Centre, and that the programme is full of graphs, statistics and additional material, is worth pausing over. In this complicated story, causal connections have not yet been fully mapped out, and multiple factors and mixed outcomes make it hard to form judgements. The additional material is partly an aid to understanding, but the breakdowns of arrests by age and gender, type of charge and location are also there to forestall assumptions. The relationship between personal testimony and statistics, then, is more significant than the statistics alone. In the back and forth between numbers and emotions, Slovo and Kent attempted to create a body of 'sensible evidence' to counterbalance the broad brushstrokes that were, in other forms of discourse, making calls for retributive justice seem common sense. The commitment to using the theatre work as a starting point for further discussion might then be seen as part of an attempt

not just to have a conversation but to shift the discourse; to ensure that grievances are heard, not erased.

The Riots, then, tries to help us understand some of the histories that were resurfacing in August 2011, often in very local contexts; the piece I am about to turn to brings some rather different grievances, evidences and histories to the discussion. *Riots Reframed* (2013) is a documentary film by first-time director and producer Fahim Alam. Alam, a law graduate with a master's degree from the London School of Economics and Political Science, was charged with, but acquitted of, throwing bricks at the police. After his arrest he was held in police cells for forty-eight hours and remanded in custody for six weeks, before being let out on bail under electronic curfew until his trial in March 2012. *Riots Reframed* was, in large part, filmed while Alam was under curfew, and was informed by his experience of both the criminal justice system and the media (although the film is not his story). His arrest was major news, appearing in both tabloid and broadsheet newspapers (which often pointed out that he is an Oxford graduate). Suspicious of the ways in which the mainstream media – which Alam sees as part of the problem – were interested in portraying and using his story, as well as the ways they reported the riots generally, Alam made an independent and self-funded documentary. His experience of prison was disturbing but formative; according to him 'bear[ing] witness to that form of oppression – it allows one to develop a rigour against injustice and a deeper sense of solidarity with oppressed people' (Alam in Francois-Cerrah 2012).

Since *Riots Reframed* was released in 2013, it has been screened across the UK and in a number of other cities across Europe, the US, Canada and New Zealand. As the film's website says, Alam himself has presented the film to thousands of audience members: one of the most noteworthy distribution strategies used in the first year of the film's release was for Alam to be present at screenings (usually free and open to all) and to hold post-screening discussions. This initial, pre-DVD release, strategy is evidence of Alam's desire (shared by many of the people he interviewed or who contributed music or spoken word poetry) to use the film as a way of generating debate and solidarity. The documentary becomes – as with *The Riots* – a starting point for discussion; the shared time and space during screenings and post-show talks offer a forum for dialogue and exploration.

Riots Reframed also unpacks the opening events and images of early August, drawing attention to the gendered aspects of the initial protests. Interviewees discuss the effect of women's bodies on protest front lines, suggesting that this tactic evokes ideas around both humiliation

and dignity. The film then shows footage of a police assault against a young woman, which cultural historian Paul Gilroy reads in relation to a 'known script' in which violence against a woman's body proves to be the tipping point for collective disorder. The documentary goes on to discuss numbers of deaths in police custody and race-related issues and inequities, but its focus on a specific moment of violence against a young woman's body shows, right from the outset, an interest in going beyond the gendered assumptions that underpinned many responses to the riots in which the focus was often on a violent and disenfranchised – and typically male – youth, and in which young women who had taken part were particularly vilified.[13]

Like *The Riots*, *Riots Reframed* points to continuing racial tensions and inequities – but the picture is more fully, and more bleakly, drawn here. It argues that both the cries from the public gallery for justice to be done and the responses of the criminal justice system betrayed continued and deep-rooted racism. Gilroy, whose sociological work has, over the past thirty years, consistently and influentially revealed and challenged racist structures, argues that the riots were the near-inevitable effect of over twenty years of the demonisation of young poor people, particularly those of colour, and positions this demonisation in relation to the history of colonialism.

The attention paid to the criminal justice system highlights the effects of prison on individuals: one interviewee describes the 'little ways of making you suffer'; Gilroy describes it as 'a living death'. But it also considers prison more systemically. Britain's developing securitocracy is critiqued, as are the ironies of the UK prison system in which numbers of inmates doubled following increased privatisation: in this reading, a society of mass imprisonment has less to do with crime and law, and more to do with capital and the corporation. During the post-screening discussion at Whirled Cinema, Brixton, considerable attention was placed on the idea of prison as a way of effectively extracting profit from the poor. That is, prison may have become a way of making people who are otherwise economically 'unviable' into a tappable resource for private companies. This discussion of the 'prison industry' – currently more privatised in the UK than elsewhere in Europe, but in all cases another arena of the crisis – acts as a counter to cries for retribution or punishment.

In *Rebel Cities*, David Harvey discusses political and media responses to the riots:

> The word 'feral' pulled me up short. It reminded me of how the communards in Paris in 1871 were depicted as wild animals, as hyenas,

that deserved to be (and often were) summarily executed in the name of the sanctity of private property, morality, religion and the family. (2012: 155)

For Harvey, 'the problem is that we live in a society where capitalism itself has become rampantly feral', and a 'political economy of mass depression, or predatory practices to the point of daylight robbery – particularly of the poor and the vulnerable, the unsophisticated and the legally unprotected – has become the order of the day' (2012: 156). In Harvey's analysis, the rioters 'mimic on the streets of London what corporate capital is doing to planet earth' (2012: 156–7); he suggests that this explains 'why political power so hastily dons the robes of superior morality and unctuous reason, so that no one might see it as so nakedly corrupt and stupidly irrational' (2012: 157).

Riots Reframed faces such predatory practices head on, notably in a scene, filmed outside one of London's prisons, which also highlights some increasingly pressing issues around space. Shooting an interview with the prison in the background, the filmmakers are told that they are not allowed to film the prison; that their materials could be confiscated should they continue. The interviewee, reflecting on this, wonders 'what have they got to hide', suggesting that 'deep down people know that prison is a wrong, awful place'. But this scene also resonates with Stephen Graham's critique of 'the New Military Urbanism', where he explores the 'crossover between [...] the surveillance and control of everyday life in Western cities and the prosecution of aggressive colonial and resource wars' (2011: xiii). Graham argues that 'military urbanism' has come about with:

the paradigmatic shift that renders cities' communal and private spaces, as well as their infrastructure – along with their civilian populations – a source of targets and threats. [...] This development incorporates the stealthy militarization of a wide range of policy debates, urban landscapes, and circuits of urban infrastructure, as well as whole realms of popular and urban culture. [...] [T]hese work to bring essentially military ideas of the prosecution of, and preparation for, war into the heart of ordinary, day-to-day city life. (2011: xiii–xiv)

The explanation given to validate the claim that the filmmakers were not permitted to film outside the prison was precisely the vague suggestion of 'security reasons'; the emergency – as Gilroy, borrowing from Agamben points out – has become the rule, and the space of the street or public space is increasingly, via nonsensical gestures and rules

masquerading as common sense, being shut down and controlled. Indeed, as Hall *et al.* wrote in 1978: 'Liberalism, that last back-stop against arbitrary power, is in retreat. It is suspended. The times are exceptional. The crisis is real. We are inside the "law-and-order" state' (1979: 323). If that was the picture then, *Riots Reframed* argues, the situation has – for those outside the 'pathologies of privilege' – only worsened.

Representational strategies

The question of whose voices are heard and how they are represented is particularly pressing when such 'pathologies of privilege' are being explored and – apparently – challenged. Attempting to create a piece that engages with the issues from many angles, Slovo and her researchers talked to local community members, victims of the violence, police officers, rioters, legal experts, several well-known MPs, political commentators, charity workers, doctors. Those interviewed, then, have some expertise – either because they were there and directly affected or involved, or because of their area of work. But Slovo struggled to access the range of material or voices that she wanted: finding rioters to interview proved difficult. Two sections of the play are therefore based on letters written from prison; three come from footage shot by a TV company making its own documentary about the riots. The Twitter feeds and phone-filmed footage projections also acted as a scenographic means of communicating a range of voices and perspectives where interviewing had proved limited.

This difficulty is worth pausing over since it also reflects an issue that Slovo found increasingly pressing. She points out that 'in the riots' immediate aftermath, politicians and the media conspired to make it seem like the people who did this were not like us' (Allfree 2011). *The Riots* draws attention to this dynamic, right from its opening stage directions about 'MAN 1' and 'MAN 2': *'It is almost as if they are disembodied voices. They are rioters and [...] they should be separated from the rest of the other characters. They are Other. A world apart from the audience'* (2011: 7). Performed by actors in baseball caps and hoodies, and 'separated' by dimmed lighting states whenever they appeared onstage, these unnamed figures do complex – sometimes uneasy – theatrical work. Slovo wanted to create a multi-layered picture, so it was important not to shy away from some of the explicit bandwagonning, opportunism and confusion that characterised some of the looting. Further, the play's foregrounding of the disturbing effects of the exemplary justice meted out means that these Other voices are not the only representatives or

stand-in for rioters. And yet Slovo also describes the 'shadowy figures' of Man 1 and 2 as 'a visual representation of the fact that we are all living in the same country [...] and yet their lives do not intersect with ours' (Addley 2011). The differentiation between the characters seen onstage thus at least partly replicates the 'them' and 'us' division, which had characterised the public discourse in the months preceding the play's opening. These 'disembodied voices' might also perpetuate problematic assumptions about criminal behaviour as much as they challenge them, sitting uncomfortably close to some of the dehumanising media discourse in terms of both image and language.

Although Slovo says that 'in general the police are cautious and disciplined in interviews' (Slovo 2011b), the perspective of the officers on the front line, or with oversight of events, provided useful detail and points of view that went some way to answering initial questions about the problems caused by the initial failure to, as it were, regain control in Tottenham. *The Riots* (and several television documentaries about the riots[14]) takes an editorial line that sees the telling of the 'whole' story via two extremely different or opposing subject positions as a way of making sense of what happened. In contrast, in *Riots Reframed*, Alam had no interest in interviewing or engaging in conversation with the police. One reading of this might imply that the film is partisan, that its focus is too narrow, that its picture is unbalanced: questions around the absence of police voices have been raised at both screenings that I have attended. Alam's response is that 'the establishment has enough space'; that the police have the means and the mechanisms to get their side of the story out. Thus, *Riots Reframed* is situated emphatically as a resistant, or counter, narrative. Further, making the case for this explicitly selective structure is particularly pertinent in a moment when the truism of 'two sides to every story' has resulted in diminishing standards of journalism.

Alam's insistence that his limited means should go towards creating space for voices that have fewer channels for being heard speaks back to Dikeç's thinking about 'sensible evidence' and 'geographies of grievances'. Rather than giving more space to narratives and voices that already contribute to prevailing ideologies, *Riots Reframed* aims to map not just the geographies but also the histories of grievances, suggesting that we continue to live, to borrow the title of Derek Gregory's 2004 book, in *The Colonial Present*. The refusal of a police/rioters binary structure also allows Alam to create more nuanced, troubled textures through the interview material gathered. This is not a documentary that positions its interviewees as people to be wholeheartedly agreed with or endorsed; rather, it positions them as people to be listened to seriously.

So, where *The Riots* had contested the 'criminality pure and simple' common sense, rendering it nonsensical through an exploration of Tottenham's history and the travesties of exemplary sentencing, *Riots Reframed* takes a more challenging route. The documentary takes on the authority of Cameron's statement by positioning it in relation to the UK's recent and repeated incursions into open-ended global counter-insurgency wars and multiple military engagements. Pointing to the military and colonial roots of looting as word and idea, multiple inter-viewees argue that the state apparatus of police, army and politicians continues to teach the cliché that 'might is right' while simultaneously enacting and loudly performing their own self-righteousness.

The disconnect between reality and prevailing narratives in the case of the London riots is particularly acute in Lammy's suggestion that '[j]ust 19 teenagers were arrested in Tottenham in connection with the riots, yet all 10,000 of Tottenham's teenagers will share the stereotyping' (2012: 258). *Chalk Farm*'s attention to Jamie is an attempt, as mentioned, to use specificity and character depiction as a way of avoiding such stereotyping. The dance and poetry piece *Unleashed* – performed three times on the Barbican Theatre's main stage in November 2013, directed by Walter Meierjohann and Boy Blue Entertainment – goes about redressing stereotyping in a different way. Made by and with the Barbican's Creative Learning ensembles (including Future Band, Young Filmmakers, Drum Works and Young Poets) along with Boy Blue's youth street dance groups (Da Bratz and Da Bluez), the joint project started in August 2011 and involved 152 participants aged between eight and twenty-four. Facilitated by ten artist leaders, the different groups devised and workshopped materials through 2012, working with the material that the young performers brought into the room.[15] Through a combina-tion of music, poetry, projected visuals and hip-hop dance, *Unleashed* set out to explore the experience of being a teenager in London.

Unleashed's most direct discussion of the riots was in a scene involv-ing some of its youngest participants. As a large rubbish bin burned centre stage, and projections of fire surrounded them on the produc-tion's three huge screens, these performers, seated on top of upright pianos, recounted what they remembered – from being driven through Tottenham while people on the streets were throwing things, to being on holiday and only hearing about the riots afterwards, and what they heard and saw – the sound of the police; a cash machine lying on the pavement; bits of the news; seeing a girl their age joining in 'and think-ing, she just wanted to be part of it'. The collage that builds up is not one of consensus – ripples of disagreement or different answers are staged

and overlap (a chorus of yeses and nos to the question 'Do I know anyone involved?'). Instead, the scene explores impact: a lone voice repeats 'I don't remember', but the haphazard and collected memories here create an impression of what these children and teenagers had experienced, of how they were affected. Juxtaposed immediately with footage of Michael Gove verbally attacking Deputy Labour Leader Harriet Harman on *Newsnight* (9 August 2011) on the subject of whether politicians are out of touch with young people, both politicians came off less well than the young performers whose ability to empathise and sit with differences of opinion opened up space for reflection rather than vilification.

Further, where *The Riots* turned to a restricted set of aesthetic shorthands – broken glass around the foot of the apron and a handful of pyrotechnic effects; the use of steel flats, designed to echo the security cladding of unoccupied houses; the piles of TV and electricals' boxes; the footage of events on the streets – *Unleashed* resisted this visual language. Taking a cue from one of the most widely circulated images of the riots – a hooded youth dragging a bin into a road full of burning bins – *Unleashed* flipped the picture. The scene starts with the image as already seen and recognised: a hooded figure drags a burning bin onstage. But it shifts as, instead of more bins, upright pianos are pushed on (also by hooded, masked figures). The unexpectedness of this image, its tenderness, its refusal to fit wholly within the visual repertoire that had built up around the riots, points to a discomfort with the ways in which images and stereotypes circulate. By creating a stage picture that doesn't fully collocate, the production avoided simply repeating and reinforcing the imagery and imaginaries of the riots.

Unleashed and *Chalk Farm* share a focus on teenage experience and its potentialities. Lammy – who opens his book with his own experiences of the Broadwater Farm riots, and pays close attention to the specificities of his own borough, not least the fact that '[t]hree of the areas worst affected by the riots – Haringey, Hackney and Lewisham – are the three places with the highest levels of unemployment in England' (2012: 82) – also argues that the rioting and looting were 'an explosion of hedonism and nihilism' (2012: 17). His overarching argument is that '[p]eople need a proper stake in society and a much deeper sense of responsibility towards others' (2012: 18). The question of what stakes a teenager – particularly those young enough to still be in full-time education – might have in society is interesting, given their economic position: too young to be either employed or unemployed, but old enough to understand the possibilities and problems facing them in relation to the economic precarity of young people in their area and, indeed, across the UK and Europe.

Unleashed focused on aspiration, hope and energy, with the performance bookended by the poem 'Dream Dealer' written and performed by Kareem Parkins-Brown. The speaker imagines himself as a dealer of dreams, 'Armed with an arsenal of aspirations and achievements', watching what people do with his paper plane dreams (put them in their pockets, wrap them in a fiver, fail to let them fly), and cautions, wittily, against being dragged 'to a territory where failure's hereditary'.[16] Throughout *Unleashed*, poets, dancers and musicians demand that the audience bear witness to their collaboration and skill. In entirely different ways from *Chalk Farm*, we might identify another move towards shifting stereotypes and the 'sensible evidence' around inner-city youth. In both works, nuanced ideas are explored with wit, lyricism and clarity. These pieces push against stereotypes, staging – both imaginatively but also via direct community engagement – a range of voices and perspectives that, without being perfect or romanticised, open up possibilities for a future in their humour, complexity and criticality.

Conclusion: making space

In their recent book *Dispossession: The Performative in the Political*, Judith Butler and Athena Athanasiou think about various social movements and actions in relation to questions of precarity, injustice and the performative. Butler says:

> When people take to the streets together, they form something of a body politic, and even if that body politic does not speak in a single voice – even when it does not speak at all – it still forms, asserting its presence as a plural and obdurate bodily life. (2013: 96)

In the aftermath of the 2011 riots, one prevailing set of ideas circulated around the disorder as wantonly criminal, nonsensical, feral, inarticulate. The knee-jerk reaction in the early days of August was to slam the door on anything that looked like an attempt to understand the actions of – in the final analysis – a small number of people, because of a semantic slippage through which 'understanding' seemed closer to 'condoning' or 'justifying' than it may, in fact, be.

The works explored here respond not just to the riots but to this sense of immediate lock-down. Made, staged and seen by audiences at various points in the aftermath, they all – to different ends, for different spaces, with differing agendas, with different senses of where problems might lie and how their particular form and content might speak back to, highlight, or even directly counter these problems – try to ask what

the political significance of the events as witnessed and responded to might be. None of these works presents us with a wholly hopeful future vision, nor with the practical tools to deal with economic or social crisis. Nevertheless, all four of them stage potential moments of resistance and possibility, both through their content and their distribution.

Although it might now appear somewhat limited, particularly in its visual language, it is worth positioning *The Riots* within the context of the discourse of those couple of months in 2011, when attempts to understand, contextualise or explain were often loudly critiqued as condoning, and when little mainstream attention was paid to the ironies of disproportionate sentences and exemplary justice (which were, of course, their own forms of violence). Slovo's play set out to address these problems, unapologetically shaping a collage of conflicting, often contradictory voices. In a moment of hyperbole and overreaction, it attempted to trace threads and connections, placing the urgent contemporary moment within a broader context of cuts, a wider historical sweep of long-running tensions, hauntings, and a picture that was both specific to its places and moments and also more widely indicative. *Chalk Farm* and *Unleashed* reveal as nonsensical the tarring-with-the-same-brush of London's youth. Delineating the precarious position of many teenagers, they shift attention towards the austerity measures (including the removal of the Education Maintenance Allowance and youth service provision at a local council level) that have increasingly ostracised and demonised a sometimes vulnerable demographic. Staging articulacy, poetry and virtuosity, these pieces, particularly *Unleashed*, celebrate rather than vilify the teenage experience. *Riots Reframed* takes issue with not just the prevailing discourse but also its 'two sides' framework and rhetoric, explicitly reframing its analysis in relation to histories of colonialism and warmongering, and asking questions about current structures of power and authority.

In their explicit attempts to open and create space for dialogue, to pay close attention to *whose* voices and perspectives are given space, and to provide both the information and arguments and the emotional, compassionate experience, then, these four works create counter-narratives that intervene in the production and understanding of 'sensible evidence' and the mapping and understanding of histories and geographies of grievances.

Notes

1. This analysis is based on: performances of *The Riots* on 8 December 2011 (Tricycle) and 6 January 2012 (Bernie Grant Arts Centre) along with the published playtext, and the recording of the production at the Theatre Museum

(8 December 2011); the published playtext of *Chalk Farm* and performance at the Underbelly, Edinburgh (21 August 2013); the recording of *Unleashed* (with thanks to Walter Meierjohann); screenings of *Riots Reframed* at Whirled Cinema, Brixton (25 November 2014) and Goldsmiths, University of London (28 February 2014).

2. The beginning of the Occupy movement in the autumn of 2011 also suggests that Lammy's is a narrow, perhaps Whitehall-centric, reading of the times.
3. *Chalk Farm* tells, retrospectively, the story of one teen's experience of the London riots, and the after-effects on him and his mother.
4. Chalcots Estate, where Jamie lives, is a north London housing estate made up of several tower blocks.
5. For a discussion of this process and a description of the play, see Stoller (2013). Holdsworth's chapter also contains an insightful analysis of the play's strategies and structures.
6. Importantly, the Centre is close to Tottenham police station, the focus of the initial, peaceful, march by family and friends of Mark Duggan on 6 August, and later the scene of the first outbreaks of violence and looting.
7. Both the areas and, more specifically, the shorthand for the 'darker inhabitants' (Dikeç 2012: 25) and especially youths, who live in these peripheral social housing areas of Paris.
8. 'nobody shoots at the police in Tottenham. [...] [W]e've got a history [...] of gun offence and even more importantly a history of death by the police [...] that go way back' (*The Riots*, 8).
9. 'I felt that it was right that somebody gave them answers. And if they weren't getting it at home, they had a right to stand where they were standing, with the community, and get the answers they requested' (*The Riots*, 10–11).
10. 'they kept looking at the police and it's like, wow, they're not doing nothing. These kids have never ever seen this before in their life. They're used to getting stopped before they do something' (*The Riots*, 14).
11. These riots, in early October 1985 – sparked at least in part by the death of Cynthia Jarrett from a heart attack following a police search of her house – also started after protests at Tottenham police station. Violence escalated, and during rioting at the Broadwater Farm Estate, PC Keith Blakelock died after falling, being surrounded by attackers, and suffering multiple injuries. For a particularly interesting comparison of events and responses, see Gilroy (2013).
12. Cameron used this phrase on several occasions, notably his public address outside Downing Street on 9 August (*Telegraph* 2011) and in his introductory remarks to the House of Commons two days later (House of Commons 2011).
13. The case of Chelsea Ives, which appears in *The Riots*, also draws attention to this.
14. See BBC (2011c; 2012a; 2012b).
15. See Barbican (2013).
16. A longer version of this poem appears in Parkins-Brown (2012).

9

'We are Athens': Precarious Citizenship in Rimini Protokoll's *Prometheus in Athens*[1]

Marissia Fragkou

We are Athens. [...]
We are no actors.
We are one protagonist with 103 heads. [...]
We are a choir that doesn't speak synchronously.
We are a choir that hasn't rehearsed a song.
Our city is our stage.
Our living rooms are our dressing rooms.
We are looking at the city from 103 perspectives. (Raddatz 2011b: 53)

With this preamble, Rimini Protokoll's *Prometheus in Athens* (hereafter *Prometheus*) opened for one night on 15 July 2010 at the Roman Odeon of Herodes of Atticus (Herodion) at the foot of the Acropolis in Athens. The company had selected 103 Athenian residents to represent the city on stage statistically; each participant was asked to identify with the characters of Aeschylus's *Prometheus Bound* (Prometheus, Hephaestus, Kratos/Via, Io, Hermes, Oceanus and the Oceanids), and justify their choice to the audience. The original core of the statistical chain reaction was formed by ten 'experts', including a conscientious objector, a prison guard, an immigrant activist, a human resources employee and an architect. The piece's dramaturgy was further underpinned by Greek tragedy conventions: episodic structure, the use of a chorus, *ekkuklema*[2] and mask. Aeschylus's text and the Promethean myth further cemented the performance's ideological and narrative spine: our relationship to power; resistance to authority; human rights and social (in)justice; democracy; responsibility and ethics.

Prometheus is an example of the 'theatre of experts' or Reality Theatre pioneered by the theatre collective, which has its roots in documentary theatre. The company uses non-professional actors, selected on the basis

of their expertise on the subject at hand, who are given the platform to share their personal stories with the audience. According to two of the company's artistic directors, Helgard Haug and Daniel Wetzel, the group is committed to 'bring[ing] people on stage that might as well be sitting in the audience' (Raddatz 2011a: 25) and attracting spectators who do not normally go to the theatre (Wetzel 2014). *Prometheus* was presented under the aegis of *Promethiade*, a transnational project which used the myth of Prometheus as a vehicle to revisit the origins of European civilisation and to reimagine the connective tissues across different cultures inside and outside Europe (Terzopoulos *et al.* 2011: 7).[3] The journey of *Prometheus*, originally commissioned in 2008 to specifically respond to the social unrest in Greek society at the time (Lasarzik 2011: 6), coincided with a significant rupture in the Greek and European social fabric. Following the Herodion performance, the piece was reincarnated in the form of a lecture performance that toured European cities and which also addressed the impact of the Greek debt crisis. Arguably, the fiscal crisis in Greece and Europe has generated a wider distrust towards the EU and its policies, particularly in the countries of the European South; following numerous instances of social inequalities, lack of solidarity among member states, and hijacking of democracy, instigated by the failed attempts of governmental practices to rectify the EU's inherent 'construction flaw' (Habermas 2012: vii) and secure its political and economic structures, European citizens have started questioning the neoliberal consensus. Against the above backdrop, this essay examines *Prometheus*'s dramaturgies, particularly its uses of myth and symbol, and its engagement with both dominant hegemonic discourses vis-à-vis identity, belonging and democracy, and local (national) or transnational (European) structures of feeling.

In *We, the People of Europe*, Étienne Balibar maintains that, in times of crisis, Europe may 'bring about a new political culture', acting as an *'interpreter of the world*, translating languages and cultures in all directions' (2004: 234, 235). The act of cross-cultural *interpretation* as a political project requires anchoring it in a language that can be communicated across borders. For Luisa Passerini, myths can perform this act of interpretation: 'myth is [...] capable of illuminating areas of meaning within reality, of making certain parts of the world narratable and re-narratable, along a line of "intersubjective communicability"' (2003: 22–3). She further argues that a 'new view of myths and symbols' can play a significant role in constructing a sense of belonging to Europe operating as a point of application to 'new forms of Europeanness' that would 'overcome the so-called symbolic deficit which results partially

from a construction based on the economic and financial aspects of reality [...] as a basis for federation' (2003: 23). The inherent ideological challenge of focusing on European myths to imagine 'new forms of Europeanness' is that it partly reinforces a Eurocentric hegemony and, ultimately, as Stuart Hall warned, 're-imagine[s] the new Europe as somehow beginning with and continuous with that old Europe celebrated in classical Greek mythology' (2003: 42). In the case of theatre, Hall's caveat becomes particularly pertinent when it comes to contemporary stage adaptations of ancient Greek drama which, according to Margherita Laera, often reproduce mythologies of classical Greece as the origin of Western civilisation, thus fuelling the ways in which 'European democracies define themselves and reinforce their identity on the international global stage' (2013: 7).

In order to address the relations of power that Hall infers, Passerini stipulates that a definition of European identity should be followed by a 'deconstruction of internal hierarchies and exclusions' (2007: 8); she specifically makes a case for rediscovering Europe's 'utopian dimension' (2007: 101) and examining possible identifications with notions of Europeanness that resist hegemonic discourses on Europe. This approach begs the question how Europe and its people can play a crucial role in revisiting and reshaping past histories and ideas that have contributed in the making of the European self. For the purposes of the present study, Passerini's vision also creates an aperture for considering the role of the theatre in instigating new identifications and imaginings of belonging in Europe and the world at large.

I am interested in Passerini's emphasis on the interplay of the axes of space and time, as well as Balibar's understanding of mediation and translation as purveyors of change during a critical moment in time. Passerini proposes that, in overcoming the pitfall of erasing local specificities and power structures intrinsic in the inside/outside or north/south Europe tensions, we need to view continuity with the European past in spatial terms, and to speak of 'a shared European space' (2003: 25). As the myth of Europa and the bull suggests, the origin of Europe can be located in modern Lebanon (2003: 31); in this sense, a focus on spatiality may foreground the permeability of borders and the connection of Europe with its outside, asking questions about origins, space, borders and identity. Similarly, for Balibar, 'Europe is a borderland rather than an entity that "has" borders' (2004: 220) and it should 'use its own fragilities and indeterminacies, its own "transitory" character' to achieve a political transformation (2004: 234). Echoing this, Passerini highlights that calling oneself European requires a critical acceptance of

the European heritage and a recognition of its 'breaks' (2003: 25). The potentiality of focusing on certain 'breaks' in historical time or 'fragilities' of the European self as vehicles to reinterpret history and culture opens up a critical examination of the continuity of European heritage and how this resonates with a rupture in the present.

In investigating how *Prometheus*'s dramaturgy and its participants translate the ruptures within their own present, I will also be focusing on the ways in which the performance revisits past identifications with the myth while also forging future ones. The myth's archetypal connection to freedom and resistance against authoritarian rule has been key in previous re-readings of the myth;[4] other endemic symbolisms of Prometheus as a defender of human rights and the father of civilisation, arts and crafts chime with ideas that shaped European identities in the 1960s and 1970s, including 'principles of representative democracy, rule of law, social justice and respect for human rights' and 'youth revolt' (Passerini 2007: 80, 82).[5] At a time when the production of cultural and civic identities in contemporary Europe is underpinned by exclusionary practices, which favour assimilation over difference, masked behind discussions around 'failure of multiculturalism',[6] an intensification of border-patrolling and the application of punitive measures for border crossing, it is necessary to explore whether the re-appropriation of myths and symbols associated with values such as human rights and democracy might gesture towards imagining 'new forms of Europeanness' and a political community of (European) citizens beyond the borders of Fortress Europe.

This essay, then, particularly considers how the performance's interpretation of the myth and the identifications created, coupled with its dramaturgies of participation, might unsettle commonsensical narratives regarding nation and belonging. In addition, it asks what types of spaces of resistance and communities can be produced to renegotiate neoliberal systems of organisation and knowledge, and what is the role of the citizen and performance in uncovering those spaces. In pursuing this, I will be using the term 'precarious citizenship' as one of my conceptual frames to reflect, firstly, on the current state of uncertainty in contemporary Europe that sanctions practices of safeguarding national security at the cost of human and citizens' rights. Judith Butler's understanding of precarity and dispossession in her recent writings (2004; 2009a; 2009b; Butler and Athanasiou 2013) on how normative rhetoric regulates the perception of the human in the context of the war on terror and the fiscal crisis provides a useful framework for the understanding of precarity as both troubling and enabling. Butler appropriates the

terms precarity, vulnerability and dispossession as tropes that might be able to mobilise an awareness about the collective responsibility for human life and to renegotiate our mutual dependency on people we do not know (2009a: 13–14). Here, I follow a similar trajectory to examine how the adaptation of a classical myth around revolt and human rights serves as a platform for a new encounter with citizenship and precarious subjectivity as productive forces. I argue that, in interpellating its participants as citizens and interpreters of the myth, *Prometheus* sheds light on Other(ed) (in)visible realities and allows for different readings of citizenship and belonging. My analysis also considers the performance's affective registers and the ways in which it engages its participants and audience as members of national and transnational communities in a line of 'intersubjective communicability', asking them to imagine the future to come. For this, I shall use Jill Dolan's term 'utopian performative' to describe those moments in performance that 'offer a fleeting glimpse, an ephemeral feeling, of what a better world might be like' and 'to move spectators and performers to *communitas*' (2004: 165) in order to discuss how affect might fuel community relations and civic engagement (Dolan 2005: 2–5).

'Bourgeois democracy reeks of tear gas':[7] de-democratisation and street politics

The implementation of austerity measures and practices of dispossession across Europe, legitimated by practices and discourses that turn the crisis into 'a rule and common sense' (Butler and Athanasiou 2013: 149), have deepened the fissures between centres and peripheries, while the increasing uncertainty, lack of security and 'de-democratisation' of the public sphere (Brown 2012: 46) have consolidated the ideological underpinnings of the neoliberal consensus. In 'We Are All Democrats Now', Wendy Brown argues that the saturation of political life by neoliberal ethics has debilitated the main tenets of democracy, which has been 'voided of content' (2012: 46–7). Brown names this process 'de-democratisation' to suggest how democratic law is suspended in moments of crisis. Since the eruption of the Greek debt crisis in 2010, manifestations of de-democratisation have been made palatable in multifarious ways and have often been accompanied by a banalisation of concepts such as 'common good', 'responsibility' and 'democracy' and the thorny dilemma of Greece's position inside or outside the EU. Moreover, the country's democratic deficit has been manifest in numerous events, including: the appointment of the expert technocrat

Loukas Papademos in 2011[8] (with a view to ensuring that the austerity measures proposed by the *Troika* would be approved by the Greek parliament); the performance of extreme police violence against protesters (2011, 2012, 2013); and the closure of the Greek state broadcaster (ERT) in the summer of 2013.

The post-2008 fiscal crisis has further revealed cracks in the EU's humanitarian and democratic identity. The activation of the support mechanism in Greece and its accompanying series of austerity packages has been followed by a rapid deterioration of living conditions, or what Athanasiou in her dialogue with Butler names 'precaritization' (2013: 2).[9] What is more, the rhetoric regarding the sacrifices in the Eurozone that Greek and European citizens have to make in order to safeguard a common viable future has led to an increase of Euroscepticism, generating competitive binary discourses between the 'hard-working' North and the 'lazy' South. Mainstream Greek media and political rhetoric within and beyond the Greek borders have often rehearsed the unquestioned argument that the Greek debt crisis was a local phenomenon caused by excessive state expenditure and an inflated public sector.[10] This position was further buttressed by an Orientalist iconography of the country promoted by national and global mainstream media, which openly painted Greece as a country of profligate tax evaders who do not work enough.[11]

Prior to the austerity packages and memoranda of understanding, traditional modes of democratic participation and the EU's neoliberal practices were already under attack; the December 2008 riots in response to the assassination of fifteen-year-old Alexis Grigoropoulos by a policeman in the centre of Athens were followed by general social unrest and a series of performances of anger against systems of governance, which were read as nonsensical by mainstream discourse.[12] Those performative expressions of disillusionment and anger, which ranged from protests by students, immigrants and pensioners to street slogans that proliferated in public spaces, not only articulated an acute anxiety for the precarious future of the young generation and anger against the legitimation of anti-democratic practices that sanction police violence; they also revealed a wider social grievance vis-à-vis the State's impotence to pay attention to popular discontent against political corruption and global neoliberal capitalist practices while also implicitly targeting practices promoted by the EU and global international institutions (Anastassakis 2009: 7).

Such articulations of discontent were not exclusive to Greece: the return of street politics in Egypt, Spain, Greece, the US, Great Britain, Mexico and Turkey expressed a strong quest for new forms of

governance and ways of belonging to local and global political communities. Notwithstanding the specific socio-political and economic conditions determining those performances of street politics, they nevertheless shared a common understanding of urban space as public sphere: public spaces were reclaimed and transformed, while alternative ways of urban cohabitation were often tested through the social practice of 'commoning'.[13] According to David Harvey, the city is a 'site where people of all sorts and classes mingle [...] to produce a common [...]' (2012: 66). For Harvey, a 'common' does not suggest a fixed space but rather 'an unstable and malleable social relation' and a product of collective political and affective labour within a particular milieu (2012: 73). In this sense, the social practice of 'commoning' may produce a shared non-commodified symbolic space that will enable citizens to discover ways of living together.

Echoing this sentiment, Butler and Athanasiou argue that, post-2011, performances of global street politics served to 'displace conventional conceptions of the "public sphere," or the polis, understood as the particular spatial location of political life' (2013: 194) and that they exercised a politics that 'spaced appearance' as a way of resisting practices that render human bodies disposable (2013: 196–7). Here, the concept of 'spacing appearance' is useful for two reasons: firstly, Butler and Athanasiou do not deem appearance to be a representation of 'surface phenomenality', but rather draw attention to performance elements that speak to 'the unperformable', particularly the 'affective politics of the performative' (2013: 194). Further, their conceptual attachments to Hannah Arendt's understanding of the *polis* as a 'space of appearance' that 'lies between people' (1958: 198) draw attention to how political action can produce public space; here, political action translates into a resistant 'body politic', which may not be 'speak[ing] in a single voice' but marks its 'presence as an obdurate bodily life' (Butler and Athanasiou 2013: 196). In this sense, such appearances in the public space facilitate the emergence of another polis, while testing a practice of citizenship beyond the normalising power of (neo-)liberal consensus that punishes any form of dissent.

The above reading of urban performances that articulate a resistant body politic grounded in dissenting voices chimes with Chantal Mouffe's conception of radical democratic citizenship: a form of political identity rooted in plurality and antagonism that helps us conceptualise a way of belonging to a political community (1992a: 29–30). The 'radical democratic citizen', Mouffe highlights, should be 'someone who *acts* as a citizen, who conceives of herself as a participant in a collective

undertaking' (1992b: 4). She envisages an 'agonistic' model of pluralist democracy and participation whereby the identity of institutions and communities and the public sphere will be shaped by a 'conflictual consensus' (2005: 121) rooted in a common 'language of civil intercourse' (1992a: 31). In this light, the polis appears as a site of 'struggle between different interpretations of shared [ethico-political] principles' (Miessen and Mouffe 2010: 109).

While *Prometheus* is not an example of street politics, such a relationship between space and action seems pertinent, as the performance deals with the appearance of a polis on the cusp of the private and the public. Negotiating how space (or the city) 'appears' as the result of a resistant 'body politic', performing a radical democratic citizenship and engaged in an 'affective politics of the performative' and the practice of 'commoning', therefore offers a useful model of analysis vis-à-vis *Prometheus*'s dramaturgy and its material contexts.

Myth, chorality and radical democratic space

Erika Fischer-Lichte (2013) maintains that choric forms of theatre in the new millennium articulate 'utopian visions' of community and open up spaces for considering new types of participatory democracy. *Prometheus* belongs to Rimini Protokoll's transnational city-specific projects that use choruses as vehicles to explore questions around representation, participation, community, citizenship and democracy:[14] 100 inhabitants of a city are asked to represent a percentage of their cities, sharing their personal stories with the audience and responding to questions related to the city and/or country where they perform. For *Prometheus*, the company harnessed two of their distinct dramaturgical strategies: their adaptation of canonical texts[15] and their use of statistics as a tool to locate performers who would represent a city on stage.[16] Stage action was generated by means of a simple device: the onstage chorus had to move around the space and take the position of 'Me' and 'Not Me' when prompted to answer questions emanating from the myth and its relevance to the individual participants: 'Who has defied authority?', 'Who faces ethical dilemmas in their jobs?', 'Who considers himself to be a philanthropist?' They also captured national structures of feeling, reflecting current debates and dilemmas: 'Who does not pay their taxes?', 'Who thinks that it would be heroic for Greece to default?', 'Who wants immigrants to leave the country?'

Despite recent developments in theatre scholarship suggesting that theatre emerged in the age of the tyrants rather than in democratic

Athens, the myth of the simultaneous birth of theatre and democracy continues to retain a strong hold on the popular imagination.[17] Notwithstanding its ahistoricity, the connection between theatre and democracy, which both intimate 'an embodied practice and a process' (Wiles 2011: 23), might serve as a useful platform to reconsider and explore practices of civic and national belonging and narratives of exclusion. I suggest that the use of chorality in *Prometheus* evokes, as Fischer-Lichte argues, a quest for another form of participatory democracy as a 'utopian vision'. Contrary to the homogeneous identity of the ancient chorus and its hierarchical relationship to the main protagonists, the chorus of *Prometheus* places emphasis on dissent and alterity, while the experts/protagonists are fully integrated in the choric body. This rupture of homogeneity also works in juxtaposition to the ancient chorus for an additional reason: it produces a body not composed by the marginalised Other,[18] but which also includes images of the self.

The dramaturgy of identifications enacted on the city stage produced a pluralist polis which was both public and private; such connections between both realms were enhanced by sharing different points of view of the city through the use of photographs taken from the participants' homes or by posting individual itineraries to Herodion on the company's website (Rimini Protokoll 2010). Meanwhile, its performers/citizens rehearsed a type of radical democratic citizenship, acting as *mediators/interpreters* between the past and the present. In examining the production of the onstage polis, it is also useful to consider Mouffe's understanding of 'radical democratic citizenship' as a 'precarious "in-between"' position (1994: 112) and its association with a poststructuralist understanding of identity as a form of identification that is 'necessarily precarious and unstable' (1992b: 10). In shaping the stage's topography, the onstage citizens transformed it into a 'live' map of the city whose identity was constantly reconfigured. This discursive and embodied process of (dis)identification playfully produced and dissolved boundaries, resulting in the articulation of 'an ensemble of subject positions, constructed within specific discourses and always precariously and temporarily sutured at the intersection of these positions' (1992b: 10). According to this analogy, the identities of the spontaneous communities of consent and dissent that were created on stage produced a precarious in-between space whose identity was porous and relational and resisted crystallisation.

In *Theatre and Citizenship*, David Wiles asserts that '[c]itizenship addresses the fundamental problem of cohabitation' (2011: 2). In this sense, citizenship implies a responsibility for a shared (urban) space and

the conditions of living in that space. One of *Prometheus*'s experts, the architect Andreas Kourkoulas, alluded to our responsibility to change the conditions of cohabitation through the creation of 'commons'. Kourkoulas drew links between space and democracy, arguing that, unlike spaces divided with walls – such as Berlin or Palestine – the theatre space enables the formation of communities across citizens and reinforces their relationship with their city. He also raised the question of responsibility 'to defend the city in order to defend a faltering democracy and to resist the waves of fear and violence',[19] inviting the audience to imagine the new city of Athens together. Kourkoulas's address to shape the city in order to impact on the way in which we perceive cohabitation enacts a 'utopian performative' gesture (Dolan 2004: 165), which puts forward the right to reinvent our cities (Harvey 2012: 4). As Harvey notes, such a (human) right emerges as 'a response to the existential pain of a withering crisis of everyday life in the city' and articulates the demand 'to create an alternative urban life that is less alienated, more meaningful and playful but, [...] conflictual and dialectical, open to becoming, to encounters (both fearful and pleasurable), and to the personal pursuit of unknowable novelty' (2012: x). The question of cohabitation in a metropolitan city was also embedded in the piece's dramaturgy; as Haug notes, 'people who usually have nothing in common who just ride the subway together or pass each other in shopping malls [...] are standing on stage together [...] they are exposing themselves to each other as it were' (Haug in Raddatz 2011a: 33). Haug's observation chimes with Butler's understanding of precariousness as representing the life of the *socius*:

> precariousness implies living socially, that is, the fact that one's life is always in some sense in the hands of the other. It implies exposure both to those we know and to those we do not know; a dependency on people we know or barely knew or know not at all. Reciprocally, it implies being impinged upon by the exposure and dependency of others [...]. (Butler 2009a: 14)

This life is also precarious because of the specific material conditions in the city in question: the performance's soundscape also evoked the Athens post-2008 demonstrations, which invested the agonistic sphere with a revolutionary identity that was also pregnant with the possibility of danger and subjection to police violence.

Kourkoulas's connections across space, theatre and democracy, as well as the performance's material contexts and utilisation of myth,

operate along the axes of spatiality and temporality. Here, I will expand on the intersection of both axes, so as to consider how myth and site work in conjunction to produce a previously invisible civic space. Echoing Lefebvre, Sophie Nield reminds us that space is created by the very activities taking place within it (2012: 223). In this regard, Nield continues, monumental space embodies a sense of timelessness; while inspiring awe and mystification, it makes 'power *felt*' (2012: 225). This relationship between space and power can be seen in the context of ancient Greek and Roman amphitheatres, which, as Eleftheria Ioannidou highlights, 'impose the treatment of the text as a monument which is to remain intact by all means' (2011: 123). This 'monumental view', Ioannidou continues, 'sustains the grandeur of tragedy in order to authenticate Greek culture as an uninterrupted process' (2011: 123). The ideological connections between ancient Greek culture and the modern Greek nation-state (formed in the nineteenth century), born out of the Greek self-perception as filtered by the European gaze, are often consolidated by performances of Greek tragedy in monumental spaces, and reproduce, as Marilena Zaroulia observes, 'narratives of the nation's historical continuity' that are 'particularly pertinent during times of crisis' as they celebrate 'the nation's cultural legitimacy or superiority' (2014: 201).[20]

Following on from the above, it is significant to briefly consider the interplay between theatre space and stage action in *Prometheus*. Herodion is a Roman amphitheatre built around 170 BC and strongly attached to the Hellenic (formerly Athens) Festival, and it often hosts performances of classical Greek drama. It is situated directly below the Parthenon (which is also visible from the stage and the auditorium), and is in close proximity to the theatre of Dionysus as well as to Pnyka, the city-state assembly where Athenians could vote. This 'strategic' position, also acknowledged as a conscious choice by the company (Raddatz 2011a: 32), not only reinforces the hosted performances' legitimacy by capitalising on the power of ideology and the historical past, but also invites audiences to imagine that they share some part of this historical continuity. Against this backdrop, the choice to stage *Prometheus* in this particular monumental space partly 'deceived audiences' (Laera 2013: 275), buttressing myths of continuity with the ancient Greek past that form the bedrock of Western civilisation and European heritage.

On the other hand, it can be argued that Rimini Protokoll's *Prometheus* reinvents the space by rewriting the text in a way that partly contrasts the monumental view of performances of ancient Greek tragedy. The lack of virtuosity of its performers, rhythms and choreography disrupts

mimesis while stripping the text of its 'auratic' quality and producing pluralist interpretations of the past. As shown earlier, the dramaturgies of participation and action at play further ascribe the space with new meanings: the precarious polis with its 'amateur' actors emerges at the intersections of multiple identifications and interpretations which present an alternative, 'messier' and more plural version of the polis. Such a version exposes the antinomies inherent in Athenian democracy, which reserved citizen rights exclusively for its indigenous and 'free' male population, excluding women, foreigners and slaves, and reveals a tension with the myths of origin that underpin ideologies surrounding both the modern Greek nation and European heritage.[21] In this sense, the appearance of the precarious polis proffers a critical revisiting of hegemonic understandings of myth, ancient text and national identity, and its attachments to narratives that erase historical ruptures and exclusions: it specifically asks, following Kourkoulas, to imagine different ways of 'acting' in and belonging to the polis.

Ethics, (in)visibility and the precarious subject

In the context of the Eurozone crisis, the IMF's and EU's austerity practices, as applied to the European periphery, have yielded devastating consequences, with numerous incidents of human rights abuse. As Butler argues, in moments of crisis, 'certain lives will be highly protected [...]. Other lives will not find such fast and furious support and will not even qualify as "grievable"' (2004: 32). Similarly, the Greek governments' failure to tackle the influx of refugees and asylum seekers (cf. UN 2010), the intensification of street violence and the promulgation of hate speech through political rhetoric (including nationalist right-wing discourses) and the media have been promoting a culture of fear that has led to the escalation of racism and xenophobia. In an acutely aggressive 'differential allocation of recognizability' (Butler 2009b), the migrant Other, whether documented or *sans papiers*, is forced to rehearse the identity of the menace, the less-than-human, the stranger, the invader.[22]

The politics of visibility underpinning the inclusion of Othered identities in the mapping of the city-stage mosaic (made up of European migrants, non-European asylum seekers, and disabled performers) underscored their paradoxical status of (in)visibility in the context of modern Greek society. The three asylum seekers – Ishmael Hassan from Palestine, Omar Farouk from Pakistan and Angelos Carino – representing an invisible (for the official Greek state), excessive 3 per cent of

the Athenian population, made their entrance from a hatch below the stage to punctuate their precarious status between visibility and invisibility and its incumbent risks in the contemporary West.[23] Hassan and Farouk traced their connection to the myth by identifying with the female character Io, a victim of patriarchy and divine will, who was transformed into a heifer by Zeus and later persecuted by a lethal fly sent after her by goddess Hera, Zeus's jealous wife. While their identification with Io's dehumanisation and her state of constant mobility, as she tries to escape her maddening pain, echoes their own sense of displacement and lack of security, their inscription in the ecology of *Prometheus*'s polis, which contrasts idealised perceptions of democracy, rendered visible 'the modes of exclusion in which the nation imagines its own unity' (Butler 2009b). Furthermore, the performance's frame ascribed them with a 'precarious citizenship', which, on the one hand, facilitated their intelligibility as human beings and active participants in the city mosaic, while also implying the danger of living without citizen rights.[24]

I am not suggesting here that visibility grants the marginalised subject with power; rather, I argue that the use of personal testimony in *Prometheus* offered the public arena in which to articulate and politicise the private and invisible stories of its citizens and to bring politics, theatre and representation together. Here, I will briefly focus on the most salient example of an 'expert' story of a modern-day Prometheus (also ostensibly placed at the centre of the performance):[25] Konstantina Kouneva, a trade union activist from Bulgaria and a cleaner for a private company hired by Athens municipality, was violently attacked with acid in late December 2008 for her disclosures of the company's abuse of its employees' rights. Following the 2008 unrest, Kouneva became a symbol of dispossession and resistance, particularly within 'revolutionary' circles and non-mainstream media, and was associated with the same neoliberal practices of disposability that sparked the December riots and subsequent street politics. Kouneva's performance of precarious citizenship and the exposure of her corporeal dispossession, directly aligned with Prometheus's resistance to authoritarian rule, articulates and exercises the right to have rights in the context of neoliberal capitalism while investing the practice of citizenship with a certain risk.

Due to the risk of skin infection (Raddatz 2011a: 31), Kouneva could not be present on stage and was represented by her friend Efi Kiourtidou, who appeared on a type of *ekkuklema* wearing a disfigured ancient Greek mask. At the same time, she was present throughout

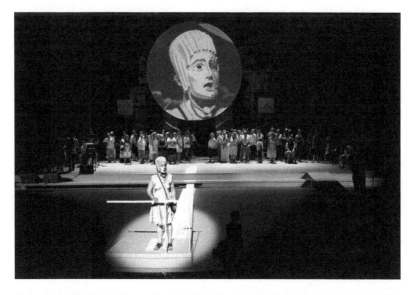

Figure 9.1 Efi Kiourtidou as Konstantina Kouneva in *Prometheus in Athens*, 2010. Photo credit: © Leonidas Dimakopoulos/Rimini Protokoll

the performance by means of a (pre-recorded) telephone conversation. Her two interventions offered details about the death threats she received the night she was attacked and the series of operations her body had to endure. Contrary to the legibility of other migrants' bodies on stage, Kouneva's mediated body and voice and the absence of a recognisably human face resisted the fetishisation and spectacularisation of her 'unintelligible' body. As Sara Ahmed writes: 'when the experience of pain is described as private, that privacy is linked to the experience of being with others [...] it is the apparent loneliness of pain that requires it to be disclosed to a witness' (2004: 29). Despite the absence of a face, the pre-recorded testimony of Kouneva's private pain undoes the boundary of private/public, placing spectators in the position of witnesses to, rather than consumers of, her story.

While the emphasis on Kouneva's and the asylum seekers' dispossession might be seen to rehearse a commonly accepted discourse around the immigrant as 'vulnerable, frightened and traumatized' (Jeffers 2012: 153), I argue that, in the context of the particular performance, this device is justified for its specific political function. Recent theatre scholarship has focused on the ethics of encounter

between performers and audiences:[26] for Nicholas Ridout, theatre activates an ethical call to spectators 'to recognize that there is a relationship between what is shown [on stage] and their own experience of the world. In responding to this call, spectators take responsibility for making what is shown part of their personal experience' (2009: 59). Following Butler's thesis that the body 'is constituted as a social phenomenon in the public sphere, my body is and is not mine' (2004: 26), the precarious body in *Prometheus* operates as a trope that mobilises a 'collective responsibility for the physical lives of one another' (2004: 30). In this sense, Kouneva's disappearing body stages an ethical encounter that highlights its public dimension and porous relationship with Otherness and, by extension, with the community surrounding it; this 'utopian performative' disrupts the boundaries between self and Other, addressing an ethical call for a collective responsibility for the body of the Other. At the cusp of appearance and disappearance, Kouneva's performance of dispossession exposes the conditions of the erasure of her subjectivity while also asserting her presence as an enduring and 'liveable' life.

In representing Prometheus, Kouneva doubles as both margin and centre: while her Othered subject position as a non-Greek, displaced, working-class woman is made visible, she also transforms into a synecdoche of modern Greece. This double appearance shifts perspectives from 'the inside' as it unsettles understandings of nation as masculine, indigenous and natural, while interpreting it from 'the outside'. In this sense, nation is portrayed as a process of 'hybridisation', which resists the notion of 'origin' (Mouffe 1994: 110) and dismantles the narratives of the modern Greek nation's continuity with the classical past. Writing from a 2014 perspective, Kouneva's double appearance in the public sphere is also firmly yoked to the EU's future; after being elected as a Member of the European Parliament in June 2014 with the left-wing Syriza party, Kouneva exposes the conditions of neoliberal practices that subject the (European) body to dispossession and, thus, asserts the collective presence of the invisible micro-narratives of resistance.

Feeling citizen, feeling European

In the early 1990s, Mouffe warned that '[i]f Europe is not to be defined exclusively in terms of economic agreements and reduced to a common market, the definition of a common European identity must be at the heart of the agenda, and this requires addressing the question of citizenship' (1992b: 8). Nearly two decades later, questions around European

identity are still at the forefront of discussions surrounding integration, making Mouffe's call to reconsider (European) citizenship even more pertinent and urgent.

It has often been argued that European identity should not be read as homogeneous and superimposed on national identity, but rather as another form of identification.[27] Drawing on Jacques Derrida's version of Europe in *The Other Heading*, Passerini also makes a case for approaching European identity as a form of identification among 'other things', beginning within 'sites much smaller than the nation such as a city' (2007: 99). She specifically places emphasis on identifications with sidelined voices:

> Being European *among other things* means both being *among the others* and taking on roles that have traditionally being assigned to those who represented for many years the other, such as Jews, women, and immigrants, and therefore taking side with those who today are cast in the role of representing the other. (2007: 93, emphasis in original)

Echoing Passerini, *Prometheus*'s precarious city appears as the first site of identifications of the self as Other against a larger canvas of nation and Europe (as suggested by the transnational nature of *Promethiade*). Such identifications were consolidated by different forms of 'intersubjective communicability', which translated into affective vocabularies between participants[28] or between performers and audience; these exchanges were facilitated by several dramaturgical choices such as the mirroring device between the stage and the auditorium, direct address and the use of song, which invited the audience to imagine themselves *appearing* as co-actors and citizens of the precarious city on stage.

As shown, the performance's 'utopian vision' was articulated via its claims regarding community, democracy and the audience's relationship to Otherness. In probing the manifestation of utopia even further, I will now shift focus to the Epilogue, where performers were asked to symbolically identify with Prometheus by raising their hand in response to the statements: 'We support Prometheus's position' and 'We know that Prometheus wins in the end'. This was followed by the creation of a human pyramid formed by the performers' bodies; the image of the pyramid was projected on the screen hanging above the stage, creating multiple copies that gave the impression of an extended 'imagined community' that traverses time and space.

On a local level, this 'utopian performative' gesture rests on the affective association between modern Greece with the suffering Promethean hero, and pronounces the hope that the nation will overcome its

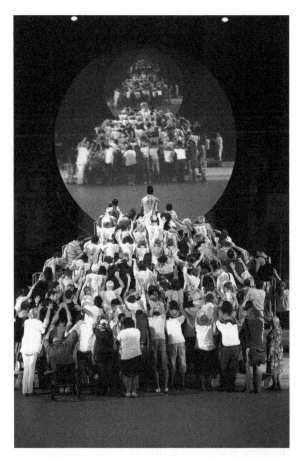

Figure 9.2 The members of the chorus creating a human pyramid in *Prometheus in Athens*, 2010. Photo credit: © Leonidas Dimakopoulos/Rimini Protokoll

calamities. While, on the one hand, this moment rehearses a banal association between nation and heroism, it can also be read as a performative act of 'spacing appearance' where bodily action produces public space: here, the 'affective politics of the performative', galvanised through the exposure and mutual dependency on people we do not know, is iterated through a resistant body politic of the city that reaffirms its presence as a 'plural and obdurate bodily life' (Butler and Athanasiou 2013: 196).

Viewed within the context of *Promethiade*, which aspired to explore how a common future for Europe might 'get its energy from the common roots' (Raddatz 2011b: 7), this 'utopian performative' also gestures

towards the creation of a shared European space. *Promethiade*, a collaboration across three cities, two of which were European Capitals of Culture in 2010, was partly funded by the European Commission's (EC) Capital of Culture initiative, whose mission statement highlights the commitment to embrace cultural diversity that enables Europeans 'to experience the feeling of belonging to the same European community' (European Commission 2013). The project's entanglement with institutional structures such as the EC, which are often underpinned by essentialist understandings of community, nation and heritage, raises several questions; as Laera argues, as a 'transnational European myth', classical Athens may serve as a way to articulate a narrative of transnational belonging with the view to legitimise 'the European political project' during times of crisis (2013: 28). Moreover, transnational city-specific projects, such as Rimini Protokoll's *100% London*, presented as part of London's 2012 Cultural Olympiad, and their dramaturgies of participation might be seen to embrace a transnational urban citizenship, thus serving institutional frames that assuage, rather than promote, plurality and difference.[29] Yet, such analyses are largely determined by the performances' different contents and material contexts; as discussed in this essay, *Prometheus* engages with the idea of citizenship and belonging in more complex ways that do not necessarily fulfil hegemonic aspirations for a united Europe based on assimilation.

Further, *Prometheus*'s afterlife suggests its endurance beyond such institutional structures: in the summer of 2012, it toured as a performance lecture across a number of European cities.[30] This involved some members of the original cast, including the assistant director Prodromos Tsinikoris, and one inhabitant of each city in which they were performing who held some connection to Greece and who would act as the mediator between the city and its audience, and the cast.[31] The performance's scope included a presentation of the original 2010 performance event using video footage and commentary on the performers' journey during this time. Participants were asked to (dis)identify with their older selves on screen by detailing how their life has changed (as some had migrated due to unemployment) or whether they would still respond to the questions in the same way. Still acting as interpreters of the past (i.e. 2010) and the present, they discussed dilemmas faced in Greece at that particular moment; for instance, during the Vienna performance, which took place in the interim period between the two election rounds, Tsinikoris expressed his dilemma over which party to vote for, detailing the culture of fear generated by the local and global (including German-speaking) media and political rhetoric that aimed to guide the Greek vote towards the right-wing party New Democracy

in order to safeguard stability in the Eurozone.[32] Similar to the performance's original form, the audience was addressed with several questions, such as 'Who is in favour of Greece's financial support?', and was further offered the opportunity to take turns in asking their own questions to the actors on stage in a type of post-show talk. As Tsinikoris explains, spectators showed interest in learning about several issues vis-à-vis the Greek crisis not often reported by the German-language media (such as, for instance, different types of debt, the rise of Golden Dawn, unemployment rates) (2012). Arguably, then, such performance choices allowed participants to act as translators both spatially and temporally against the backdrop of a European space, attempting an interpretation of their lived experience of the current rupture and allowing for Other narratives to appear in the public sphere.

In brief, Rimini Protokoll's *Prometheus* challenges the emphasis on 'authentic' representations of ancient Greek tragedies as remains of the ideal, ancient past. In rehearsing a form of radical democratic citizenship, the performance critiques current forms of democracy and understandings of nation as homogeneous and defined in opposition to the Other. Moreover, the pluralist interpretations of the lived experience of its experts, against the backdrop of *Prometheus*, spaced the appearance of the utopian city on stage; in placing emphasis on resistance to forms of domination and oppression, the performance also unsettled hegemonic neoliberal practices rehearsed by the technocrat experts dictating Europe's 'democratic' future. The emphasis on the micro-narrative of the city, as a synecdoche of larger frameworks, was further fuelled by the ways in which performers and audiences were invited to participate in the formation of the precarious city on stage and draw 'connections between the public and the private, the individual and the collective' (Passerini 2003: 26). In this vein, the metaphors of the 'body in pain' or the 'precarious citizen' on stage might be seen to break a strictly Eurocentric perception of self, stretching beyond and outside Greek and European geographical borders to become the synecdoche of Other similar stories of resistance, which have yet to appear.

Notes

1. I would like to warmly thank Prodromos Tsinikoris and Daniel Wetzel for their valuable input during two Skype interviews (1 November 2012 and 19 June 2014 respectively) and for email correspondence throughout the project. My thanks also go to the editors for their constructive feedback. The present analysis and quotes are taken from the Herodion performance which I attended and its video documentation.

2. *Ekkuklema* was a Greek tragedy device revealing acts of violence taking place indoors.

3. The project was a Greek, German and Turkish co-production funded by the Hellenic Festival, the Zollverein Foundation, Istanbul and RUHR.2010 European Capitals of Culture. It also included Theodoros Terzopoulos's *Prometheus Bound* and Sahika Tekand's *Anti-Prometheus* (*Forgotten in Ten Steps*).

4. Aeschylus's text has been frequently associated with 'romantic dreams of liberty', 'revolutionary socialism' and politics and narratives against slavery (Hall 2005: 175; 2013: 293; 2011). The play was also banned in Greece during the Colonels' Junta (1967–74), being deemed 'anarchocommunist' (Hall 2005: 172).

5. Also, see Tassin (1992: 171).

6. The most prominent voices against multiculturalism between 2010 and 2011 were EU leaders Angela Merkel, David Cameron and Nicolas Sarkozy (see Siebold 2010; BBC 2011a; Heneghan 2011).

7. Author's translation of a Greek slogan in the streets of Athens during December 2008 (Kuriakopoulos and Gourgouris 2009).

8. Prior to this appointment, Papademos had served as: financial adviser of former Greek PM George Papandreou; vice president of the European Central Bank; and president of the National Bank of Greece.

9. Unemployment rates were catapulted to 14.8 per cent in December 2010, reaching 27.5 per cent in 2013; particularly affected were young people under 25 (58.3 per cent in 2013) and women (31.6 per cent) (Eurostat News Release 2014). According to statistics, 44 per cent of the population was living below the poverty line in 2013 (*Ekathimerini* 2014).

10. For example, the International Monetary Fund's (IMF) former managing director Dominic Strauss Kahn and EU political leaders Angela Merkel and David Cameron often made a case for Greece's inability to sustain a healthy economy. In retrospect, those practices worked to legitimise the neoliberalisation of the public sphere through the privatisation of public services, which, at the time of writing, is still in progress.

11. In a 2012 *Spiegel* interview, former French president and one of the leading architects of the EU, Valéry Giscard d'Estaing, argued that Greece is 'an Oriental country' (2012). Other manifestations of Orientalist discourse can be found in the controversy stirred up by covers of the German weekly news magazine *Focus* that feminised Greece in the form of Aphrodite of Milos performing an insulting gesture and begging for money (published in February 2010 and April 2011 respectively). Another salient example is the British documentary *Go Greek for a Week* broadcast on Channel 4 in 2011, which aimed to explore the principal reasons behind Greece's financial crisis by regurgitating the argument on tax evasion and corruption. In February 2012, a statistics report showed that Greeks work more hours than the average European (McDonald 2012).

12. See, for instance, Anastassakis (2009), Gavriilidis (2009) and Sotiris (2013).

13. For such practices in Syntagma Square, Athens, see Hager (2013); for Occupy LSX, see Fragkou and Hager (2013) and Hager's chapter in this volume.

14. Similar concerns have been explored by the company in different types of projects, for example in the controversial *Deutschland 2* (2002), which included participants replaying a debate unravelling in Berlin's *Bundestag* (see Boenisch 2008; Raddatz 2011b).
15. Previous pieces include Schiller's *Wallenstein* (2005), Marx's *Das Kapital* (2007) and Dürenmatt's *The Visit* (2007).
16. Previous examples include *100% Berlin* (2008), *100% Vienna: A Statistical Chain Reaction* (2010), *En Folkefiende i Oslo* [*An Enemy of the People in Oslo*] (2012) and *100% London* (2012). For *Prometheus*, the selection process was conducted on the principles of age, gender, occupation, country of origin, and place of residence in Athens. The company collaborated with the Hellenic Statistical Authority in order to determine the exact percentages they should have on stage.
17. For a summary of the debate, see Wiles (2011: 23).
18. Goldhill has pointed out the use of Othered subjectivities in the ancient Greek chorus (2007: 51).
19. Author's translation from Greek.
20. The modern Greek nation's identity formation in relation to antiquity and Europe has been widely examined. See, for instance, Leontis (1995), Smith (1999) and Calotychos (2003).
21. For a discussion on the construction of myths of origin in Europe, see, for instance, Pagden (2002) and Laera (2013).
22. This is reflected by the rise of racist attacks against immigrants often carried out by members of the far-right Golden Dawn party. This violence was also sanctioned by a number of hasty measures adopted by the Ministry of Public Order and Citizen Protection to tackle illegal immigration, including the creation of detention centres in 2012.
23. This percentage was approximate, as the statistical authority could not determine the exact number of 'invisible' immigrants, which could range from 50,000 to 200,000 (Tsinikoris 2012). At the time of the performance, all three were holders of a pink card, which granted them asylum in Greece for a short period of time.
24. For an examination of Rimini Protokoll's approach to the representation of the Other, see Mumford (2013).
25. For more details on other expert stories in *Prometheus*, see Laera (2013: 267–74).
26. See Ridout (2009) and Pewny (2012).
27. See, for instance, Mouffe (1994), Passerini (2007) and Tassin (1992).
28. Assistant director Prodromos Tsinikoris also described the process as enabling the exchange of affects, dialogue and friendships between participants whose political views may have differed.
29. For a discussion on the subject, see Fragkou and Hager (2013).
30. The performance lecture was originally created for Essen (2010) as part of *Promethiade*. Subsequently, the company discovered the potential and uniqueness of making work that reflected on previous performances and toured the piece to Hamburg, Mainz, Milan, Oslo and Vienna. The selection of the cities was not intentional but determined by invitations the company received to present the work (Wetzel 2014).

31. Some were either of Greek descent or were attached to Greece in other ways (Wetzel 2014).
32. Such discourses targeted left-wing party Syriza, which was presented as an enemy of Europe in order to persuade voters that such a decision would cause Greece to default and exit from the EU ('Grexit') (see Zaroulia and Hager 2014).

10
At the Gates of Europe: Sacred Objects, Other Spaces and Performances of Dispossession

Marilena Zaroulia

'What makes political responsiveness possible?' (2013: xi) ask Judith Butler and Athena Athanasiou, concluding the preface to *Dispossession: The Performative in the Political*. This series of dialogues offers two interpretations of dispossession: first, as deprivation, due to injustices (neoliberalism, conflict, environmental crises) stripping people of their material possessions; second, as the ways in which one can be separated from 'the sovereign self'. Extending Butler's previous work on violence and ethics, dispossession recognises life as interdependent and vulnerable; it signifies how one is moved by what one is exposed to and thus 'finds oneself transported elsewhere, into another scene, or into a social world in which one is not the center' (2013: xi). For the two theorists, being affectively moved and dispossessed of the 'sovereign self' are necessary conditions for Western citizens to join resisting collectivities that demand the end of injustice.

Can this experience of being 'transported elsewhere' emerge through performance as mediator of dispossession, in both its meanings? The discussion that follows focuses on a visual arts project that was inspired by the suffering of dispossessed, displaced Others[1] and aspired to affect European audiences, to shed their 'sovereign selves', potentially as a step towards political and ethical responsiveness. *Crossings: A Sculptural Trilogy about Migration* was a public art installation produced by Greek-born, London-based visual artist Kalliopi Lemos and presented in three parts: *Crossing* in Eleusis, Greece (2006–09); *Round Voyage* in Istanbul, Turkey (2007); and *At Crossroads* in Berlin, Germany (October 2009). The project's starting point was 'transforming real boats used by migrants and left abandoned on the beaches of Greek islands in the eastern Mediterranean into monumental sculptures in public space as a memorial to a repressed human tragedy' (Odenthal and Kountouri

2011). Although the artist often stressed her work's humanitarian dimension, denying explicit political intentions, Klaus Staeck, President of Akademie der Künste, which co-produced the trilogy's last part in Berlin,[2] approaches Lemos's work as protest, an interpretation of the migrants' predicament. For him, the work participates in the immigration debate, stressing the need for responsibility among citizens, beyond EU official bodies. Indeed, the work was conceived in parallel with developments in Greek immigration policies, offering a response to national issues, as the country's acceptance rate of asylum applications sank as low as 1.3 per cent at the time that the trilogy's third part was staged (2009). Greece's responses to asylum applications and its treatment of asylum seekers while in detention have been condemned by various organisations, such as the UN Refugee Agency and Amnesty International, or by non-governmental organisations (NGOs) such as No Borders, while in 2011 the country was found to be in breach of the Convention of Human Rights.[3]

Immigration, as lived experience and in its legal dimensions, has been a thorny issue for the EU since the Schengen Agreement and Convention (1985 and 1990 respectively) solidified the 'borderless Europe' principle, safeguarding 'free movement of people' who are citizens of the participating countries. European enlargements (in 2004 and 2007) and the changing global context since 9/11 were key factors in the shaping of a new phase in mobility and migration, exposing inequalities and asymmetries inside and outside Europe. The Common European Asylum System, particularly through the Dublin II Regulation (2003), established criteria and parameters that determine one member state to be responsible for dealing with asylum applications lodged by a third country national. Most applications are processed by the first member state where the application was lodged, normally a country in the periphery of Europe; these places can be described as the gates of Europe but not the migrants' desired destinations.[4] Frontex was established in 2004 as 'an independent body' in order to 'promote, coordinate and develop European border management',[5] thus monitoring 'irregular migration' (Europa n.d.).

Social anthropologist Sarah Green, in her reading of borders as 'conceptual entities that are performed' (2010: 264), argues that Frontex's main aim is to keep non-European citizens *outside* the EU borders. In other words, this transnational body's mission is not concerned with the tensions *inside* the EU, as it is the product of a post-Schengen, European unity founded on '*anti-citizenship*' where 'on "its" border [...] each member-state is becoming the representative of the others' (Balibar

2002b: 78). Such bodies enforcing EU immigration policies produce a context in which nation-states' borders operate as a synecdoche of Europe, while the specificity of the point where migrants attempt to cross seems to disappear. What connects such locations is violence and death; for instance, during the period of research for this piece, the EU saw two major disasters with migrant boats in the Mediterranean – first in Italy (Lampedusa, October 2013) and second in Greece (Farmakonisi, February 2014).

Against this backdrop, and in order to assess the resistant potential of the *Crossings* trilogy, this article explores two aspects: first, it discusses strategies of representation, particularly through the boats as hyper-authentic devices, used to mark the presence of the displaced, biopolitically excluded Others. In all parts of the trilogy, the boats are real, empty 'relics of human suffering' (Odenthal and Kountouri 2011); by exploring the aesthetics of battered, destroyed boats alluding to wrecked human lives, I read this example as an attempt at hospitality that exposes the limits of the contemporary world and the continuity of European histories, from colonialism to the present.[6]

Second, this essay examines the places where the works were staged.[7] Although *Crossings* can best be described as three site-specific pieces, in dialogue with their environments and their history, their key element is mobility; the boats that the sculptures were made of are reminders of the migrants' crossings in these vessels, while their remains were displaced for a second time from the Mediterranean Sea to mainland Europe. This interplay between displacement and site offers insight into the work's ethics and politics, particularly when approaching the three cities that hosted the works as spatial and temporal borderlands. Eleusis stands at the border between myth and modernity; Istanbul, in its very geography, is divided between East and West, which also represents the border between Islam and Christianity; while Berlin marks a different border – that of Europe's divided past and promises of future unity.

As artworks that were conceived for specific sites, *Crossings* responded to how national borders work as representations of lines separating Fortress Europe, and, in doing so, they attempted to consider what migration might mean in specific terms. Local communities in the East Aegean islands – such as Chios, where Lemos found the boats-materials for her artworks – face the consequences of these crossings on a daily basis (in the establishment of detention centres, the presence of Frontex agents and the dead bodies found in the Aegean waters); however, legislation displaces decision-making elsewhere: for example, Strasbourg or Brussels. *Crossings* attempted to stop associating these crossings with

'elsewhere' – either the place that migrants have left behind or the European bureaucratic centres – by placing them, instead, in specific contexts, here and now. In doing so, the works invite us to think about actual geographies of state, sovereign power and dispossession across Europe.

Dispossession, in the following pages, is understood as a condition of suffering, framing the migrants; it refers to the legal, bureaucratic incarceration of those 'bodies of water' (Pugliese 2009: 676) who are deprived of the right to life or death and often disappear in plain sight (cf. Nield 2006a; 2008). The 'frame', as elaborated by Butler, is pertinent for this analysis, which considers whether and how *Crossings* may constitute a 'breaking out' or a 'breaking from' (Butler 2009a: 11) the frames of migrants' bodies and lives. One meaning of framing, writes Butler, is to be 'set up', found guilty without any valid evidence, by repeating a particular (discursive or visual) frame of reference: for example, framing migrants as potential terrorists or causes of unemployment, tropes that are often used in debates about immigration. This 'moral panic' cannot be disassociated from crisis capitalism, which frames the migrants as scapegoats, blaming them for any socio-economic malaise that a nation may be undergoing (cf. Hage 2003; Jeffers 2012).

Undocumented migrants have been framed either as threats for European nation-states or as invisible bodies, removed from sociality, lives that are not recognised as such. In the trilogy's first part, Lemos used the boats as a way of breaking a frame that is constantly reproduced but rarely apprehended – that of abandoned boats or dead bodies on the shores of Southern Europe. Joseph Pugliese has deconstructed such persistent frames of reference in a discussion of two photographs (one taken at Zahara beach at the Strait of Gibraltar and the second at the Italian beach of Torregaveta) where tourists sit next to refugees' drowned bodies. He points to the stark opposition of experiences of living and dying in specific locations in the Mediterranean, as these 'subjects remain proximate yet invisible to each other, even as they generate radically different modalities of living and dying' (2009: 674). In the first part of the trilogy, the artist used the sea-wrecked boats as vessels through which the dead migrants could 'break from' persistent frames of reference and appear in Eleusis, a mythical space of hospitality, where Mysteries took place in antiquity.[8] Further, *Crossing* was situated in a location next to an abandoned olive oil refinery, a sign of the country's failed processes of modernisation, which Eleusis, as a whole, captures. In this way, *Crossing* was situated in a place loaded with historical continuity, adding a further layer of meaning while staging a metaphorical

passing from life to death, displacing the performance of grief for lives lost from *elsewhere*, resituating it *here*.

Crossing: boats as sacred objects

'The ship is heterotopia par excellence,' said Michel Foucault in his 1967 lecture 'Of Other Spaces', referring to those places that sit in relation to all other sites existing in society, which are 'simultaneously represented, contested, and inverted' (1986: 24). Foucault's thinking on heterotopias has informed scholarship on migration and national sovereignty (Pugliese 2009), particularly with reference to asylum processes and detention camps. Theorists maintain that the places that migrants occupy sit somewhere between a 'crisis heterotopia' and a 'heterotopia of deviation' (Foucault 1986: 24, 25). Migrants are thus conceived as being in limbo, not yet complying to society's 'required norm', and the places in which they reside function as nowhere places that frame them.

Here, I am interested in the value of the boat as heterotopia and how it works in the context of an artwork made of authentic boats, paradoxical remains of hope and exploitation, escape and incarceration. A boat can be read as a symbol of salvation (Noah's Ark), as 'rootless, it floats around' (Žižek quoted in Ahmed 2010: 197), a temporary place, 'a place without a place' (Foucault 1986: 27) that is not fixed but en route to a new place and time, a future. In ancient Greek mythology, boats marked the passage from the land of the living to the underworld, and Lemos, who has used boats as a consistent motif in her sculptural work, gave them a similar function in the trilogy's first part: 'the passage through which we enter the world and through which we leave the world' (Lemos in Koroxenidis 2011). Having admitted that when she first found the boats in 2003, she instantly saw them as 'sacred objects', the artist built an installation that commemorated the dead women, men and children, and, three years later, she hosted a mystical ritual of cremation, mourning and, in her words, 'release'. In this way, the boats' heterotopic quality, this 'sort of simultaneously mythic and real contestation of the space in which we live' (Foucault 1986: 24), became the primary material for a monument of passing to another place – after death.

The boats, standing in for migrants' bodies, were framed in 'unnatural positions' (Lemos in Koroxenidis 2011), in the same way that migrants find themselves in unnatural positions, in states of emergency. In *Crossing*, the seven boats were standing upright, in a circle, like emaciated skeletons, humans 'showing their wounds' (Lemos in Koroxenidis

2011). By covering the inside of the boats with wax in order 'to purify and heal the huge wound that was the opening of the boat' and marking human bodies in wax in a structure surrounding the boats – 'a protective embrace for the upright forms' (Danto 2011) – the artist attempted to reconfigure the human dimensions of violent displacement and 'to declare a tragedy to the whole world' (2011). Lemos acquired refugees' names from port authorities and wrote them on the surrounding structure, attempting to replace anonymous data with specifics. Audiences were invited to read the names/indications of the victims' Eastern or African origin and then move on to the centre of the installation, where the boats were standing, to smell the wax as it melted under the sun; to see 'the wound oozing, being still raw' (2011); to touch the wooden surfaces. *Crossing* was conceived as a sensory, emotional crossing from the site to an elsewhere, while the artist's work aspired to be a healing process for the absent, dispossessed Others, who were metonymically present through their boats, and for audiences, who often take the role of a passive bystander of this ongoing tragedy.

The artist's role as healer became even more explicit in July 2009, when Lemos staged a private, ritual performance to accompany the boats' cremation (Lemos and Koutsaftis 2009). In a letter quoted in the exhibition's catalogue, she admits that her desire was 'to release them, to free them from their environment' (quoted in Danto 2011), and, to that end, she produced a setting comparable to a 'crisis heterotopia', a sacred, forbidden place which presupposed 'a system of opening and closing' – that is, the ritual – 'that both isolate[d] them and [made] them penetrable' (Foucault 1986: 26). She invited seven women, one for each boat, all friends of hers, to perform the Mysteries' priestesses. Dressed in black, from dusk until night they stood over a cauldron of fire and recited excerpts from two poems concerned with the descent into the underworld, temporality, nature and loss: Yiannis Ritsos's *Persephone* (1972, in Greek) and T. S. Eliot's *Four Quartets* (1943, in English).

As darkness fell, spotlights targeted different parts of the installation, perhaps alluding to coastguard authorities looking for people or bodies in the sea, while a soundscape of winds, waves and sails blended with their voices. Delivering the poems in a chorus-like chant, the women approached the cauldron, lit their torches and set fire to the boats; they stood silent until the boats – and the bodies they represented – were consumed by flames. This performance was conceived as a gift to the displaced Others, as grieving and burial. Lemos treated the boats not as the remains of a *homo sacer*, '*life that cannot be sacrificed and yet may be killed*' (Agamben 1998: 82), but as their last possessions, in a way of

honouring them through the ceremony, which would have occurred elsewhere, otherwise, had they lived longer. The cremation performed a form of welcoming the dead into the national community, recognising them as 'grievable' lives; a quasi-religious, mystical ceremony attempted to remove them from the space of double exclusion that Agamben identifies as the defining element of 'bare life' – through banishment from law, bare lives are included in the political. In the moment of the boats' dissolution, the dead were re-inscribed with life beyond the sovereign (Fortress Europe) law. This performance appears to be staging dispossession – of the boats and what they represented in the present of the installation or contained in the past, but also of the women's sense of self. In a way, the spirits of the dead possessed the women in order to be able to dispossess their 'sovereign self'. Can we then read this performance as an example of affective dispossession, a first step to political responsiveness as Butler and Athanasiou would call for?

The cremation gestured to a mythical past and historical continuity, potentially inviting Greeks to reconnect to their ancestors and national imaginings; in other words, the ritual performed a peculiar form of domestication of the dead, which does not work towards a dispossession of the 'sovereign self'. This enactment of a ritual, combined with the frequent use of the word 'tragedy' in the exhibition catalogue, depoliticised the context of injustice, the double exclusion that triggered the deaths.[9] The myth was employed in such a way as to bring back empathy for the Other and produce a sense of community with the dead spirits, *thanato-citizens*, who did not have the necessary documentation to become legal citizens in life – but can or should be able to, after death. I am borrowing the concept of 'thanato-citizenship' from Green's ethnographic analysis of reactions to dead, unnamed bodies in the East Aegean islands (2012: 139–40). Green argues that, in contrast to Giorgio Agamben's 'thanatopolitics' – which emphasises the state's role in the production of death during life – 'thanato-citizenship', as another performance of Foucauldian biopolitics, refers to the ways in which a state *should* recognise a person after his or her death. This term, then, refers to how the state manages non-citizens' deaths; however, the cremation produced a heterotopia that occurs in a time separate to bureaucratic or legislative time, in a liminal sense of time 'at a sort of absolute break with [...] traditional time' (Foucault 1986: 26).

Crossing, as a reflection on real spatial politics and inclusion/exclusion debates, produced a temporary 'crisis heterotopia', a real place that reflected on all other places. Welcome though this may seem, it reproduced a problematic image, of the displaced Other as victim, assuming

their death and refusing possibilities of visibility beyond the mystic heterotopia's borders. The work also raised ethical questions such as: At what stage did the boats transform from means of escape or migrants' heterotopias into the artist's possessions? What was the (material and symbolic) value of the boats as found objects and what was their value as artistic objects? How does the value of the boats as 'sacred objects' relate to perceptions of or 'regard' (Butler 2009a: 25) to the value of human life?

At Crossroads: boats facing monumental gates

If *Crossing* attempted to put to rest the dead spirits by welcoming them to the land of Eleusis, *At Crossroads* used the remains of the dead to construct an installation that would haunt the living; this work marks a transition from the mythical to the civic. Responding, perhaps unconsciously, to populist figurations of migrants entering countries through 'the back door', which 'is more secretive and callers can be over the threshold before the house owner is aware of their presence' (Jeffers 2012: 29), Lemos placed this last part of her ambitious project in front of the most iconic European gate, the Brandenburg Gate. Originally a triumphal arch rebuilt in the eighteenth century, facing Unter den Linden, which initially led to the Prussian kings' city palace and where later Hitler staged his parades, the Gate was severely damaged during the Second World War and was isolated during the Cold War. It became an iconic location during the events of November 1989, partly because most of the Western media reported from that area, and it was restored in the early 2000s. In November 2009, a few days after the completion of Lemos's project, the site hosted celebrations for the twentieth anniversary of the Berlin Wall's fall and, supposedly, the dawn of a new era for a united Europe.

 At Crossroads faced this site inscribed with history; indeed, in a city where it is almost impossible to escape its past, 'the much restored but never removed Brandenburg Gate [...] is as authentic a symbol as Berlin can offer' (Ladd 1998: 81). The Gate is an example of what Sophie Nield, in her discussion of ceremonial performance and protest as site-specific theatre, calls 'monumental space', which:

> is not just a space that contains monuments: it is a space which itself is monumental, in that it embodies and describes a projection of political realities. [...] Monumental space not only mystifies, it makes the individual tiny in relation to the architectural grandeur, the scale

of the ceremonial avenue or building [...] Monumental space makes
power *felt*. (2012: 225)

This state power can be felt when looking to the right of the Gate, where
stands the Reichstag, Germany's house of parliament with its rebuilt
glass cupola. This panoptical glass dome offers a temporary position of
power to the citizen, an illusion of transparency as she thinks that she
can control the workings of the German state, which sits at the heart
of the bureaucratic EU. This illusion of transparency was disturbed by
the presence of the installation, the boats/relics next to the monuments
of past and present European prowess. Following Nield's proposition
that the site is not to be understood as 'preceding performance, or
performance animating or inscribing site' but instead that 'the site and
the performance can be seen to be producing each other in a recipro-
cal exchange of nuanced and subtly shifting meanings' (2012: 232),
At Crossroads marked that monumental site with a new meaning, trans-
forming the gates of Europe from limits to thresholds of possibilities.

The installation was a 13-metre high construction made of nine
wooden boats, turned upside down and crashed into a solid structure,
potentially as a metaphor for legal structures implemented across
Fortress Europe. Four boats were on the structure's base, forming a cross,
while the other five formed a tower over them. The boats were upside
down, emptied of their contents, indicating the end of life. Their names
(for example, *Ugur* [Luck] and *Umut* [Hope]) captured the migrants'
(now annihilated) desire for another place, a better life. Art critic Arthur
C. Danto (2011) writes in the trilogy's exhibition catalogue: 'No longer
able to stay afloat in the element they were designed for, the boats seem
to sail in formation as if through the air, like the spirits of boats.' Boats
are removed from their element – the sea – as they are relocated in a
symbolic, touristic location in mainland Europe. Further, Lemos named
the work after those 'magical places' that are the crossroads, 'a place
where one stops and makes a conscious choice about where to go next'
(Lemos in Koroxenidis 2011). Certainly, the Brandenburg Gate stands –
literally and metaphorically – at a crossroads; Dutch journalist Geert
Mak, writing about 1920s Berlin, observes: 'Here lay Europe's natural
crossroads. Everything and everyone passed through the city' (2008:
205). But can a boat be found at a crossroads? Are there crossroads in
the sea? Who is the subject who has to stop and make the choice about
the next step?

Lemos described her work as 'respecting' the Gate's history but also
attempting to engage it 'in a dialogue with the contemporary issue of

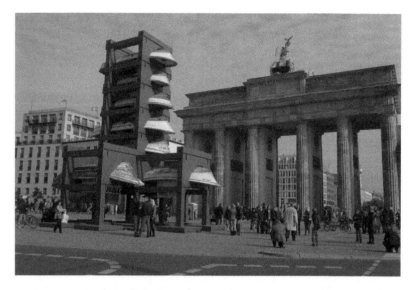

Figure 10.1 Boats of undocumented migrants crossing the Aegean in Lemos's *At Crossroads*, Brandenburg Gate, Berlin, 2009. Photo credit: © Theodore Scrivanos/ Kalliopi Lemos

borders. The boats were behind the statue of Nike. They were standing in her shadow, 'knocking' at the gateway of Europe and waiting for an answer. Their presence was discreet, but firm' (Lemos in Koroxenidis 2011).[10]

Lemos described *At Crossroads* as 'a plea for acceptance and integration on behalf of the immigrant', but an emphasis on 'acceptance' implies the persistence of clear 'us/them' divides, perpetuating problematic hierarchies, as Europeans perform hospitality to non-European Others who wish to be 'integrated'. Lemos spoke in terms of human empathy and guilt; yet, she failed to recognise that the statue of Nike and the Victory column (commemorating Prussia's victory over France in 1871) at the end of Strasse des 17. Juni, which starts at the Gate – both touristic, emblematic attractions at the heart of Europe – not only testify to European greatness but also to the exclusion and exploitation that building this greatness may have involved.

However, the installation had the potential of working in rich, if not resistant, ways, depending on the viewer's point of view (both ideologically and with regard to location). Its presence in the Gate's shadow, in semi-darkness, offered a poignant reminder that these boats – and the people who once used them – exist obscured by European histories and their spectacular monuments; they constitute dark, invisible spots in the majestic histories of European hospitality. As Lemos chose to

leave the installation unlit – in her words, as a sign of 'humility and humanity' – she avoided the production of another spectacle, that of the dispossessed. Many visitors saw the structure as it was staged in an iconic place at a symbolic moment; it blocked the view, obstructing the seduction of an icon of European unification. It disrupted a touristic location, in the same way that the presence of detention camps and dead bodies disrupts holiday destinations which function, to borrow Pugliese's sharp engagement with Foucault's heterotopic thinking, as 'crisis heterotopias'. In these 'other spaces', 'space–time continuums [...] overlap but remain heterogeneous to each other' (Pugliese 2009: 674); the same space presents both tourists and migrants with possibilities of 'escape', but actual experiences of time and space are radically different. The boats in Lemos's installation performed a similar act of disturbance to the tourists' free time, as they appeared unexpectedly in that monumental site.

There, facing the installation, the gates of Europe were momentarily transformed: this was no longer a monument under capitalism, where history is often framed as or consumed like a commodity; rather, through the performance, a new meaning was produced for the site. Apart from being a symbol of glory of a former empire, a remnant of Nazi trauma and a void no man's land during the city's division, the Brandenburg Gate hosted and made space for an alternative history of post-1989 Europe. In this way, the new memorial for the 'repressed tragedy' disrupted 'the partition of the sensible' – that is, 'the distribution that determines those who have a part in the community of citizens' (Rancière 2006: 12) – raising the question: What is worthy of our attention: the myth of a unified Europe or the realities of uneven development inside and outside Europe? Ultimately, *At Crossroads* presented a monument made of the ruins of people's lives; it performed the displaced Other's ambiguous cenotaph.

At Crossroads can be seen as a temporary commemoration of the dead migrants in a semi-monumental way, inscribing their histories next to other European histories. But specific migrants' stories are obscured and largely unknown, and, in this sense, the installation not only mapped the crossing from life to death but seemed to condemn the displaced Other to a monumental form of metonymic representation where he or she used to be there (in the boats) but is no longer and, most importantly, will never again be here (on European land). The cenotaph, as Benedict Anderson (1991: 4) has famously argued, works through affect, binding national communities; similarly, the temporary cenotaph of the displaced Others appears to be serving the Western visitor, offering her emotional release as she encounters that vessel to another life

which may have led to the end of the migrant's life. Further, the installation hosted in that site would soon be replaced by other uses of the space; immediately after its completion, the symbolic giant domino of the twentieth anniversary celebrations followed *At Crossroads*. During that performance, the German chancellor and ex-leaders of Eastern European countries witnessed together the symbolic re-enactment of 'the end of history', when Lech Walesa initiated the fall of the replica Wall. Amidst this celebratory atmosphere, *At Crossroads* remained a dispossessed *ghost* haunting the site in the same way that immigration haunts the Old Continent.

But if, as Nield convincingly argues, 'the work of performance is not a haunting; it is a battle for the right to determine, inflect, and produce the site itself' (2012: 232), then the second way of reading *At Crossroads* is as new space. This is a space of hospitality, which, following Jacques Derrida (2000; 2001), is nothing but a paradox, a yet-to-arrive. While the EU's laws on immigration limit hospitality as ethics, artistic practices can produce 'other spaces' that attest to *and* resist the migrants' quests for another world, those 'heterotopias of loss, death and mourning' (Pugliese 2009: 677). These 'other spaces' expose the limits of hospitality, crashed between an absolute *law* of hospitality and juridical perversions regulating hospitality (or asylum and migration); in these 'other spaces', hospitality is exposed as that which can be achieved only after death.

In the case of Lemos's work, this 'other space' was produced in front of the Brandenburg Gate, where what Foucault would describe as 'the near and the far' (in temporal, spatial, social and even metaphysical terms) were gathered. In that space, a temporary theatre (another heterotopia), the invisible dead and disappeared migrants appeared via their boats, alongside tourists and city-dwellers. The *via negativa* appearance of the dead through boats, 'mere carcasses beyond repair' (Danto 2011) occupying a public space, gives some insight into what remains 'unperformable' (Butler and Athanasiou 2013: 194): displacement as violence and labour. The 'unperformable' that the boats' appearance may also confess is the assumption of the Other's death – either in reality or in symbolic terms – having arrived at Fortress Europe and existing, sometimes, in hiding or exploited as living dead.

Performance in crisis works through an aesthetics of absence of the human body, by means of objects in space; the ways in which this object–space relation is framed and understood by the subject who stands at the crossroads, before the next step, ultimately determine meaning and action. One way of challenging how the relation between

space, time and individual works is through heterotopias 'juxtaposing in a single, real place several spaces, several sites that are in themselves incompatible' (Foucault 1986: 25). In such real 'other spaces', for instance public spaces, which are usually populated by the sovereign subject of liberal democracies, the Western visitor may be able to *stand alongside* the invisible, dispossessed, displaced Other instead of *standing in for* them.[11]

Conclusion: the promise of other shores

Apart from disturbing perceptions in monumental European locations, Lemos's work engages with migration as a foundational element of European history. The artist admitted that she felt 'very close to those objects [i.e. the boats], as if they were part of me, perhaps because of my family's history and my grandparents having been uprooted from Izmir to Greece during the Asia Minor disaster'[12] (Koroxenidis 2011), thus referring to the Aegean as a site 'of historico-topological repetition' (Pugliese 2009: 667). Since imperial times, when it was marked as *mare nostrum*, signifying 'a transparently known entity inscribed by fields of force, possession and containment' (Pugliese 2010: 11), the Mediterranean Sea has been a sign of European sovereignty and 'embodied histories of relations, connections, exchanges and interdependencies' (2010: 20). As Lemos's comment shows, trans-Mediterranean movement is not a new phenomenon; what we are currently witnessing, though, is a redefinition of the concept of border. Green, following political theorists, suggests that borders in the nineteenth century worked as a *line*, 'two-sided, rigid, precisely drawn, defined by laws and regulations, immovable and policed' (2010: 263). However, current performances of borders at Fortress Europe's edges reveal that what is protected now is not the line but the *region* beyond. What is performed in the Aegean, then, is 'the borders of a virtual space' (2010: 262), not the nation's borders; in this performance, Europe as territory is imagined in imperial terms anew and the Aegean hosts a return to pre-national models of border management and power.

Responding to xenophobia, hostility and violence against migrants, Greek commentators have often referred to the 1922–23 '"almost theatrical" performances of the border' (2010: 267) to express their surprise that Greeks – a nation that welcomed refugees in the past – can now refuse hospitality.[13] However, what is neglected is the particularity of the Greek nation's formation: abiding to the Lausanne Treaty's terms, Greece welcomed 'relatively homogenous groups (to

the country's "nationals"), rather than groups that were "mixed," [in order to] prevent too many further nationalist claims for territory' (2010: 267). Ultimately, though, this configuration solidified an ideology of national and territorial alignment, creating new iterations of nationalism. Perhaps, remembering the region's history is necessary for the battle against nationalism and fascism, but it can also articulate a limited, ethnocentric understanding of hospitality, which fails to recognise the specificity of the current waves of forced displacement. In other words, this repetition of memories of national uprootings perpetuates a fascination with the 'sovereign self', which may hinder the possibilities of a true engagement with the Other. Writing about the notorious images of Iraqi detainees 'bagged' by their torturers in Abu Ghraib and their reception or 'drama of interpretation' (2008: 374) in the US, Peggy Phelan makes a sharp observation that is pertinent for my argument:

> Our obsessive focus on what the photographs said about us [...] obscured the pain the prisoners endured; thus the act of looking at these photographs repeats the original failure-to-see-the-other that the photographs frame so dramatically. (2008: 379–80)

By overplaying how torture caused sexual shame and by neglecting the atrocities' religious dimension, even when launching a critique, commentators remained obsessed with the American psyche and that it was not at all expressed in the Abu Ghraib atrocities. Similarly, by overplaying the memories of national trauma – for example, the 1922 'Asia Minor disaster' – in order to put forward a hospitable attitude to the Other and strike against xenophobia, Greeks run the risk of 'failing to see the Other' and the specificity of their uprooting, and thus are not dispossessing their 'sovereign self'.

I am not making an argument against empathy, which always comes in relation to one's self, experiences and point of view. In fact, as Green points out in concluding her ethnographic study of citizens' reactions to undocumented bodies, 'the basis for social recognition [of the dead] came through the shock that only a certain social familiarity can cause: the absence of the victims' families connects this small place in the Aegean with other places across the world, the places of origin of the dead' (2012: 152). The global crises of displacement trigger moments of recognition or, borrowing Doreen Massey's terms, 'articulated moments in networks of social relations and understandings' (1994: 154). In this expanding geography of interconnectedness, a possibility of collective response to the suffering of Others may appear.

But, when these resonances are obscured by a limited and limiting obsession with national or European histories, I wonder whether we fail to really engage with the Others but only reproduce them as victims or dead. Judith Still, reflecting on Derrida's writings on ethics and politics of hospitality, has suggested that 'our [i.e. European] current fascination with ourselves as magnanimous or less than magnanimous hosts ought to be tempered by a sense of ourselves as guests or visitors' (2010: 267). Performing hospitality requires a redefinition of power relations, similar to the dispossession of the 'sovereign self' that Butler and Athanasiou are calling for. This performance of dispossession facing the displaced Others is the hardest labour required from Europeans – at a legal, juridical level and as artistic practice or everyday expression. *Perhaps,* the boats should not be displaced from the seas – 'border zones of the dead', to borrow Pugliese's terms – to Europe's symbolic, monumental locations. Instead, *perhaps,* it is a question of 'heading'.

In the terms Derrida used over two decades ago, considering Europe's histories, identities and imminent future and returning to the writings of a 'Mediterranean spirit' (Paul Valéry), the word 'heading' captured a personal route from the other shore (Algeria, the colony) to Europe. The Other heading also implied a shift in destination, literally or metaphorically. Derrida's call to perceive

> another heading, the heading being not only ours [le nôtre] but the other [l'autre], not only that which we identify [...] and decide upon, but *the heading of the other*, before which we must respond (1992: 15),

this attack on a Eurocentric thinking about the world outside Europe is imperative today. But how can this happen? *Perhaps,* we can think of Europeans on 'floating pieces of space' (Foucault 1986) as Others sailing to other shores, as 'guests or visitors'.

In the last chapter of her inspiring book *The Promise of Happiness*, Sara Ahmed offers a different way of thinking about boats as metaphors in the collective Western imaginary, particularly their association with a promise of a happy future; her approach to representations of boats and 'the role of despair and hope in the struggle for a "tomorrow," and what it means to be fighting for the future when "today" seems so hopeless' (2010: 164) offers a good way of concluding this essay with a note on hope. If, as Ahmed reminds us, 'hope anticipates a happiness to come' (2010: 181), boats in Foucault's theory, which reflects on Western societies, constitute 'a happy object' (2010: 198). *Perhaps,* a boat will arrive to take us, Europeans, away from the crisis and lead us to a secure port; a boat promises happiness. In a similar way, the real migrant boats

promise happiness but they are also imbued with an anxious hope, a fantasy of a better life and an agony for a future that may never arrive. *Perhaps*, if we Europeans resist the promise of our happiness, this future that bears a content and a meaning already, a future that forgets any unhappiness – especially that of the Other – *perhaps if we dismiss such a hope* there is hope. The contemporary world, a version of Foucault's dystopia, is a world 'without boats, [where] dreams dry up, espionage takes the place of adventure, and the police take the place of pirates' (1986: 27). But if Europeans head into the sea, beyond their sites and monuments, with an Other heading, then *perhaps* they can also imagine what is possible. They will:

> say yes to the future. [...] the future [as] what is kept open as the possibility of things not staying as they are [...] Perhaps a revolutionary happiness is possible if we allow our boats to flee. Such a happiness would be alive to chance, to chance arrivals, to the perhaps of a happening. We would not wait for things to happen. (Ahmed 2010: 197–8)

Perhaps, after all, there are crossroads only in the sea.

Notes

1. Throughout the piece, I use the term 'displaced Others' or migrants as a shorthand for what are different groups experiencing forced migration: economic migrants, asylum seekers and people who are granted the status of 'conventional refugees'. Certainly, I do not mean to suggest that we should ignore (as authorities and the media often do) the complex nuances differentiating these migrant identities, but for the purposes of this discussion it is impossible to be more specific, as the fate of people alluded to in this artwork remains unknown.
2. The project was also funded by the Hellenic Ministry of Culture and the Hellenic Institute of Migration Policy in Athens.
3. Since then, the Dublin II Regulation has not been applicable to Greece; if an asylum seeker manages to arrive in a country, other than Greece, their application for asylum will have to be examined there rather than being sent to Greece, as the EU Court of Justice has ruled that there are systematic deficiencies.
4. For instance, in the *Panorama* programme 'Breaking into Britain' (BBC 2011b), two journalists of Afghani and Ugandan origin followed migrants attempting to arrive in the UK through the European periphery. Some of them, sleeping rough in the streets of Athens, suggested that Athens – now a 'hell' for migrants – was not their desired destination.
5. See http://frontex.europa.eu/.

6. Peo Hansen (2004) has convincingly shown how decolonisation and European integration coincided, producing a hegemonic narrative, which ignores the persistence of EU territories outside the continent (in Africa and the Pacific). Frontex, for example, has signed agreements with non-European countries, such as Cape Verde, Libya and Nigeria, in an attempt to keep Others outside Fortress Europe. In this way, the borders of Europe stretch, perpetuating uneven relations – and legacies of colonialism and notions of Europeanness that are subject to racial and ideological definitions rather than geography.

7. Although the significance of the trilogy's second part (*Round Voyage*) should not be neglected, this analysis focuses only on the first and third parts, responding to the book's aim to study performance in the three European cities. *Round Voyage* consisted of two boats suspended from a bridge-like, metal structure; the first was upside down, facing the deck of the second, with one facing west and the other facing east. Lemos, in a discussion published in the trilogy's exhibition catalogue, explains that the Istanbul part aimed to 'invite Turkish people to join in a dialogue about immigration', while the shape of the installation was 'a life-carrying seed', an 'archetypal symbol of two halves coming together to create a unity'.

8. According to the myth, the Goddess of Harvest Demeter lost her daughter, Persephone, when the God of the Underworld, Hades, abducted her. Her mother, in despair, did not allow anything to grow on earth until she had found her daughter. The goddess arrived in Eleusis as a woman wearing rags and the locals took care of her; her daughter reappeared in the spring and, from then on, the Eleusinian Mysteries were set up to celebrate the cycle of life and nature – from abduction to disappearance to rebirth.

9. It is beyond the scope of this essay but worth pointing to the reappropriation of ancient Greek and Roman mythology in this context. For example, all Frontex operations have had names of ancient Greek or Latin mythical figures: Ariadne in Poland's eastern borders; Herakles in the south-east region; Nautilus in the central Mediterranean Seas; Hera in the border with the North African coast; Minerva in the western part of the sea; and Poseidon in the Aegean. Further, Frontex's subtitle in its mission statement, cited in Latin (*'Libertas, Securitas, Justicia'*), disguises the performance of border militarisation as protection of the continuity of European history and its principles.

10. Interestingly, the installation was located on the Western side of the Gate, facing the East; this offers a further layer to Lemos's work as the boats may be 'knocking' on Europe's doors but may be equally understood as staging a desire for return home (in the East).

11. Here, I am alluding to a concept that the Inside/Outside Europe network formulated during the workshops, that of *stasis*. Moving beyond David Harvey's approach to stasis as the moment when cities perform 'gridlock' to shut down capitalism (Harvey 2011), stasis here emerges as an ethical process and practice, where 'being beside oneself' disturbs capitalism's temporalities and hierarchies. Stasis manifests a 'corporeal and affective disposition' where bodies appearing together in public are recognised as 'turbulent performative occasion[s]' (Butler and Athanasiou 2013: 178); it does not imply waiting but instead it resonates with rehearsal processes, when an

actor, working through material, experiences an impulse and takes a breath just before a step is made.

12. Lemos refers to the events of August 1922, when the army of the recently founded Turkish nation-state attacked the Greek communities of Anatolia. Greeks had to flee in boats and made the same crossings as today's migrants: from the Anatolian coast to the East Aegean islands and then into cities. The tumultuous period concluded with the 1923 Lausanne Treaty, which dictated the compulsory exchange of Greek and Turkish populations and, like today, 'interlinked the Aegean border with a network of other borders that were similarly formally defined by [...] political interests represented by the League of Nations' (Green 2010: 267).

13. An additional reason for concern was the strong electoral support for Golden Dawn (in 2012 and 2014) in areas where Asia Minor refugees had settled over eight decades ago.

11
Economies of Atonement in the European Museum: Repatriation and the Post-rational

Emma Cox

As rhetorical devices, formal declarations tend to obscure power as legitimacy. In 2002, the directors of eighteen major museums and art galleries signed a 'Declaration on the Importance and Value of Universal Museums', setting out a multilateral case for their institutions as repositories of much of the world's tangible cultural and artistic heritage.[1] The locations of signatory museums trace a northern hemispheric path, spanning Saint Petersburg in the east, clustering in Western Europe and the north-eastern seaboard of the US, and stretching as far west as Los Angeles. In allying institutional interests to world interests, then, the Declaration magicked up a cosmopolitan sleight of hand, an affirmation and justification for centralised object possession that would override the imperial and neo-imperial histories that facilitated accumulation (of vast proportions) in the first place. Enlisting the language of universality, the Declaration attempted to submerge historiography while projecting a hegemonic utopian future:

> The objects and monumental works that were installed decades and even centuries ago in museums throughout Europe and America were acquired under conditions that are not comparable with current ones. Over time, objects so acquired – whether by purchase, gift, or partage – have become part of the museums that have cared for them, and by extension part of the heritage of the nations which house them. (International Council of Museums 2004: 4)

The museums' contemporary relationships to objects are framed here in a way that circumvents prevailing commodity ownership and exchange paradigms by prioritising the respectful custodianship and care of priceless heritage. The Declaration was partly a rejoinder to

creeping attitudinal shifts regarding the role of museums – particularly mega-museums that hold immense collections of displayed and stored objects – and, more overtly, an ideological riposte to repatriation discourse in a time of uncertainty.

This chapter concentrates on a museum object category about which the Declaration is silent, but which is profoundly fraught in the contexts of histories of possession and debates on repatriation: human remains. Institutions outside Europe are obviously embroiled in these histories and debates, but my discussion concerns Europe's former colonial powers, most prominently Britain and France, the two nations whose cultural and scientific institutions hold the bulk of the world's collections of human remains. Indeed, repatriation of remains maps the ongoing reconfiguration of transnational relationships, inside and outside Europe, that characterises decolonisation's long wake. Peo Hansen usefully reminds us that, while colonialism can in one sense be understood 'as a shared (Western) European experience which in many ways transgresses the particular national outlooks' (2002: 485), there has been relatively little attention paid to how the project of constructing an integrated European identity has impacted on understandings of the colonial past (and the neocolonial present) (2002: 486). The repatriation of human remains, however, has the peculiar quality of implicating both 'shared' and 'national' visions of Europe.

As a material transfer, repatriation is negotiated between institutions and indigenous claimants, with both parties operating as representatives of and within the legislative limits set by their respective nations. As a subject of vexed cross-institutional and cross-cultural debate, repatriation demands that European institutions – whether situated in nations such as the UK or France, which were major colonial powers, or in nations such as Sweden, which were a fringe beneficiary of colonialism's remaking of the globe – face up to their legacies on national and supranational levels.

While the repatriation issue predates by some two decades the current economic crisis, which has put enormous pressure on European museums, recent funding cuts have underscored just how low the arts and heritage sectors rank as state and corporate spending priorities, and how hard museums have to work to safeguard the rationale for their existence. Massimo Negri, Director of the European Museum Academy, notes that recession has led to museum budget cuts across Europe, with the exception of Germany (2013: 29). He observes that 'these cuts involved virtually the entire continent, ranging from an average of 10%, up to 50% for the state museums in Latvia, and 30% in the UK and Greece' (2013: 21). Interestingly, Negri's observations are presented within the

context of a wider discussion of new trends in the European museum 'panorama' (2013: 16), which he situates as a dynamic component of European integration: museums, he contends, 'play a special role in the dialectic process of safeguard[ing] of diversities (of languages, of beliefs, etc.) and enhancement of common European characteristics' (2013: 16). He explains that the 'increase of sustainability awareness within the [European] museum world has coincided significantly with the unfolding of the effects of the global financial crisis' (2013: 21). Part of sustainability awareness is the taking stock of institutional histories and ethics. Much of the reason for the complexity and sensitivity of repatriation in the context of biological remains concerns their multiple and contradictory qualities, their predicament as sites of spectral and organic ancestry, as well as itemised material culture. My discussion uses as primary reference points recent repatriations of Aboriginal Australian and New Zealand Maori remains, highlighting the ways in which indigenous mobilisation, curatorial discourses and repatriation ceremonies are enmeshed in an ontological unsettling of human remains as objects to which accrue secular-scientific value and indigenous religious or metaphysical attachment. The chapter seeks, first, to think through the conditions under which human remains repatriated from European museums become 'grievable dead', and, from this, to evaluate how performances of regret and mourning position European partners to repatriation within a framework of atonement, both as a metaphysical ecology and as a material, political transaction. The discussion's broader aim is to evaluate what purchase there might be in thinking about repatriation as an 'economy of atonement' that preserves European museums' ethical claims to universality while servicing a small, sym-bolic fraction of a postcolonial sovereign debt that can never be paid.

To contextualise this discussion, it is necessary to outline the prevalent historical dynamics that prompted the acquisition of human remains by or for Europeans in the colonial era. The collection of remains is directly consequent on the ideological and scientific imperatives of colonialism (itself an Enlightenment project), and, specifically, on the systematisa-tion of anthropology and ethnography as disciplines, energised by the 'discovery' of non-European lands and peoples. The persistent assump-tion within many European colonial regimes that indigenous peoples represented 'dying races' has been cited by several scholars as one of the reasons for the collection of indigenous human remains and cultural objects (cf. Jacknis 1996: 274; Gelder and Jacobs 1998: 82; Simpson 2009: 128; Hole 2007: 7). The extent to which indigenous body parts became European prestige currency is grotesquely illustrated by the fact that, in

1803, the New South Wales Governor, Captain Philip Gidley King, gifted the famed English botanist Sir Joseph Banks with the preserved head of Pemulwuy, an Aboriginal man. Pemulwuy had been a leader in the resistance to British invasion and was shot and decapitated by a British sailor (Turbet 2011: 126). While murder and grave robbery by Europeans were common, numerous scholars have noted that the acquisition of intricately tattooed *toi moko*, the preserved heads of high-ranking Maori men and women taken in inter-tribal warfare, and later those of Maori slaves tattooed for the purposes of trade, took place in a cross-cultural compact, for economic reasons (Thompson 2006: 32–3; Hole 2007: 8; Armit 2012: 53). However procured, the non-European dead were part of a burgeoning European economy, their remains often taken for private collections and only emerging in museums years or decades later, if at all.

But as the market expanded, so too did distaste for it; trade in Maori heads grew to such proportions by the early nineteenth century that General Sir Ralph Darling, Governor of New South Wales, was eventually compelled in 1831 to issue an order forbidding it:

> [S]uch disgusting traffic tends greatly to increase the sacrifice of human life among savages whose disregard of it is notorious [...] His Excellency [...] will feel it an imperative duty to take strong measures for totally suppressing the inhuman and very mischievous traffic in question [...] His Excellency further trusts, that all persons who have in their possession human heads, recently brought from New Zealand [...] will immediately deliver them up for the purpose of being restored to the relatives of the deceased parties to whom those heads belonged; this being the only possible reparation that can now be rendered. (1831: Government Order no. 7)

Evidently, Governor Darling's deepest moral condemnation was reserved for the Maori, whose involvement in this trafficking is disconnected from European social and economic paradigms and bluntly attributed to 'savagery'. Governor Darling's instruction signals that the collection and trade of body parts did not fit within the rational world order that British imperialism was intent on concretising, and it is interesting to note that he understood the return of heads in terms of reparation. We can identify from this a divergence between the Enlightenment ideal of rationality, to which a brutal colonial regime wishes to align itself, and the improper appetites of colonial taxonomy and trade. Darling's order also hints at the extent to which the 'mischievous' market was driven by fascination and desire for the indigenous abject.

The fetishisation of non-European ethnographic 'specimens' started to be critiqued in the contexts of race and racism only relatively recently. The most famous case of the return of human remains concerns the so-called 'Hottentot Venus', the remains of Saartjie (also known as 'Sara') Baartman, a Khoikhoi woman born in what is now the Eastern Cape of South Africa, who was sold into slavery in the early nineteenth century and taken to Europe in 1810, where she was exhibited as a hypersexual 'freak' in London and Paris. Gilles Boëtsch and Pascal Blanchard observe, '[t]hough she was not the first person to be put on exhibit in Europe – a number of "savages" and "exotics" had come before [...] the "Hottentot Venus" was the *first* to be an object at once of entertainment, media interest, "sexual fantasy", and science' (2014: 188, italics in original). Baartman's preserved brain and vulva, as well as her skeleton, were displayed at the Musée de l'Homme until 1974 and were held by the Musée until France finally permitted her body's return to South Africa in 2002. While the push to repatriate Baartman's remains coincided with the African cultural resurgences that followed the end of apartheid, France was slow to play its part in what was ultimately a reconciliatory act; it was not until former President Thabo Mbeki entered into direct negotiations with the French government that the return was enacted (Kerseboom 2011: 64).[2] My discussion here is contextualised by the racialised violence of European imperialism and colonialism, and its implications for European museum collections, but it is worth remembering that issues of social class intersect with race (and gender) in determining the way that death and rights are yoked; as Jane Hubert and Cressida Fforde note in their introduction to *The Dead and their Possessions*, a key collection of essays on repatriation:

> Many accounts of the colonists' treatment of the bodies of indigenous people from the late eighteenth through to the early twentieth centuries are shocking, but it should be remembered that in Britain, for example, as recently as the early nineteenth century, surgeons and anatomists were employing people to dig up the graves of the British poor to provide bodies for dissection by medical students. Although the Anatomy Act of 1832 made the practice of grave-robbing illegal, over 50,000 bodies of poor people who died in institutions are said to have been used for dissection up until the 1930s. (2002: 3)

Of course, now, throughout Europe, poverty and the corporatisation of burial have direct consequences for the differential treatment of human remains, to the extent that in a crisis economy, people are increasingly

unable to afford the cost of dying (Institute for Policy Research 2014). It is, perhaps, by historicising the violence of colonialism as it manifested in the treatment of 'lesser' human lives after death that we might situate the transformation of colonial legacies into the hierarchies that order European lives and deaths today.

Grievable dead and atonement theology

What kinds of relationships with bones and with history are activated by repatriation? From the perspective of claimants, the transfer of remains from European collections seems to function transnationally and cross-culturally to bring back into knowledge latent relationships with the dead. In this sense, repatriation can re-legitimise ancestral ties, which often (as I will outline) manifest in repatriation ceremonies as performances of grief. Hubert and Fforde explain:

> Indigenous groups request the return of the human remains of their ancestors for a number of reasons, but primarily on the grounds that their ancestors must be accorded funerary rituals appropriate to their cultural beliefs. [...] Death rituals may serve to reaffirm cultural beliefs, but they may also be, or form part of, a display by the living of their own standing and aspirations in society. (2002: 1–2)

This comment underscores two pertinent points for this discussion: first, that repatriation must be understood in terms of the various kinds of performance work that it facilitates; and second, that such work has ontological as well as political ends.

In this context, it is worth asking whether Judith Butler's concept of 'grievable life' can offer a perspective on rights and relationships with the dead that might be retooled in the context of repatriation politics, illuminating how and for whom remains become 'grievable dead'. In *Frames of War*, Butler argues that *social* ontology precedes *biological* ontology and makes the case that life only appears as grievable – and therefore may be recognised as precarious – within social relations: that is, 'under conditions in which the loss would matter' (2009a: 14). This underpins Butler's call for ethical recognition of the Other, which in the context of repatriation may encompass the Other's ancestors. But assessing the value of human remains on these terms can lead to an impasse because of relations of possession that order the sociality of human remains, and, specifically, when remains have entered a museum from which their loss would matter. Ethnographic theories of sociality do

not necessarily clarify the issue; Annette B. Weiner's observation in *Inalienable Possessions: The Paradox of Keeping-While-Giving* that '[w]hat makes a possession inalienable is its exclusive and cumulative identity with a particular series of owners through time' (1992: 33) could conceivably be used to make a case that the continuity of European institutional possession of remains constitutes an inalienable cultural relation. Indeed, the Declaration on Universal Museums invoked continuity in direct response to the issue of repatriation: 'Calls to repatriate objects that have belonged to museum collections for many years have become an important issue for museums. Although each case has to be judged individually, we should acknowledge that museums serve not just the citizens of one nation but the people of every nation' (International Council of Museums 2004: 4). Of course, in practice, to be in receipt of this 'service' one has to be capable of assuming the privileged cosmopolitan subjectivities of tourist or visiting expert. Flattening such contingencies, the Declaration's circular, encircling logic displays a firm grip on who and what are served and preserved inside the European–North American sphere.

Cases for repatriation must engage complexly with bioethics, heritage legislation and evidentiary work concerning provenance, acquisition and/or DNA. But the grounds on which indigenous claimants most often request repatriation – that is, on ancestral as opposed to scientific or aesthetic bases – reifies genealogy as both ontology and indigenous religious cosmology. In other words, for ancestral claimants, relatedness can exist outside sociality *and* biology. Memories of the dead need not be the primary basis for repatriation (although that is not to say that the loss has faded from cultural memory and oral narrative), but nor is genealogy attendant only on biological ontology as genetic science quantifies it. Rather, repatriation enfolds history, science, culture, politics and the communicable sacred. In Maori culture, for instance, European notions of familial genealogy align inadequately with their ostensible cognate, whakapapa, which describes social, cultural and metaphysical ideas and (crucially) practices that transmit meaning between individuals and across generations. Whakapapa is a historical record that is also literally a practice in its form as an oral recitation of ancestor names.[3] As Elizabeth Deloughrey explains, '[u]nlike the noun "genealogy", which signifies an originary moment or ancestor, whakapapa, an intransitive verb and noun, suggests a *performative* rendering of meta-physical history rather than a static or essentialist lineage system' (2007: 164). Once again, it is performance, rather than documentation, that brings history and culture into being in such a context.

It would seem that repatriation must, then, inevitably involve institutional acquiescence to indigenous world views that are fundamentally different from Western rationalism. But the way in which human remains are dealt with in contemporary European curatorial practice is at variance with strict rationality. Most of the time remains (in an unaltered state, and so excluding, for example, masks that contain human bones, teeth or hair, or drinking vessels made from skulls) are uniquely 'protected' from display; Samuel J. M. M. Alberti *et al.* note that, in England, '[f]ew human remains originating in the last century from outside Europe continue to be displayed [...] although large holdings of physical anthropology remain in storage' (2009: 134). In the Swedish context, attempts are being made to reckon with taboo or sacred associations of objects in ethnographic collections. Lotten Gustafsson Reinius, Director of the Världskulturmuseet in Stockholm, situates this in terms of the role of the 'postsecular museum', a concept that seeks to intervene in the Enlightenment rationalist inheritance of European collecting, and is concerned with exhibition practices (including performance within museums) that apprehend more fully what she terms 'power charged objects' (2013: 7).[4] Recent developments in France have highlighted institutional unease over the possession of remains. In 2007, five years prior to a major French repatriation of Maori heads (which I discuss below), the Musée d'Histoire Naturelle de Rouen sought to return to New Zealand a tattooed Maori head but was blocked by the French Ministry of Culture; the museum released a sketch of the head but prohibited photographs. The attempted repatriation prompted Stéphane Martin, President of the Musée du quai Branly in Paris, to explain why Maori heads in its possession would not be put on display, but also why they were not subject at that point to return: 'From my point of view, they are cultural artifacts that had a function in society. [...] They are stored in a very special area, and absolutely will not be put on public display' (quoted in Sciolino 2007). What type of cultural or ethnographic object, we might ask, is 'absolutely' not for display? Part of the answer, of course, concerns fragility, but the deference contained in Martin's statement betrays a sense of sacred significance, or, at the very least, the view that human remains belong in the private sphere. The removal of human remains from the predominantly visual economy of the European museum seems to signify an attempt to construct an ethical private sphere – or even a secret space – within the civic sphere of the institution. It also seems to be a move to ward off a crisis of legitimacy.

Because, as I am arguing, repatriation does not take place entirely or even *mostly* within a context of rationalism, I want to try to understand

it in terms of two forms of atonement; first, as restitution; and second, as an economy. Atonement has roots in Christian theology, and, in its manifestation in the 'satisfaction' theory of atonement, it concerns restitution of an injustice; as Jeffrey C. Tuomala explains, Anselm of Canterbury (1033–1109) 'based the justice of Christ's atonement not on vicarious punishment but on payment as positive performance of some good' (1993: 225). Tuomala explains that Protestant reformers objected to the concept of atonement as positive civil payment; as he notes, 'they believed that punishment is a necessary component of atonement' (1993: 226). Museum repatriation in Europe, most would agree, is not implicated in anything resembling a relation of punishment. But the resonance of the Christian idea of atonement in this context lies in its meaning as a restitution that has a beneficial effect on those who atone as well as on those who are the recipients of justice, and, moreover, in the way it underscores how repatriation operates as a cross-cultural practice that cannot be entirely rationalised. Indeed, a 2011 repatriation of ninety-four Skolt Saami skeletons purchased by the University of Oslo in 1915 involved the university issuing an apology and was marked by a funeral ceremony in Neiden attended by several hundred people, led by the late Eastern Orthodox Archbishop Gabriel of Komana (Karlsbakk 2011). Christian paradigms of atonement also comingle with indigenous belief systems in non-European indigenous cultures in Australia and New Zealand that bear the significant influence of missionary projects.

In the context of the repatriation of Aboriginal objects from Australian museums, Ken Gelder and Jane Margaret Jacobs refer to the 'unruly effects of the Aboriginal sacred in the postcolonial moment' (1998: 83). European museum practice, too, is in the midst of its own postcolonial moment; even though it is more common to hear museum crises attributed to monetary woes, Europe's museums are, I maintain, haunted by the encroaching crisis of their histories. When European museum professionals atone by repatriating human remains taken from former colonial possessions, they effectively *admit* to the secular sins of imperial and colonial history, and they *permit* indigenous ontologies; in both respects they rebalance a power differential. Even outside the context of repatriation, European museology bears the weight of its historical impunity; Laura Peers, a curator at the Pitt Rivers Museum at the University of Oxford, explains in the context of her discussion of a museum loan project, '[r]ecently, museums have extended the "right" to handle "real" objects (as opposed to duplicates in educational handling collections) to indigenous researchers, as a mechanism for cultural

learning as well as an acknowledgment of shifting relations of power' (2013: 142). While engagement with indigenous world views tends to be framed in UK institutions in terms of a discourse of ethics and rights, a less rationalist tone, one that trades overtly on the spectrality of objects, is apparent in the prevailing exhibition practices of another of Europe's major former colonisers, France. This was prominent in the Musée du quai Branly's exhibition, *'Maori: leurs trésors ont une âme'* ('Maori: their treasures have a soul'; April 2011 to January 2012), which displayed some 250 pieces from the collection of New Zealand's national museum, Te Papa Tongarewa. James Clifford notes incisively that a spiritually inflected museology can allow a big French institution such as quai Branly to distance itself from its messy implication in colonial histories; as he archly puts it, with reference to the cultural universalist biases of then President and quai Branly stakeholder Jacques Chirac and its architect Jean Nouvel, 'Chirac's aesthetic universalism and Nouvel's mystical/natural environment remain largely undisturbed by history, politics, or the arts and cultures of a contradictory (post) modernity' (2007: 14).

The increasing seriousness with which European museums take repatriation means that the indigenous world views that construe human remains as ancestors are allowed to enter into transnational discourse, not just for recuperative politics, or as tactics in diplomacy, but as the foundation upon which objects are relinquished by major cultural and scientific institutions. That is, atonement is not just symbolic, but patently material. At the same time, I am suggesting, repatriation as atonement is not entirely rational, even when it involves traditional bastions of Enlightenment rationality such as the British Museum or the Pitt Rivers. In order to begin to explain what I mean by this, consider the difference in conceiving and construing remains *of ancestors* as opposed to *as ancestors*; saying 'These are the remains of my ancestor' performs subtly different semantic work to saying 'This is my ancestor'. The first implies a split between the indivisible person that was once alive and the biological materials of which they were comprised. The second represents less a collapsing of such distinctions than an aggregation of meanings, associations and materials. It is important to be clear that this aggregation is not unique to indigenous discourses on ancestry, but can be seen in the way people speak of remains in many different contexts, whether with reference to a deceased loved one or a long-dead historical figure; indeed, this may be one reason why indigenous claimants have been able to gain traction on this issue in the context of institutional rationality. To put it more directly, the ontology

of human remains is universally unsettled, and *unsettling*. An alternative term might be 'numinous', a concept that was explicated by the influential German Lutheran theologian Rudolf Otto in *The Idea of the Holy* and developed by psychoanalyst Carl Jung, among others; for Otto, three components to numinous experience are *tremendum* (awe, terror, 'overpoweringness'), *mysterium* (the 'wholly other') and *fascination* (attractiveness) (1958: Chapters 4, 5, 6). It is important to recognise that the idea of the numinous describes human experience or sensation, and does not necessarily have to be regarded as making a case for religious divination. As I will argue in the next section, repatriation in practice, particularly diplomatic and ceremonial performativity, can intensify the numinosity of remains.

Policy frameworks and repatriation in practice

Article 12.1 of the UN Declaration on the Rights of Indigenous Peoples (2007) states that: 'Indigenous peoples have [...] the right to the repatriation of their human remains' (United Nations 2007). The declaratory neatness of this document, which has no legal effect, seems just as inadequate and wilfully utopian in its own way as the Declaration on Universal Museums. Paradoxically, the codification of universal rights both enshrines them and announces their non-universality in practice; certainly, it is difficult to conceive of an inalienable indigenous relationship with human remains when possession of them is so radically contingent on power, politics and temporality. Whatever ideological weight the UN Declaration may carry, in practice indigenous claimants have fought for the repatriation of their ancestral remains in accordance with often convoluted policy, rather than universalist doctrines.

Emerging in the late twentieth century, policy frameworks pertaining to the repatriation of human remains highlight its imbrication in questions concerning bioethics, science, culture, history and consensus. The US was a pioneer in establishing a legislative tool in the Native American Graves Protection and Repatriation Act of 1990. The UK has been a frontrunner in Europe in terms of setting up repatriation frameworks, and its developments are worth outlining in some detail here because they have been instrumental for indigenous claimants from Australia and New Zealand.[5] The first repatriations in the UK were from the Manchester Museum, which repatriated Maori human remains in 1990, and the Pitt Rivers Museum, which repatriated Aboriginal Australian remains the same year (Weeks and Boot 2003: 29). In the 1990s and early 2000s, UK collectives such as the Museum

Ethnographers Group and the Working Group on Human Remains produced reports and guidelines on repatriation. In 2003, a scoping survey commissioned by the latter reported that twenty-four of the thirty-three requests for the repatriation of human remains that had thus far been received by English museums had come from Aboriginal Australian or Maori communities, and that more than half were to three institutions: the British Museum, the Natural History Museum and the Royal College of Surgeons (2003: 4). Requests dated from 1985 and many were repeat requests (2003: 28–30). Refusal to repatriate was usually on one of three grounds: the institution being prevented by legislation; the scientific significance of the remains; or the name of the deceased being unknown (2003: 30). The year after this report was published, the Human Tissue Act 2004 was passed, section 47 of which gave named English museums the power to deaccession the remains of people who had died less than 1,000 years ago 'if it appears to them to be appropriate to do so for any reason' (s. 47.2). Repatriation of human remains from Scottish museums is covered by the Human Tissue (Scotland) Act 2006. To date, several UK institutions have returned remains to institutions or ancestral communities in Australia and New Zealand.

In France, on the other hand, cultural legislation remains a stumbling block to repatriation of remains held in state collections. Article L451-5 of France's *Code du Patrimoine* (Heritage Code) specifies that objects held in state museums are, along with historical monuments, inalienable: *'Les biens constituant les collections des musées de France appartenant à une personne publique font partie de leur domaine public et sont, à ce titre, inaliénables'* ('The property constituting the collections of the museums of France belong to the public entity as part of the public domain and are, as such, inalienable'). To date, repatriation of remains has been based on two pieces of legislation, both of them narrowly defined. The first, passed in 2002, was the law that permitted the repatriation of Saartjie Baartman's remains: *Loi no. 2002-323, 6 mars 2002*. In 2010, another French law, *Loi no. 2010-501*, modified Article L451-5 of the Heritage Code with specific reference to Maori heads, determining their status as biological remains to be returned to New Zealand, rather than as inalienable cultural heritage of France. This legislation paved the way for the repatriation of Maori remains. The fact that the UK and France have, more comprehensively than other European nations, developed policy frameworks (divergent in terms of impetus and effect though they are) relating to museum holdings and the conditions under which items might be relinquished seems to speak to both nations' historical predicament as major former colonisers, in possession of major colonial-era collections.

Prior to 2003, repatriation to Australia was negotiated independently by indigenous organisations, and since then it has been overseen by various Australian government agencies (Performance Audit 2009: 15).[6] The case study for the following discussion of ceremony is derived from a 2013 Berlin repatriation of Aboriginal remains. This repatriation coincided with the German Museums Association's release of guidelines on the treatment of human remains, but Germany does not have a legislative framework for museum repatriation. For many years, Aboriginal lawyer Michael Mansell has articulated the distress experienced by Aboriginal people as a result of their ancestral remains being held in European institutions. In 1990, referring to Aboriginal remains in British collections, he stated: 'The damage to the Aboriginal community of having remains here is astronomical. The spirits of our dead are disturbed by being separated from their bodies. The remains are as important to us as land rights' (quoted in Langsam 1990: 10). In 2007, in the context of a debate over the Natural History Museum's intention to carry out scientific tests on Aboriginal remains, Mansell explained that repatriation is not just a material transaction but one that allows for crucial ceremonial work: 'Unless we carry out the traditional ceremony, we can't rejoin the spirit that has been disturbed from the body of the dead' (quoted in Nettlefold 2007). In 2013, the Australian government installed a fully indigenous-led Advisory Committee for Indigenous Repatriation (ACIR), and in the same year the Charité Medical University in Berlin repatriated thirty-three remains of Aboriginal people originating from Far North Queensland, New South Wales, Western Australia and South Australia. As far as ceremony is concerned, repatriation involves two events: the relinquishment by the institution, and the reception in the homeland. The Berlin ceremony took place in a lecture hall in which the remains were situated prominently in cardboard boxes, draped in the Aboriginal flag (this has become an important political symbol, cohering pan-Aboriginal identity, mobilising resistance and land rights struggles). The event was attended by an Aboriginal delegation from ancestral communities, including Ned David, Tauto Sansbury, Sandra Miller and Ian Crombie, as well as people from the university and non-indigenous Australian representatives. The Australian Parliamentary Secretary for the Arts, Michael Danby, spoke about the colonial and contemporary contexts of the repatriation, while Karl Max Einhäupl, the Chairman of the Executive Board of Charité, affirmed his institution's support and respect for the rights of the Aboriginal people to bury their ancestors' remains (Danby 2013). David, a Torres Strait Islander and co-chair of

the ACIR, described the ceremony's significance in terms of international politics as well as emotional resonance:

> These are very moving moments for indigenous people around the world [...] They are bringing their ancestral remains home. There are mixed emotions, one obviously of relief, so it's a celebration. And then the moment is tinged with sadness for what was involved with the removal of the remains. (quoted in Carvajal 2013)

Upon the arrival of the remains in Australia, purification and/or burial ceremonies were performed at various ancestral lands. The ceremony in the South Australian capital of Adelaide was filmed and has been disseminated publicly as a video entitled 'The Homecoming' (2013). This sombre event took place on the lawn outside the South Australian Museum. The remains were held in several boxes, placed on a low wheeled trolley, over which two Aboriginal flags were draped. Aboriginal elder Major Sumner from the Ngarrindjeri people, his body painted in traditional ochres, performed a chant with carved wooden clapsticks, followed by a smoking ceremony. Sumner has been closely involved in Aboriginal repatriation negotiations with UK museums and has led similar repatriation ceremonies upon the return of remains from the UK (Scobie 2009). A smoking ceremony is an ancient purification ritual that is performed at burials and births as well as diplomatic events and involves the lighting of a bunch of native leaves, such as eucalyptus, which emits a thick smoke. In this ceremony, the smoking purified the three Aboriginal representatives – Sansbury, Miller and Crombie – and a non-Aboriginal museum representative, all of whom stood in silent vigil as Sumner directed the smoke around their bodies, focusing on their shoulders and heads, and then moved on to the boxes containing the remains. Members of the public stood and watched from a distance of several metres.

Because of the French patrimony policy framework outlined above, to date, France has not agreed to repatriate human remains to Australia. However, in January 2012, the Musée du quai Branly returned twenty Maori remains from ten French institutions[7] to Te Papa Tongarewa in Wellington. Te Papa has been responsible for the repatriation of Maori remains and objects to New Zealand since 2003, when it established the Karanga Aotearoa Repatriation Programme; it has negotiated the repatriation of over 200 Maori biological remains, which it refers to as ancestors or *kōiwi tangata* (literally 'bone people'; significantly, in Maori, the word for bone contains the word for tribe: *iwi*), from institutions

around the world (International Repatriations 2014). Prior to the 2012 repatriation, the Musée du quai Branly's institutional imperative had been to invoke a discourse of rationality in the face of Maori repatriation requests, asserting mastery over history. In 2007, the museum's former scientific director, Emmanuel Désveaux, commented:

> Although we will take them into account, we do not think it is wise to construct a discourse on the collections that purely respond to Indigenous claims. They are unstable, rarely consistent and they collide with the present state of scientific knowledge. More than that, their ideological roots, however legitimate, tend to filter out the realities of history. (quoted in Sauvage 2007: 145)

Beyond the obvious contradiction in this statement – that a claim can be ideologically legitimate but scientifically and historically illegitimate – it demonstrates the competing epistemologies that are tangled up with repatriation claims and underscores why indigenous claimants have to comply with evidentiary paradigms.

Groundwork for the 2012 French repatriation involved legal, diplomatic and scientific work, the latter including non-invasive DNA testing carried out by the Musée National de la Marine (Agence France Presse 2012). As with the Berlin event, the codified, performative elements of the handover ceremony in Paris were designed to emphasise cross-cultural cooperation and respect; in this case, the ceremony to receive the remains in Wellington was also attended by the French ambassador. The Paris event was hosted by French Minister for Culture Frédéric Mitterrand. Boxes containing the remains were placed on a woven mat and covered in black cloth and cloaks. Key components of Maori protocol were the same as those of the *powhiri* (welcome) commonly performed in New Zealand to welcome guests. The Maori delegation's entry was signalled by the sound of a conch shell and a *karanga* (summoning call) performed by Georgina Kerekere. A member of the repatriation advisory panel led the *karakia*, a prayer invoking and honouring ancestors, and a group lament for the ancestors followed. These elements of the ceremony spatio-temporally marked the event as sacred. Members of the French and New Zealand delegations gave speeches on the importance of the repatriation, acknowledging the work that had facilitated it, and on the anticipation of an ongoing relationship between the Musée du quai Branly and Te Papa Tongarewa. The reception ceremony in Wellington took place at Te Papa's *marae* (meeting house) and involved similar *powhiri* protocols to those that took place in Paris. The ceremony

at the *marae* was a large occasion, and one of its key features was the formalised cries of lament performed by Maori women who sat on the floor, encircling the boxes containing the ancestral remains, affectively intensifying the occasion's funerary meaning (Westbrook 2012).

In both these Aboriginal Australian and Maori repatriations, the ceremony orchestrated the liminal time–space between the bones existing as the property of European institutions and their return to ancestral lands. In both cases, the ceremonies, while culturally specific in the ways outlined, were organised around certain key tropes: the simultaneous visible prominence and cloaking of the human remains; speeches from indigenous and European representatives; and the solemn orientation of the transaction as both a homecoming and a funeral. Hubert and Fforde suggest that, in the context of repatriation, funeral rites function 'to formalize the death, to make the break between life and death visible and help people come to terms with the death, and enable them to mourn their dead' (2002: 1–2). Visibility and proximity emerge as critical here. It is difficult to imagine repatriation occurring satisfactorily as a purely administrative transaction – in the cases at hand, in the shipping of remains from Europe to Australasia. Ceremony, here, brought people into close proximity with the remains and with each other, and permitted participants to *attend* to the remains, both in the sense of care, and in the sense of the Latin *attendere*, meaning 'to stretch' one's mind towards. In the context of Aboriginal repatriation, Gelder and Jacobs argue that when objects are returned to an indigenous system, their sacredness within that system is not just 'residual' but 'emergent' (1998: 85). This offers a way of understanding the work of ceremony not just as marking a transition, but as activating for participants and spectators certain sensorial responses in the presence of remains; in this sense, repatriation ceremonies can be seen as intensifying their numinosity, with or without ancestral ontology.

Atonement as a post-rational economy?

At the start of this chapter, I considered Christian theology's 'satisfaction' theory of atonement in the context of human remains and grievability. But what if the atonement enacted by repatriation from European museums is to be understood in terms of an economy as well as a metaphysical ecology? In this context, it becomes necessary to elucidate more clearly the condition of human remains that have become items in an institutional inventory. What are human remains 'doing' in the possession of Europe's museums? Are they 'useful' items? Are they at

work, or are they congealed commodities? Are they commodities at all? (Certainly, they were in the colonial era.) These questions are important because one of the secular arguments made for repatriation is that many of the remains possessed by museums are not 'used' in the sense that they are not objects of active research practice. Neither are they on display, in most cases, for ethical reasons. Indeed, even the word inventory has to be used with some caution in this context. Writing from the vantage point of 2002, Hubert and Fforde noted that several major museums had only recently started to rectify an 'unprofessional state of affairs' by cataloguing their large collections of uninventoried biological remains and funerary objects; they cite London's Natural History Museum, which 'is only now beginning to catalogue its large and very long-standing collection of indigenous material'. As they add: 'This situation severely undermines claims that the material is held by museums because it is a source of important information for use by researchers' (2002: 7). In this sense, bones may be characterised as twice dead – both the material remainders of death and dormant commodities in Europe's museum economy.

But the unique intervention that repatriation represents is not a corrective to the apparent condition of remains as congealed commodities. Repatriation from Europe does not reinstate remains into the global capitalist economy that in many cases procured them – certainly, Te Papa's repatriation policy explicitly states that it 'does not purchase kōiwi tangata' (Kōiwi Tangata Policy 2010: 2); rather, it is a form of material transfer that operates according to a non-*materialistic* logic. But the wider apparatus of repatriation bears the residues of broadly economic interests in the form of agreements to foster ongoing relationships between repatriating and receiving institutions or communities. Collaborative relations between the Musée du quai Branly and Te Papa, for instance, were marked in the run-up to the 2012 repatriation by the abovementioned exhibition, '*Maori: leurs trésors ont une âme*'. A 2011 repatriation of Australian Torres Strait Islander remains facilitated cultural exchange whereby London's Natural History Museum sponsored the six-month research and study residency of a Torres Strait woman, Emma Loban. Fairly immediately, then, repatriation can generate cultural (if not economic) capital for European museums, the benefits of which may be seen as analogous to the goodwill that multinational corporations receive through their charitable partnerships. There is even a case to be made that repatriation represents an operational release valve for contemporary museums. Bones that are not appropriate for display from the perspective of contemporary sensibilities are something

European museums can 'afford' to give in a time of crisis, while shoring up their ethical credentials in the process.

The task of clarifying the transactional paradigm in which repatriation is situated has important spatio-temporal aspects. Repatriations of ancestral remains are frequently described in terms of a language of homecoming, or 'coming to rest'. Gelder and Jacobs's observation, quoted above, that repatriation makes the sacredness of human remains an 'emergent' and not just 'residual' quality (1998: 85) speaks not only to the ontological change attendant upon repatriation, but also to some kind of dormancy in the context of a century or more of residence in a museum. But as material possessions, remains are, like most everything else held in museums, maintained in a state of preservation – although, here, their value may have depreciated over time, as the willingness of visitors to accept remains as spectacles has waned. But museal preservation, even outside the context of spectatorship, is in direct contrast to what happens to remains if and when they are reburied upon return to ancestral communities, an issue that continues to be subject to debate both across and *within* cultural groups (cf. Ubelaker and Grant 1989; Hubert and Fforde 2002; Hole 2007). One of the objections expressed by Musée du quai Branly President Stéphane Martin five years prior to the 2012 repatriation was that '[s]ending back these artifacts to New Zealand, and destroying them by burying them is a way of erasing a full page of history' (quoted in Sciolino 2007). As well as positioning museums as entities that bring indigenous peoples *into history*, this comment bizarrely equates the biological disintegration of bodies with the violence of cultural erasure. Insofar as it lets us decipher exactly whose past is threatened with erasure, Martin's comment is opaque – perhaps deliberately so – but whether he has in mind France's colonial-era history, or Maori history over the same period, his interests in both remaining on the metaphorical 'page' of the French institution reflect a particular conception of how the bodies of the non-European dead can be made to signify.

As objects that seem so insistently to be both material and spectral, indigenous remains might be understood as existing in Europe's museums in a kind of temporal pause, a suspended inanimation – *not yet back home*. Ewa Domanska's conceptualisation of the missing bodies of the Argentinian *desaparecidos* is instructive here: she argues that the missing are located in the 'non-absent past' or the 'past that will not go away' (2005: 404–5). The idea is that the disappeared-presumed-dead, indexed to the absence of their bones, collapse linear temporality. Human remains that are held in ambiguous stasis, both inside and outside the

visual economy of European museums, are analogous in many ways to missing persons (encompassing that which is 'missed' or 'absent'), and the potent affective as well as diplomatic stakes in their return may be explained in part by the idea that bones instantiate history's presence. A linguistic approximation of this philosophical idea may be found in the Maori language; as Maori scholar Joan Metge explains, 'the word mua means "in front" in terms of space, but "the past" in terms of time. [...] Where English speakers think of history as being behind them and look forward to the future, Maori think of themselves as facing the past in front of them' (2010: 107). In the contexts at hand, of course, history's 'imminence' has a profoundly political inflection, which testifies to the voraciousness of Europe's historical appetites for the accumulation and taxonomy of 'specimens' and the global reach of its acquisition practices. But this formula of history requires that both parties to repatriation or collaboration be politically, culturally or socially engaged; as Diane Hafner demonstrates in her cogent discussion of ambivalent responses among the Lamalama Aboriginal Australian community to being presented with artefacts made by their ancestors (not human remains) that had long been in museum collections (2013: 360–4), sometimes, for dispossessed communities, the past may indeed go away.

The analysis proffered by Hafner contains a caution insofar as disentangling sociality and spectrality is concerned, as well as in relation to the attribution of agency to objects. In this light, the collective belief attached to remains as objects might not appear to be fundamentally different from the consensus that upholds international monetary systems. But the secular 'magic' of money and financial instruments, whose palimpsest of meanings and capacities overdetermines their (im)materiality as paper, plastic, metal or computer code, is not, for most of us, of the same order as the numinosity of human remains, if we understand numinous objects to be those whose presence provokes sensations, in Otto's terms, of *tremendum, mysterium* or *fascination.* Human remains *exceed* but do not *supersede* rational knowledge of the organic matter that constitutes them. Ultimately, I want to argue, repatriation cannot be fully understood within human rights frameworks, or even frameworks of grief, but calls for comprehension in terms of a *post-rational economy of atonement.* I use the term 'post-rational' here instead of 'irrational' or even 'non-rational' to denote an economy that is informed by numinosity *and* in which rational thought is prevalent. To put it differently, it is an economy formed from the discontents of rationalism, and in this way is symptomatic of a twenty-first-century predicament.

Given that European museums have only properly started to get to grips with repatriation as Europe's privilege has come under scrutiny, we might perceive a post-rational economy of atonement as a crisis economy, one that is necessary to ensure the survival of the European museum as an institution whose primary *raison d'être* is to centralise material culture. The decisions of museum professionals across Europe to consider or enact repatriation are indicative of relationships and economies that exceed the dossiers of evidence attached to specific cases, and so the nature of this transnational crisis economy is uniquely paradoxical. Atonement, as I have begun to develop it here, has a complex and contradictory relationship to history, capital and belief in the metaphysical. As a 'return', an economy of atonement is distinct from a gift economy, but the cultural capital absorbed by institutions that have repatriated remains means that it is not about reparation either, nor the repayment of a loan. Understood as a post-rational transaction, repatriation does something to a museum's, and thus a culture's, relationship with its history; it can project partners into an 'imminent' past. Of course, we are always latecomers to history, and, as Governor Darling knew very well when he attempted in 1831 to halt the 'disgusting' trade in Maori heads, dead bodies have an abiding power to provoke fear and awe. European museums have never managed to effect the disenchantment of these particular possessions, and it may even be argued that they seek a kind of immunity to crisis by relinquishing them. Perhaps, in the end, while repatriation from Europe to former territorial possessions is part of a political and ethical vocabulary of restitution, completion and closure, what it signifies more is the capacity of human remains, across time and culture, to disturb.

Notes

1. The Declaration was signed by the directors of a number of leading museums and art institutions from Europe and North America (International Council of Museums 2004). It has been reproduced widely; the version from which I quote here is a 2004 discussion document that places the Declaration side by side with commentaries from the then General Director of the State Museums of Berlin and the former Director of the National Museums of Kenya. This document lists nineteen signatories, including the British Museum. Kwame Opoku (2010) has discussed the curious arrangement whereby the British Museum initiated and helped to draft the Declaration, but did not sign it, instead issuing a press release in support of the Declaration and publishing it on its website.
2. Simone Kerseboom makes a compelling argument for how, in the years since the return of her remains to South Africa, 'Baartman's story has been

appropriated and adapted in order to serve as a narrative for nation-building in a nationalist agenda inherently constructed "from above"' (2011: 64).

3. For a succinct summation of the cultural significance of whakapapa as world view and practice, see Hirini Moko Mead (2003: 42–3). As crucial as the recitation of whakapapa remains, it was augmented by the emergence in Maori culture of the written text. Tony Ballantyne offers an insightful discussion of the cultural shifts attendant upon 'whakapapa books' (2014: 221–2), or written genealogical records, making the point that, as writing became increasingly authoritative in Maori communities after colonisation, the embodied character of whakapapa started to change; even as it 'diversified and amplified' knowledge of genealogies, the whakapapa book meant that knowledge became 'disembodied and consumed in a range of social contexts and physical locations quite distant and dislocated from those learned individuals who still retained genealogical narratives' (2014: 222).

4. Sweden has committed to repatriate all Aboriginal remains in its possession to Australia (Performance Audit 2009: 27).

5. In 2009, the overwhelming majority of the more than 900 Aboriginal Australian human remains still outside Australia were held in England (Performance Audit 2009: 24). While most repatriation to Australia has been from England, New Zealand has successfully negotiated repatriation from several countries (International Repatriations 2014).

6. Of the more than 1,000 Aboriginal human remains repatriated from overseas since 1990, 94 per cent have been returned from the UK (Performance Audit 2009: 29).

7. Repatriating institutions included the Musée du quai Branly; Musée National d'Histoire Naturelle; Musée National de la Marine (Paris); Musée d'Histoire Naturelle (Nantes); Musée d'Histoire Naturelle (Lille); Musée des Beaux-Arts de Dunkerque; Musée des Confluences de Lyon; Musée de Sens; Musée d'Arts Africains, Océaniens, Amérindiens (Marseille); the Université de Montpellier.

Bibliography

Adamczak, Bini (2013) 'The end of the end of history – and why the era of revolutions is upon us', *Truthout*, 10 July, http://truth-out.org/news/item/17485-the-end-of-the-end-of-history-and-why-the-era-of-revolutions-is-upon-us?tsk=adminpreview, accessed 2 September 2014.

Adams, Stephen (2009) 'Anti-racist protesters target new play about migrants', *The Telegraph*, 4 March, p. 13.

Addley, Esther (2011) 'Burn Britain Burn: Gilian Slovo's *The Riots*', *Guardian*, 22 November, http://www.theguardian.com/stage/2011/nov/22/gillian-slovo-the-riots-play, accessed 3 September 2014.

Agamben, Giorgio (1998) *Homo Sacer: Sovereign Power and Bare Life*. Trans. Daniel Heller-Roazen. Stanford, CA: Stanford University Press.

Agence France Presse (2012) 'In pomp, New Zealand recovers severed Maori heads', 23 January.

Ahmed, Sara (2004) *The Cultural Politics of Emotion*. Edinburgh: Edinburgh University Press.

Ahmed, Sara (2010) *The Promise of Happiness*. Durham, NC: Duke University Press.

Alam, Fahim (2013) *Riots Reframed*. VoiceOver Productions.

Alberti, Samuel J. M. M., Piotr Bienkowski, Malcolm J. Chapman and Rose Drew (2009) 'Should we display the dead?', *Museum and Society* 7(3): 133–49.

Alibhai-Brown, Yasmin (2009) 'Being offensive is no joke', *Independent*, 5 March, p. 14.

Allfree, Claire (2011) 'Gillian Slovo's new play *The Riots* looks for the truth behind UK unrest', *Metro*, 16 November, http://metro.co.uk/2011/11/16/gillian-slovos-new-play-the-riots-looks-for-the-truth-behind-uk-unrest-222362/, accessed 21 June 2013.

Amin, Ash (2002) 'Ethnicity and the multicultural city: living with diversity', *Environment and Planning A* 34: 959–80.

Amin, Ash (2012) *Land of Strangers*. Cambridge: Polity Press.

Amnesty International (2010a) *The Dublin II Trap: Transfers of Asylum-seekers to Greece*. London: Amnesty International Publications, http://www.amnesty.eu/en/news/statements-reports/eu/asylum-and-migration/the-dublin-ii-trap--transfers-of-asylum-seekers-to-greece-0446/#.VACP2YWVgZY, accessed 29 August 2014.

Amnesty International (2010b) *Greece: Irregular Migrants and Asylum-seekers Routinely Detained in Substandard Conditions*. London: Amnesty International Publications, http://www.amnesty.eu/en/news/statements-reports/eu/asylum-and-migration/greece-irregular-migrants-and-asylum-seekers-routinely-detained-in-substandard-conditions-0461/#.VSQr8IWVgZY, accessed 29 August 2014.

Amnesty International (2012) *Greece: The End of the Road for Refugees, Asylum-seekers and Migrants*. London: Amnesty International Publications, http://files.amnesty.org/archives/eur250112012eng.pdf, accessed 19 August 2013.

Amoore, Louise and Alexandra Hall (2010) 'Border theatre: on the arts of security & resistance', *Cultural Geographies* 17(3): 299–319.

Anastassakis, Othon (2009) 'The new politics of the new century', in Spyros Economides and Vassilis Monastiriotis (eds) *The Return of Street Politics? Essays on the December Riots in Greece*. London: The Hellenic Observatory, LSE, pp. 5–8, http://www.lse.ac.uk/europeanInstitute/research/hellenicObservatory/pdf/Various/Greek_Riots_09_FINAL.pdf, accessed 9 April 2014.

Anderson, Benedict (1991) *Imagined Communities: Reflections on the Origin of Nationalism*. 2nd edition. London: Verso.

Anonymous (2001) 'Give up activism', *Do or Die: Voices from the Ecological Resistance* 9 [online journal], http://www.eco-action.org/dod/no9/activism.htm, accessed 12 April 2014.

Arendt, Hannah (1958) *The Human Condition*. Chicago, IL: University of Chicago Press.

Arendt, Hannah (1961) *Between Past and Future: Eight Exercises in Political Thought*. New York, NY: Viking Press.

Argyropoulou, Gigi (2012) 'Embros: twelve thoughts on the rise and fall of performance practice on the periphery of Europe', *Performance Research* 17(6): 56–62.

Armit, Ian (2012) *Headhunting and the Body in Iron Age Europe*. New York, NY: Cambridge University Press.

Arnold, Matthew (1879) 'The French play in London', *The Nineteenth Century: A Monthly Review* 30: 228–43.

Arts Against Cuts (2010) 'The Nomadic Hive manifesto', Arts Against Cuts [online], 10 December, http://artsagainstcuts.wordpress.com/2010/12/10/after-the-national-gallery-teach-in/, accessed 1 September 2014.

Ash, Lucy (2014) 'Ada Colau: Spain's anti-eviction crusader', BBC News, 19 February, http://www.bbc.co.uk/news/magazine-26228300, accessed 12 April 2014.

Avanessian, Armen (2013) 'Krise – Kritik – Akzeleration', in Armen Avanessian (ed.) *#Akzeleration*. Berlin: Merve, pp. 71–7.

Badiou, Alain (2005) *Being and Event*. Trans. Oliver Feltham. London: Continuum.

Badiou, Alain (2009a) *Logics of Worlds: Being and Event II*. Trans. Alberto Toscano. London: Continuum.

Badiou, Alain (2009b) *Theory of the Subject*. Trans. Bruno Bosteels. London: Continuum.

Badiou, Alain (2012) *The Rebirth of History: Times of Riots and Uprisings*. Trans. Gregory Elliott. London and New York, NY: Verso.

Balezdrova, Anastsia (2011) 'The humanitarian crisis in Greece is deepening, Medecins du Monde is warning', *GR Reporter*, 26 October, http://www.grreporter.info/en/humanitarian_crisis_greece_deepening_medecins_du_monde_warning/5337, accessed 7 April 2015.

Balibar, Étienne (2002a) 'World borders, political borders', *PMLA*, 117(1): 71–8.

Balibar, Étienne (2002b) *Politics and the Other Scene*. London: Verso.

Balibar, Étienne (2003) 'Europe, an "unimagined" frontier of democracy', *Diacritics* 33.3/4: 36–44.

Balibar, Étienne (2004) *We, the People of Europe: Reflections on Transnational Citizenship*. Trans. James Swenson. Princeton, NJ and Oxford: Princeton University Press.

Balibar, Étienne (2010) 'Europe: final crisis? Some thesis', *Theory and Event* 13(2) [online journal], http://muse.jhu.edu/journals/theory_and_event/v013/13.2.balibar.html, accessed 2 September 2014.

Ballantyne, Tony (2014) *Webs of Empire: Locating New Zealand's Colonial Past*. Vancouver: University of British Columbia Press.

Barbican (2013) 'Unleashed at the Barbican', 23 May [online video], http://blog. barbican.org.uk/2013/05/unleashed-at-the-barbican/, accessed 7 September 2014.

Barroso, José-Manuel and Herman van Rompuy (2012) 'From War to Peace: A European Tale. Acceptance speech of the Nobel Peace Prize to the European Union', Oslo, 10 December, http://europa.eu/about-eu/basic-information/eu-nobel/index_en.htm, accessed 2 September 2014.

Baudrillard, Jean (2005) 'L'Europe divine', *Libération*, 17 May, http://www.liberation. fr/tribune/2005/05/17/l-europe-divine_520090, accessed 2 September 2014.

Bauman, Zygmunt (1997) *Postmodernity and its Discontents*. Cambridge: Polity Press.

Bauman, Zygmunt (2011) 'The London riots: on consumerism coming home to roost', *Social Europe Journal*, 9 August, http://www.social-europe.eu/2011/08/the-london-riots-on-consumerism-coming-home-to-roost/, accessed 1 March 2014.

BBC (2011a) 'State multiculturalism has failed, says David Cameron', BBC News, 5 February, http://www.bbc.co.uk/news/uk-politics-12371994, accessed 30 June 2014.

BBC (2011b) *Panorama: Breaking into Britain*, BBC One, 16 June.

BBC (2011c) *Panorama: Inside the Riots*, BBC One, 14 November.

BBC (2012a) *The Riots: In Their Own Words, The Rioters*, BBC Two, 13 August.

BBC (2012b) *The Riots: In Their Own Words, The Police*, BBC Two, 20 August.

BBC (2013a) *Arena: The National Theatre. Part One: The Dream*, BBC Four, 24 October.

BBC (2013b) *Arena: The National Theatre. Part Two: War and Peace*, BBC Four, 31 October.

Bean, Richard (2009) *England People Very Nice*. London: Oberon.

Bellamy, Richard and Dario Castiglione (2005) 'Building the union: the nature of sovereignty in the political architecture of Europe', in D. Karmis and W. Norman (eds) *Theories of Federalism: A Reader*. Basingstoke and New York, NY: Palgrave Macmillan, pp. 293–310.

Benjamin, Walter (1994) 'Left-wing melancholy', in Anton Kaes, Martin Jay and Edward Dimendberg (eds) *The Weimar Republic Sourcebook*. Berkeley, CA and Los Angeles: University of California Press, pp. 304–6.

Benjamin, Walter (1996) 'Capitalism as Religion', in Marcus Bullock and Michael W. Jennings (eds) *Walter Benjamin, Selected Writings 1913–1926: Volume 1*. Trans. Rodney Livingstone. Cambridge, MA: Harvard University Press, pp. 288–91.

Benjamin, Walter (1999) 'Theses on the philosophy of history', in Walter Benjamin, *Illuminations*. Trans. Harry Zorn. London: Pimlico, pp. 245–55.

Benjamin, Walter (2003a) 'A chronicle of Germany's unemployed', in Howard Eliand and Michael W. Jennings (eds) *Walter Benjamin, Selected Writings 1938–1940: Volume 4*. Cambridge, MA: Harvard University Press, pp. 126–34.

Benjamin, Walter (2003b) 'The Paris of the Second Empire in Baudelaire', in Howard Eliand and Michael W. Jennings (eds) *Walter Benjamin, Selected Writings 1938–1940: Volume 4*. Cambridge, MA: Harvard University Press, pp. 3–92.

Benjamin, Walter (2009) 'The work of art in the age of mechanical reproduction', in Walter Benjamin, *One-way Street and Other Writings*. Trans. J. A. Underwood. London: Penguin Modern Classics, pp. 228–59.

Berardi, Franco 'Bifo' (2010) 'transverse / transversal', d*OCUMENTA* (13): 100 Notes – 100 Thoughts, No. 094. Ostfildern: Hatje Cantz.

Berardi, Franco 'Bifo' (2011) *After the Future*. Edited by Gary Genosko and Nicholas Thoburn. Edinburgh: AK Press.

Beswick, Katie (2014) 'Bola Agbaje's *Off the Endz*. Authentic voices, representing the council estate: politics, authorship and the ethics of representation', *Journal of Contemporary Drama in English (JCDE)* 2(1): 97–112.

Bhabha, Homi (1994) *The Location of Culture*. London: Routledge.

Billings, Joshua, Felix Budelmann and Fiona Macintosh (eds) (2013) *Choruses, Ancient and Modern*. Oxford: Oxford University Press.

Billington, Michael (2013) 'The National Theatre at 50: Michael Billington's view from the stalls', *Guardian*, 18 October.

Bloom, Clive (2012) *Riot City: Protest and Rebellion in the Capital*. Basingstoke and New York, NY: Palgrave Macmillan.

Boenisch, Peter M. (2008) 'Other people live: Rimini Protokoll and their "Theatre of Experts"', *Contemporary Theatre Review* 18(1): 107–13.

Boëtsch, Gilles and Pascal Blanchard (2014) 'From cabinets of curiosity to the "Hottentot Venus": a long history of human zoos', in Nicolas Bancel, Thomas David and Dominic Thomas (eds) *The Invention of Race: Scientific and Popular Representations*. Oxford and New York, NY: Routledge, pp. 185–94.

Boggs, Carl (1997) 'Marxism, prefigurative communism and the problem of workers' control', *Radical America* 11(6): 99–122.

Boltanski, Luc and Eve Chiapello (2005) *The New Spirit of Capitalism*. Trans. Gregory Elliot. London: Verso.

Bourdieu, Pierre (1999) *Acts of Resistance: Against the Tyranny of the Market*. New York, NY: The New Press.

Brecht, Arnold (1968) *Prelude to Silence: The End of the German Republic*. New York, NY: Fertig.

Brecht, Bertolt (1974) 'A small contribution to the theme of realism', *Screen* 15(2): 45–8.

Brecht, Bertolt (1992) 'Thesen zur Theorie des Überbaus', in Werner Hecht *et al.* (eds) *Bertolt Brecht. Werke: Große kommentierte Berliner und Frankfurter Ausgabe*, Volume 21. Berlin and Frankfurt am Main: Aufbau-Verlag and Suhrkamp, pp. 570–2.

Brecht, Bertolt (1997a) 'Fatzer', in Werner Hecht *et al.* (eds) *Bertolt Brecht. Werke: Große kommentierte Berliner und Frankfurter Ausgabe*, Volume 10.1. Berlin and Frankfurt am Main: Aufbau-Verlag and Suhrkamp, pp. 387–529.

Brecht, Bertolt (1997b) 'Die Grosse und die Kleine Pädagogik', in Werner Hecht *et al.* (eds) *Bertolt Brecht. Werke: Große kommentierte Berliner und Frankfurter Ausgabe*, Volume 21. Berlin and Frankfurt am Main: Aufbau-Verlag and Suhrkamp, p. 396.

Brecht, Bertolt (1997c) 'Über die Person', in Werner Hecht *et al.* (eds) *Bertolt Brecht. Werke: Große kommentierte Berliner und Frankfurter Ausgabe*, Volume 21. Berlin and Frankfurt am Main: Aufbau-Verlag and Suhrkamp, p. 404.

Brecht, Bertolt (1997d) 'Der Rundfunk als Kommunikationsapparat', in Werner Hecht *et al.* (eds) *Bertolt Brecht. Werke: Große kommentierte Berliner und Frankfurter Ausgabe*, Volume 21. Berlin and Frankfurt am Main: Aufbau-Verlag and Suhrkamp, pp. 552–7.

Brecht, Bertolt (1997e) 'Das Lehrstück "Die Maßnahme"', in Werner Hecht *et al.* (eds) *Bertolt Brecht. Werke: Große kommentierte Berliner und Frankfurter Ausgabe*,

Volume 24. Berlin and Frankfurt am Main: Aufbau-Verlag and Suhrkamp, p. 96.

Brown, Wendy (2012) 'We are all democrats now', in Giorgio Agamben *et al.* (eds) *Democracy in What State?* New York, NY and Chichester: Columbia University Press, pp. 44–57.

Bull, John (2010) 'England People Very Nice: intercultural confusions at the National Theatre', in Werner Huber, Margarete Rubik and Julia Novak (eds) *Staging Interculturality*. Trier: Wissenschaftlicher Verlag Trier, pp. 123–44.

Burgen, Stephen (2012) 'Catalan independence rally brings Barcelona to a standstill', *Guardian*, 11 September.

Burgen, Stephen (2014) 'Catalan president faces multiple charges after independence referendum', *Guardian*, 21 November, http://www.theguardian.com/world/2014/nov/21/catalan-president-face-several-charges-after-unofficial-independence-referendum, accessed 3 April 2015.

Butler, Judith (2004) *Precarious Life*. London and New York, NY: Verso.

Butler, Judith (2009a) *Frames of War: When is Life Grievable?* London and New York, NY: Verso.

Butler, Judith (2009b) 'Performativity, precarity and sexual politics', lecture given at Universidad Complutense de Madrid, 8 June, http://www.aibr.org/antropologia/04v03/criticos/040301b.pdf, accessed 10 October 2012.

Butler, Judith (2011) 'Bodies in alliance and the politics of the street', European Institute for Progressive Cultural Politics, November [online], http://eipcp.net/transversal/1011/butler/en, accessed 1 September 2014.

Butler, Judith and Athena Athanasiou (2013) *Dispossession: The Performative in the Political*. Cambridge: Polity Press.

Callow, Simon (1997) *The National: The Theatre and its Work 1963–1997*. London: Nick Hern Books in association with the Royal National Theatre.

Calotychos, Vangelis (2003) *Modern Greece: A Cultural Poetics*. Oxford: Berg.

Calvino, Italo (1997) *Invisible Cities*. Trans. William Weaver. London: Vintage Classics.

Cameron, David (2011) 'Daily Hansard debate', 11 August, http://www.publications.parliament.uk/pa/cm201011/cmhansrd/cm110811/debtext/110811-0001.htm, accessed 1 March 2014.

Carlson, Marvin (2008) 'National theatres: then and now', in S. E. Wilmer (ed.) *National Theatres in a Changing Europe*. Basingstoke and New York, NY: Palgrave Macmillan, pp. 21–33.

Carvajal, Doreen (2013) 'Museums confront the skeletons in their closets', *The New York Times*, 24 May, http://www.nytimes.com/2013/05/25/arts/design/museums-move-to-return-human-remains-to-indigenous-peoples.html?_r=1&, accessed 14 July 2014.

Cavafy, C. P. (1984) 'Waiting for the Barbarians', in George Savidis (ed.) *Collected Poems*. Trans. Edmund Keeley and Philip Sherrard. London: Hogarth Press, pp. 18–19.

Cavendish, Dominic (2011) 'The riots: duo who turned a crisis into a drama', *Telegraph*, 8 November, http://www.telegraph.co.uk/culture/theatre/theatre-features/8877272/The-Riots-duo-who-turned-a-crisis-into-a-drama.html, accessed 21 June 2013.

Ceberio Belaza, Mónica and Luis Doncel (2013) 'European court rules Spanish mortgage law is abusive', *El País*, 14 March, http://elpais.com/elpais/2013/03/14/inenglish/1363264199_406548.html, accessed 5 May 2014.

Chatziprokopiou, Marios (2014) 'What does this country kill in you?', Activist Performance: Gestural Notes [online blog], 24 March, http://activistper-formance.wordpress.com/2014/03/24/what-does-this-country-kill-in-you/, accessed 7 September 2014.

Chatzistefanou, Aris (2012a) 'Golden Dawn has infiltrated Greek police, claims officer', *Guardian*, 26 October, http://www.guardian.co.uk/world/2012/oct/26/golden-dawn-infiltrated-greek-police-claims, accessed 18 November 2014.

Chatzistefanou, Aris (2012b) 'Greece's biggest hospital struggles as austerity cuts bite', *Guardian*, 15 June, http://www.guardian.co.uk/world/greek-election-blog-2012/video/2012/jun/15/greece-hospital-austerity-cuts-video, accessed 18 November 2014.

Christopoulou, Zacharoula (2014) 'Live your myth in Greece: the mythology of crisis', in Myrto Tsilimpounidi and Aylwyn Walsh (eds) *Remapping 'Crisis': A Guide to Athens*. Winchester: Zer0, pp. 267–80.

Churchill, Caryl (1996) *Plays: Two*. London: Methuen.

Clark, T. J. (2012) 'For a left with no future', *New Left Review* 74: 53–75.

Cleaver, Harry (1979) *Reading Capital Politically*. Austin, TX: University of Texas Press.

Clifford, James (2007) 'Quai Branly in process', *October* 120: 3–23.

Colau, Ada and Adrià Alemany (2014) *Mortgaged Lives: From the Housing Bubble to the Right to Housing*. London: Journal of Aesthetics and Protest.

Cuevas-Hewitt, Marco (2011) 'Towards a futurology of the present: notes on writing, movement, and time', *Aesthetics and Protest* 8, http://joaap.org/issue8/futurology.htm, accessed 10 April 2014.

Danby, Michael (2013) 'Indigenous ancestral remains returning home', remarks at the Charité Medical University, Berlin, 26 April, http://www.danbymp.com/recent/1896-indigenous-remains-returning-home.html, accessed 14 July 2014.

Danto, Arthur C. (2011 [2009]) 'Embarkation for Chios: Kalliopi Lemos's trilogy with broken boats', in Johannes Odenthal and Elina Kountouri (eds) *Kalliopi Lemos: Crossings, A Sculptural Trilogy about Migration*. Gottingen and Berlin: Steidl and Akademie der Künste.

Davenport-Hines, Richard (2007) 'Rayne, Max, Baron Rayne (1918–2003)', in *Oxford Dictionary of National Biography*. Oxford: Oxford University Press.

Davies, Lizzy (2012) 'Greek debt crisis: chronic drug shortage risking lives of the sick', *Guardian*, 8 June, http://www.guardian.co.uk/world/2012/jun/08/greek-drug-shortage-worsens, accessed 18 November 2014.

Davies, Norman (2014) *Europe: A History*. 2nd edition. London: Bodley Head.

de Haas, Hein (2008) 'African migration to Europe: the myth of invasion', Living in Diversity [online], http://www.livingindiversity.org/2011/03/01/african-migration-to-europe-the-myth-of-invasion/, accessed 6 October 2013.

de Jongh, Nicholas (2009) 'Cruel cartoon not Very Nice', *Evening Standard*, 12 February.

Deck, Jan and Angelika Sieburg (eds) (2011) *Politisch Theater machen. Neue Artikulationsformen des Politischen in den darstellenden Künsten*. Bielefeld: Transcript.

Dejonge, Alex (1978) *The Weimar Chronicle: Prelude to Hitler*. New York, NY: Paddington Press.

Delanty, Gerard (1995) *Inventing Europe: Idea, Identity, Reality*. Basingstoke and New York, NY: Palgrave Macmillan.

Delanty, Gerard (2014) 'Introduction: perspectives on crisis and critique in Europe today', *European Journal of Social Theory* 17(3): 207–18.

Delanty, Gerard and Paul R. Jones (2002) 'European identity and architecture', *European Journal of Social Theory* 5(4): 453–66.

Delanty, Gerard and Chris Rumford (2005) *Rethinking Europe: Social Theory and the Implications of Europeanization*. London and New York, NY: Routledge.

Deleuze, Gilles (1992) 'Postscript on the societies of control', *October* 59 (Winter): 3–7.

Deleuze, Gilles (1993) 'One less manifesto', in C. V. Boundas (ed.) *The Deleuze Reader*. New York, NY: Columbia University Press, pp. 204–22.

Deleuze, Gilles and Felix Guattari (2004) *A Thousand Plateaus: Capitalism and Schizophrenia*. Trans. Brian Massumi. London and New York, NY: Continuum.

Delgado, Maria M. (2003) *'Other' Spanish Theatres: Erasure and Inscription on the Twentieth Century Spanish Stage*. Manchester: Manchester University Press.

Delgado, Maria M. and Caridad Svich (2002) *Theatre in Crisis? Performance Manifestos for a New Century*. Manchester: Manchester University Press.

Delgado, Maria M. and Dan Rebellato (eds) (2010) *Contemporary European Theatre Directors*. Abingdon and New York, NY: Routledge

Delgado-García, Cristina (2013) *The Aesthetics and Politics of Character and Subjectivity in Contemporary British Theatre*. PhD thesis, Aberystwyth University.

Deloughrey, Elizabeth (2007) *Routes and Roots: Navigating Caribbean and Pacific Island Literatures*. Honolulu, HI: University of Hawai'i Press.

Derber, Charles and Yale Magrass (2012) 'History's magic mirror: America's economic crisis and the Weimar Republic of pre-Nazi Germany', *Truthout*, 1 November, http://truth-out.org/opinion/item/12477-historys-magic-mirror-americas-economic-crisis-and-the-weimar-republic-of-pre-nazi-germany, accessed 2 September 2014.

Derrida, Jacques (1992) *The Other Heading: Reflections on Today's Europe*. Trans. Pascale-Anne Brault and Michael B. Naas. Bloomington, IN: Indiana University Press.

Derrida, Jacques (2000) *Of Hospitality*. Trans. Rachel Bowlby. Stanford, CA: Stanford University Press.

Derrida, Jacques (2001) *On Cosmopolitanism and Forgiveness*. Trans. Mark Dooley and Michael Hughes. London and New York, NY: Routledge.

Derrida, Jacques (2006) 'A Europe of hope'. Trans. Pleshette DeArmitt, Justine Malle and Kas Saghafi. *Epoché* 10(2): 407–12.

Die Welt (2013) 'Festnhamen nach Attacke auf AfD-Chef Lucke', *Die Welt*, 25 August, http://www.welt.de/politik/deutschland/article119357488/Festnahmen-nach-Attacke-auf-AfD-Chef-Lucke.html, accessed 2 September 2014.

Dikeç, Mustafa (2012) 'Immigrants, *banlieues*, and dangerous things: ideology as an aesthetic affair', *Antipode* 45(1): 23–42.

Dolan, Jill (2004) 'Introduction', *Modern Drama* 47(2): 165–76.

Dolan, Jill (2005) *Utopia in Performance: Finding Hope in the Theater*. Ann Arbor, MI: University of Michigan Press.

Domanska, Ewa (2005) 'Toward the archaeontology of the dead body'. Trans. Magdalena Zapędowska. *Rethinking History* 9(4): 389–413.

Donnell, Alison (2001) 'Introduction', in Alison Donnell (ed.) *Companion to Contemporary Black British Culture*. London and New York, NY: Routledge, pp. xxii–xvi.

Doughty, Sally and Mick Mangan (2004) 'A theatre of civility: Quarantine Theatre's *EatEat*', *Performance Research* 9(4): 30–40.

Douzinas, Costas (2012) 'Greece is ripe for radical change', *Guardian*, 8 November, http://www.guardian.co.uk/commentisfree/2012/nov/08/greece-ripe-radical-change-austerity, accessed 17 November 2013.

Duller, Sebastian and Ulrike Guérot (2013) *The Long Shadow of Ordoliberalism: Germany's Approach to the Euro Crisis*. London: European Council on Foreign Relations, http://www.ecfr.eu/page/-/ECFR49_GERMANY_BRIEF.pdf, accessed 3 September 2014.

Economides, Spyros and Vassilis Monastiriotis (eds) (2009) *The Return of Street Politics? Essays on the December Riots in Greece*. London: The Hellenic Observatory, LSE

Ekathimerini (2012) 'Olympic stadium opens doors to Athens homeless', Ekathimerini.com, 1 February, http://www.ekathimerini.com/4dcgi/_w_-articles_wsite1_1_01/02/2012_425521, accessed 17 November 2014.

Ekathimerini (2014) 'Nearly half of incomes below poverty line', Ekathimerini.com, 6 January, http://www.ekathimerini.com/4dcgi/_w_articles_wsite2_1_06/01/2014_534747, accessed 6 August 2014.

Ηλιάδου, Ευγενία (2012) 'Τόποι στο πουθενά και ετεροτοπίες: Το παράδειγμα του κέντρου Κράτησης στην Παγανή Μυτιλήνης.'*Το Προσφυγικό και μεταναστευτικό ζήτημα: Διαβάσεις και μελέτες συνόρων*. Σεβαστή Τρουμπέτα. Athens: Papazisis, pp. 315–38.

EUR-Lex (2014 [1951]) 'Preamble', in *Treaty Establishing the European Coal and Steel Community*, Paris, 18 April, http://old.eur-lex.europa.eu/LexUriServ/LexUriServ.do?uri=CELEX:11951K:EN:PDF, accessed 6 September 2014.

Europa (n.d.) 'Free movement of persons, asylum and migration', Europa, http://europa.eu/legislation_summaries/justice_freedom_security/free_movement_of_persons_asylum_immigration/index_en.htm, accessed 30 August 2014.

Europa (2012) 'Nobel Peace Prize 2012 awarded to European Union, one year on', Europa, http://europa.eu/about-eu/basic-information/eu-nobel/index_en.htm, accessed 6 September 2014.

European Commission (2010) *Table of Results: Standard Eurobarometer 73. Report*. Brussels: European Commission, http://ec.europa.eu/public_opinion/archives/eb/eb73/eb73_anx_full.pdf, accessed 6 September 2014.

European Commission (2013) *European Capitals of Culture: The Road to Success: From 1985 to 2010*. Brussels: European Commission, http://ec.europa.eu/programmes/creative-europe/actions/documents/ecoc_25years_en.pdf, accessed 2 September 2014.

European Network Against Racism (2013) 'Recycling hatred: racism(s) in Europe today', *Anti-Racism in Focus* 1 [online], http://cms.horus.be/files/99935/MediaArchive/publications/SymposiumReport_LR%20final%20final.pdf, accessed 10 October 2013.

Eurostat News Release (2014) 'Euro area unemployment rate at 11.9%. EU28 at 10.6%', 1 April, http://europa.eu/rapid/press-release_STAT-14-52_en.htm, accessed August 2014.

Evans, Lloyd (2013) 'Nicholas Hytner's National Theatre: Ten years and a million cheap tickets', *The Spectator*, 6 April, http://www.spectator.co.uk/arts/arts-feature/8878931/power-player/, accessed 9 May 2014.

Federici, Silvia (2011) 'Über affektive Arbeit', in Felicita Reuschling and Kunstraum Kreuzberg Bethanien (eds) *Beyond Reproduction/Mothering*, exhibition catalogue. Berlin: Revolver, pp. 14–20.

240 *Bibliography*

Federici, Silvia (2012 [1975]) 'Wages against housework', in Silvia Federici, *Revolution at Point Zero: Housework, Reproduction, and Feminist Struggle*. Oakland, CA: Common Notions/PM Press, pp. 15–22.

Federici, Silvia and Nicole Cox (2012 [1975]) 'Counterplanning from the kitchen', in Silvia Federici, *Revolution at Point Zero: Housework, Reproduction, and Feminist Struggle*. Oakland, CA: Common Notions/PM Press, pp. 28–40.

Ferrell, Jeff (2001) *Tearing Down the Streets: Adventures in Urban Anarchy*. Basingstoke and New York, NY: Palgrave Macmillan.

Ferrell, Jeff (2006) *The Empire of Scrounge: Inside the Urban Underground of Dumpster Diving, Trash Picking, and Street Scavenging*. New York, NY: New York University Press.

Fischer-Lichte, Erika (2013) 'Revivals of choric theatre as utopian visions', in Joshua Billings, Felix Budelmann and Fiona Macintosh (eds) *Choruses, Ancient and Modern*. Oxford: Oxford University Press, pp. 347–61.

Fisher, Mark (2009) *Capitalist Realism: Is There No Alternative?* Winchester: Zer0.

Fisher, Mark (2014) *Ghosts of My Life: Writings on Depression, Hauntology and Lost Futures*. Winchester: Zer0.

Fisher, Mark and Franco 'Bifo' Berardi (2013) 'Give me shelter', *Frieze Magazine* 152, http://www.frieze.com/issue/article/give-me-shelter/, accessed 24 April 2014.

Forster, Anthony (2002) *Euroscepticism in British Politics: Opposition to Europe in the British Conservative and Labour Parties since 1945*. London and New York, NY: Routledge.

Foucault, Michel (1986) 'Of other spaces', *Diacritics* 16(1): 22–7.

Fragkou, Marissia and Philip Hager (2013) 'Staging London: participation and citizenship on the way to 2012 Olympic Games', *Contemporary Theatre Review* 23(4): 532–41.

Francois-Cerrah, Myriam (2012) 'Fahim Alam: riots and the invisible hand of race', *Huffington Post*, 5 April, http://www.huffingtonpost.co.uk/myriam-francois/fahim-alam-_b_1406377.html, accessed 30 August 2014.

Fricker, Karen and Milija Gluhovic (eds) (2013) *Performing the 'New' Europe: Identities, Feelings and Politics in the Eurovision Song Contest*. Basingstoke and New York, NY: Palgrave Macmillan.

Fukuyama, Francis (2012) 'The future of history: can liberal democracy survive the decline of the middle class?', *Foreign Affairs* 91(1): 53–61.

Gardner, Lyn (2011) '*Entitled* – review: Royal Exchange, Manchester', *Guardian*, 13 July, http://www.theguardian.com/stage/2011/jul/13/entitled-review-manchester-royal-exchange, accessed 5 May 2014.

Gasché, Rodolphe (2009) *Europe, or the Infinite Task: A Study of a Philosophical Concept*. Stanford, CA: Stanford University Press.

Gavriilidis, Akis (2009) '[Greek riots 2008]: a mobile Tiananmen', Spyros Economides and Vassilis Monastiriotis (eds) *The Return of Street Politics? Essays on the December Riots in Greece*. London: The Hellenic Observatory, LSE, pp. 15–19.

Gelder, Ken, and Jane Margaret Jacobs (1998) *Uncanny Australia: Sacredness and Identity in a Postcolonial Nation*. Melbourne: Melbourne University Press.

Gilroy, Paul (2013) '1981 and 2011: from social democratic to neoliberal rioting', *South Atlantic Quarterly* 112(3): 550–8.

Gindin, Sam (2013) 'Art in the age of fatalism', *Jacobin Magazine*, https://www.jacobinmag.com/2013/12/art-in-the-age-of-fatalism/, accessed 31 May 2014.

Gluhovic, Milija (2013) *Performing European Memories: Trauma, Ethics, Politics*. Basingstoke and New York, NY: Palgrave Macmillan.

Golash-Boza, Tanya (2010) 'Notes from the field the criminalization of undocumented migrants: legalities and realities', *Societies Without Borders* 5(1): 81–90.

Goldhill, Simon (2007) *How to Stage Greek Tragedy Today*. Chicago, IL and London: University of Chicago Press.

Gómez-Peña, Guillermo (2000) *Dangerous Border Crossers: The Artist Talks Back*. London: Routledge.

Gómez-Peña, Guillermo (2005) *Ethno-Techno: Writings of Performance, Activism, and Pedagogy*. New York, NY: Routledge.

Gómez-Peña, Guillermo (2008) 'Border hysteria and the war against difference', *TDR: The Drama Review* 52(1): 196–203.

Gómez-Peña, Guillermo, Ramon Treves, James McCaffrey and Ric Malone (2006) '"The new barbarians": a photo-performance portfolio', *Journal of Visual Culture* 5(1): 17–27.

Goodwin, Tim (1988) *Britain's Royal National Theatre: The First 25 Years*. London: National Theatre in association with Nick Hern Books.

Graham, Stephen (2011) *Cities Under Siege: The New Military Urbanism*. London and New York, NY: Verso.

Granville Barker, Harley (1907) 'Preface (1907)' in William Archer and H. Granville Barker, *A National Theatre: Schemes and Estimates*. London: Duckworth & Co.

Green, Sarah (2010) 'Performing border in the Aegean: on relocating political, economic and social relations', *Journal of Cultural Economy* 3(2): 261–78.

Green, Sarah (2012) 'Απούσες λεπτομέρειες: Οι Διεθνικές ζωές των χωρίς έγγραφα νεκρών σωμάτων στο Αιγαίο.' *Το Προσφυγικό και μεταναστευτικό ζήτημα: Διαβάσεις και μελέτες συνόρων*. Σεβαστή Τρουμπέτα. Athens: Papazisis, pp. 133–58.

Gregory, Derek (2004) *The Colonial Present*. Oxford: Blackwell Publishing.

Gregory, Richard (2007) 'Paper to a Conference on Social Engagement at Tramway, Glasgow', Quarantine, http://qtine.com/resources/articles-interviews/richard-gregorys-paper-to-a-conference-on-social-engagement-at-tramway-glasgow/, accessed 21 April 2014.

Gregory, Richard (2013) 'You're just not going fast enough: Richard Gregory's opening address at Noorderzon Performing Arts Festival, Groningen, August 2013', Quarantine, http://qtine.com/resources/articles-interviews/you-are-just-not-going-fast-enough-richard-gregorys-opening-address-at-noorderzon-performing-arts-festival-groningen-august-2013/, accessed 9 May 2014.

Gregory, Richard (n.d.) 'White Trash', Quarantine, http://qtine.com/work/white-trash/, accessed 21 April 2014.

Habermas, Jürgen (2012) *The Crisis of the European Union: A Response*. Trans. Ciaran Cronin. Cambridge: Polity Press.

Hafner, Diane (2013) 'Objects, agency and context: Australian aboriginal expressions of connection in relation to museum artefacts', *Journal of Material Culture* 18(4): 347–66.

Hage, Ghassan (2003) *Against Paranoid Nationalism: Searching for Hope in a Shrinking Society*. Melbourne: Pluto Press Australia.

Hager, Philip (2013) 'Dramaturgies of crisis and performances of citizenship: Syntagma Square, Athens', in D. J. Hopkins and Kim Solga (eds) *Performance and the Global City*. Basingstoke and New York, NY: Palgrave Macmillan, pp. 245–65.

Haidinger, Bettina and Käthe Knittler (2014) *Feministische Ökonomie*. Vienna: Mandelbaum.

Haill, Lyn (2001) *In Rehearsal at the National: Rehearsal Photographs 1976–2001*. London: Oberon Books in association with the Royal National Theatre.

Halevi, Joseph (2012) 'Monti, Merkel e lo spettro di Brüning', *Il Manifesto*, 29 January, http://contropiano.org/news-politica/item/6394-mr-monti-fra%C3%BC-merkel-e-lo-spettro-di-br%C3%BCning, accessed 2 September 2014.

Hall, Edith (2005) 'Aeschylus, race, class and war in the 1990s', in Edith Hall, Fiona Macintosh and Amanda Wringley (eds) *Dionysus since 69: Greek Tragedy at the Dawn of the Third Millennium*. Oxford: Oxford University Press, pp. 169–97.

Hall, Edith (2011) 'The problem with Prometheus: myth, abolition, and radicalism', in Richard Alston *et al.* (eds) *Ancient Slavery and Abolition: From Hobbes to Hollywood*. Oxford: Oxford University Press, pp. 209–46.

Hall, Edith (2013) 'Mob, cabal or utopian commune? The political contestation of the ancient chorus 1789–1917', in Joshua Billings *et al.* (eds) *Choruses, Ancient and Modern*. Oxford: Oxford University Press, pp. 281–307.

Hall, Stuart (2003) '"In but not of Europe": Europe and its myths', in Luisa Passerini (ed.) *Figures d'Europe: Images and Myths of Europe*. Brussels: P.I.E.-Peter Lang, pp. 35–46.

Hall, Stuart and Bill Schwarz (1985) 'State and society, 1880–1930', in Mary Langan and Bill Schwarz (eds) *Crises in the British State 1880–1930*. London: Hutchinson & Co., pp. 7–32.

Hall, Stuart, Chas Critcher, Tony Jefferson, John Clarke and Brian Roberts (1979 [1978]) *Policing the Crisis: Mugging, the State, and Law and Order*. Basingstoke and New York, NY: Palgrave Macmillan.

Hammond, Will and Dan Steward (2008) *Verbatim Verbatim: Contemporary Documentary Theatre*. London: Oberon Books.

Hansen, Peo (2002) 'European integration, european identity and the colonial connection', *European Journal of Social Theory* 5(4): 483–98.

Hardt, Michael (2013) 'The procedures of love/Die Verfahren der Liebe', *dOCUMENTA* (13): 100 Notes – 100 Thoughts, No. 068. Ostfildern: Hatje Cantz.

Hardt, Michael and Antonio Negri (2000) *Empire*. Cambridge, MA and London: Harvard University Press.

Hardt, Michael and Antonio Negri (2004) *Multitude: War and Democracy in the Age of Empire*. New York, NY: Penguin.

Harris, Geraldine (2008) '*Susan and Darren*: the appearance of authenticity', *Performance Research* 13(4): 4–15.

Harvey, David (2005) *A Brief History of Neoliberalism*. Oxford: Oxford University Press.

Harvey, David (2011) 'David Harvey: Tent City University, OccupyLSX' [online video], http://www.youtube.com/watch?v=3sLKdLPh5Cw, accessed 6 September 2014.

Harvey, David (2012) *Rebel Cities: From the Right to the City to the Urban Revolution*. London: Verso.

Harvie, Jen (2005) *Staging the UK*. Manchester: Manchester University Press.

Hastings, Max (2011) 'UK riots: liberal dogma has spawned a generation of brutalised youth', *Daily Mail*, August, http://www.dailymail.co.uk/debate/

article-2024284/UK-riots-2011-Liberal-dogma-spawned-generation-brutalised-youths.html#ixzz3C6f7eqjr, accessed 1 September 2014.

Helms, Gesa, Marina Vishmidt and Lauren Berlant (2010) 'Affect and the politics of austerity: an interview exchange with Lauren Berlant', *Variant* 39–40: 3–6.

Hemming, Sarah (2009) 'Prompt reactions', *Financial Times*, 18 July, p. 9.

Heneghan, Tom (2011) 'Sarkozy joins allies burying multiculturalism', *Reuters*, 11 February, http://uk.reuters.com/article/2011/02/11/us-france-sarkozy-multiculturalism-idUSTRE71A4UP20110211, accessed 30 June 2014.

Herring, Christopher and Zoltán Glück (2011) 'The homeless question', in Carla Blumenkranz, Keith Gessen, Mark Greif, Sarah Leonard, Sarah Resnick, Nikil Saval, Eli Schmitt and Astra Taylor (eds) *Occupy!: Scenes from Occupied America*. London and New York, NY: Verso.

Higgins, Charlotte (2009) 'G2: Arts: Diary: England People Very Nice writer courts fresh controversy with Afghanistan play', *Guardian*, 1 April, p. 25.

Holderness, Graham (1988) 'Bardolatry: or, The cultural materialist's guide to Stratford-upon-Avon', in Graham Holderness (ed.) *The Shakespeare Myth*. Manchester: Manchester University Press, pp. 2–15.

Holdsworth, Nadine (2014) '"This blessed plot, this earth, this realm, this England": staging treatments of riots in recent British theatre', *Journal of Contemporary Drama in English (JCDE)* 2(1): 78–96.

Hole, Brian (2007) 'Playthings for the foe: the repatriation of human remains in New Zealand', *Public Archaeology* 6(1): 5–27.

Hollingsworth, Mark G. (2007) *Nineteenth Century Shakespeares: Nationalism and Moralism*. PhD thesis, University of Nottingham.

hooks, bell (1990) 'Choosing the margin as a space for radical openness', in bell hooks, *Yearning: Race, Gender and Cultural Politics*. Boston, MA: South End Press, pp. 145–54.

Hopkins, D. J. and Shelley Orr (2009) 'Memory/memorial/performance: Lower Manhattan, 1776/2001', in D. J. Hopkins, Shelly Orr and Kim Solga (eds) *Performance and the City*. Basingstoke and New York, NY: Palgrave Macmillan, pp. 33–50.

Hopkins, D. J. and Kim Solga (eds) (2013) *Performance and the Global City*. Basingstoke and New York, NY: Palgrave Macmillan.

Hopkins, D. J., Shelly Orr and Kim Solga (eds) (2009) *Performance and the City*. Basingstoke and New York, NY: Palgrave Macmillan.

House of Commons (2011) 'Daily Hansard debate', 11 August [online], http://www.publications.parliament.uk/pa/cm201011/cmhansrd/cm110811/debtext/110811-0001.htm, accessed 7 September 2014.

Hubert, Jane and Fforde, Cressida (2002) 'The reburial issue in the twenty-first century', in Cressida Fforde, Jane Hubert and Paul Turnbull (eds) *The Dead and Their Possessions: Repatriation in Principle, Policy and Practice*. London and New York, NY: Routledge, pp. 1–16.

Human Rights Watch (2011) *The EU's Dirty Hands: Frontex Involvement in Ill-treatment of Migrant Detainees in Greece*. New York, NY: Human Rights Watch, http://www.hrw.org/sites/default/files/reports/greece0911webwcover_0.pdf, accessed 2 September 2014.

Human Rights Watch (2012) *Hate on the Streets: Xenophobic Violence in Greece*. New York, NY: Human Rights Watch, http://www.hrw.org/sites/default/files/reports/greece0712ForUpload_0.pdf, accessed 2 September 2014.

Human Rights Watch (2013) *Unwelcome Guests: Greek Police Abuses of Migrants in Athens.* New York, NY: Human Rights Watch, http://www.hrw.org/sites/default/files/reports/greece0613_ForUpload.pdf, accessed 2 September 2014.

Hurley, Kieran and A. J. Taudevin (2013) *Chalk Farm.* London: Oberon.

Hussein, Nesreen (2013) 'Cairo: my city, my revolution', in D. J. Hopkins and Kim Solga (eds) *Performance and the Global City.* Basingstoke and New York, NY: Palgrave Macmillan, pp. 223–44.

Ijeh, Ike (2011) 'Culture clash – Las Arenas, Barcelona', Building.co.uk, 6 May, http://www.building.co.uk/culture-clash-las-arenas-barcelona/5017269.article, accessed 3 September 2014.

Independent (2009) 'The fall of the Wall: 20 years on', *Independent,* 9 November, http://www.independent.co.uk/news/world/europe/the-fall-of-the-wall-20-years-on-1817167.html, accessed 6 September 2014.

Institute for Policy Research (2014) *Funeral Poverty in the UK: Issues for Policy.* Bath: Institute for Policy Research, University of Bath, http://www.bath.ac.uk/ipr/our-publications/policy-briefs/funeral-poverty.html, accessed 10 July 2014.

International Council of Museums (2004) 'Declaration on the importance and value of universal museums', with a commentary by Peter-Klaus Schuster and George Abungu, *ICOM News* 1: 4–5, http://icom.museum/fileadmin/user_upload/pdf/ICOM_News/2004-1/ENG/p4_2004-1.pdf, accessed 7 September 2014.

Ioannidou, Eleftheria (2011) 'Monumental texts in ruins: Greek tragedy in Greece and Michael Marmarinos's postmodern stagings', in Conor Hanratty and Eleftheria Ioannidou (eds) *Epidaurus Encounters: Greek Drama, Ancient Theatre and Modern Performance.* Berlin: Parodos Verlag, pp. 121–45.

Jack, Ian (2013) 'Lee Rigby will be long remembered. Not so every military casualty', *Guardian,* 31 May.

Jacknis, Ira (1996) 'Repatriation as social drama: the Kwakiutl Indians of British Columbia, 1922–1980', *American Indian Quarterly* 20(2): 274–86. Special issue: 'Repatriation: an interdisciplinary dialogue'.

Jackson, Shannon (2011) *Social Works: Performing Art, Supporting Publics.* Abingdon: Routledge.

Jeffers, Alison (2012) *Theatre, Refugees and Crisis: Performing Global Identities.* Basingstoke and New York, NY: Palgrave Macmillan.

Jenkins, Simon (2011) 'The Hesitant Saviour: How Germany Bestrides Europe Once Again', *Guardian,* 13 March, http://www.theguardian.com/world/2011/mar/13/germany-bestrides-europe-again, accessed 6 September 2014.

Jestrovic, Silvija (2012) *Performance, Space, Utopia: Cities of War, Cities of Exile.* Basingstoke and New York, NY: Palgrave Macmillan.

Karlsbakk, Jonas (2011) '94 Sami skeletons brought to final rest', *Barents Observer,* 27 September, http://barentsobserver.com/en/news/94-sami-skeletons-brought-final-rest, accessed 11 July 2014.

Karschnia, Alexander (2013) 'Für ein freies und d.h. freies freies Theater!', andcompany&co., 30 October, http://www.andco.de/index.php?context=media§ion=texts_theory_theatre&id=7506, accessed 31 May 2014.

Katwala, Sunder (2012) 'How to hear one side of an argument: the missing voices of a sledgehammer polemic', openDemocracy, 14 March, http://www.opendemocracy.net/ourkingdom/sunder-katwala/how-to-hear-one-side-of-argument-missing-voices-of-sledgehammer-polemic, accessed April 2012.

Kear, Adrian (2013) *Theatre and Event: Staging the European Century*. Basingstoke and New York, NY: Palgrave Macmillan.

Kelleher, Joe (2009) *Theatre & Politics*. Basingstoke and New York, NY: Palgrave Macmillan.

Kelleher, Joe and Nicholas Ridout (eds) (2006) *Contemporary Theatres in Europe: A Critical Companion*. London and New York, NY: Routledge.

Kerseboom, Simone (2011) 'Grandmother-martyr-heroine: placing Sara Baartman in South African post-apartheid foundational mythology', *Historia* 56(1): 63–76.

Kershaw, Baz (1992) *The Politics of Performance: Radical Theatre as Cultural Intervention*. London and New York, NY: Routledge.

Kershaw, Baz (1999) *The Radical in Performance: Between Brecht and Baudrillard*. London and New York, NY: Routledge.

Khan, Rabina (2009) 'Why I've withdrawn from National Theatre debate', *Guardian*, 5 March.

Khosravi, Shahram (2007) 'The "illegal" traveller: an auto-ethnography of borders', *Social Anthropology/Anthropologie Sociale* 15(3): 321–34.

Kitchen Politics (2012) 'Queerfeministische Interventionen', in Silvia Federici, *Aufstand aus der Küche. Reproduktionsarbeit im globalen Kapitalismus und die unvollendete feministische Revolution*. Münster: Edition Assemblage, pp. 6–20.

Klug, Brian (2011) 'An almost unbearable insecurity: Cameron's Munich speech', MnM Working Paper 6. Adelaide: International Centre for Muslim and Non-Muslim Understanding, pp. 1–22, http://w3.unisa.edu.au/muslim-understanding/documents/klug-almost-unbearable.pdf, accessed 14 August 2014.

Knapper, Stephen (2010) 'Simon McBurney: shifting under/soaring over the boundaries of Europe', in Maria M. Delgado and Dan Rebellato (eds) *Contemporary European Theatre Directors*. Abingdon and New York, NY: Routledge, pp. 233–48.

Knowles, Caroline (2000) *Bedlam on the Streets*. London: Routledge.

Knowles, Caroline (2013) 'Use of photography in the practice of sociological investigation', keynote lecture, International Visual Sociological Association Conference, Goldsmiths, University of London, 8–10 July.

Knowles, Vanda (2012) 'The future of Europe: cities of Europe', *New Europe*, 15 October [online], http://www.neurope.eu/kn/article/future-europe-cities-future, accessed 7 September 2014.

Kollewe, Julia and Philip Inman (2012) 'Eurozone unemployment hits new high', *Guardian*, 31 October, http://www.guardian.co.uk/business/2012/oct/31/eurozone-unemployment-record-high-eurostat, accessed 31 October 2014.

Koroxenidis, Alexandra (2011) 'A discussion with Kalliopi Lemos', in Johannes Odenthal and Elina Kountouri (eds) *Kalliopi Lemos: Crossings, A Sculptural Trilogy about Migration*. Gottingen and Berlin: Steidl and Akademie der Künste.

Kruger, Loren (1992) *The National Stage: Theatre and Cultural Legitimation in England, France and America*. Chicago, IL and London: University of Chicago Press.

Kruger, Loren (2008) 'The national stage and the naturalized house', in S. E. Wilmer (ed.) *National Theatres in a Changing Europe*. Basingstoke and New York, NY: Palgrave Macmillan, pp. 34–48.

Kumar, Deepa (2012) *Islamophobia and the Politics of Empire*. Chicago, IL: Haymarket Books.

246 *Bibliography*

Kuriakopoulos, Alexandros and Euthumios Gourgouris (eds) (2009) *Ανησυχία:
Μια Καταγραφή του Αυθορμήτου του Δεκέμβρη του 2008.* Athens: Kastaniotis
Editions S.A.

Kwei-Armah, Kwame (2006) '"This is a cultural renaissance": an interview with
Kwame Kwei-Armah', in Geoffrey V. Davis and Anne Fuchs (eds) *Staging New
Britain: Aspects of Black and South Asian British Theatre Practice.* Brussels: Peter
Lang, pp. 239–52.

La Pocha Nostra (2013) 'Live art lab', La Pocha Nostra, http://www.pochanostra.
com, accessed 7 September 2014.

Ladd, Brian (1998) *The Ghosts of Berlin: Confronting German History in the Urban
Landscape.* Chicago, IL and London: University of Chicago Press.

Laera, Margherita (2011) 'Reaching Athens: performing participation and com-
munity in Rimini Protokoll's *Prometheus in Athens', Performance Research* 16(4):
46–51.

Laera, Margherita (2013) *Reaching Athens: Community, Democracy and Other
Mythologies in Adaptations of Greek Tragedy.* Oxford: Peter Lang.

Lahr, John (2012) 'Curtain-raiser: Nicholas Hytner's theatrical golden
age', *The New Yorker,* 23 April, pp. 32–7, http://www.newyorker.com/
reporting/2012/04/23/120423fa_fact_lahr?currentPage=all, accessed 14 August
2014.

Lammy, David (2012) *Out of the Ashes: Britain after the Riots.* 2nd edition. London:
Guardian Books.

Langsam, David (1990) 'Quest for return of the missing dead', *New Straits Times*
6: 10.

Lasarzik, Fabian (2011) 'Introduction', in Frank M. Raddatz, *Promethiade: Athens,
Istanbul, Essen.* Essen: Klartext Verlag, pp. 4–10.

Lazzarato, Maurizio (2006) 'Art and work', *Parachute* 122: 84–93.

Lazzarato, Maurizio (2012) *The Making of the Indebted Man.* Trans. Joshua David
Jordan. Cambridge, MA and London: Semiotext(e), MIT Press.

Lefebvre, Henri (1992) *The Production of Space.* Trans. Donald Nicholson-Smith.
Oxford: Blackwell.

Lefebvre, Henri (2003) *The Urban Revolution.* Trans. Robert Bonano. Minneapolis,
MN and London: University of Minnesota Press.

Lefebvre, Henri (2005) *The Critique of Everyday Life. Volume 3: From Modernity
to Modernism (Towards a Metaphilosophy of Daily Life).* Trans. Gregory Elliott.
London and New York, NY: Verso.

Lefebvre, Henri (2013) *Rhythmanalysis: Space, Time and Everyday Life.* Trans. Stuart
Elden and Gerald Moore. London and New York, NY: Bloomsbury.

Lehmann, Hans-Thies (2002) 'Versuch über Fatzer', in Hans-Thies Lehmann, *Das
Politische Schreiben.* Berlin: Theater der Zeit, pp. 250–60.

Lemos, Kalliopi (2009) *At Crossroads* [online], http://www.kalliopilemos.com/#/
projects/past/at-crossroads--berlin-2009, accessed 30 August 2014.

Lemos, Kalliopi and Filippos Koutsaftis (2009) *Crossing,* performance film, Eleusis,
31 July [online video], http://vimeo.com/28853678, accessed 30 August 2014.

Leontis, Artemis (1995) *Topographies of Hellenism: Mapping a Homeland.* Ithaca,
NY: Cornell University Press.

Levy, Carl (2010) 'Refugees, Europe, camps/state of exception: "Into the zone",
The European Union and extraterritorial processing of migrants, refugees, and
asylum-seekers (theories and practice)', *Refugee Survey Quarterly* 29(1): 92–119.

Lewis, Peter (1990) *The National: A Dream Made Concrete*. London: Methuen.

Lichtenfels, Peter and John Rouse (eds) (2013) *Performance, Politics and Activism*. Basingstoke and New York, NY: Palgrave Macmillan.

Liebknecht, Karl (1952 [1915]) 'Der Hauptfeind steht im eigenen Land!', in Karl Liebknecht, *Ausgewählte Reden und Aufsätze*. Berlin: Dietz Verlag, pp. 296–301.

Lindner, Fabian (2011) 'In today's debt crisis, Germany is the US of 1931', *Guardian*, 24 November, http://www.theguardian.com/global/2011/nov/24/debt-crisis-germany-1931, accessed 2 September 2014.

Lindner, Fabian (2013) 'Greece is like Germany's Weimar Republic', *Social Europe Journal*, 18 January, http://www.social-europe.eu/2013/01/greece-is-like-germanys-weimar-republic, accessed 2 September 2014.

londonse1 (2009) 'South Bank demo at National Theatre over "racist" play', londonse1 [online], 28 February, http://www.london-se1.co.uk/news/view/3763, accessed 6 September 2014.

López Petit, Santiago (2010) *Identitat i Crisi: Una Entrevista amb Santiago López Petit*. Barcelona: El Tangram.

Lorey, Isabell (2013) 'Präsentische Demokratie als konstituierender Prozess', *arranca!* 47: 49–51.

Lorey, Isabell, Roberto Nigro and Gerald Raunig (2012) 'Biopolitik', in Isabell Lorey, Roberto Nigro and Gerald Raunig (eds) *Inventionen 2*. Zurich: Diaphanes, pp. 188–92.

Luppa, Iris (2009) 'Pre-Fascist period: to think and to want: Kuhle Wampe', in John Gibbs and Douglas Pye (eds) *Close Up: The Police Series, Weimar Cinema, Men's Cinema*. New York, NY: Wallflower Press, pp. 109–33.

Maeckelbergh, Mariane (2009) *The Will of the Many: How the Alterglobalisation Movement is Changing the Face of Democracy*. London: Pluto Press.

Magnat, Virginie (2005) 'Devising utopia, or asking for the moon', *Theatre Topics* 15(1): 73–86.

Mak, Geert (2008) *In Europe: Travels through the Twentieth Century*. Trans. Sam Garrett. London: Vintage.

Marchetos, Spyros (2013) 'Essay: the new untouchables', *New Statesman*, 27 August, http://www.newstatesman.com/austerity-and-its-discontents/2013/08/new-untouchables, accessed 31 August 2014.

Marciniak, Katarzyna (2006) *Alienhood: Citizenship, Exile, and the Logic of Difference*. Minneapolis, MN: University of Minnesota Press.

Marcuse, Herbert (1991) *One-Dimensional Man*. 2nd edition. London: Routledge.

Martin, Lauren (2012) 'Review essay: detaining noncitizens: law, security, crime, and politics', *Environment and Planning D: Society and Space* 30: 748–55.

Marx, Karl (1977 [1867]) *Capital, Volume I*. New York, NY: Vintage.

Marx, Karl and Friedrich Engels (2012) *The Communist Manifesto*. London and New York, NY: Verso.

Mason, Paul (2012a) 'The graduates of 2012 will survive only in the cracks of our economy', *Guardian*, 1 July, http://www.theguardian.com/commentisfree/2012/jul/01/graduates-2012-survive-in-cracks-economy, accessed 20 February 2014.

Mason, Paul (2012b) 'Timon of Athens: the power of money', *Guardian*, 20 July, http://www.theguardian.com/stage/2012/jul/20/timon-of-athens-paul-mason, accessed 3 September 2014.

Mason, Paul (2012c) 'Love or nothing: the real Greek parallel with Weimar', BBC News, 26 October, http://www.bbc.co.uk/news/world-20105881, accessed 3 September 2014.

Mason, Paul (2012d) *Why It's Kicking Off Everywhere: The New Global Revolutions*. London: Verso.

Massey, Doreen (1994) *Space, Place and Gender*. Cambridge: Polity Press.

McConachie, Bruce (2008) 'Towards a history of national theatres in Europe', in S. E. Wilmer (ed.) *National Theatres in a Changing Europe*. Basingstoke and New York, NY: Palgrave Macmillan, pp. 49–60.

McDonald, Charlotte (2012) 'Are Greeks the hardest workers in Europe?', BBC News, 26 February, http://www.bbc.co.uk/news/magazine-17155304, accessed 16 November 2012.

McGuigan, Jim (2009) *Cool Capitalism*. London: Pluto Press.

McKinnie, Michael (2013) 'Performing like a city: London's South Bank and the cultural politics of urban governance', in Erika Fischer-Lichte and Benjamin Wihstutz (eds) *Performance and the Politics of Space: Theatre and Topology*. New York, NY and Abingdon: Routledge, pp. 66–80.

McLeay, Alexander (1831) 'Government order, no. 7, Colonial Secretary's office', *The Sydney Gazette and New South Wales Advertiser*, 21 April, http://trove.nla.gov.au/ndp/del/article/2200221, accessed 9 July 2014.

McNally, David (2011) *Global Slump: The Economics and Politics of Crisis and Resistance*. Oakland, CA: PM Press.

McRobbie, Angela (2009) *The Aftermath of Feminism: Gender, Culture and Social Change*. London: Sage.

Mead, Hirini Moko (2003) *Tikanga Maori*. Wellington: Huia Publishers.

Merrifield, Andy and Erik Swyngedouw (1996) 'Social justice and the urban experience', in Andy Merrifield and Erik Swyngedouw (eds) *The Urbanization of Injustice*. London: Lawrence & Wishart.

Messenger, Ben (2013) 'Greece facing big EU fines over illegal landfill violations', Waste Management World, http://www.waste-management-world.com/articles/2013/02/greece-facing-eu-fine-for-illegal-landfill-violations.html, accessed 27 January 2014.

Metge, Joan (2010) *Tuamaka: The Challenge of Difference in Aotearoa New Zealand*. Auckland: Auckland University Press.

Meyer, Kurt (2008) 'Reading, streets, cities', in Kanishka Goonewardena, Stefan Kipfer, Richard Milgrom and Christian Schmid (eds) *Space, Difference, Everyday Life: Reading Henri Lefebvre*. London: Routledge, pp. 147–60.

Mezzadra, Sandro (2005) 'Taking care: migration and the political economy of affective labor', lecture at Goldsmiths, University of London, Centre for the Study of Invention and Social Process, 16 March, https://caringlabor.files.wordpress.com/2010/12/mezzadra_taking_care.pdf, accessed 31 May 2014.

Miessen, Marcus and Chantal Mouffe (2010) 'Undoing the Innocence of Participation' in *The Nightmare of Participation*. Berlin: Stenberg Press, pp. 41–57.

Mitropoulos, Angela (2011) 'From precariousness to risk management and beyond', European Institute of Progressive Cultural Policies, January, http://eipcp.net/transversal/0811/mitropoulos/en, accessed 31 May 2014.

Moran, Dominique, Nick Gill and Deidre Conlon (eds) (2013) *Carceral Spaces: Mobility and Agency in Imprisonment and Migrant Detention*. Farnham: Ashgate.

Moran, James (2012) 'Reflections on the first onstage protest at the Royal National Theatre: What is the problem with Richard Bean's recent work?', *Studies in Theatre and Performance* 32(1): 15–28.

Mouffe, Chantal (1992a) 'Citizenship and political identity', *October* 61: 28–32. Special issue: 'The identity in question'.

Mouffe, Chantal (1992b) 'Preface: democratic politics today', in Chantal Mouffe (ed.) *Dimensions of Radical Democracy: Pluralism, Citizenship, Community*. London: Verso, pp. 1–14.

Mouffe, Chantal (1994) 'For a politics of nomadic identity', in George Robertson *et al.* (eds) *Travellers' Tales: Narratives of Home and Displacement*. London and New York, NY: Routledge, pp. 105–13.

Mouffe, Chantal (2012) 'Strategies of radical politics and aesthetic resistance', Truth is Concrete, 8 October, http://truthisconcrete.org/texts/?p=19, accessed 31 May 2014.

Mulholland, Hélène (2011) 'Occupy protesters accuse Boris Johnson of defending the rich', *Guardian*, 16 November, http://www.guardian.co.uk/politics/2011/nov/16/occupy-london-boris-johnson-defending-rich, accessed 1 September 2014.

Müller, Heiner (2005) '"Mich interessiert der Fall Althusser...", Gesprächsprotokoll', in Frank Hörnigk (ed.) *Schriften Werke*, Volume 8. Frankfurt am Main: Suhrkamp, pp. 241–6.

Müller-Schöll, Nikolaus (ed.) (2012) *Performing Politics. Politisch Kunst machen nach dem 20. Jahrhundert*. Berlin: Theater der Zeit.

Mumford, Meg (2013) 'Rimini Protokoll's reality theatre and intercultural encounter: towards an ethical art of partial proximity', *Contemporary Theatre Review* 23(2): 153–65.

Münchau, Wolfgang (2012) 'S.P.O.N. Die Spur des Geldes: Wilkommen in Weimar', *Spiegel Online*, 9 October, http://www.spiegel.de/wirtschaft/euro-krise-sparpolitik-verstaerkt-die-schuldenkrise-in-griechenland-a-832034.html, accessed 2 September 2014.

Münchau, Wolfgang (2013) 'Monti is not the right man to lead Italy', *Financial Times*, 20 January, http://www.ft.com/intl/cms/s/0/882bb27a-6166-11e2-957e-00144feab49a.html#axzz2fiBNrIbe, accessed 2 September 2014.

Nasar Meer and Tariq Modood (2009) 'The multicultural state we're in: Muslims, "multiculture" and the "civic re-balancing" of British multiculturalism', *Political Studies* 57: 473–97.

National Theatre (2010) 'Nicholas Hytner, Director of the National Theatre', in *The Royal National Theatre Annual Report and Financial Statements 2009–10*, London: National Theatre, p. 10, http://www.nationaltheatre.org.uk/sites/all/libraries/files/documents/NT_Annual_Report_0910.pdf, accessed June 2014.

National Theatre (2014) 'American Associates of the National Theatre', National Theatre, http://www.nationaltheatre.org.uk/support-us/american-associates-of-the-national-theatre, accessed 14 August 2014.

Negri, Massimo (2013) 'Emerging new trends in the European museum panorama', in Ann Nicholls, Manuela Pereira and Margherita Sani (eds) *New Trends in Museums of the 21st Century: Report 7*. Bologna: Istituto per i Beni Artistici Culturali e Naturali for The Learning Museum (LEM), pp. 15–39.

Nettlefold, Jocelyn (2007) 'Aboriginal remains row', Australian Broadcasting Corporation, 21 February [television transcript], http://www.abc.net.au/7.30/content/2007/s1853611.htm, accessed 14 July 2014.

Nield, Sophie (2006a) 'On the border as theatrical space: appearance, dislocation and the production of the refugee', in Joe Kelleher and Nicholas Ridout (eds) *Contemporary Theatres in Europe: A Critical Companion*. London: Routledge, pp. 61–72.

Nield, Sophie (2006b) 'There is another world: space, theatre and global anticapitalism', *Contemporary Theatre Review* 16(1): 51–61.

Nield, Sophie (2008) 'The Proteus Cabinet, or "we are Here but not Here"', *Research in Drama Education: The Journal of Applied Theatre and Performance* 13(2): 137–45.

Nield, Sophie (2010) 'Galileo's finger and the perspiring waxwork: on death, appearance and the promise of flesh', *Performance Research* 15(2): 39–43.

Nield, Sophie (2012) 'Siting the people: power, protest, and public space', in Anna Birch and Joanne Tompkins (eds) *Performing Site Specific Theatre: Politics, Place, Practice*. Basingstoke and New York, NY: Palgrave Macmillan, pp. 219–32.

Nielsen, Lara D. and Patricia Ybarra (eds) (2012) *Neoliberalism and Global Theatres: Performance Permutations*. Basingstoke and New York, NY: Palgrave Macmillan.

Nightingale, Benedict (2009) 'The NT – stage or soapbox?', *The Times: T2*, 9 February, p. 2.

Ntiniakos, Antonis (2012) 'Αθήνα: η πόλη του Scrap Metal', *LIFO*, 31 October, http://www.lifo.gr/mag/features/3484, accessed 22 November 2014.

Nyong'o, Tavia (2012) 'The scene of occupation', *TDR: The Drama Review* 56(4): 136–49.

Odenthal Johannes and Irene Tobben (2011) 'Europe's birth from migration: how Kalliopi Lemos's sculptures build on Europe's historical, mythological and anthropological traditions', in Johannes Odenthal and Elina Kountouri (eds) *Kalliopi Lemos: Crossings, A Sculptural Trilogy about Migration*. Gottingen and Berlin: Steidl and Akademie der Künste.

Odenthal, Johannes and Elina Kountouri (eds) (2011) *Kalliopi Lemos: Crossings, A Sculptural Trilogy about Migration*. Gottingen and Berlin: Steidl and Akademie der Künste.

Opoku, Kwame (2010) 'Is the Declaration on the Value and Importance of the "Universal Museums" now worthless? Comments on imperialist museology', *Modern Ghana* 26, http://www.modernghana.com/news/265620/1/is-the-declaration-on-the-value-and-importance-of-.html, accessed 11 July 2014.

Otto, Rudolf (1958 [1923]) *The Idea of the Holy*. Oxford and New York, NY: Oxford University Press.

Pagden, Anthony (ed.) (2002) *The Idea of Europe from Antiquity to the European Union*. Cambridge: Cambridge University Press.

Palladini, Giulia and Nicholas Ridout (2013) 'Berceuses et révolution'. Trans. David Bernagout. *La Vie Manifeste*, 6 January, http://laviemanifeste.com/archives/7505, accessed 3 September 2014.

Papastergiadis, Nikos (2002) 'Small gestures in specific places: communication and topography', *Afterall: A Journal of Art, Context and Enquiry* 6: 106–13.

Parkins-Brown, Kareem (2012) 'The dream dealer', in *Eloquence in Times of Crisis: Barbican Young Poets 2011–12*, p. 22, http://www.barbican.org.uk/media/upload/education/anthology.pdf, accessed 7 September 2014.

Passerini, Luisa (2003) 'Dimensions of the symbolic in the construction of Europeanness', in Luisa Passerini (ed.) *Figures d' Europe: Images and Myths of Europe*. Brussels: Peter Lang, pp. 20–32.

Passerini, Luisa (2007) *Memory and Utopia: The Primacy of Intersubjectivity*. London: Equinox.

Paxton, Robert O. (2004) *The Anatomy of Fascism*. New York, NY: Vintage Books.

Peacock, D. Keith (1999) *Thatcher's Theatre: British Theatre and Drama in the Eighties*. Westport, CT and London: Greenwood Press.

Peers, Laura (2013) '"Ceremonies of renewal": visits, relationships, and healing in the museum space', *Museum Worlds: Advances in Research* 1: 136–52.

Performance Audit (2009) *Performance Audit of the International Repatriation Program*. Parkes, ACT: Department of Finance and Deregulation, Australian Government, http://www.anao.gov.au/~/media/Uploads/Documents/performance_audit_of_the_international_repatriation_program.pdf, accessed 14 July 2014.

Pewny, Katharina (2012) 'The ethics of encounter in contemporary theater performances', *Journal of Literary Theory* 6(1) [online], http://www.jltonline.de/index.php/articles/article/view/483/1219, accessed 22 August 2014.

Phelan, Peggy (1993) *Unmarked: The Politics of Performance*. London and New York, NY: Routledge.

Phelan, Peggy (2008) 'Afterword: "In the valley of the shadow of death": the photographs of Abu Ghraib', in Patrick Anderson and Jisha Menon (eds) *Violence Performed: Local Roots and Global Routes of Conflict*. Basingstoke and New York, NY: Palgrave Macmillan, pp. 372–84.

Pink, Sarah (2011) 'Multimodality, multisensoriality and ethnographic knowing: social semiotics and the phenomenology of perception', *Qualitative Research* 11(1): 261–76.

Pipili, Foteini (2012) 'Κάτω τα χέρια από τα σκουπίδια μας', *To Kouti tis Pandoras*, 29 January, http://www.koutipandoras.gr/article/14709/foteini-pipili-kato-ta-heria-apo-ta-skoypidia-mas, accessed 27 January 2014.

Piscator, Erwin (1968) 'Politisches Theater heute', in Ludwig Hoffmann (ed.) *Schriften. Vol. 2: Aufsätze, Reden, Gespräche*. Berlin: Henschelverlag, pp. 333–40.

Pollesch, René (2009) 'Dialektisches Theater now! Brechts Entfremdungs-Effekt', in Corinna Brocher and Aenne Quiñones (eds) *Liebe ist kälter als das Kapital. Stücke, Texte, Interviews*. Reinbek: Rowohlt, pp. 301–5.

Power, Nina (2012) 'The pessimism of time', *Overland* 209, http://overland.org.au/previous-issues/issue-209/feature-nina-power/, accessed 8 May 2014.

Power, Nina (2014) 'Time does not always heal: state violence and psychic damage', *openDemocracy*, 28 April, http://www.opendemocracy.net/transformation/nina-power/time-does-not-always-heal-state-violence-and-psychic-damage, accessed 8 May 2014.

Puar, Jasbir (2012) 'Precarity talk: a virtual roundtable with Lauren Berlant, Judith Butler, Bojana Cvejic, Isabell Lorey, Jasbir Puar, and Ana Vujanovic', *TDR: The Drama Review* 56(4): 163–77.

Pugliese, Joseph (2009) 'Crisis heterotopias and border zones of the dead', *Continuum: Journal of Media & Cultural Studies* 23(5): 663–79.

Pugliese, Joseph (ed.) (2010) *Trans-Mediterranean: Diasporas, Histories, Geopolitcal Spaces*. Brussels: P.I.E Peter Lang.

Puig, Salvador Martí (2012) '"15M": The Indignados', in Janet Byrne (ed.) *The Occupy Handbook*. New York, NY: Back Bay Books, pp. 209–17.

Quarantine (2011a) *Entitled*, unpublished English surtitles created for the show at La Casa Encendida, Madrid, 2012, provided by the company.

Quarantine (2011b) 'The people in the room: a kind of conversation about Quarantine', in Peter Crowley and Willie White (eds) *No More Drama*. Dublin: Project Press/Carysfort Press, pp. 213–31.

Quarantine (2013) 'Quarantine: *The Dyas Sisters*', Contact Theatre, June, http://contactmcr.com/whats-on/1185-quarantine-the-dyas-sisters/, accessed 1 May 2014.

Quinn, Paul (2013) 'Romanian and Bulgarian migration stirs up ancient, dark parts of the brain', *Guardian*, 31 December, http://www.theguardian.com/commentisfree/2013/dec/31/romanian-bulgarian-migration-politicians, accessed 12 June 2014.

Rachman, Gideon (2012) 'Welcome to Berlin, Europe's new capital', *Financial Times*, 22 October, http://www.ft.com/cms/s/0/01db45ba-1c32-11e2-a63b-00144feabdc0.html#axzz2KJhHEcRj, accessed 2 September 2014.

Raddatz, Frank M. (2011a) 'Frank Raddatz in conversation with Helgard Haug and Daniel Wetzel', in Frank M Raddatz (ed.) *Promethiade: Athens, Istanbul, Essen*. Essen: Klartext Verlag, pp. 25–33.

Raddatz, Frank M. (ed.) (2011b) *Promethiade: Athens, Istanbul, Essen*. Essen: Klartext Verlag.

Rajaram, Prem Kumar and Carl Grundy-Warr (eds) (2007) *Borderscapes: Hidden Geographies and Politics at Territory's Edge*. Minneapolis, MN: University of Minnesota Press.

Rancière, Jacques (1999) *Disagreement: Politics and Philosophy*. Trans. Julie Rose. Minneapolis, MN: University of Minnesota Press.

Rancière, Jacques (2006) *The Politics of Aesthetics: The Distribution of the Sensible*. Trans. Gabriel Rockhill. London and New York, NY: Continuum.

Rancière, Jacques (2009a) *Aesthetics and Its Discontents*. Trans. Steven Corcoran. Cambridge: Polity Press.

Rancière, Jacques (2009b) *The Emancipated Spectator*. Trans. Gregory Elliot. London and New York, NY: Verso.

Rattansi, Ali (2011) *Multiculturalism: A Very Short Introduction*. Oxford: Oxford University Press.

Raunig, Gerald (2010) 'Intensifying theory production: the school of the missing teacher', European Institute for Progressive Cultural Politics, October, http://eipcp.net/transversal/1210/raunig/en, accessed 31 May 2014.

Rayner, Jay (2007) 'Why is nobody doing the right thing?', *Observer*, 11 November.

Read, Alan (2013) *Theatre in the Expanded Field: Seven Approaches to Performance*. London and New York, NY: Bloomsbury.

Red Channels (2011) 'Suicide or Solidarity: Red Channels in Berlin 2–12 July', Red Channels, http://redchannelsinberlin.wordpress.com/, accessed 3 September 2014.

Reinelt, Janelle (2001) 'Performing Europe: identity formation for a "new" Europe', *Theatre Journal* 53(3): 365–87.

Reinius, Lotten Gustafsson (2013) *Sacred Things in the Postsecular Society*. Stockholm: Världskultur Museerna.

Ridout, Nicholas (2008) 'Performance and democracy', in Tracy C. Davis (ed.) *The Cambridge Companion to Performance Studies*. Cambridge: Cambridge University Press, pp. 11–22.

Ridout, Nicholas (2009) *Theatre & Ethics*. Basingstoke and New York, NY: Palgrave Macmillan.

Rietbergen, Peter (2006) *Europe: A Cultural History*. 2nd edition. Abingdon and New York, NY: Routledge.

Rimini Protokoll (2010) 'Materialbox Prometheus in Athens by Rimini Protokoll', Rimini Protokoll [website], http://rimini-protokoll.de/materialbox/prometheus/2-2-Homepage.html, accessed 7 June 2014.

Riots Reframed (2013) 'Riots Reframed – the journey', http://riotsreframed.com/press/, accessed 6 September 2014.

Rivera-Servera, Ramòn and Harvey Young (eds) (2011) *Performance in the Borderlands*. Basingstoke and New York, NY: Palgrave Macmillan.

Rolleston, James (1996) 'The truth of unemployment: Walter Benjamin reads his own times', *South Atlantic Review* 61(2): 27–49.

Rosenthal, Daniel (2013) *The National Theatre Story*. London: Oberon Books.

Sacchi, Matteo (2013) 'Strani affari all'estero e discorsi in stile Hitler: Grillo perde la testa', *Il Giornale*, 8 March.

Samaras, Antonis (2012) 'Die griechische Demokratie steht vor ihrer größten Herausforderung', *Handelsblatt*, 5 October, http://www.handelsblatt.com/politik/international/antonis-samaras-die-griechische-demokratie-steht-vor-ihrer-groessten-herausforderung/7217474.html, accessed 2 September 2014.

Sassatelli, Monica (2002) 'Imagined Europe: the shaping of a European cultural identity through EU cultural policy', *European Journal of Social Theory* 5(4): 435–51.

Sassatelli, Monica (2009) *Becoming Europeans: Cultural Identity and Cultural Policies*. Basingstoke and New York, NY: Palgrave Macmillan.

Sauvage, Alexandra (2007) 'Narratives of colonisation: the Musée du quai Branly in context', *ReCollections: Journal of the National Museum of Australia* 2(2): 135–52.

Scanlan, John (2005) *On Garbage*. London: Reaktion Books.

Schneider, Rebecca (2011) *Performing Remains: Art and War in Times of Theatrical Reenactment*. London and New York, NY: Routledge.

Schneider, Rebecca (2012) 'It seems as if ... I am dead. Zombie capitalism and theatrical labor', *TDR: The Drama Review* 56(4): 150–62.

Sciolino, Elaine (2007) 'French debate: is Maori head body part or art?', *The New York Times*, 26 October, http://www.nytimes.com/2007/10/26/world/europe/26france.html?pagewanted=print&_r=0, accessed 14 July 2014.

Scobie, Claire (2009) 'The long road home', *Observer*, 28 June, http://www.theguardian.com/world/2009/jun/28/aborigines-reclaim-ancestors-remains, accessed 15 July 2014.

Senelick, Laurence (1991) 'General introduction', in Laurence Senelick (ed.) *National Theatre in Northern and Eastern Europe, 1746–1900*. Cambridge: Cambridge University Press, pp. 1–16.

Shore, Cris (2000) *Building Europe: The Cultural Politics of European Integration*. London: Routledge.

Siebold, Sabine (2010) 'Merkel says that German multiculturalism has failed', *Reuters Germany*, 16 October, http://www.reuters.com/article/2010/

10/16/us-germany-merkel-immigration-idUSTRE69F1K320101016, accessed 30 June 2014.

Simpson, Moira (2009) 'Museums and restorative justice: heritage, repatriation and cultural education', *Museum International* 61(1–2): 121–9.

Skribanos, Takis (2012) 'Οι δρόμοι του Scrap', *Athens Voice*, 12 June, http://www.athensvoice.gr/the-paper/article/396/%CE%BF%CE%B9-%CE% B4%CF%81%CF%8C%CE%BC%CE%BF%CE%B9-%CF%84%CE%BF%CF% 85-scrap, accessed 22 November 2014.

Slovo, Gillian (2011a) *The Riots* (from spoken evidence). London: Oberon.

Slovo, Gillian (2011b) 'Writing *The Riots*', The Arts Desk, 23 November, http://www.theartsdesk.com/theatre/gillian-slovo-writing-riots, accessed 21 June 2013.

Smith, Alistair (2013) 'Once you are being attacked by both sides you are doing ok', *The Stage*, 17 October, p. 24.

Smith, Anthony D. (1999) *Myths and Memories of the Nation*. Oxford: Oxford University Press.

Smith, Helena (2011) 'Greek crisis forces thousands of Athenians into rural migration', *Guardian*, 13 May, http://www.theguardian.com/world/2011/may/13/greek-crisis-athens-rural-migration, accessed 2 September 2014.

Smith, Helena (2012) 'Greek crackdown on illegal immigrants leads to mass arrests', *Guardian*, 7 August, http://www.guardian.co.uk/world/2012/aug/07/greece-crackdown-illegal-immigrants-arrest, accessed 17 November 2014.

Sotiris, Panagiotis (2013) 'Reading revolt as deviance: Greek intellectuals and the December 2008 revolt of Greek youth', *Interface: A Journal for and about Social Movements* 5(2): 47–77, http://www.interfacejournal.net/wordpress/wp-content/uploads/2013/11/Interface-5-2-Sotiris.pdf, accessed 12 April 2014.

Spiegel (2012) 'European luminaries reflect on Euro: "Seventeen countries were far too many"', *Spiegel Online International*, 11 September, http://www.spiegel.de/international/europe/spiegel-interview-with-helmut-schmidt-and-valery-giscard-d-estaing-a-855127.html, accessed 30 June 2014.

Squibb, Stephen (2010) 'No more séances: interview with Red Channels', *Idiom*, 18 October [online], http://idiommag.com/2010/10/no-more-seances-interview-with-red-channels/, accessed 3 September 2014.

Stegemann, Bernd (2013) *Kritik des Theaters*. Berlin: Theater der Zeit.

Steinweg, Reiner (ed.) (1976) *Brechts Modell der Lehrstücke. Zeugnisse, Diskussionen, Erfahrungen*. Frankfurt am Main: Suhrkamp.

Still, Judith (2010) *Derrida and Hospitality: Theory and Practice*. Edinburgh: Edinburgh University Press.

Stoller, Terry (2013) *Tales of the Tricycle Theatre*. London: Methuen.

Strasser, Susan (1999) *Waste and Want: A Social History of Trash*. New York, NY: Henry Holt and Company.

Tassin, Étienne (1992) 'Europe: a political community?', in Chantal Mouffe (ed.) *Dimensions of Radical Democracy: Pluralism, Citizenship, Community*. London: Verso, pp. 169–92.

Taylor, David Francis (2012) 'Shakespeare and drama', in Gail Marshall (ed.) *Shakespeare in the Nineteenth Century*. Cambridge: Cambridge University Press, pp. 129–47.

Taylor, Imogen and Katarzyna Marciniak (2013) 'Immigrant protest: an introduction', *Citizenship Studies* 17(2): 143–56.

Te Papa Tongarewa (2010) 'Kōiwi Tangata Policy', Te Papa Tongarewa/Museum of New Zealand, 1 October, http://www.tepapa.govt.nz/aboutus/repatriation/Pages/overview.aspx, accessed 12 July 2014.

Te Papa Tongarewa (2014) 'International repatriations', Te Papa Tongarewa/Museum of New Zealand, http://www.tepapa.govt.nz/AboutUs/Repatriation/Pages/InternationalRepatriations.aspx, accessed 12 July 2014.

Telegraph (2009) 'The Berlin Wall fell and a new Europe rose', Telegraph, 9 November, http://www.telegraph.co.uk/comment/telegraph-view/6528859/The-Berlin-Wall-fell-and-a-new-Europe-rose.html, accessed 6 September 2014.

Telegraph (2011) 'UK riots: David Cameron's statement in full', Telegraph, 10 August, http://www.telegraph.co.uk/news/uknews/crime/8693134/UK-riots-David-Camerons-statement-in-full.html, accessed 1 September 2014.

Terzopoulos, Theodoros, Frank Raddatz, Jolanta Nölle, Fabian Lazarisk and Dikmen Gürün (2011) 'Manifesto 2010', in Frank Raddatz (ed.) Promethiade: Athens, Istanbul, Essen. Essen: Klartext Verlag, p. 7.

'The Homecoming' (2013) Museum of South Australia, May [online video], http://www.youtube.com/watch?v=vSl0ySPe9Y0, accessed 14 July 2014.

The New Culture Forum (2007) 'Politics and the theatre: What's left?', London, 5 March, New Culture Forum [online video], http://newcultureforum.blogspot.co.uk/2007/03/politics-and-theatre-whats-left-watch.html, accessed 3 September 2014.

The Times (2009) 'Best of 2009', The Times, 12 December, p. 14.

Thompson, Christina (2006) 'Smoked heads', in Drusilla Modjesk (ed.) The Best Australian Essays: 2006. Melbourne: Black Inc., pp. 23–37.

Tomlin, Liz (2013) Acts and Apparitions: Discourses of the Real in Performance Practice and Theory, 1990–2010. Manchester: Manchester University Press.

Tsilimpounidi, Myrto (2012a) 'Athens 2012: performances in crisis, or what happens when a city goes soft?', City: Analysis of Urban Trends, Culture, Theory, Policy, Action 16(5): 546–56.

Tsilimpounidi, Myrto (2012b) 'Consumer basket', International Visual Sociological Association Thematic Group TG05 Newsletter, 4 May.

Tuomala, Jeffrey (1993) 'Christ's atonement as the model for civil justice', American Journal of Jurisprudence 38: 221–55.

Turbet, Peter (2011) The First Frontier: The Occupation of the Sydney Region, 1788–1816. Kenthurst, NSW: Rosenburg Publishing.

Turri, Maria Grazia (2013) 'I ricorsi storici e le memorie rimosse della crisi', Sbilanciamoci, 20 September, http://www.sbilanciamoci.info, accessed 3 September 2014.

Tynan, Kenneth (1964) 'The National Theatre', Journal of the Royal Society of Arts 112(5097): 687–702.

Ubelaker, Douglas H. and Lauryn Guttenplan Grant (1989) 'Human skeletal remains: preservation or reburial?', American Journal of Physical Anthropology 32: 249–87.

United Nations (2007) Declaration on the Rights of Indigenous Peoples. New York, NY: United Nations, http://www.un.org/esa/socdev/unpfii/documents/DRIPS_en.pdf, accessed 9 July 2014.

United Nations (2010) 'UNHCR says asylum situation in Greece is "a humanitarian crisis"', Briefing Notes, 21 September. Geneva: Office of the United Nations

High Commissioner for Refugees (UNHCR), http://www.unhcr.org/4c98a0ac9.html, accessed 15 October 2012.

Virilio, Paul (2008) 'On Georges Perec', in Stephen Johnstone (ed.) *The Everyday*. London: Whitechapel Gallery, pp. 108–10.

Virno, Paolo (1996) 'Virtuosity and revolution: the political theory of exodus', in Paolo Virno and Michael Hardt (eds) *Radical Thought in Italy: A Potential Politics*. Minneapolis, MN: University of Minnesota Press, pp. 189–210.

Virno, Paolo (2004) *A Grammar of the Multitude: For an Analysis of Contemporary Forms of Life*. Trans. Isabella Bertoletti, James Cascaito and Andrea Casson. New York, NY and Los Angeles, CA: Semiotext(e) and Foreign Agents.

Virno, Paolo (2012) 'Die Logik der Tumulte', in Isabell Lorey, Roberto Nigro and Gerald Raunig (eds) *Inventionen 2*. Zurich: Diaphanes, pp. 17–26.

Watkins, Susan (2012)'Presentism? A reply to T. J. Clark', *New Left Review* 74: 77–102.

Weeks, Jane and Valerie Bott (2003) *Scoping Survey of Historic Human Remains in English Museums Undertaken on Behalf of the Ministerial Working Group on Human Remains*. London: The Ministerial Working Group on Human Remains, http://www.honour.org.uk/wp-content/uploads/2014/05/ScopingSurveyWGHR-2.pdf, accessed 14 July 2014.

Weil, Simone (1960) 'L'Allemagne en attente (Impressions d'août et septembre)', in Simone Weil, *Écrits historiques et politiques*. Paris: Gallimard, pp. 102–14.

Weiner, Annette B. (1992) *Inalienable Possessions: The Paradox of Keeping-While-Giving*. Berkeley, CA: University of California Press.

Weitz, Eric D. (2007) *Weimar Germany. Promise and Tragedy*. Princeton, NJ: Princeton University Press.

Westbrook, Laura (2012) 'Tattooed Maori heads welcomed home', Stuff.co.nz. [online video], http://www.stuff.co.nz/national/6322519/Tattooed-Maori-heads-welcomed-home, accessed 10 July 2014.

Wihstutz, Benjamin (2012) *Der andere Raum. Politiken sozialer Grenzverhandlungen im Gegenwartstheater*. Zürich and Berlin: Diaphanes.

Wiles, David (2011) *Theatre and Citizenship*. Cambridge: Cambridge University Press.

Willett, John (1996) *Art and Politics in the Weimar Period: The New Sobriety 1917–1933*. New York, NY: Da Capo Press.

Williams, Zoe (2012) 'The Saturday interview: Stuart Hall', *Guardian*, 11 February.

Winter, Walter (2013) 'Care, Sorge, Für-Sorge. 5 Thesen', *Igrundrisse* 47: 7–14.

Wittgenstein, Ludwig (1986 [1953]) *Philosophical Investigations*. Trans. G. E. M. Anscombe. Oxford: Basil Blackwell.

Wolff, Janet (1995) *Resident Alien: Feminist Cultural Criticism*. Cambridge: Polity Press.

Woodcock, Andrew (2009) 'Minister sees "green shoots" of recovery', *Independent*, 14 January, http://www.independent.co.uk/news/uk/politics/minister-sees-green-shoots-of-recovery-1366124.html, accessed 12 April 2014.

Wroe, Simon (2011) 'Gillian Slovo's new play *The Riots* is at the Tricycle Theatre from November 17 until December 10', *Camden New Journal*, 10 November, http://www.camdennewjournal.com/feature-gillian-slovo%E2%80%99s-new-play-riots-tricycle-theatre-november-17-until-december-10, accessed 21 June 2013.

Yates, Luke (2014) 'Rethinking prefiguration: alternatives, micropolitics and goals in social movements', *Social Movement Studies: Journal of Social, Cultural and Political Protest* [online], doi: 10.1080/14742837.2013.870883.

Zaroulia, Marilena (2014) '"Members of a chorus of a certain tragedy": Euripides' *Orestes* at the National Theatre of Greece', in Nadine Holdsworth (ed.) *Theatre and National Identity: Re-Imagining Conceptions of Nation*. London: Routledge, pp. 200–20.

Zaroulia, Marilena and Philip Hager (2014) 'Europhile or Eurosceptic?: Gaps in the narrative and performance of panic', in Myrto Tsilimpounidi and Aylwyn Walsh (eds) *Remapping 'Crisis': A Guide to Athens*. Winchester: Zer0, pp. 226–47.

Zeit Online (2012) 'Samaras vergleicht Griechenland mit Weimarer Republik', *Zeit Online*, 5 October, http://www.zeit.de/politik/ausland/2012-10/samaras-griechenland-chaos, accessed 2 September 2014.

Žižek, Slavoj (2012) *The Year of Dreaming Dangerously*. London: Verso.

Index

Printed and bound by CPI Group (UK) Ltd, Croydon, CR0 4YY